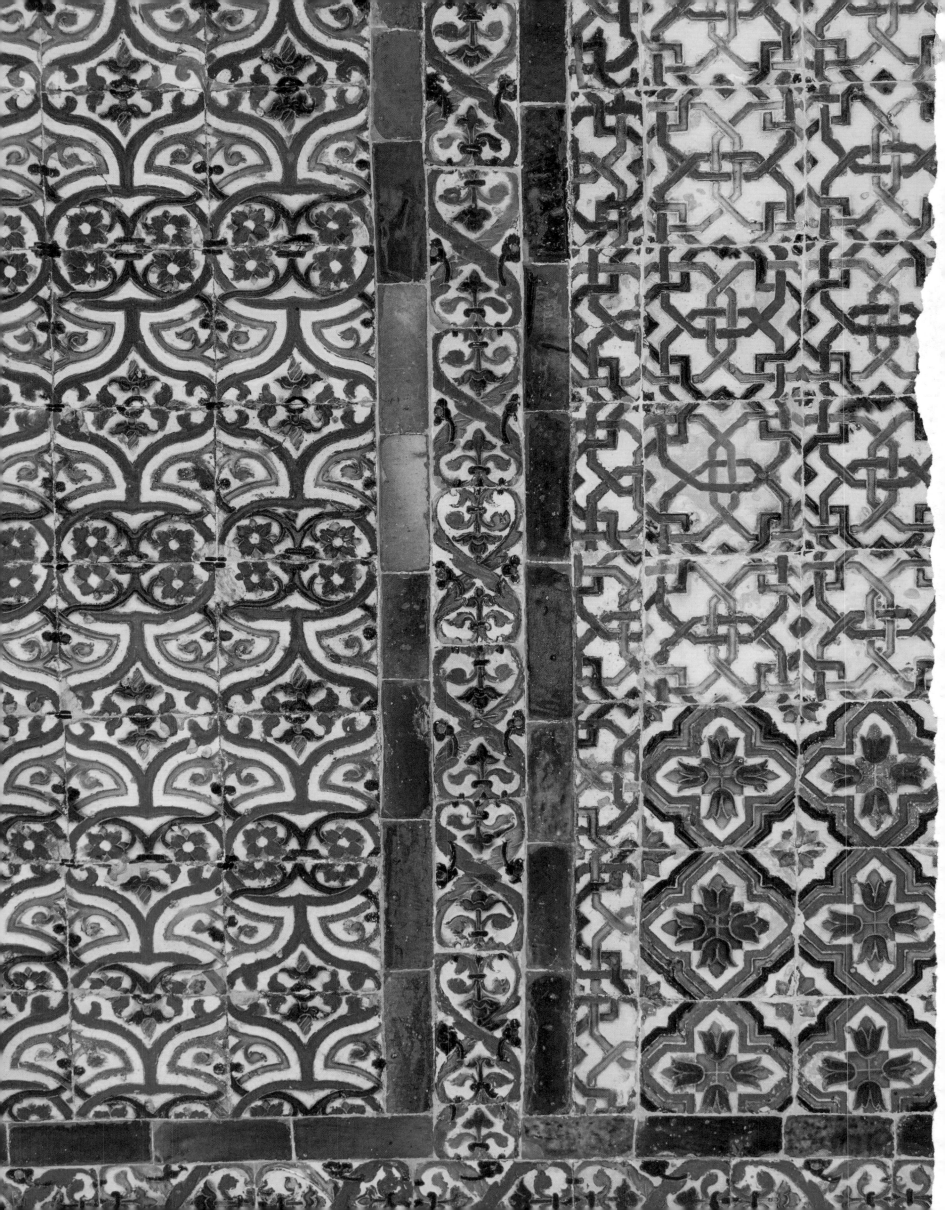

G

Forever Green
Carlos Mota

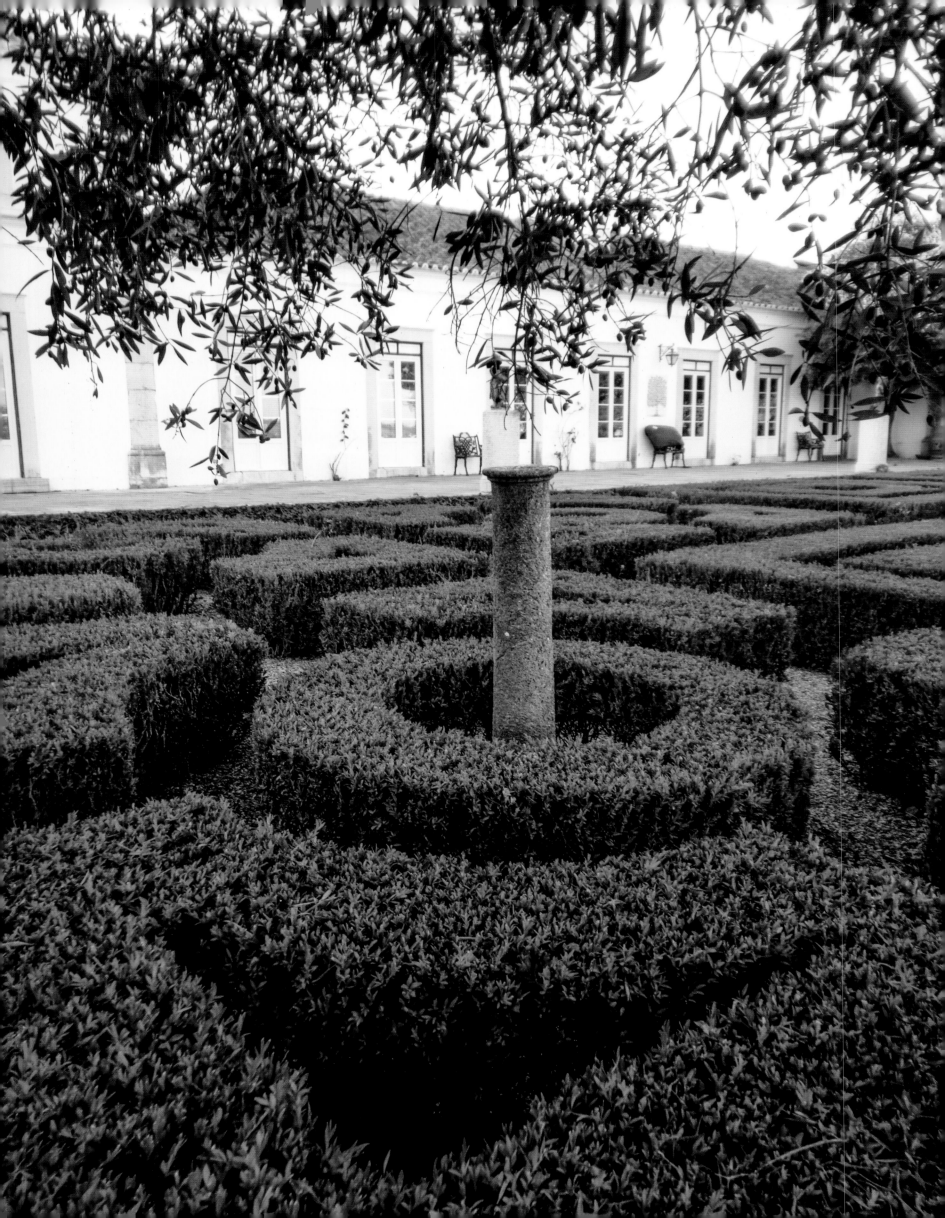

Forever Green
Carlos Mota

VENDOME

NEW YORK • LONDON

Introduction

"Toujours le vert!"
— HUBERT DE GIVENCHY

Verde, que te quiero, verde! Green is my absolute favorite color!
Okay, lavender and purple, too, but let's stick with green for now.
Everything begins with white but ends with green.

My grandfather had a farm in Venezuela. We used to go there
once a month and run wild, surrounded by animals and fruit
trees. Those visits were the highlight of my life. It was there, at a
very early age, that I discovered my passion for nature and animals,
especially birds and chickens. I vividly remember the colors of
the farm, the plantings, the mango trees, etc. Our first pets were
chickens and a goat.

We traveled a lot all over the country. Venezuela is beautiful,
blessed with the most incredible landscapes and beaches.
I think it is so important for a child to see as much as
possible in order to develop an eye. It happened to me and
opened a whole world that I cherish to this day. Sometimes
we take nature for granted, not realizing that it is probably
the best school for design—for colors, proportions, and
textures—and a never-ending source of inspiration.

I can't begin to imagine life without the color green! Can you?
For starters, green is nature, which is a symbol of life. #GreenisLife

I didn't want to do a book only on gardens (way too many),
but at the same time I needed to include gardens. After all,
private and public gardens are everywhere and provide not only
constant inspiration but escape and relaxation.

I almost called this book *50,000 Shades of Green* because it is true. Green is a neutral and looks great in any interior. You would be amazed how great and chic a room will look if you cover your lampshades in green. It is one of the few colors that you can pair with other colors and it will work. Here you will see a wide range of color combos like green and pink, green and blue, green and yellow, green and black, and the forever classic green and white.

Consisting of photos I've taken on my travels and photos by a host of renowned interiors photographers, this book is my mood board. Like all my previous books, it features some of my favorite places around the world, as well as some of my favorite paintings, gardens, historical rooms, and contemporary interiors. It also includes things I love such as emeralds, textiles, plates, birds, and souks. Some images are all green; some have just a hint of green. Some are of a single item: a chair, a flower, the tablecloth in a room at Chatsworth.

You will find not one but several images of one of my favorite interiors, the dark green rooms of the late Hubert de Givenchy's *hôtel particulier* in Paris, and of my favorite museum in the world, the Egyptian Museum in Cairo, painted the most delicious pistachio shade of green. You'll also find images of simple shacks in the Dominican Republic. Green doesn't have a price tag; it is the most universal and popular of colors. It looks great in a palazzo in Venice or a studio apartment in Brooklyn.

In these troubling times of climate change, this book is an homage to nature and the power of green. We need to celebrate nature and protect her for future generations.

When you love one particular color, your vision becomes more selective, and when you see a room or a painting or even food in your color, you will enjoy it all the more because that color is part of the picture!

Life and nature are a series of beautiful pictures waiting to be discovered. Let's conserve our environment so that we can have a lifetime of beautiful pictures and memories.

Carlos Mota

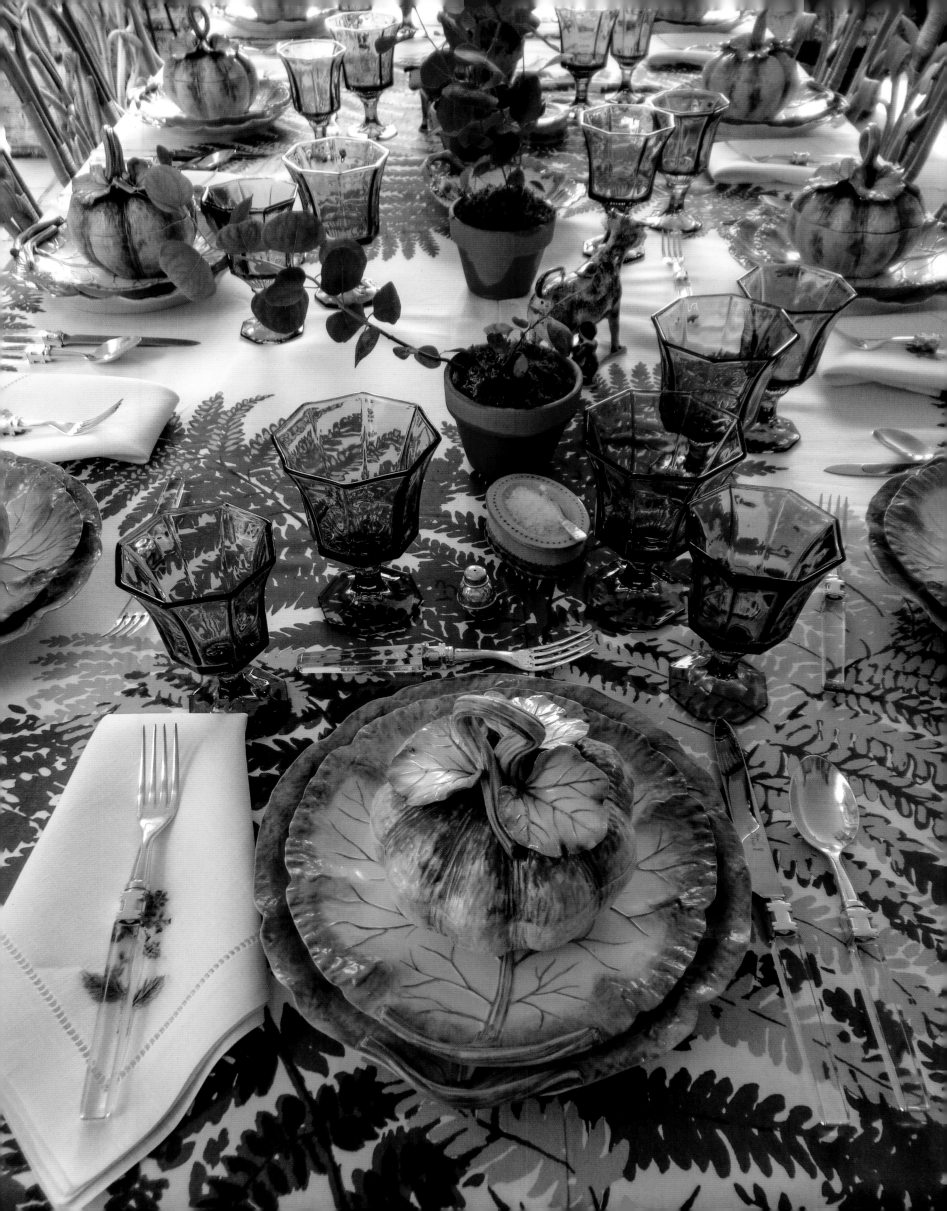

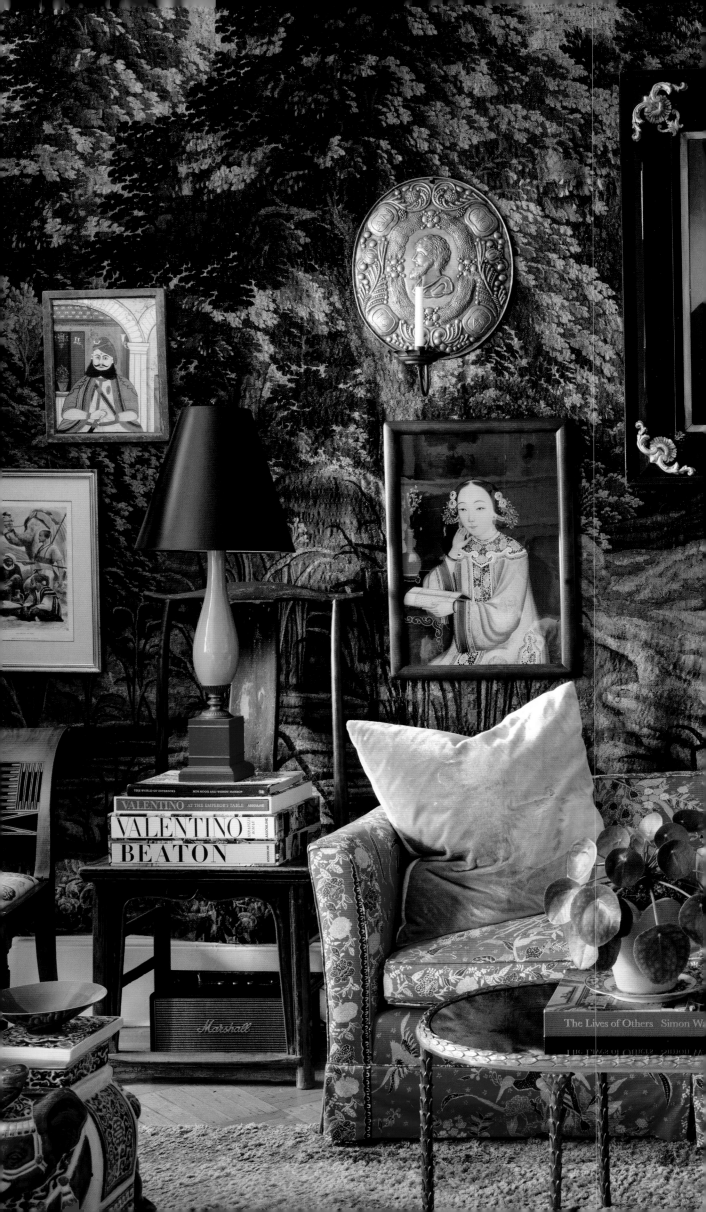

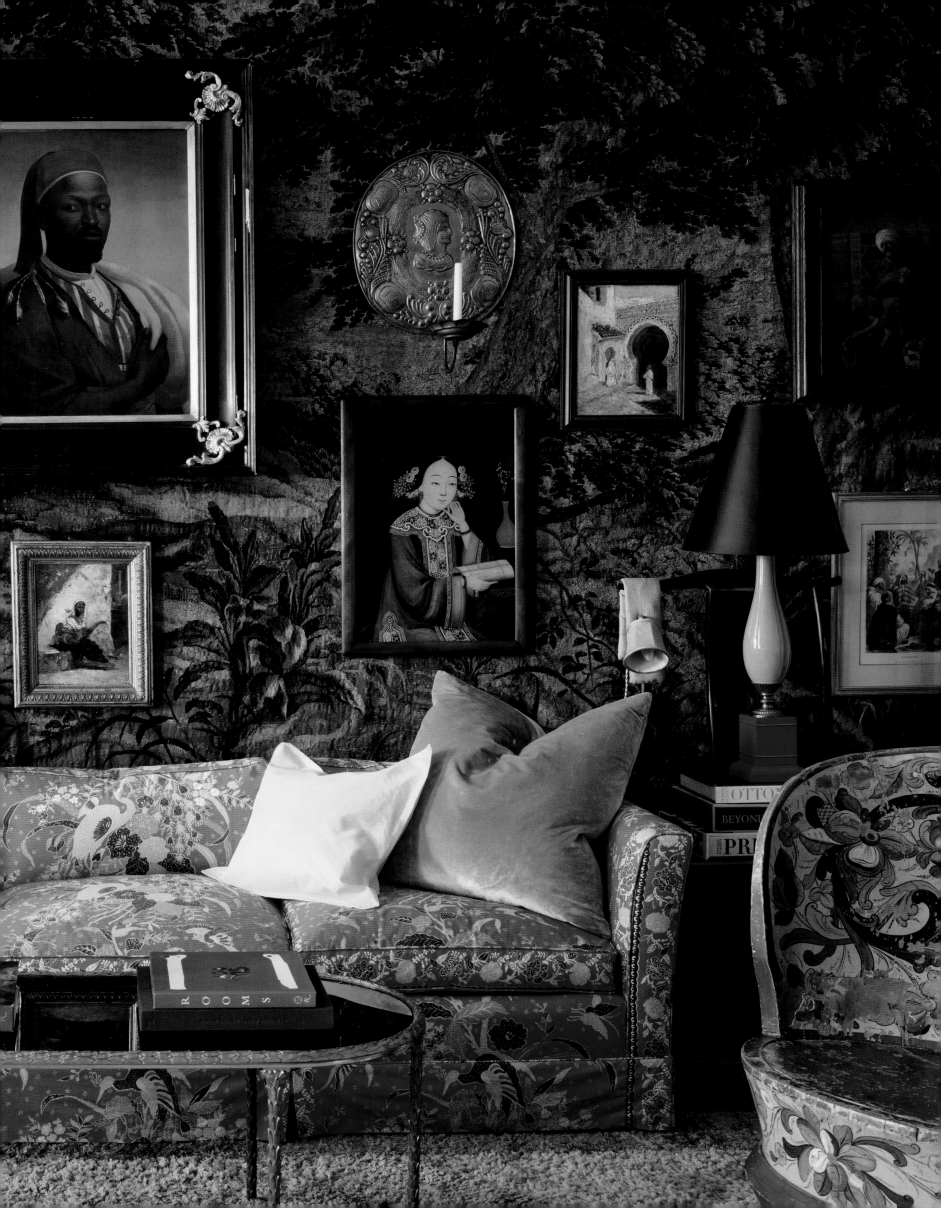

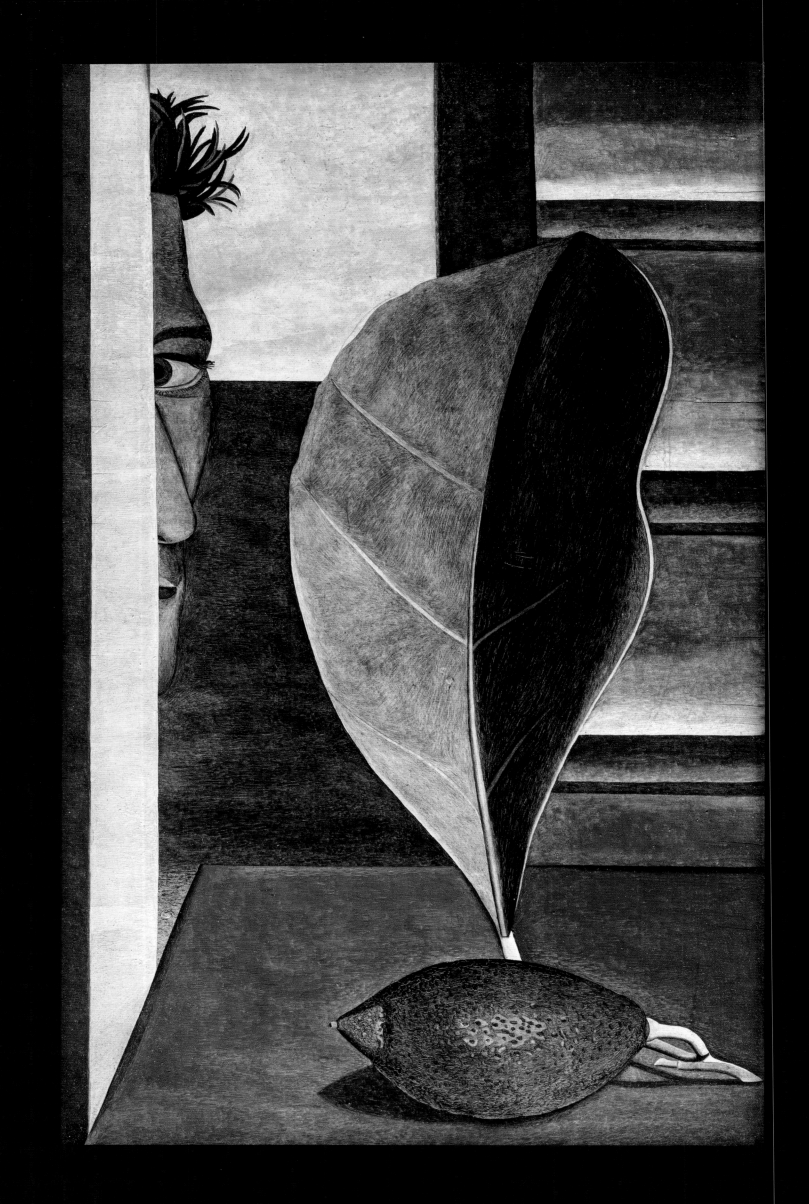

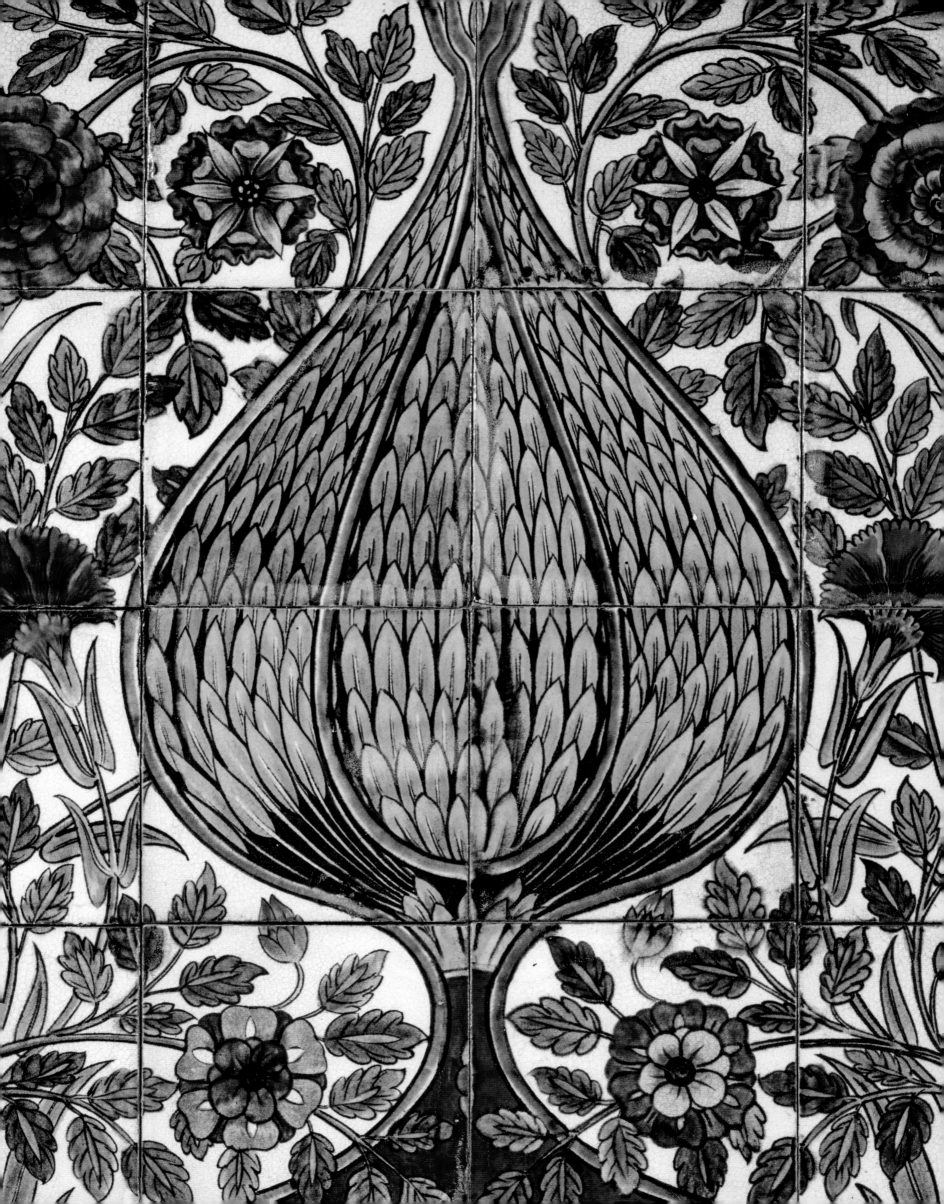

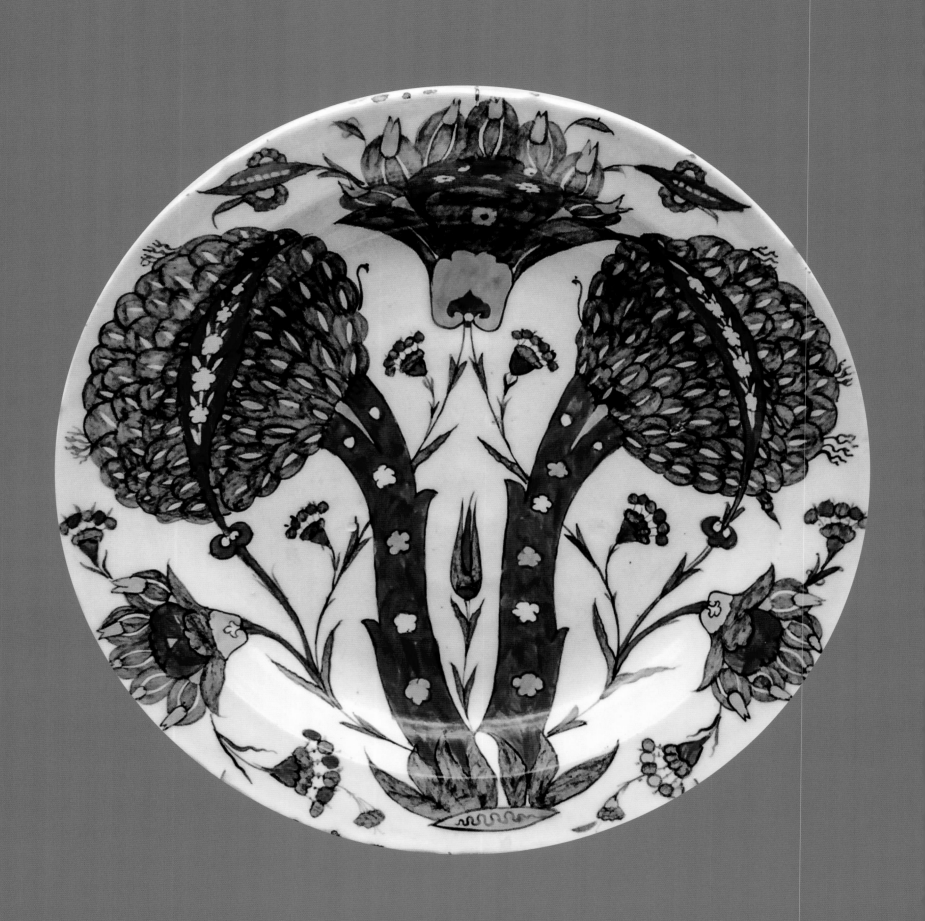

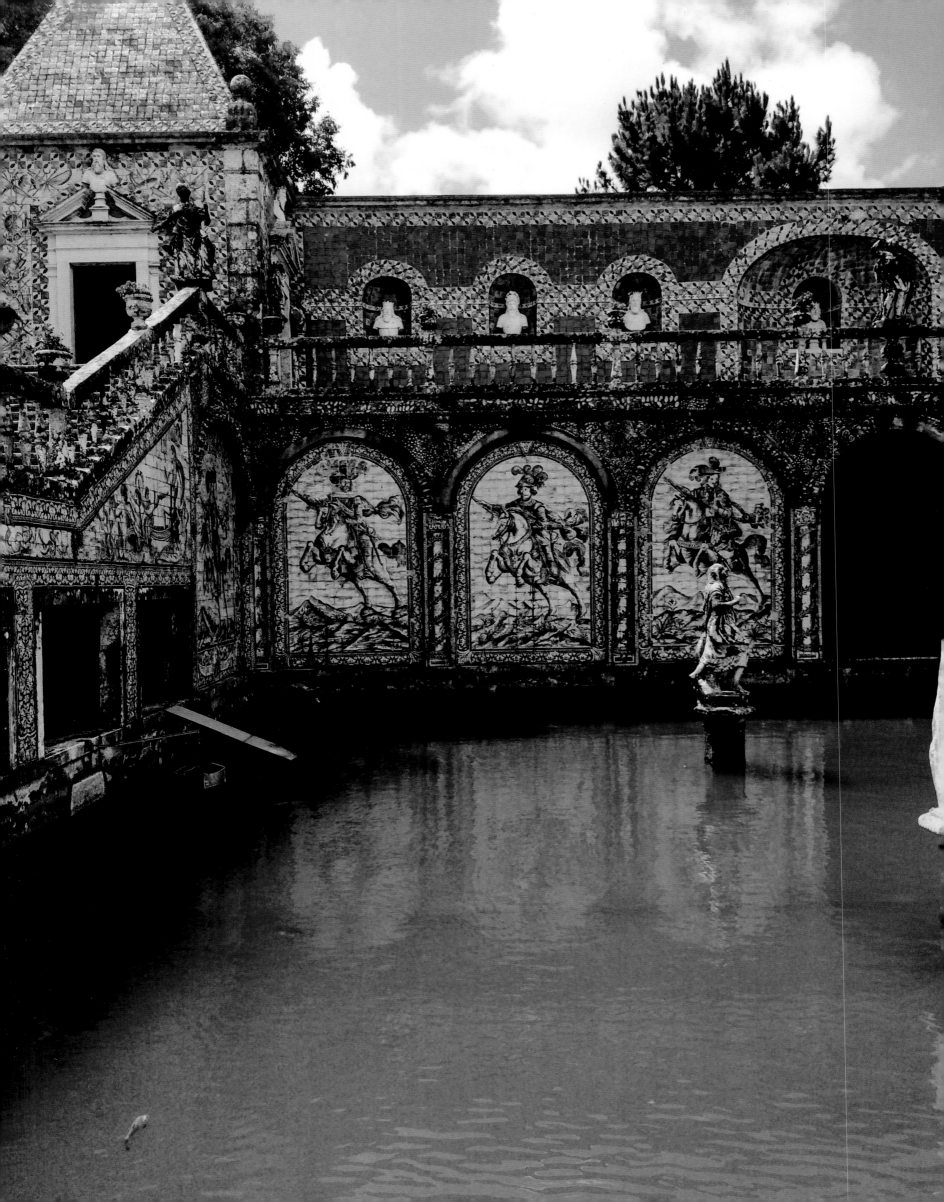

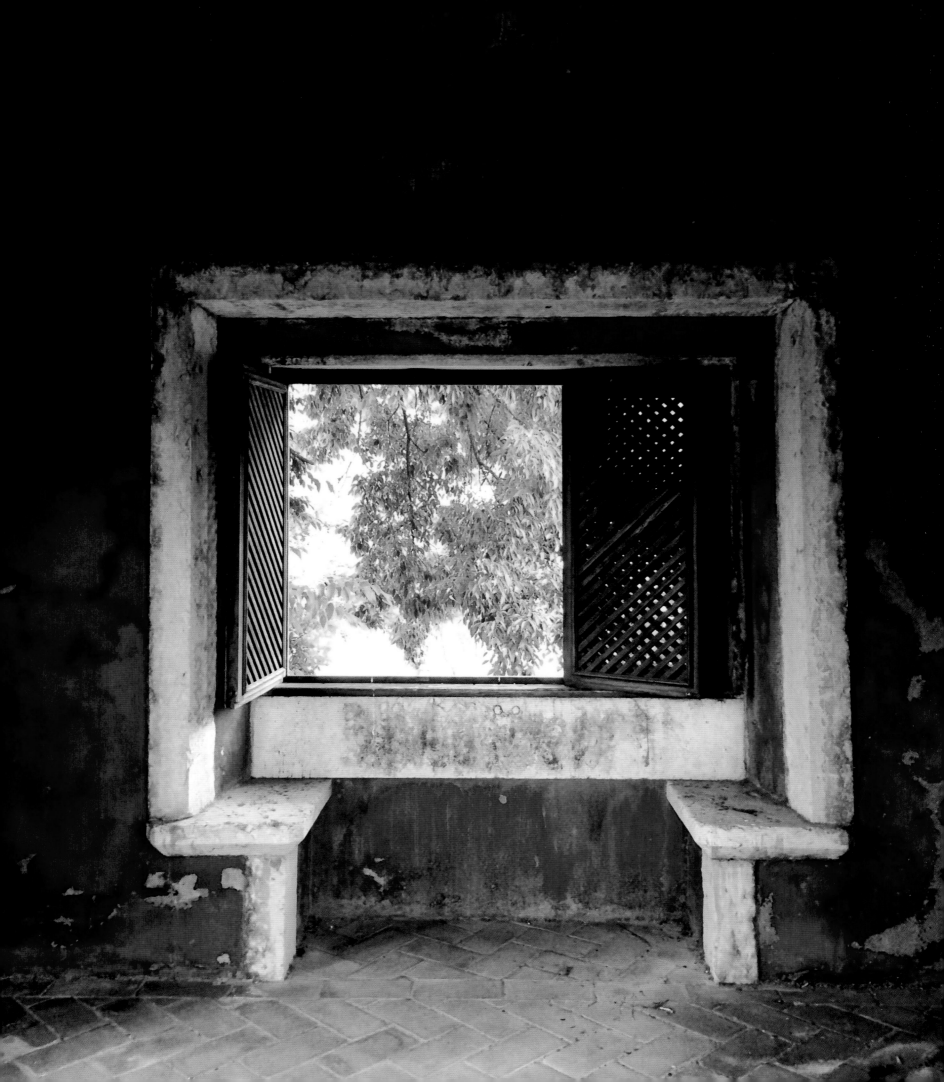

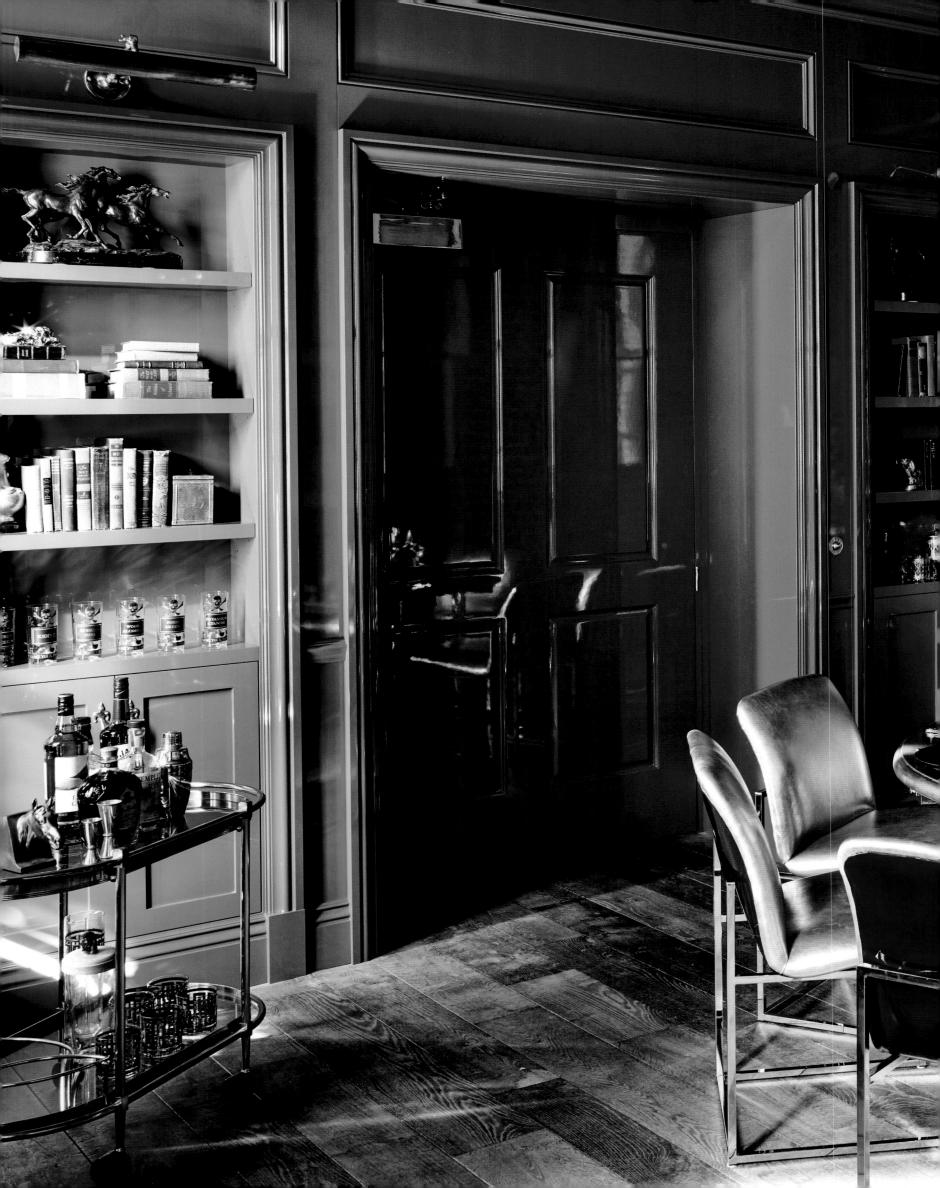

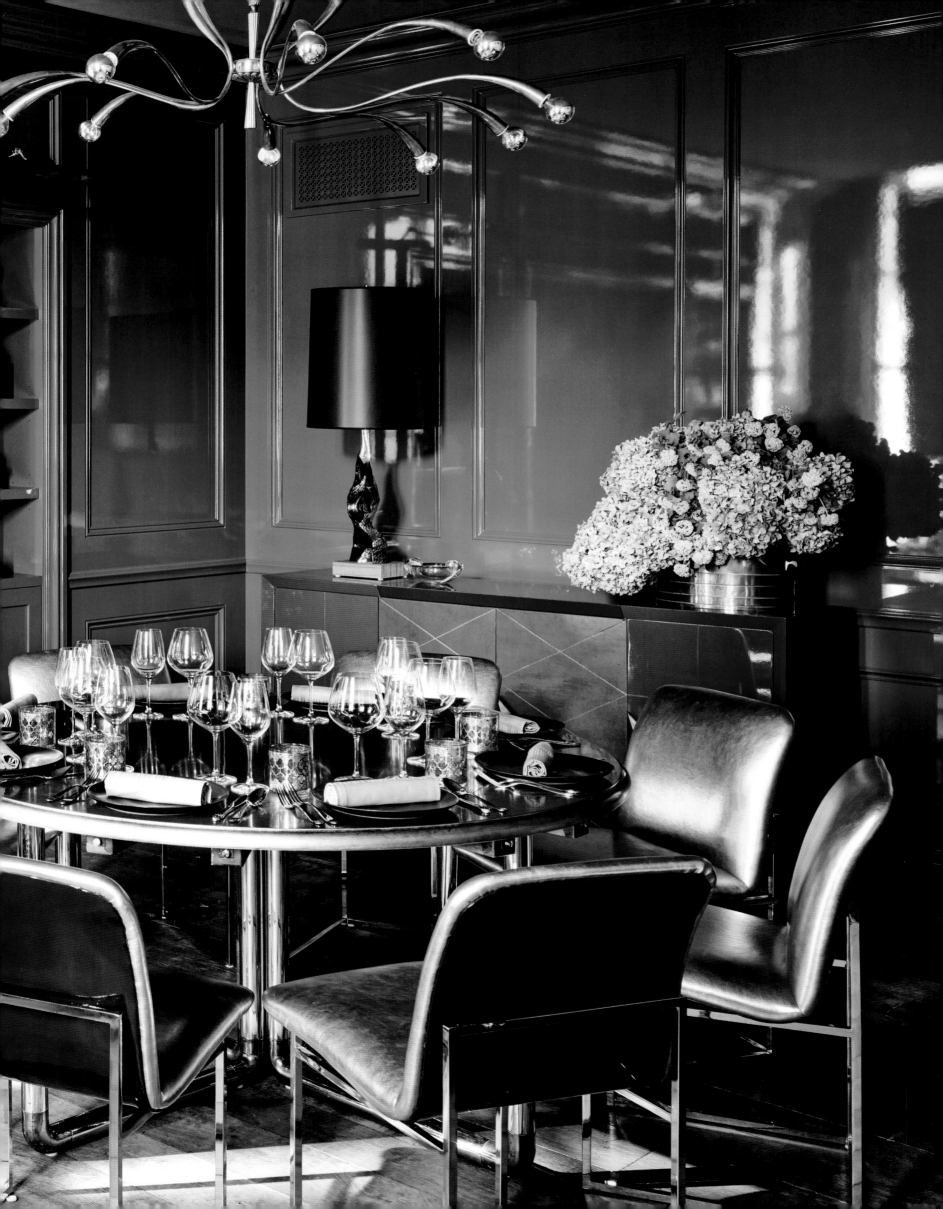

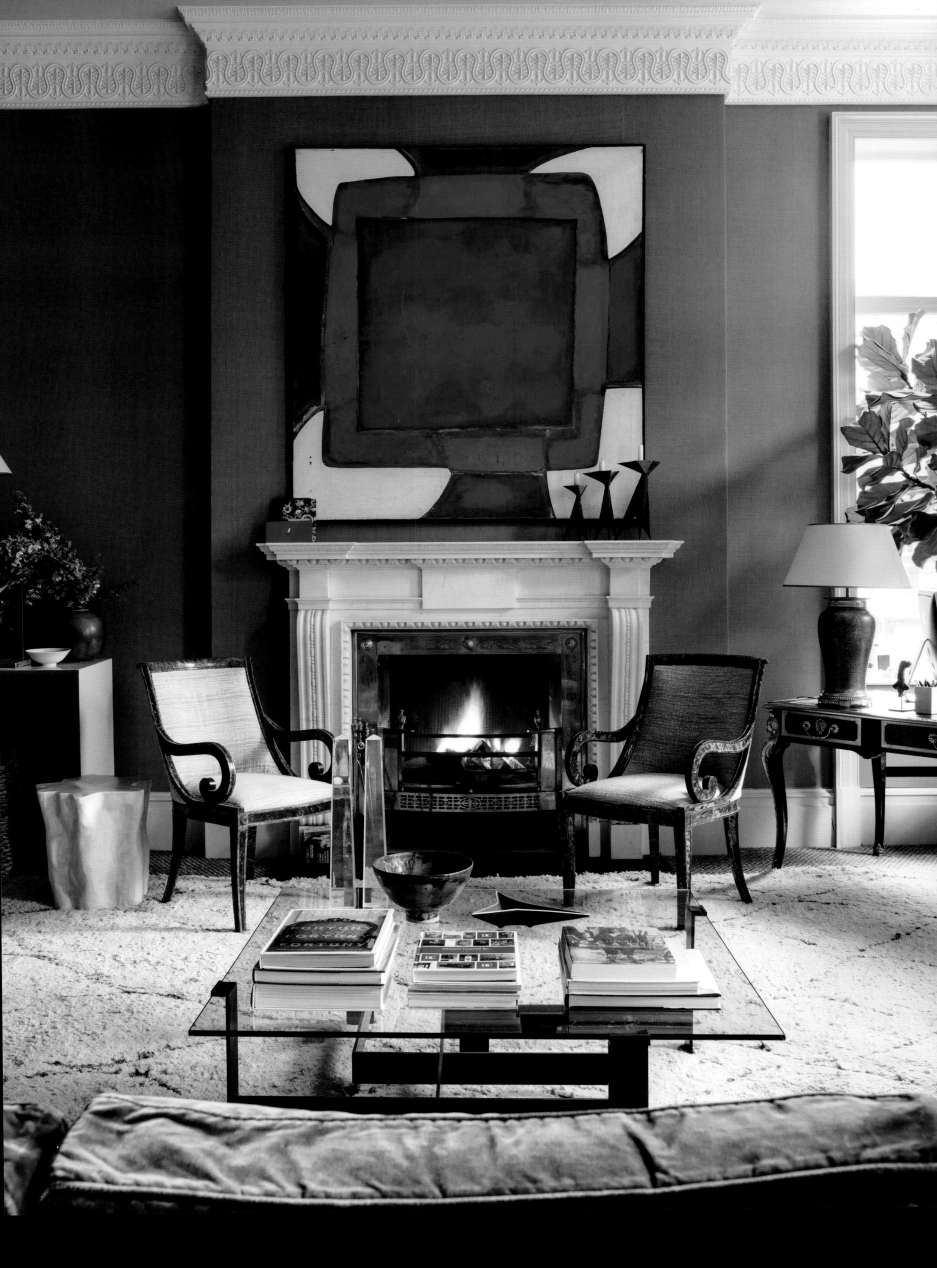

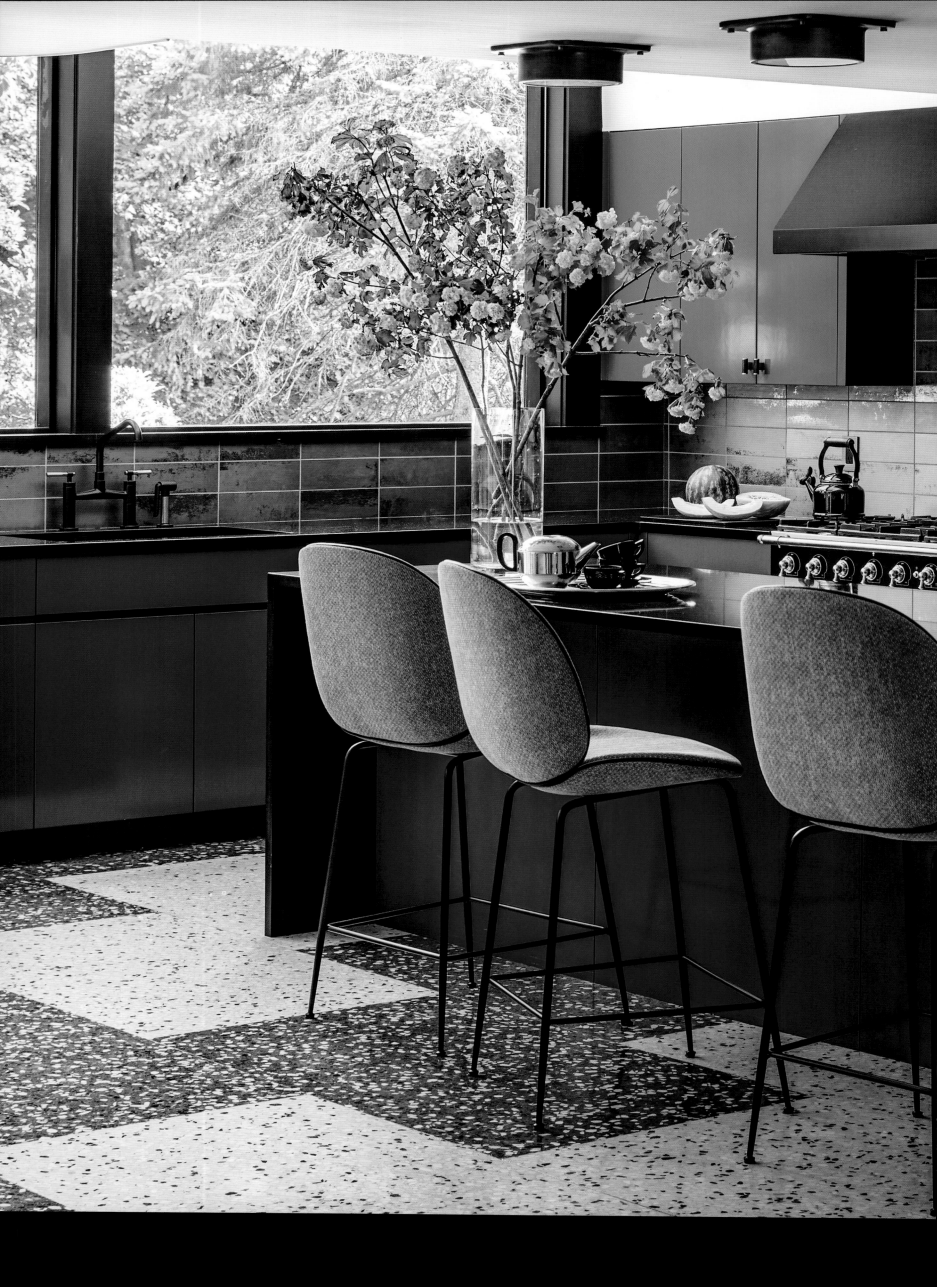

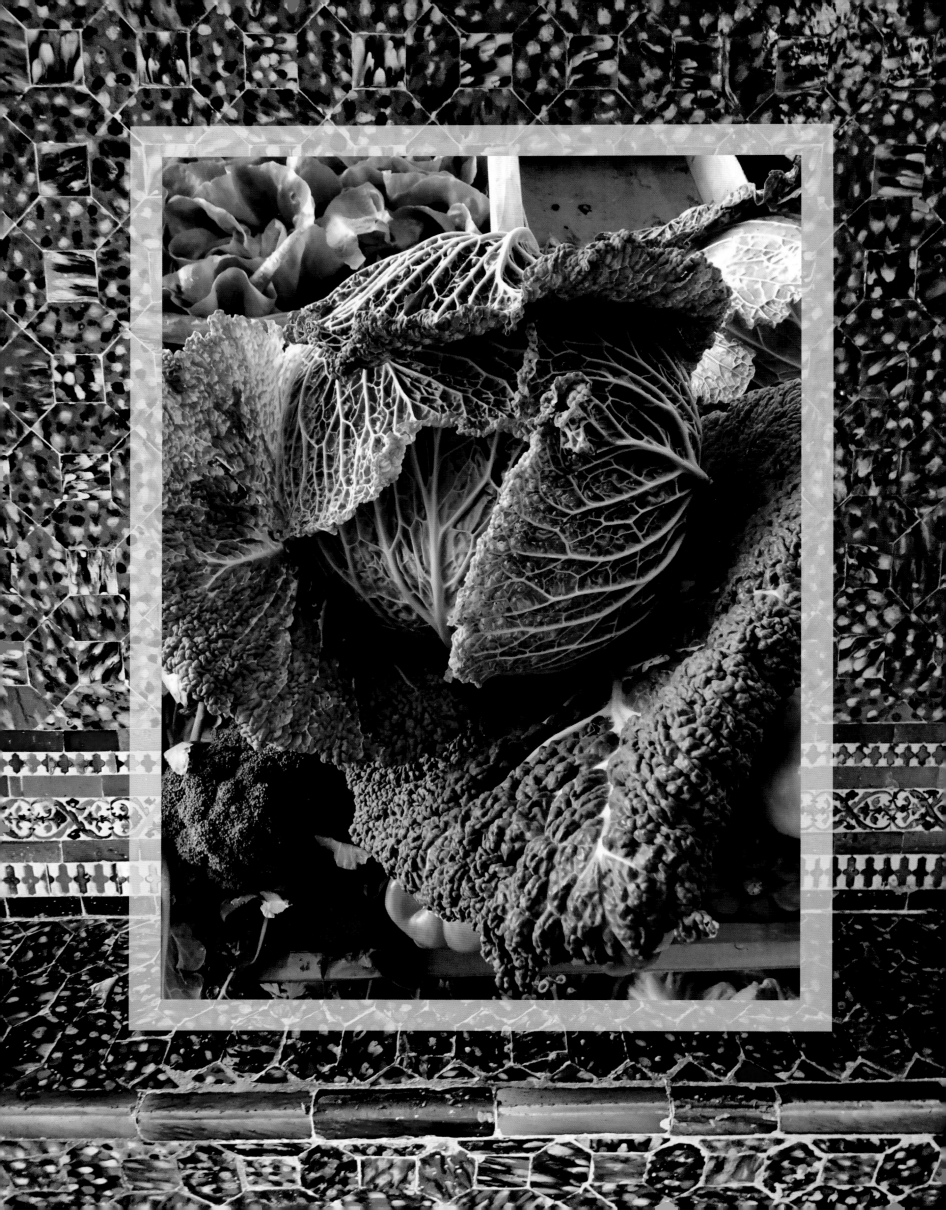

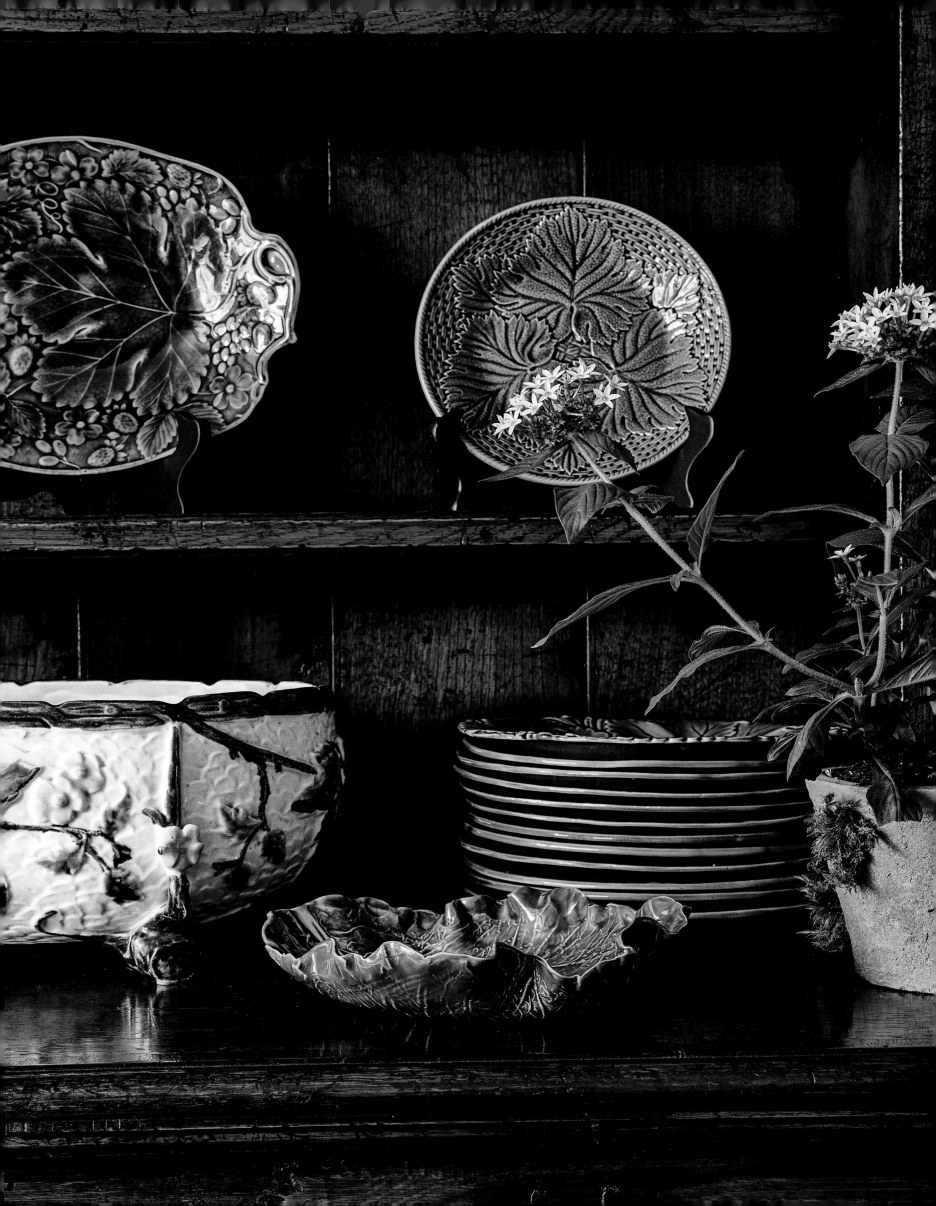

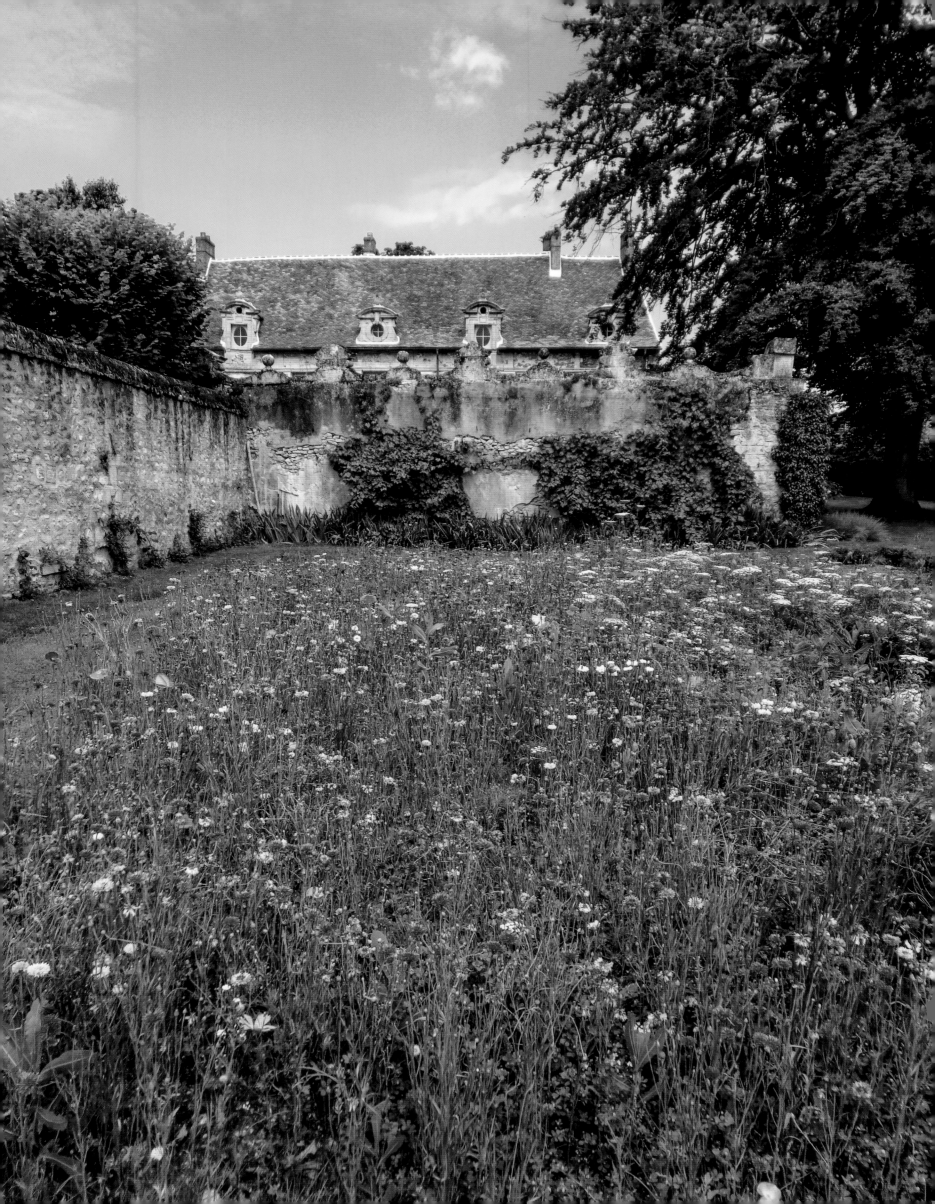

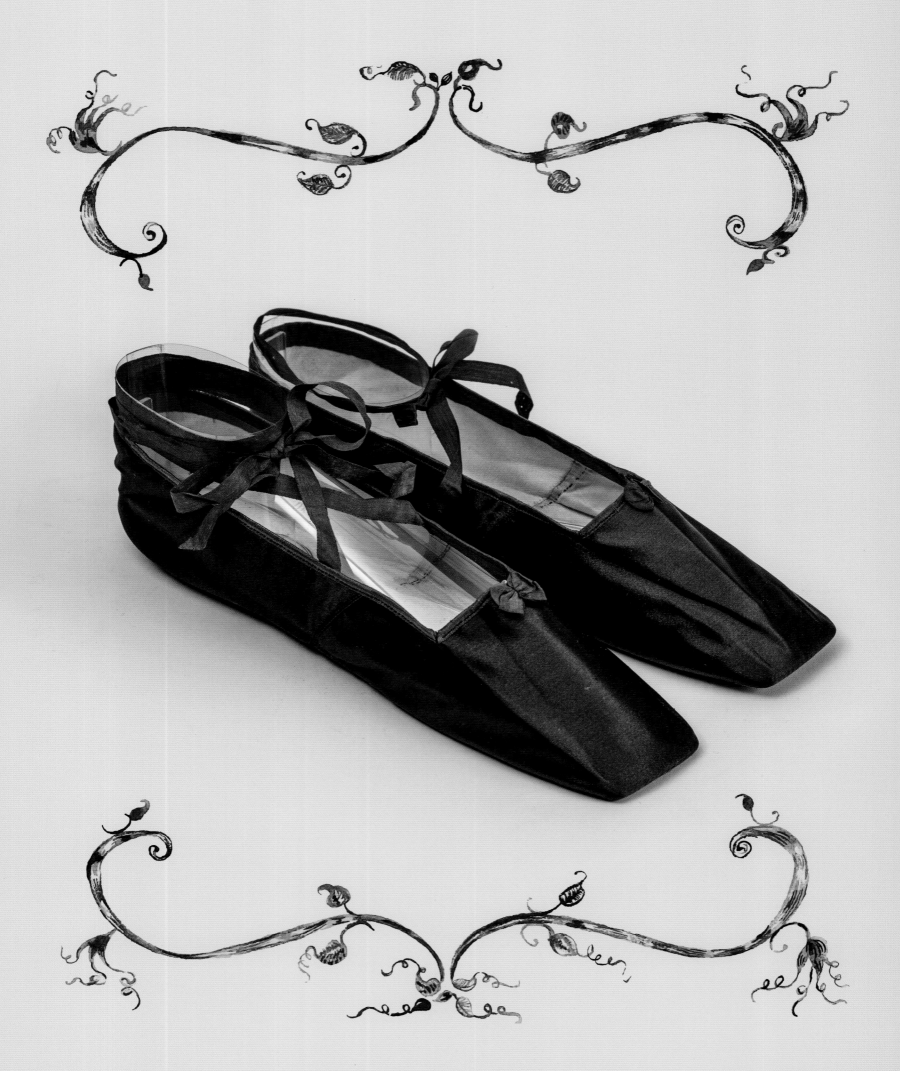

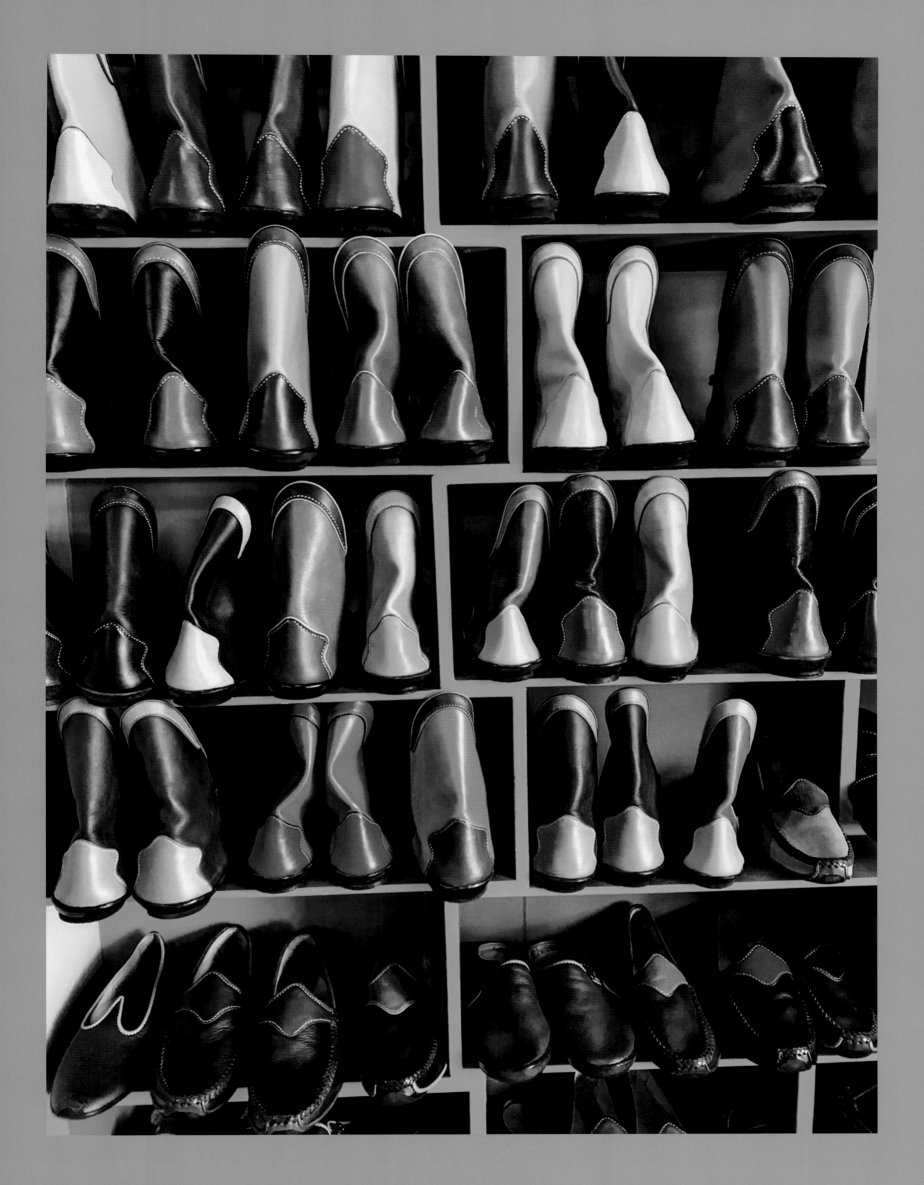

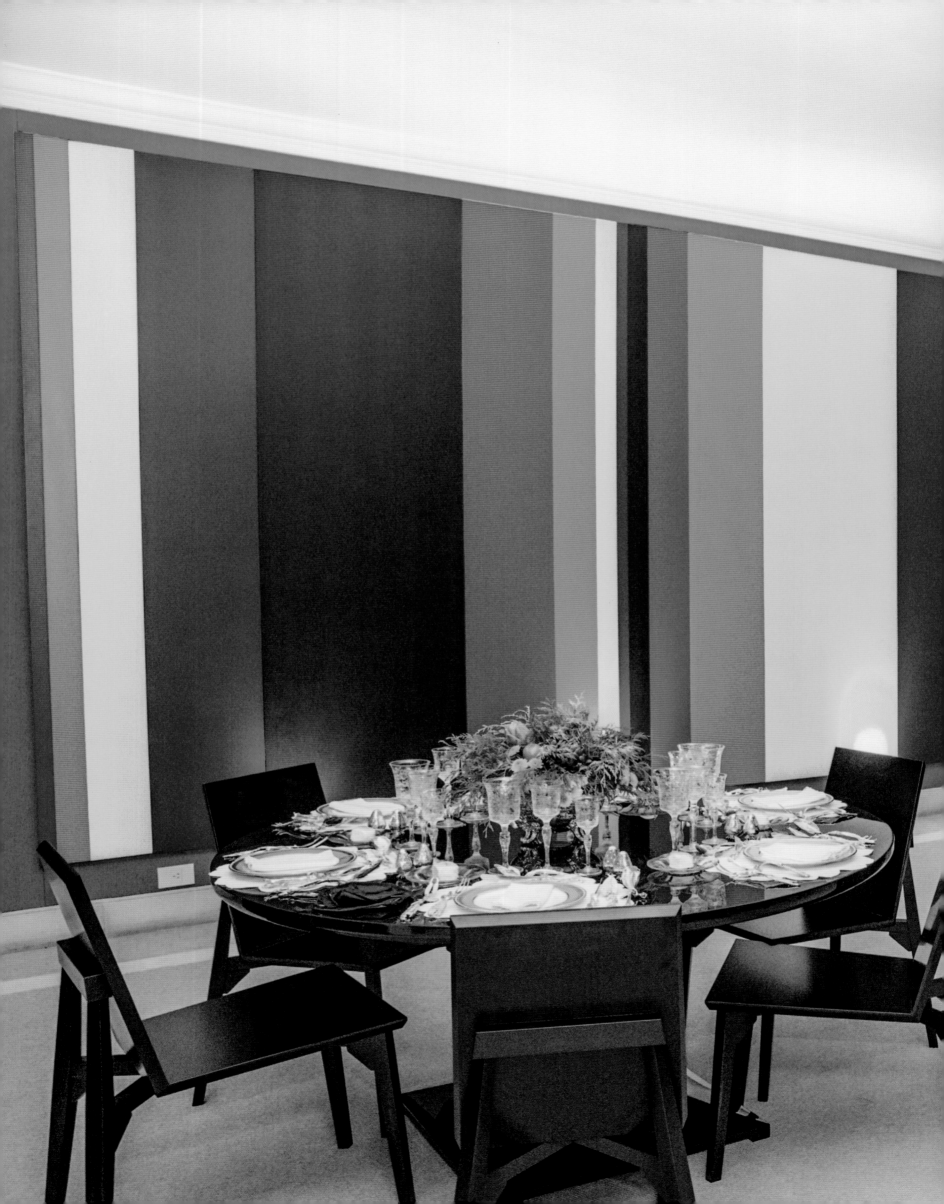

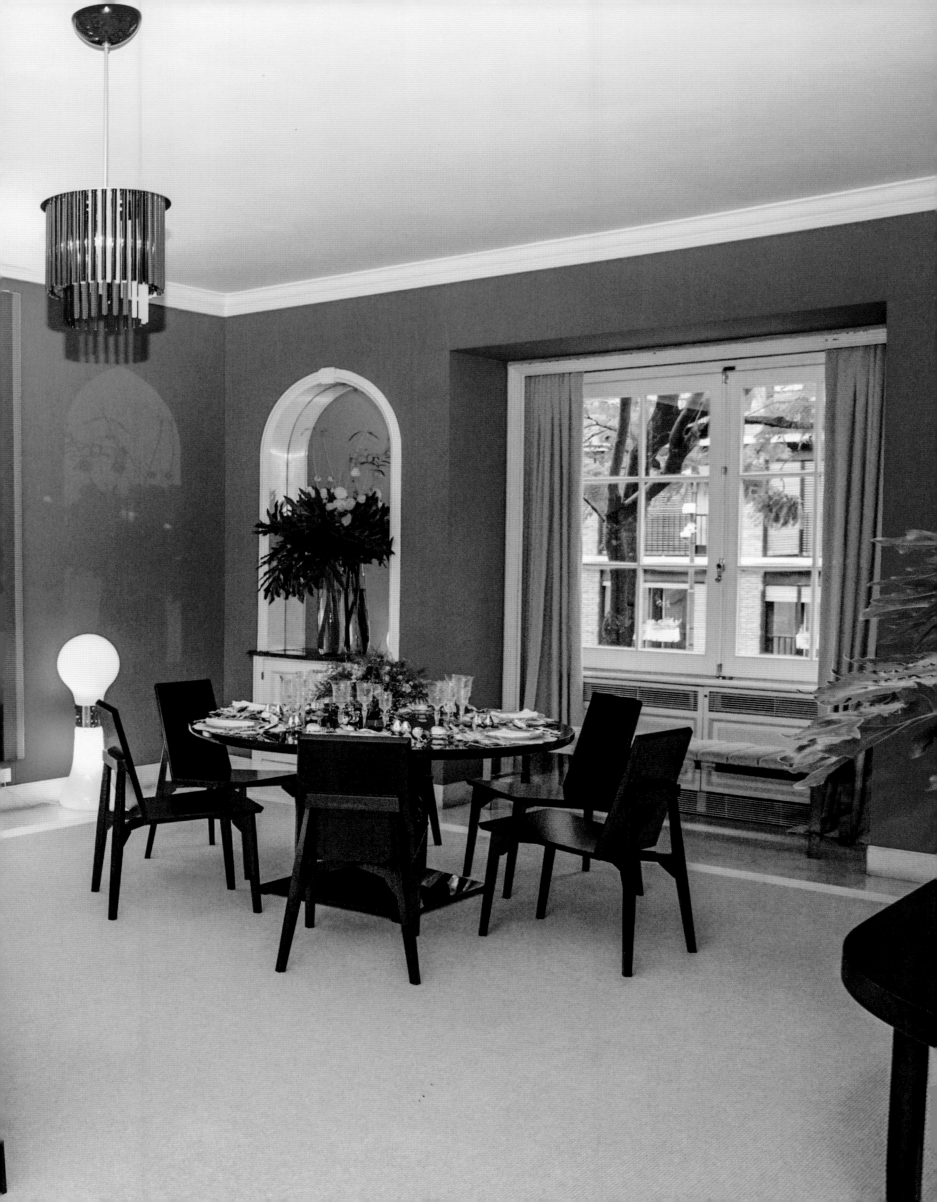

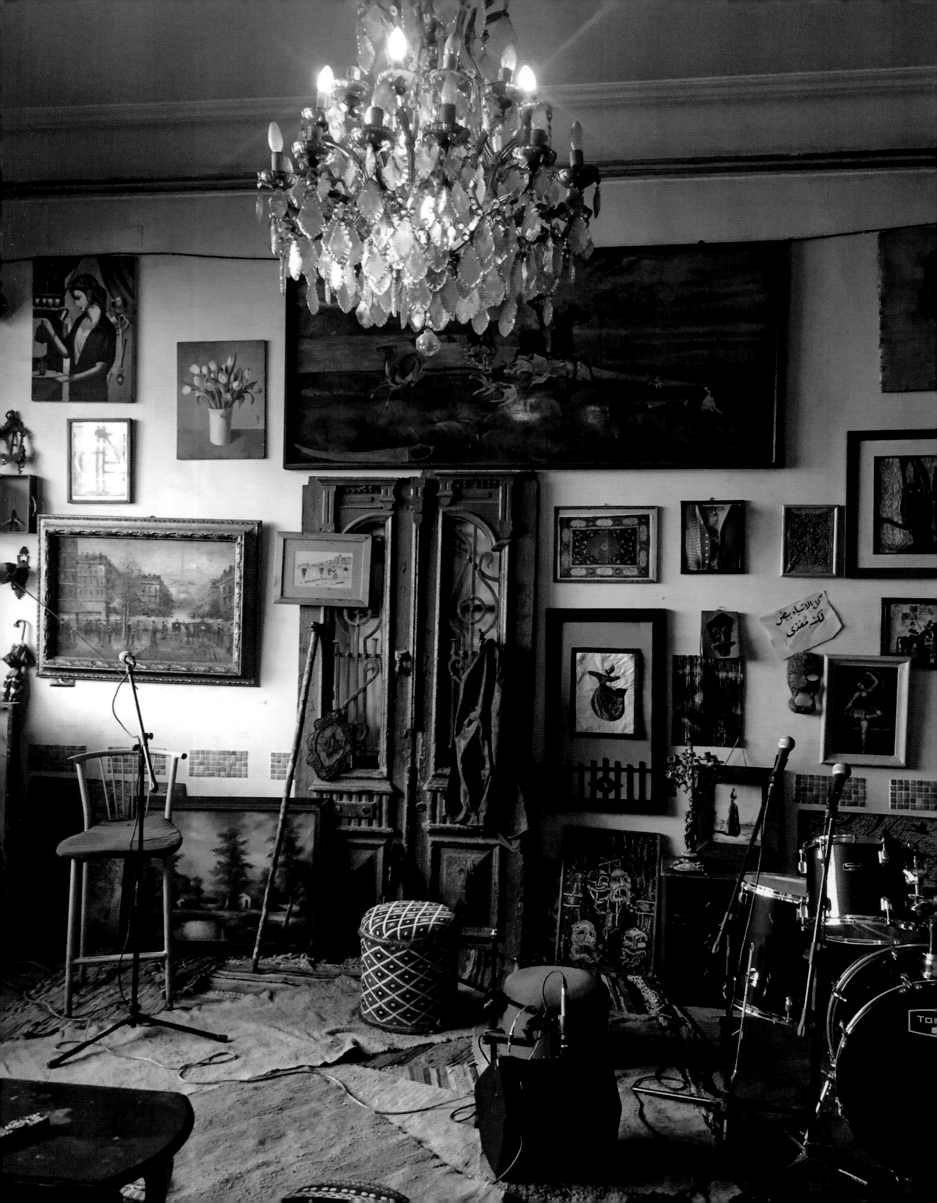

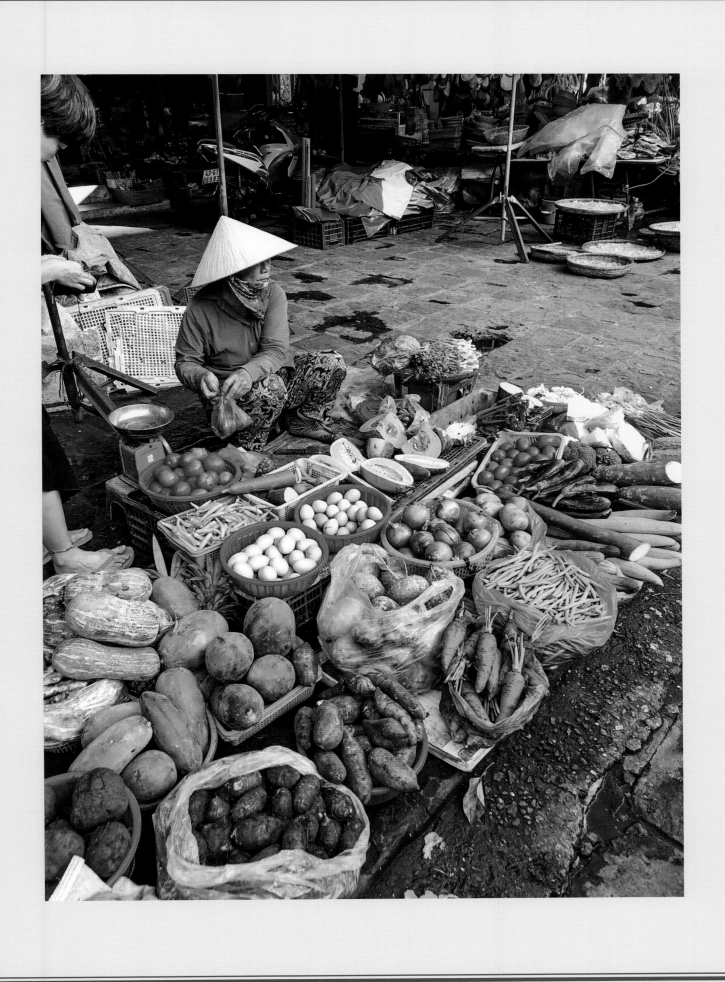

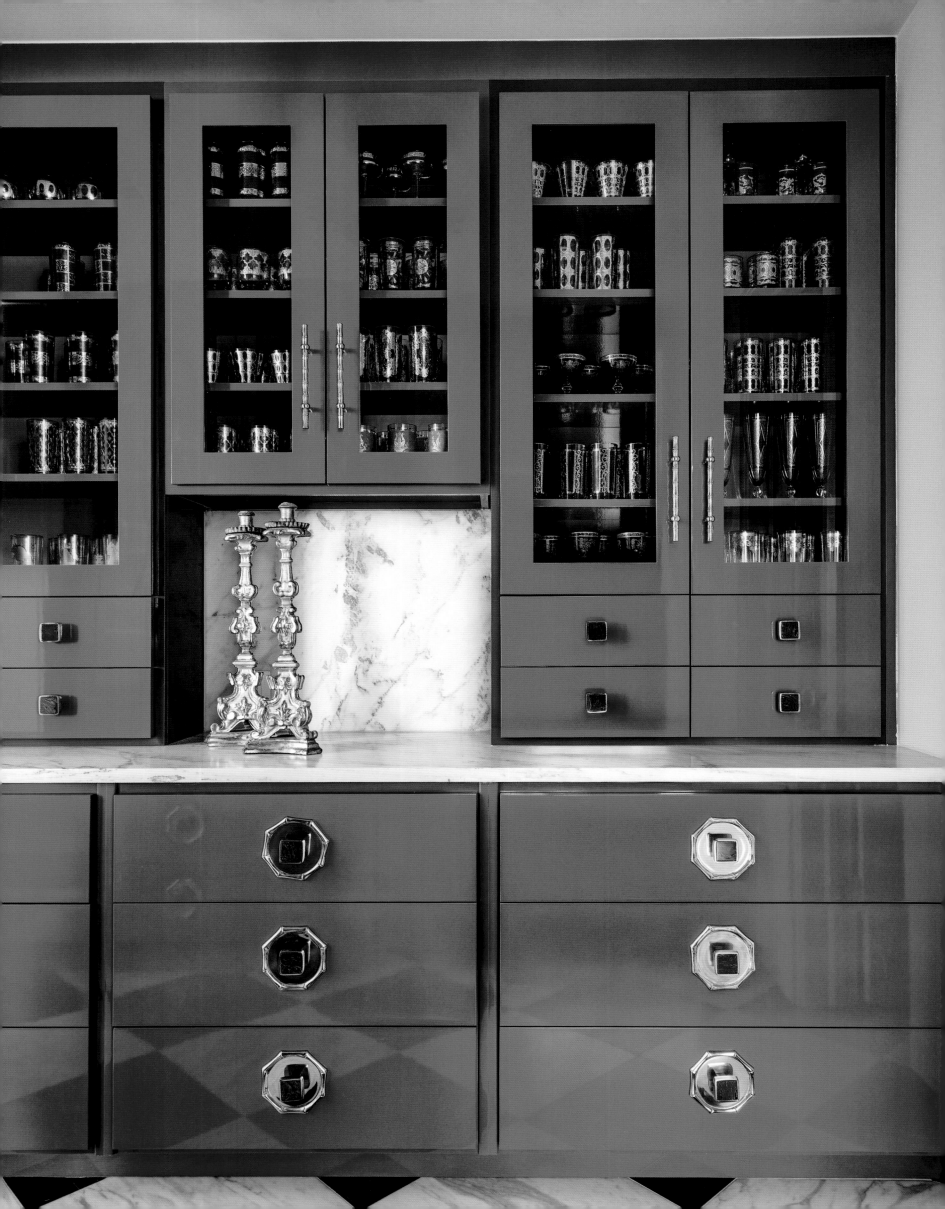

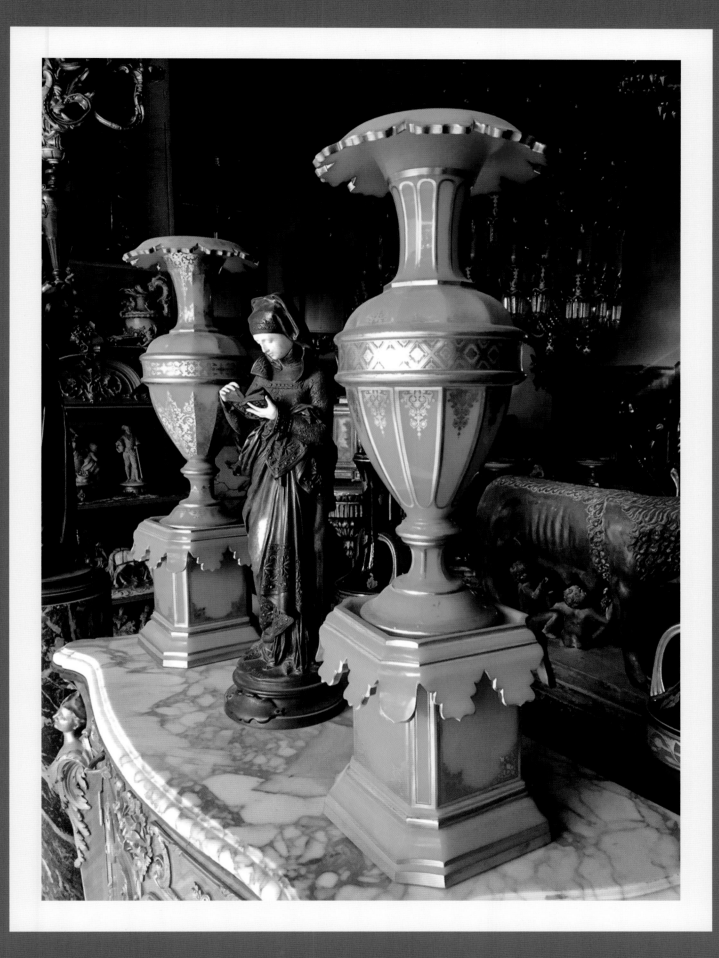

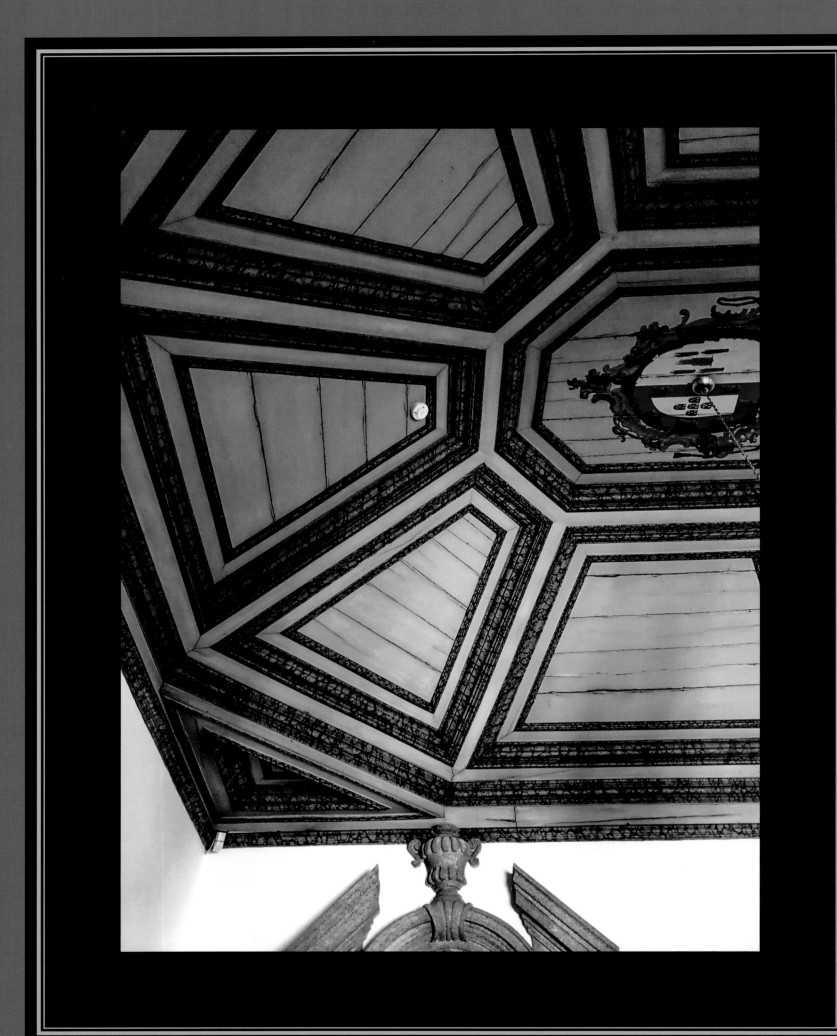

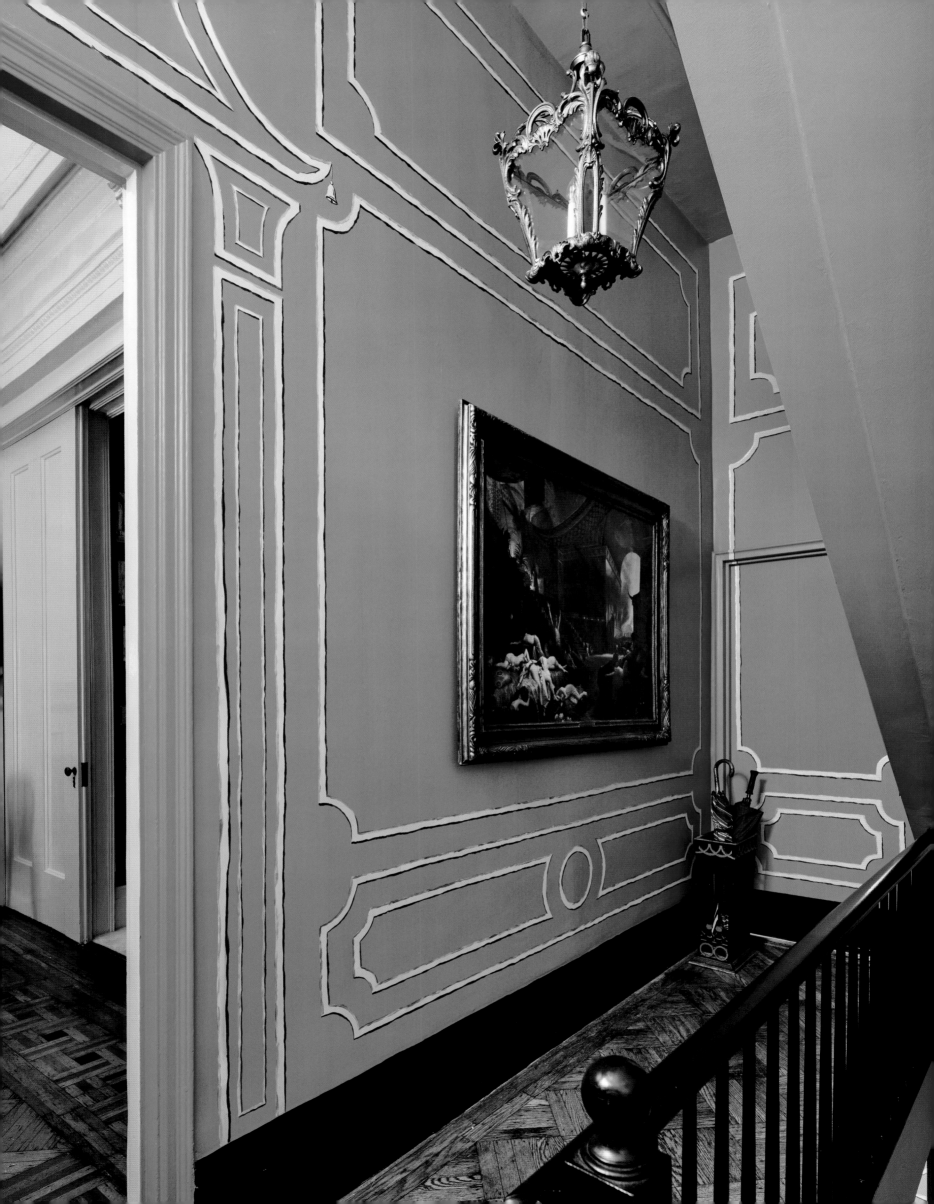

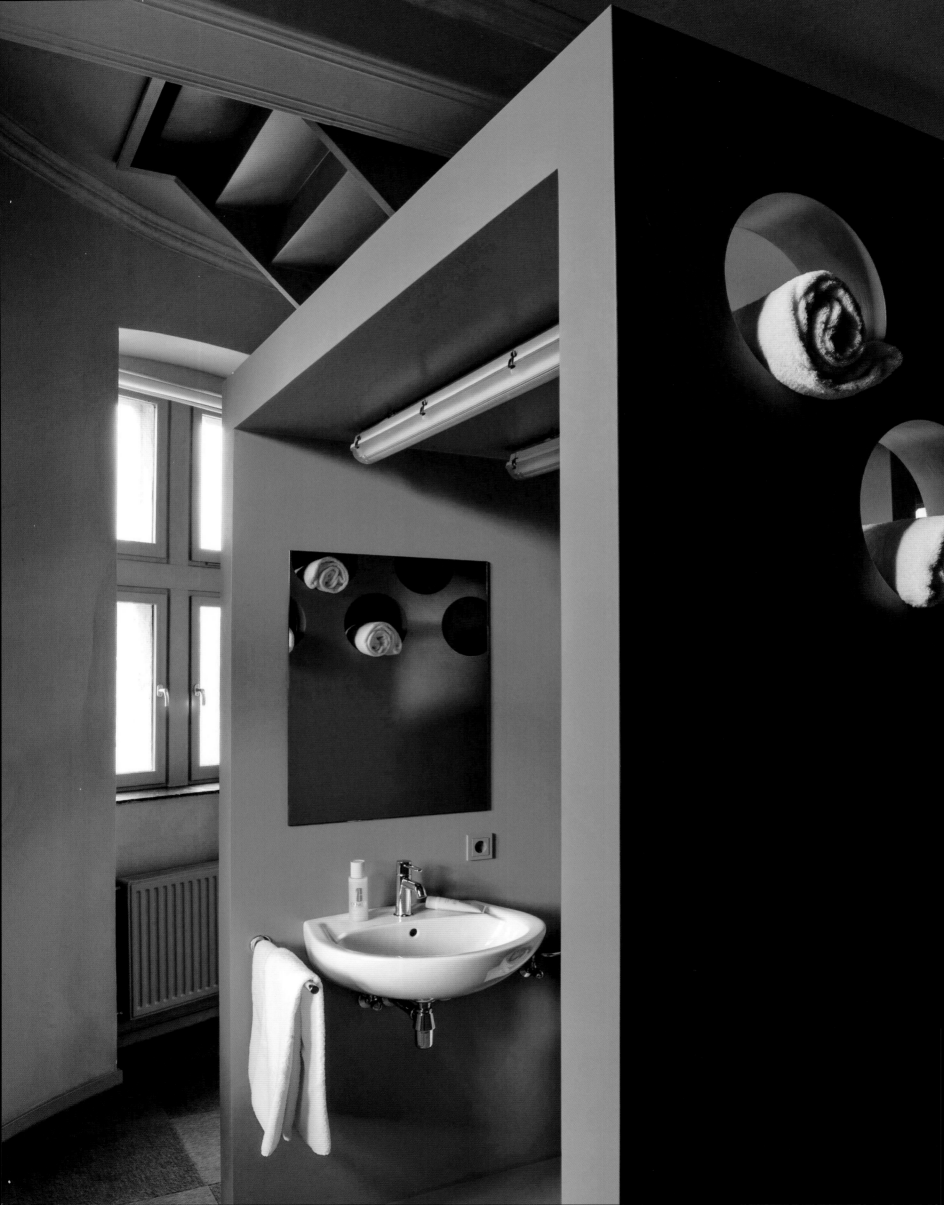

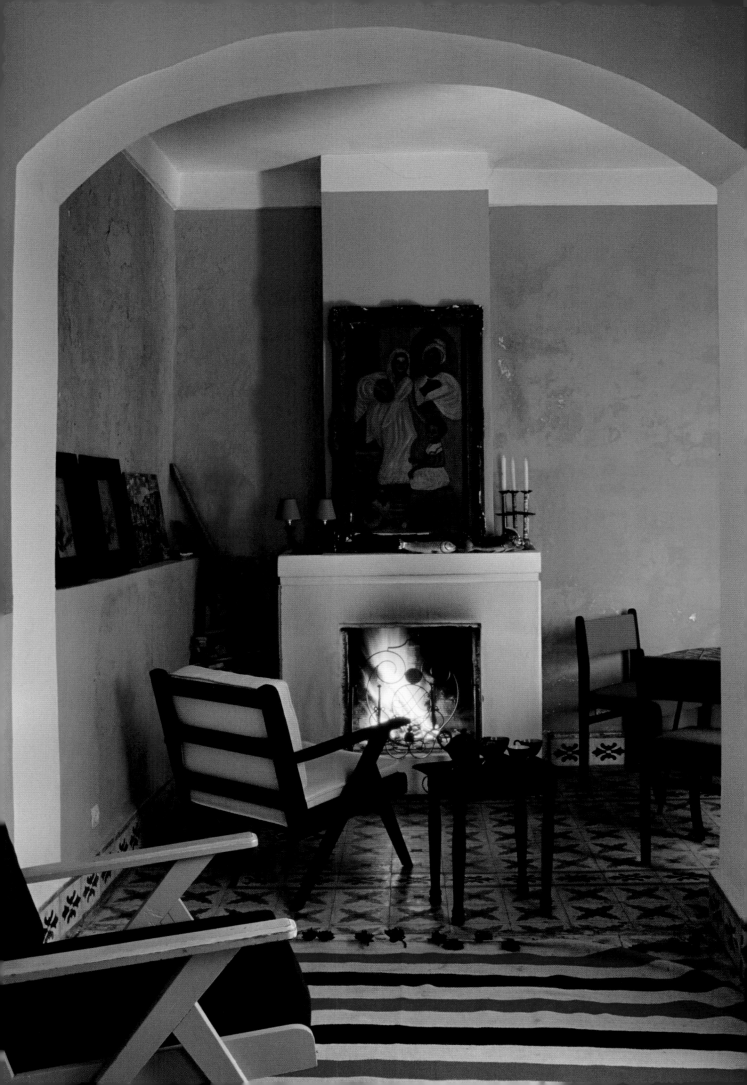

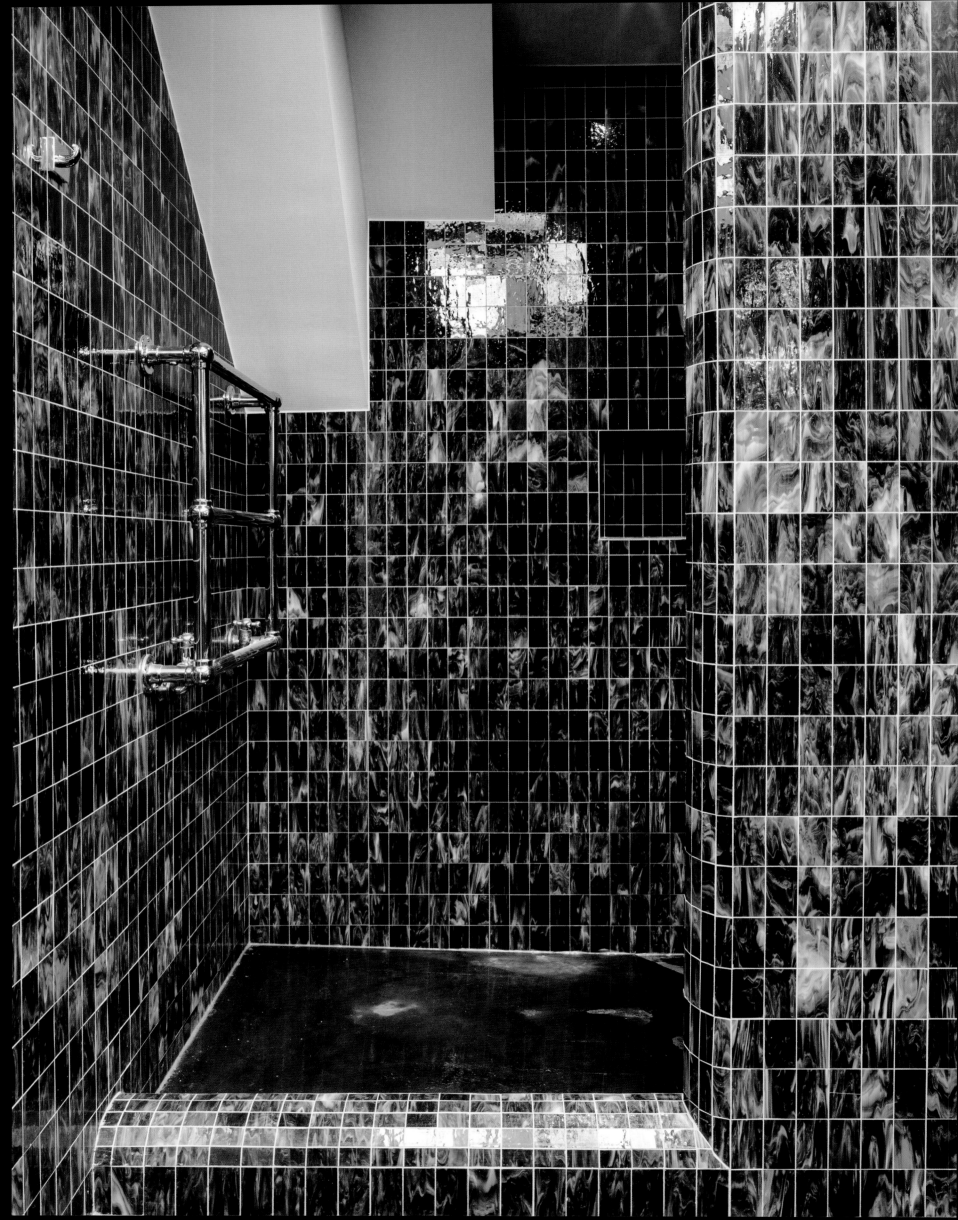

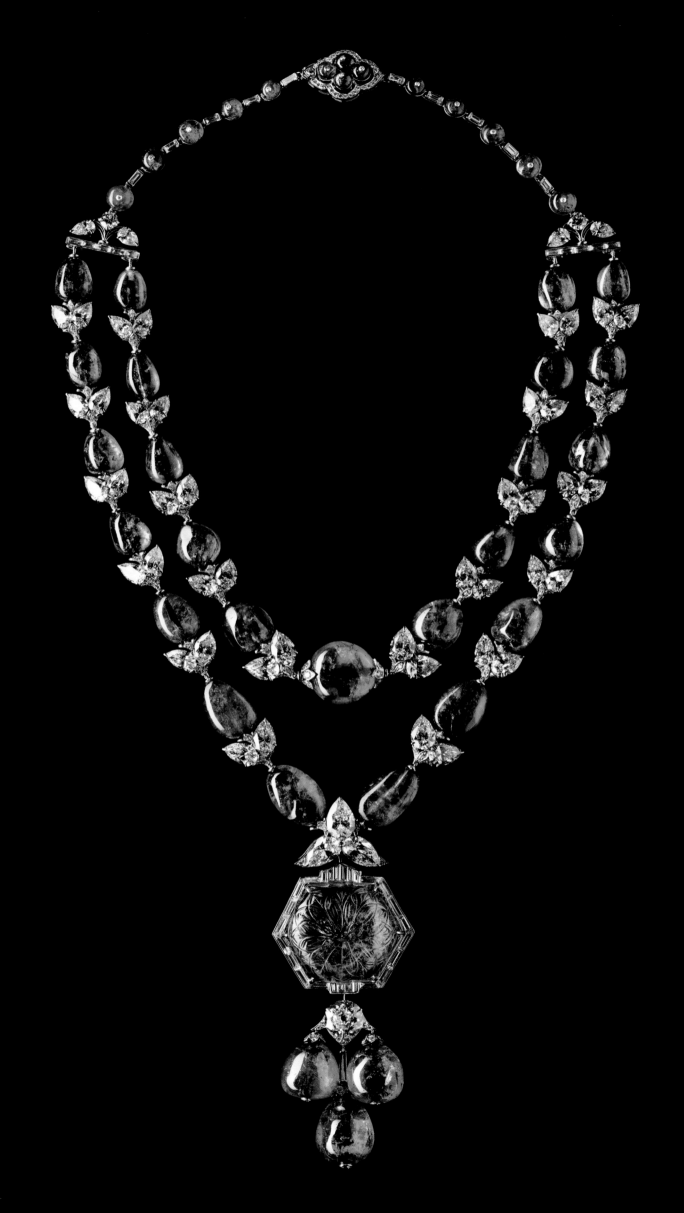

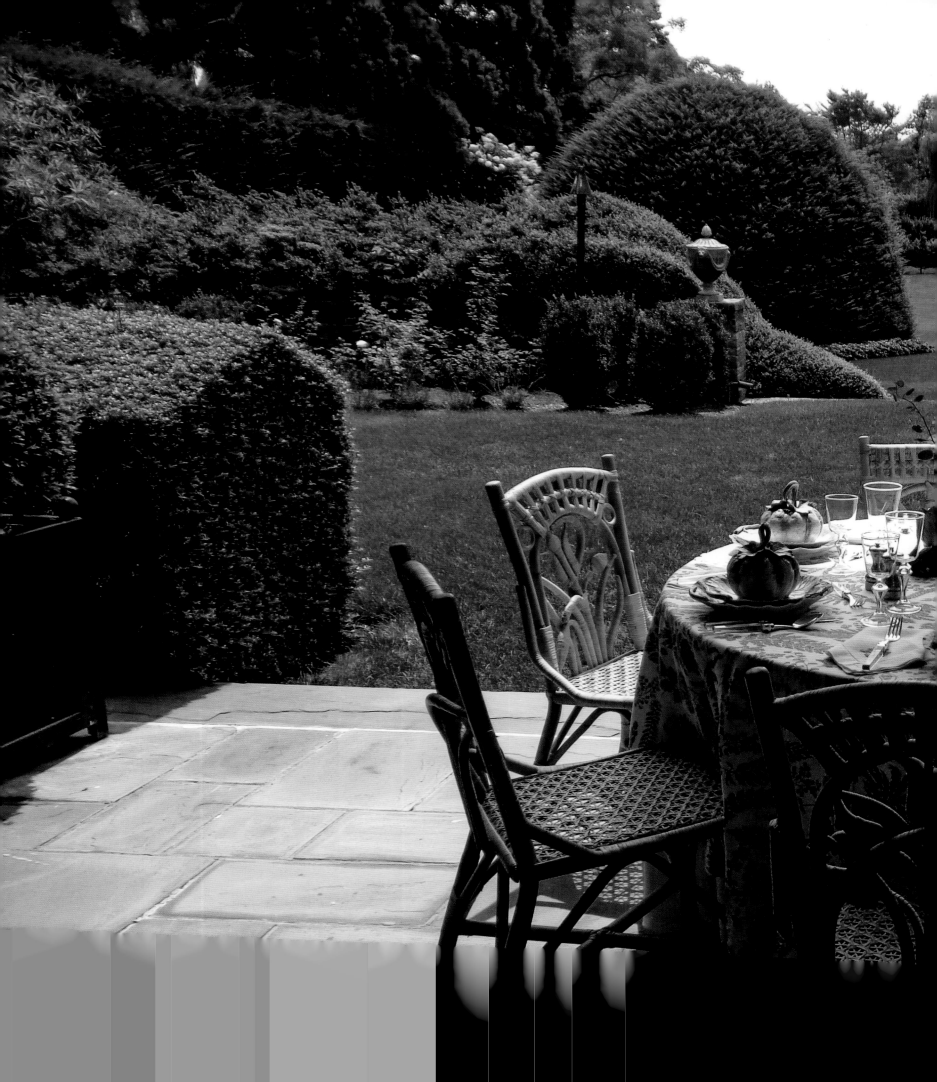

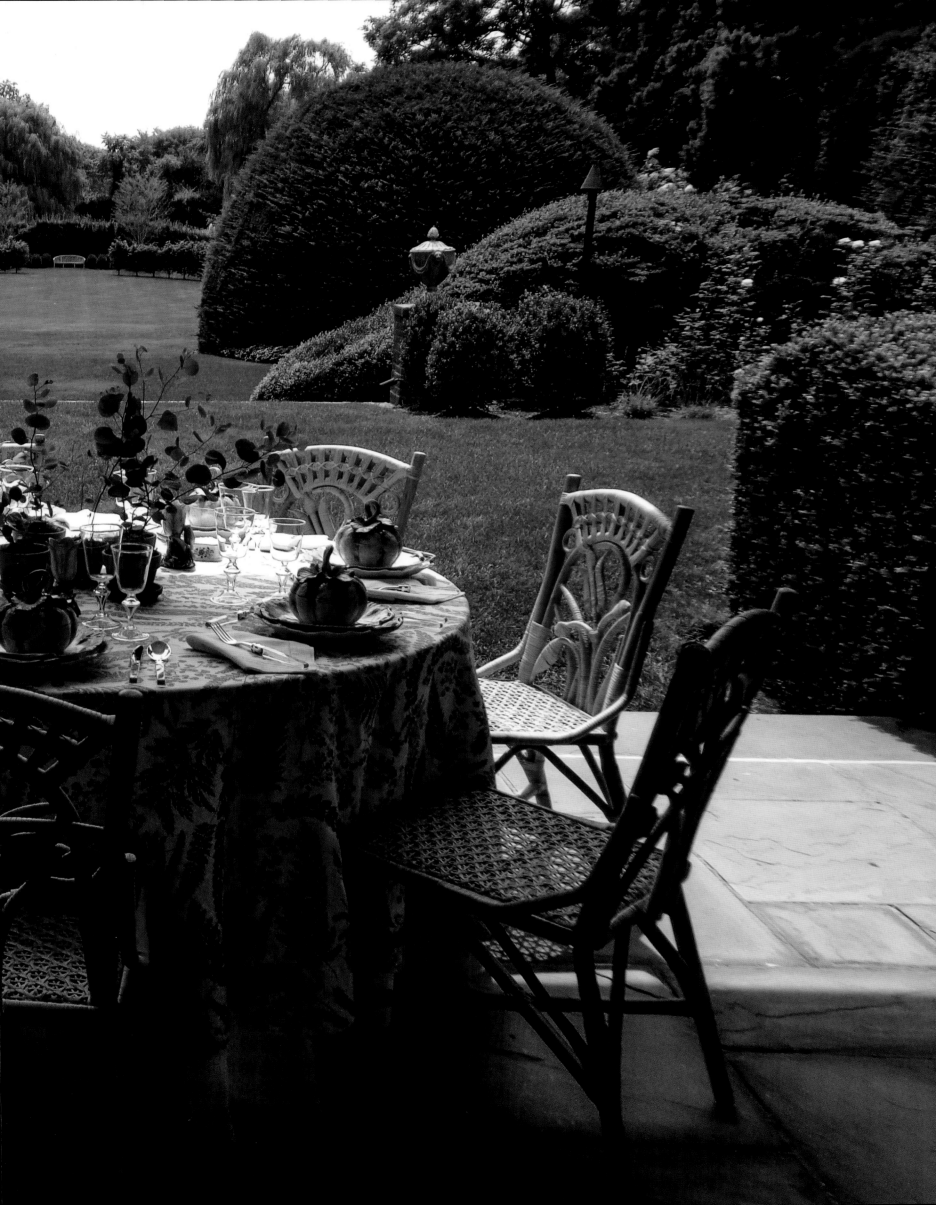

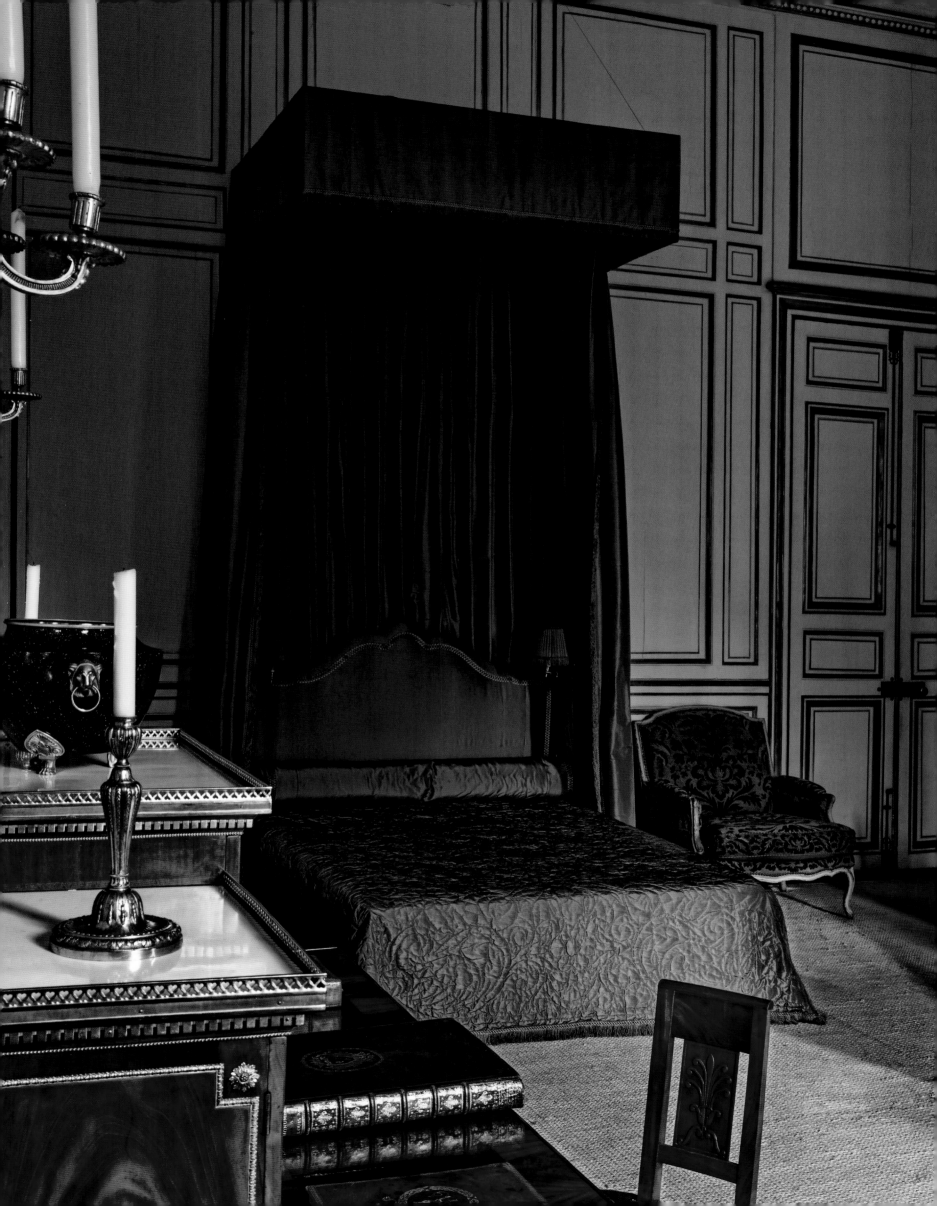

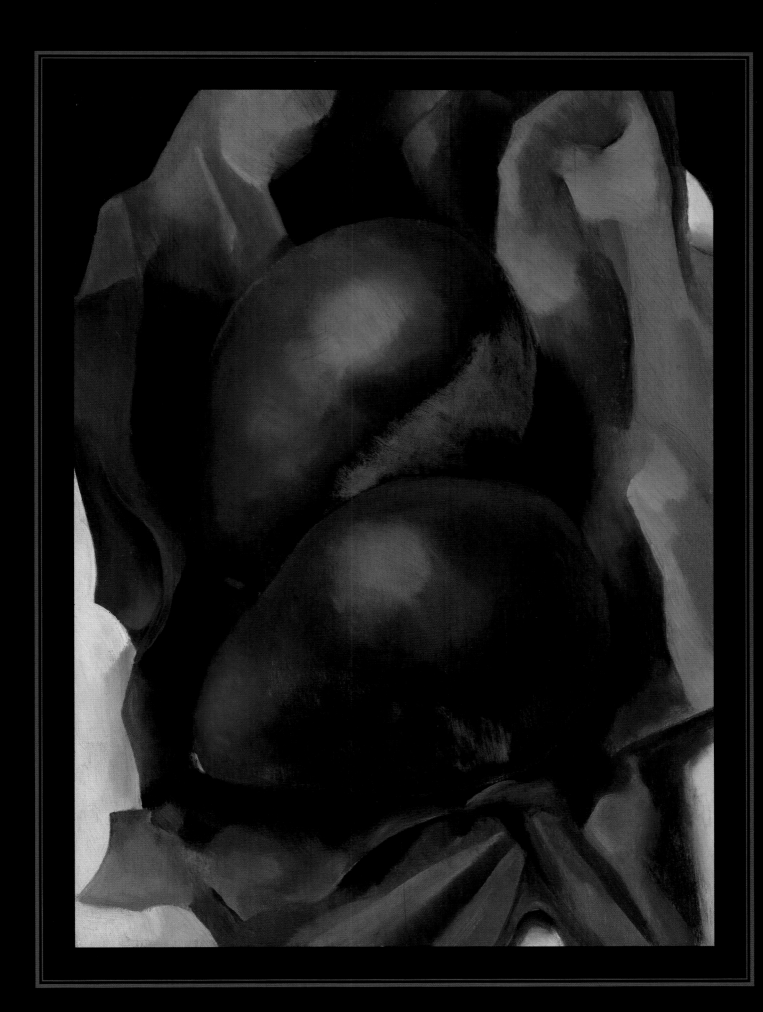

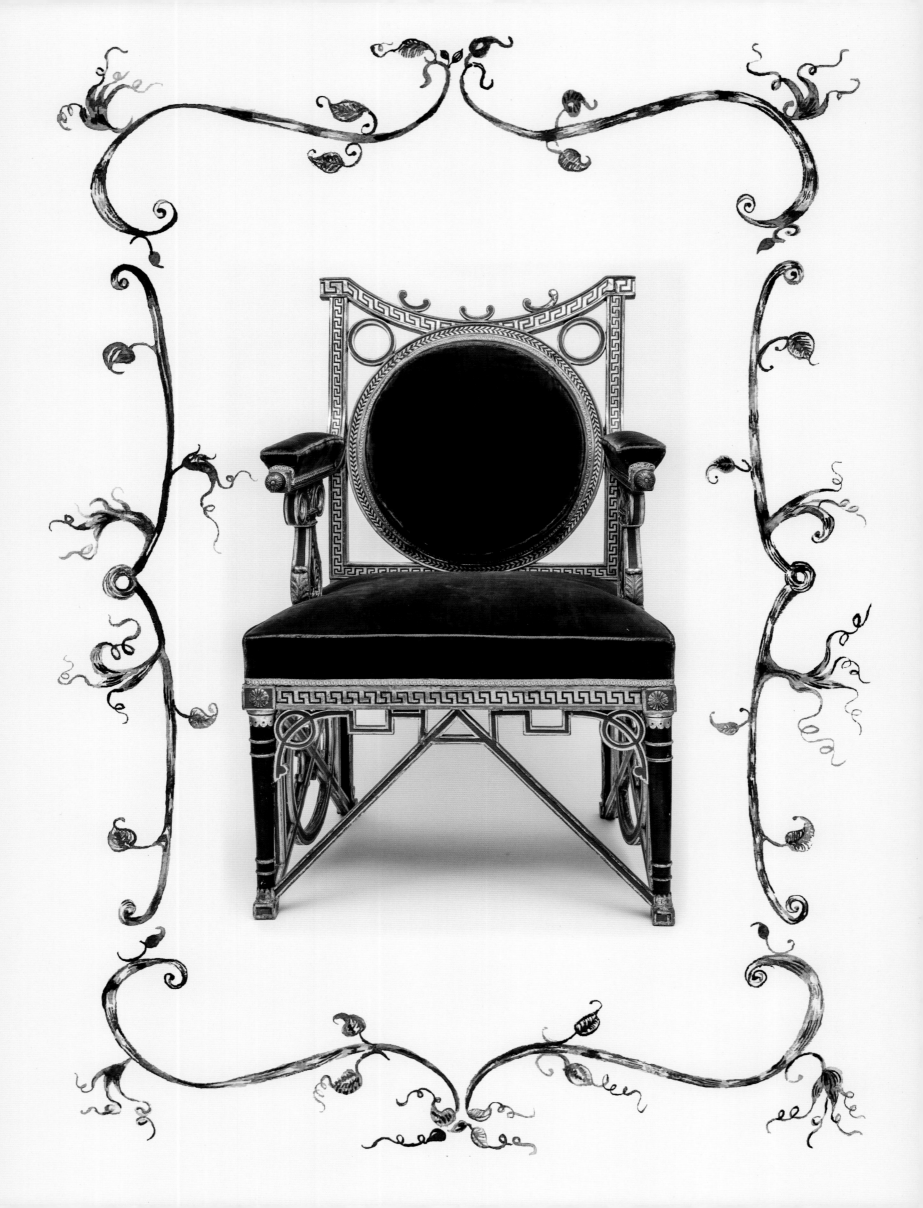

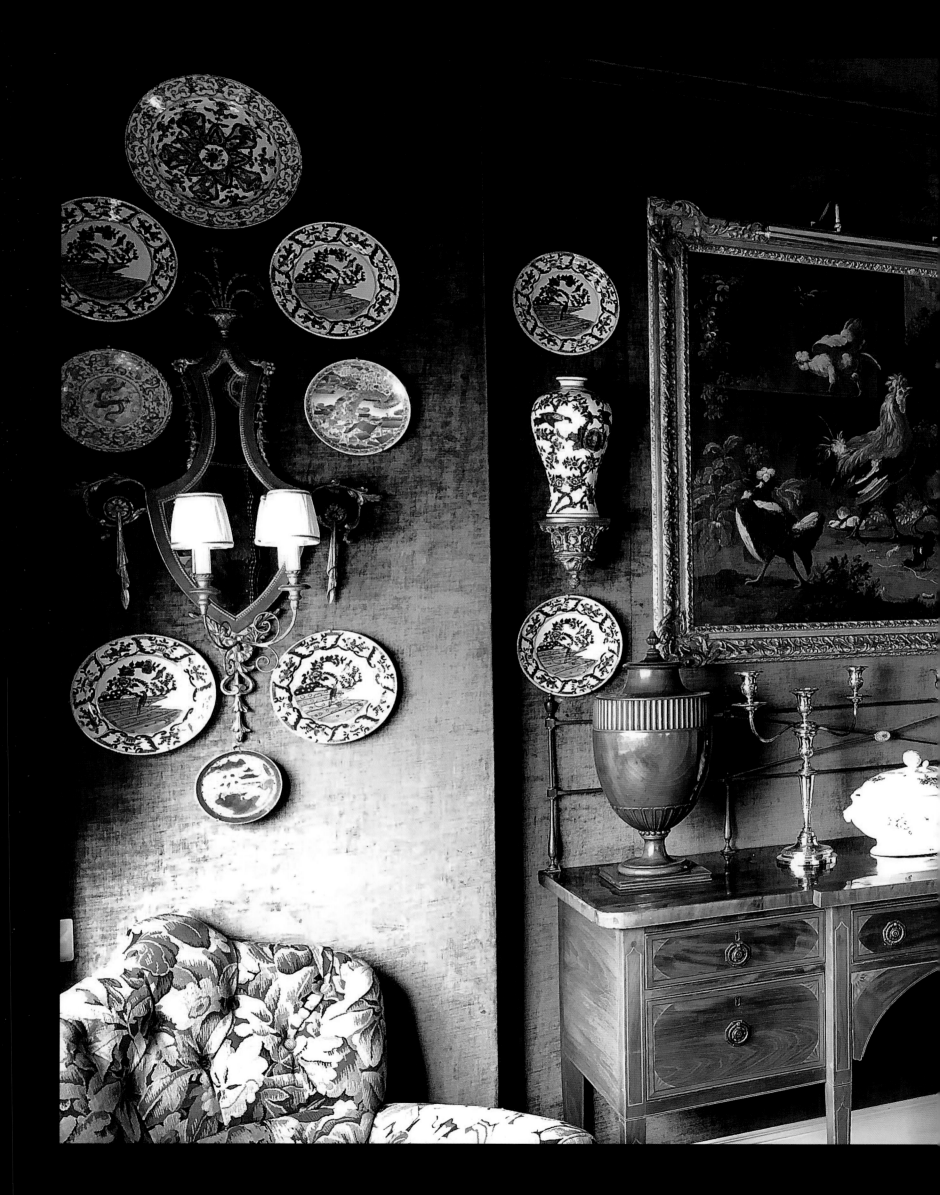

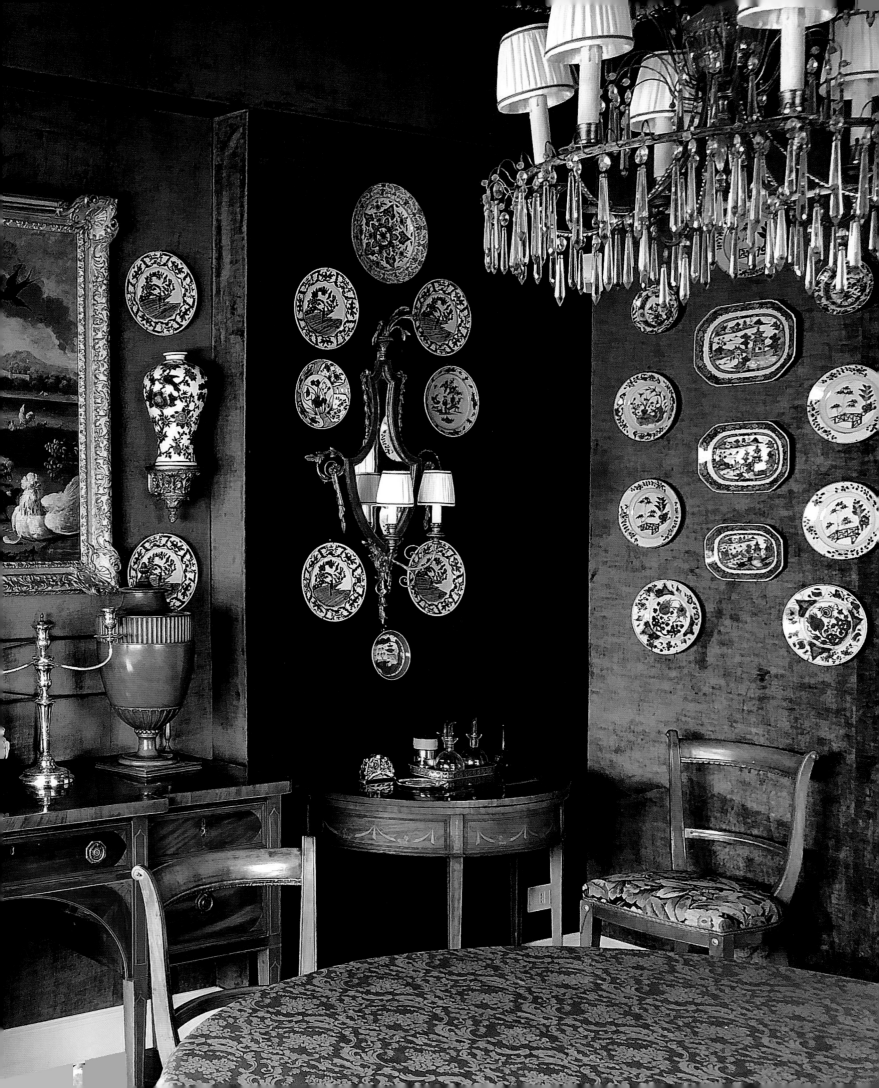

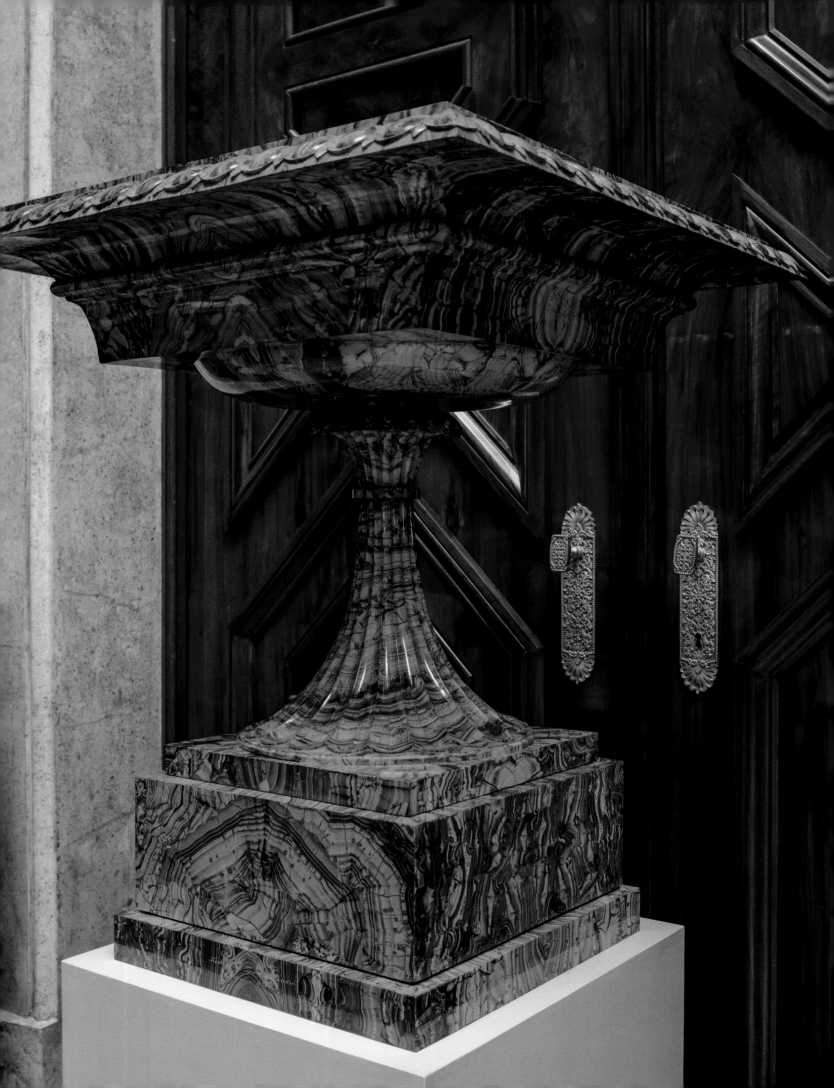

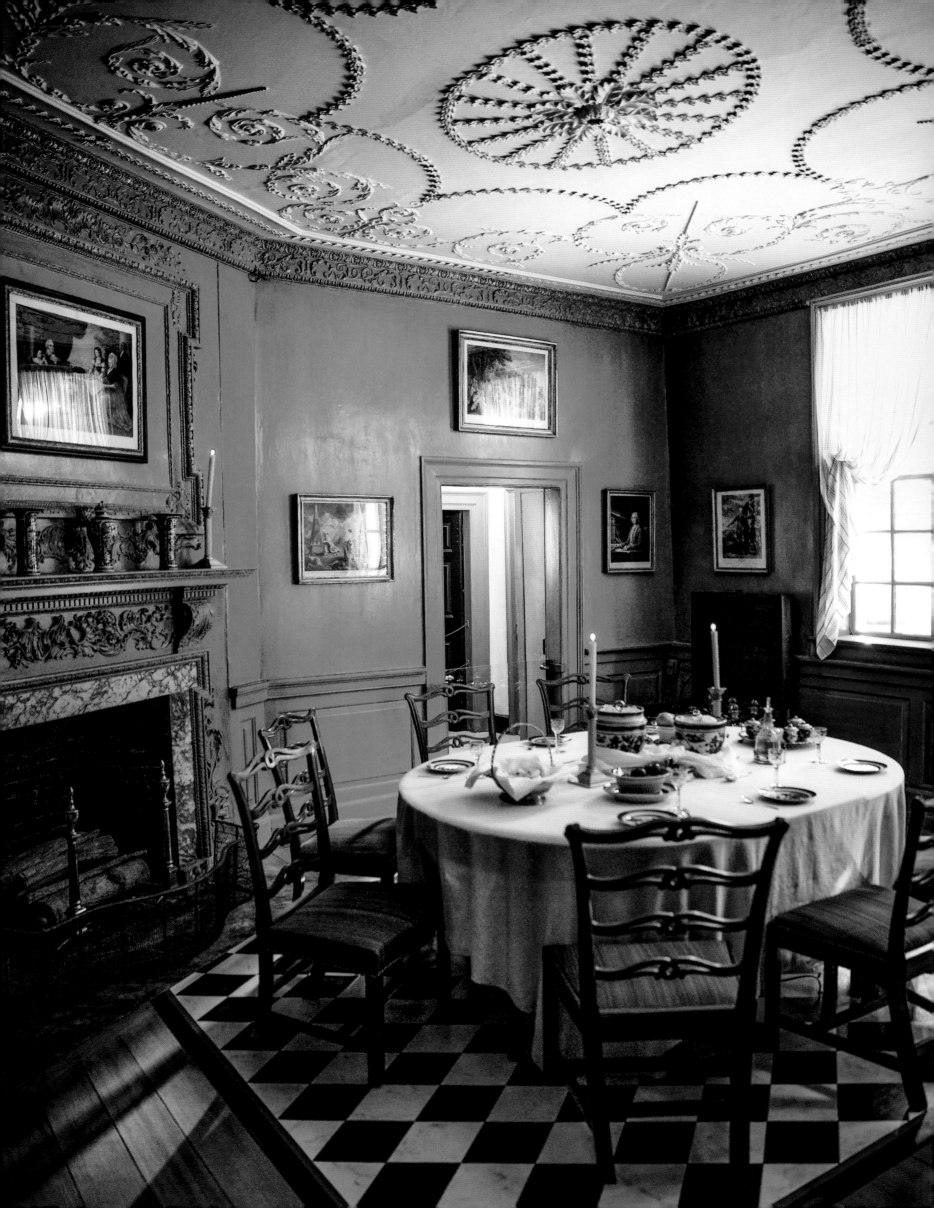

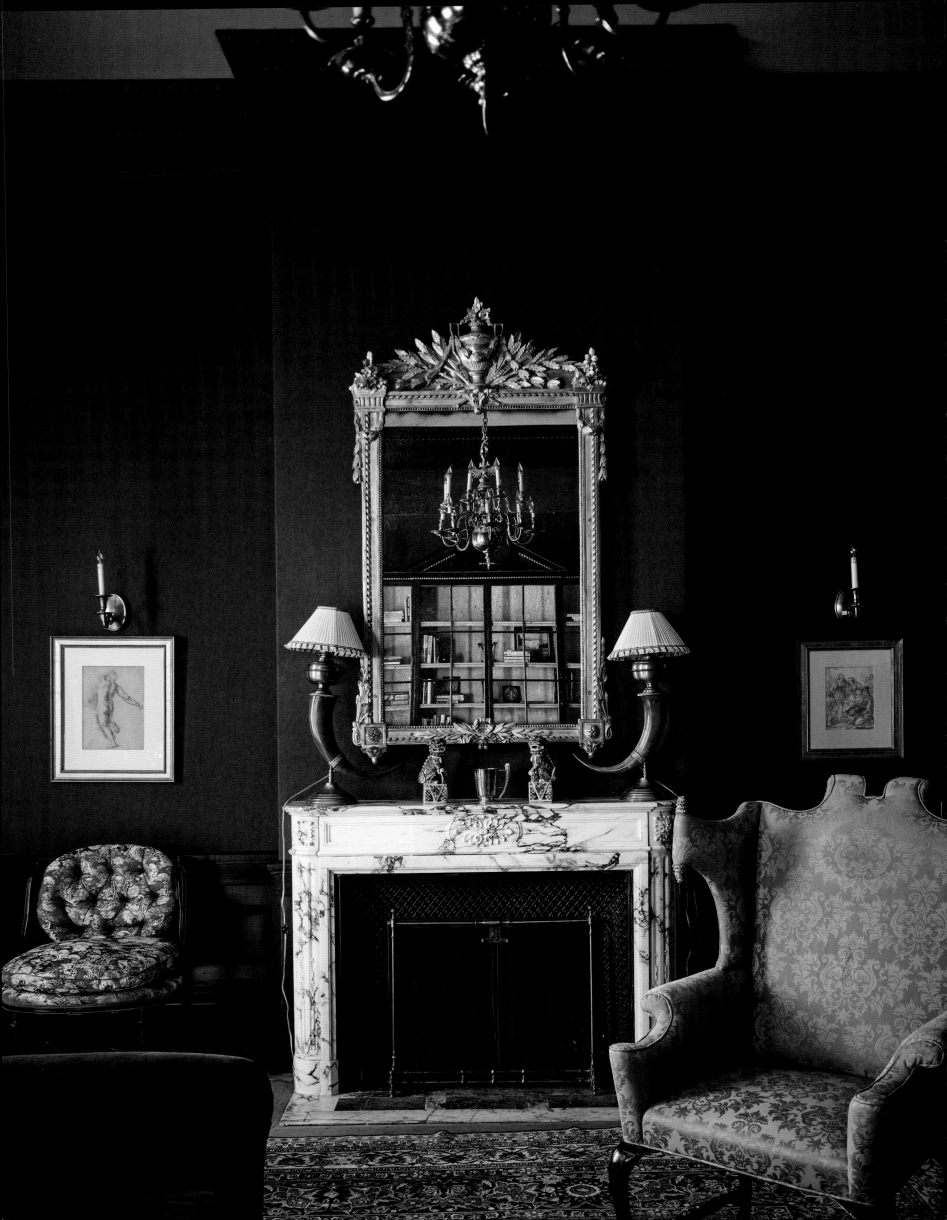

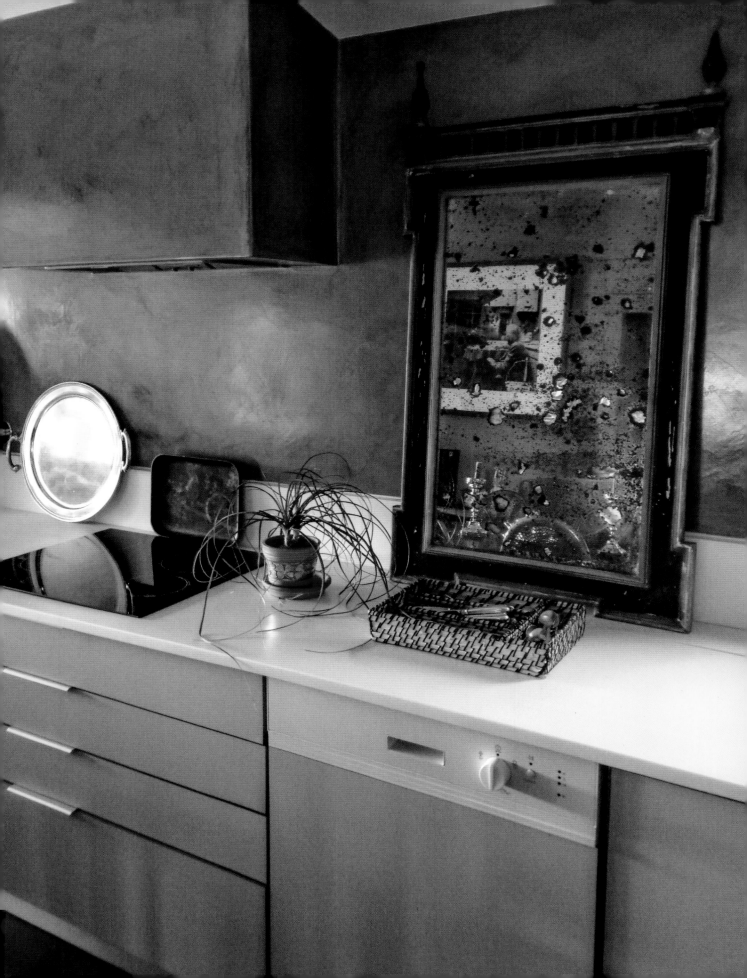

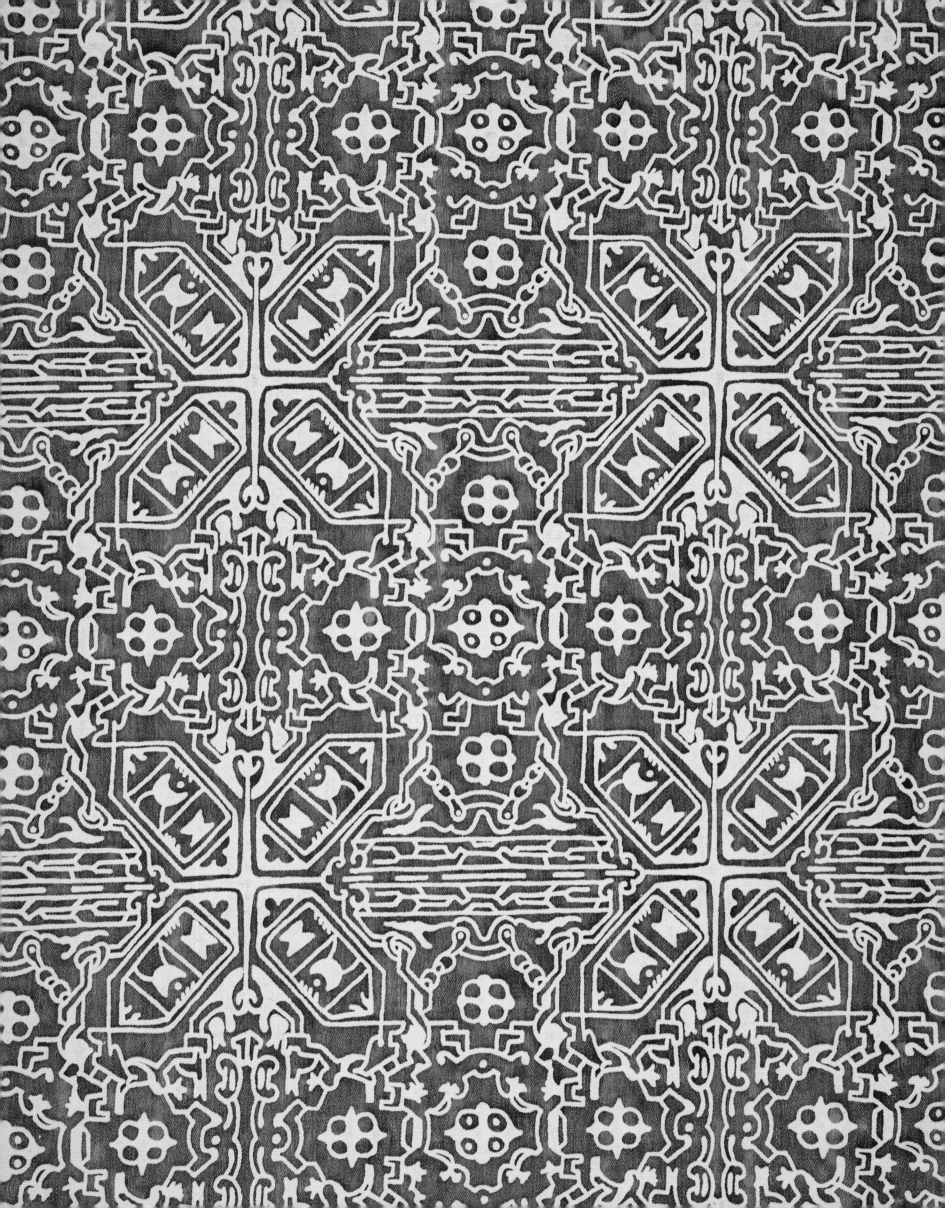

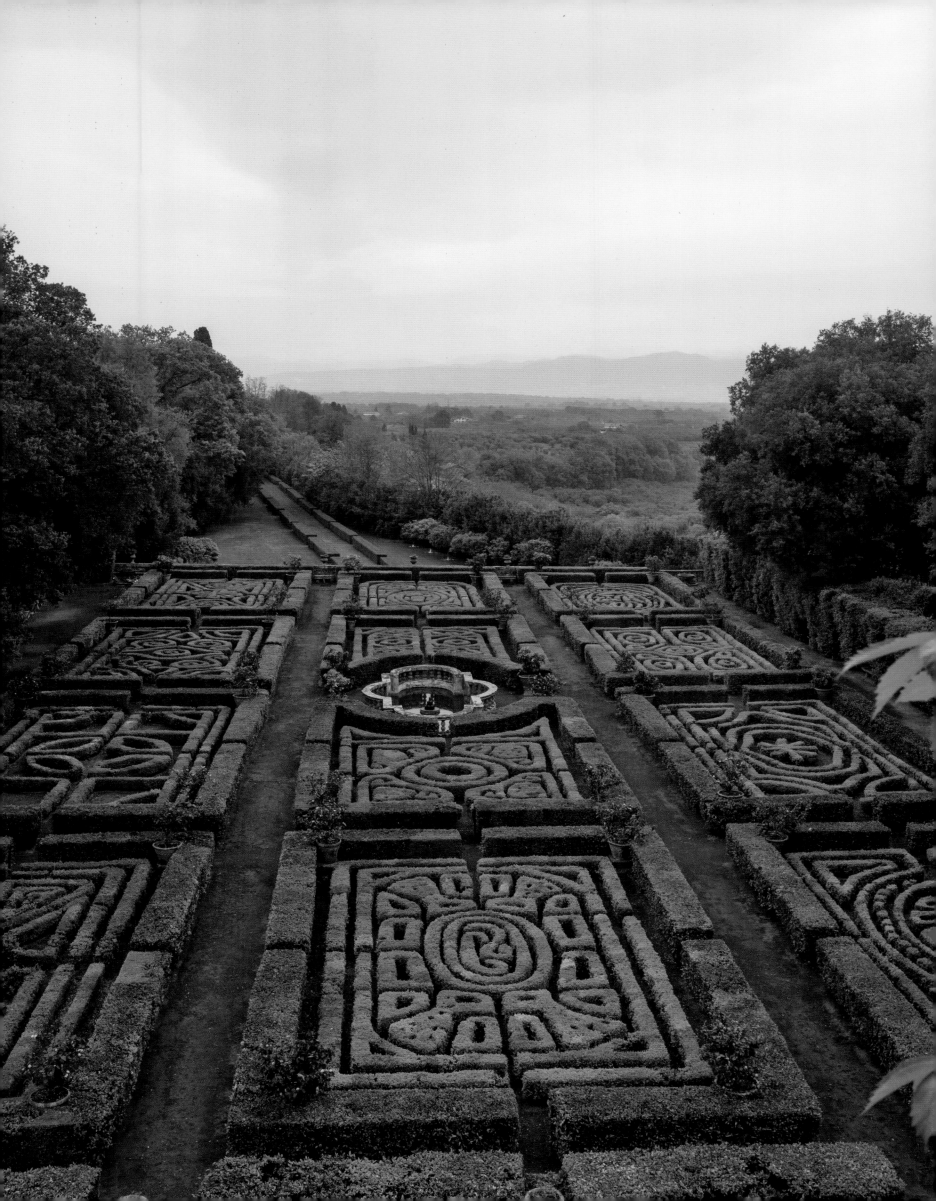

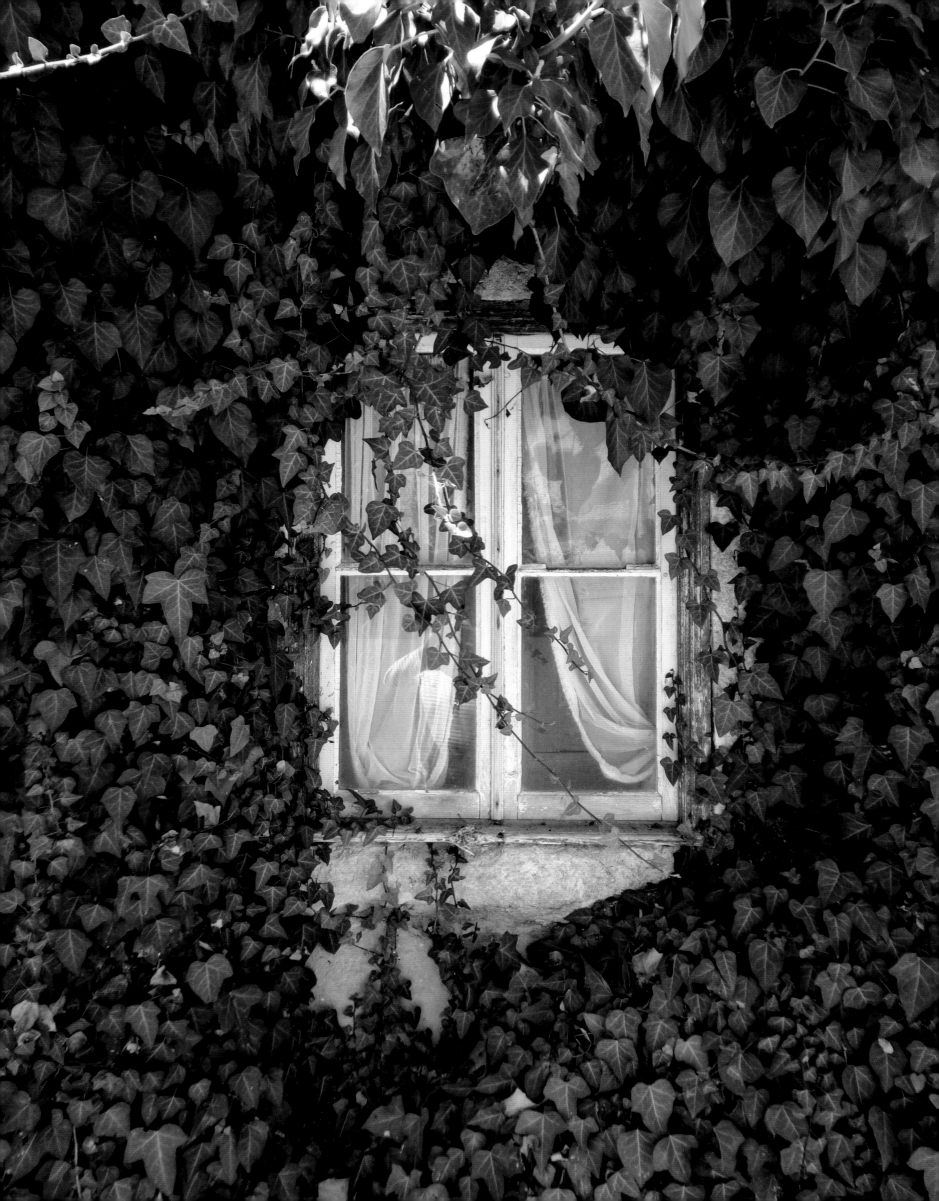

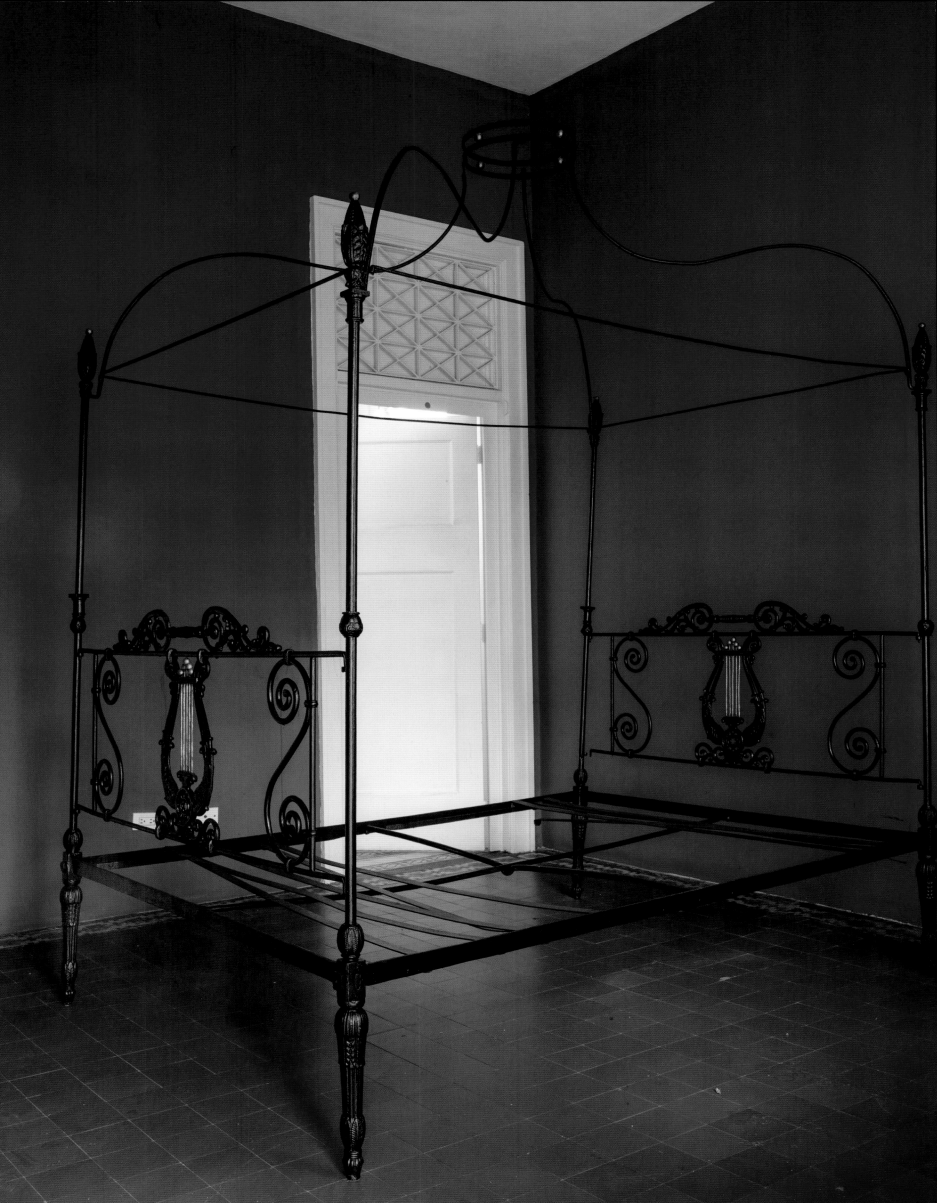

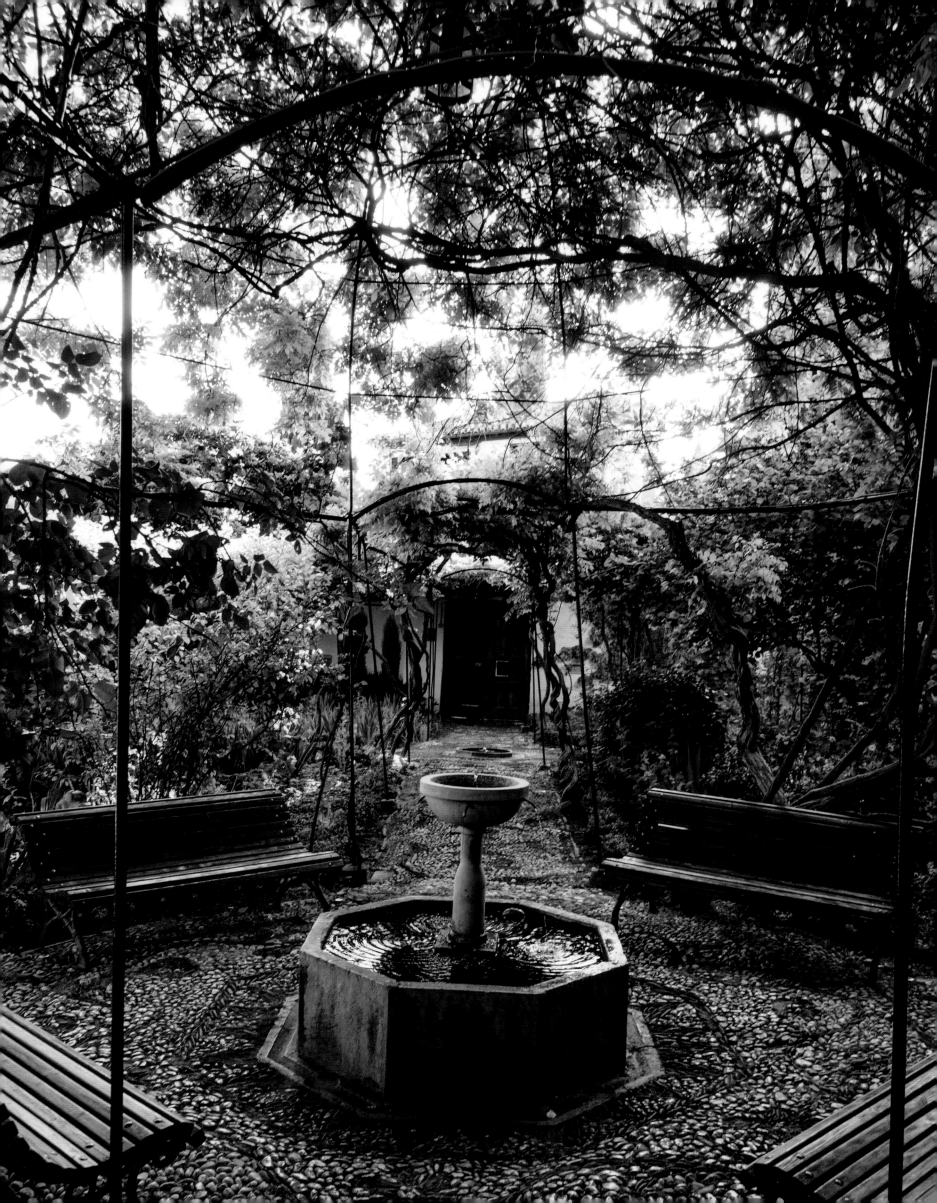

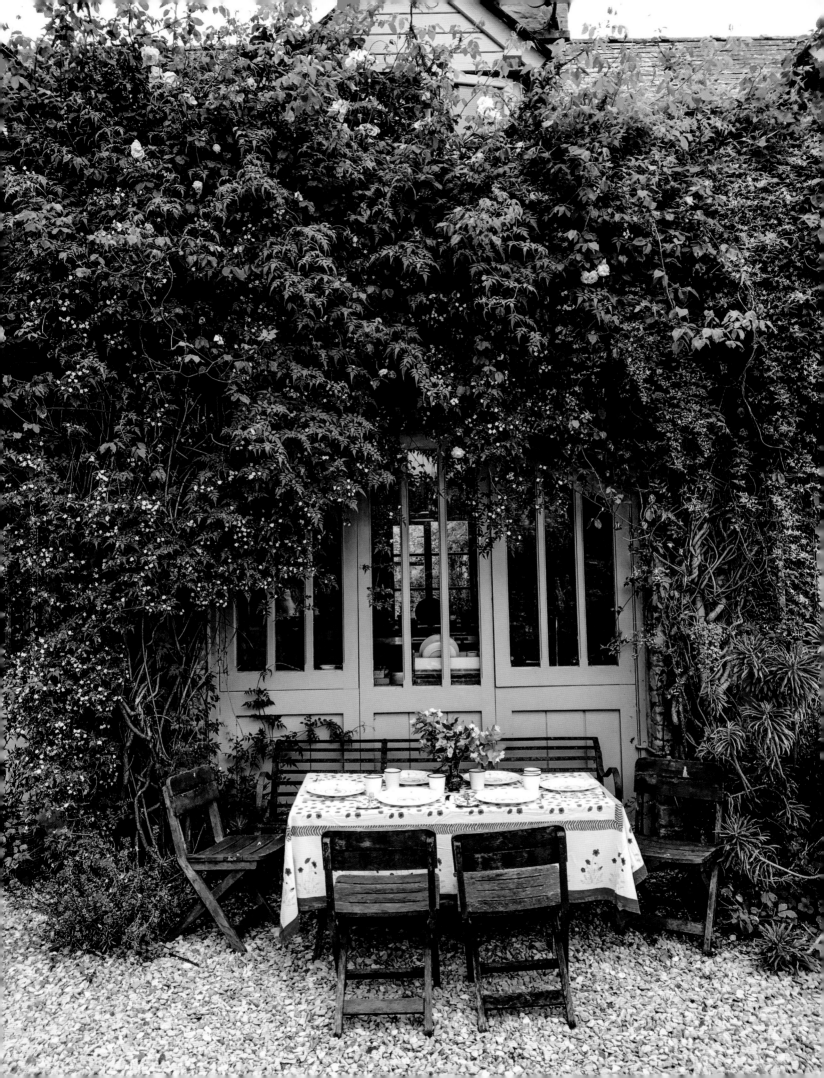

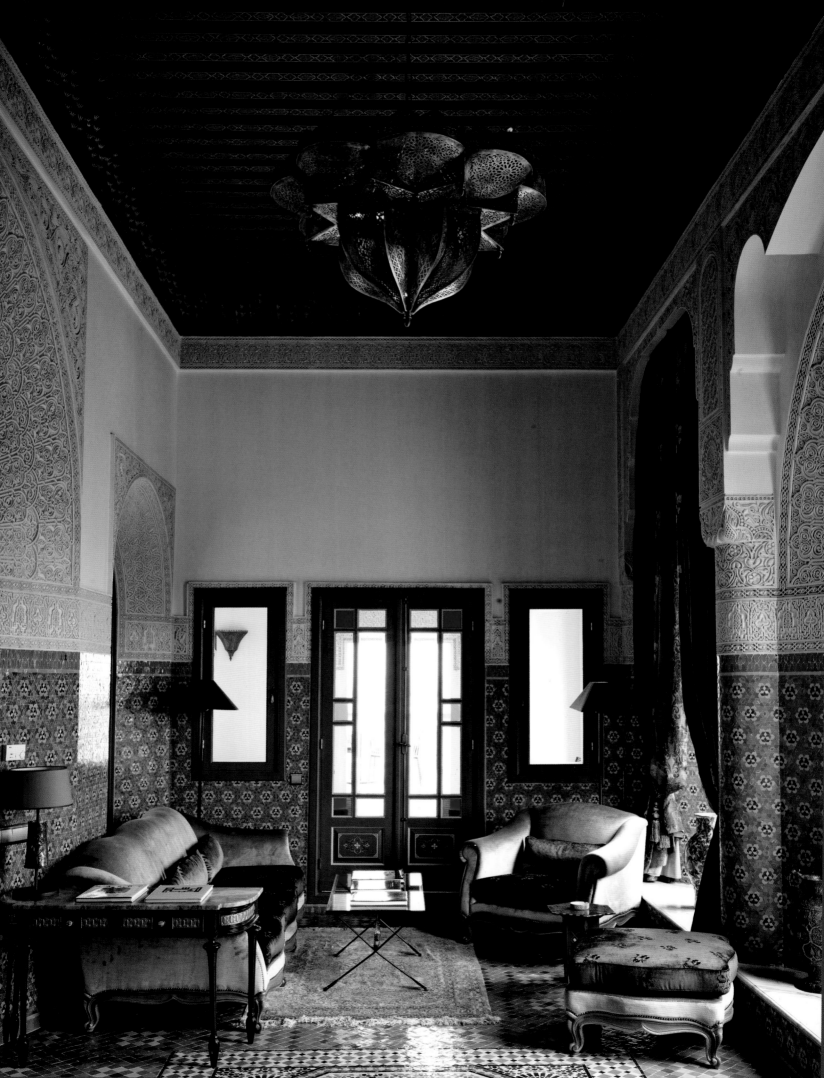

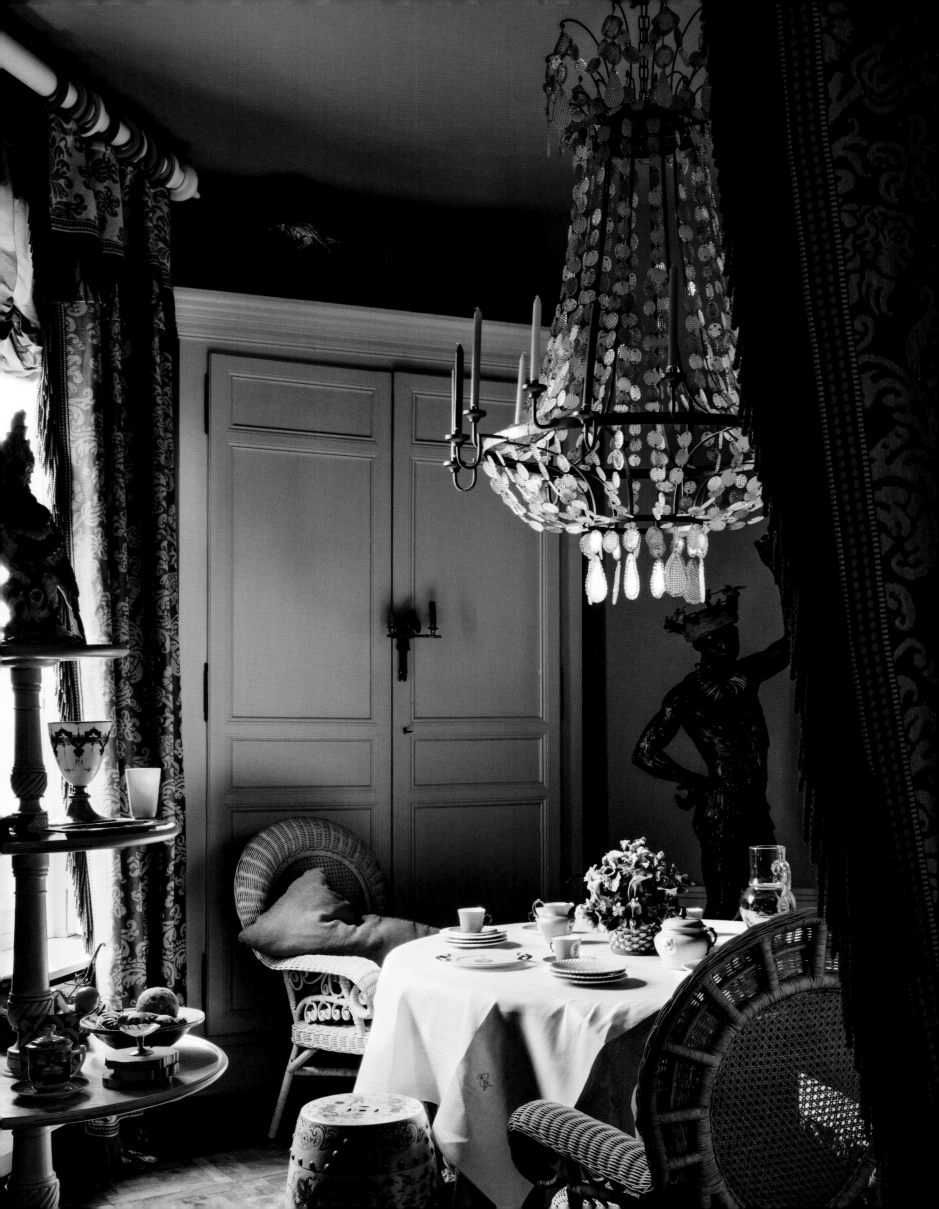

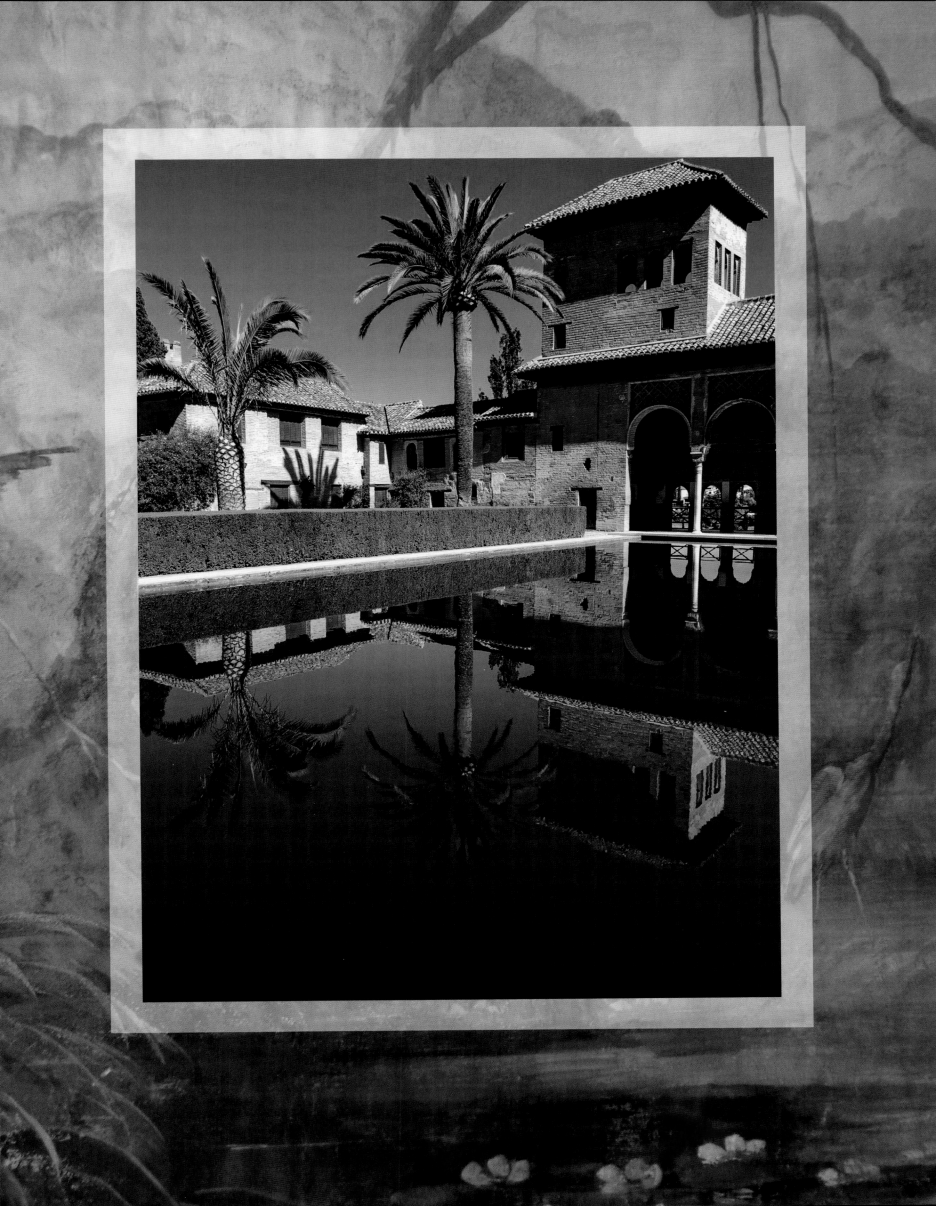

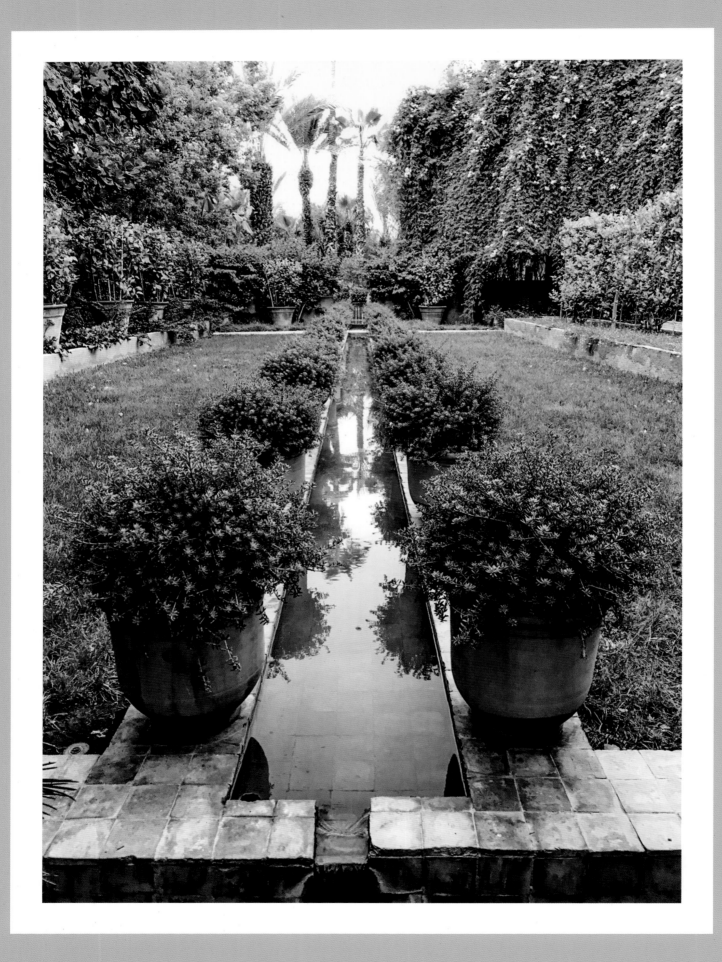

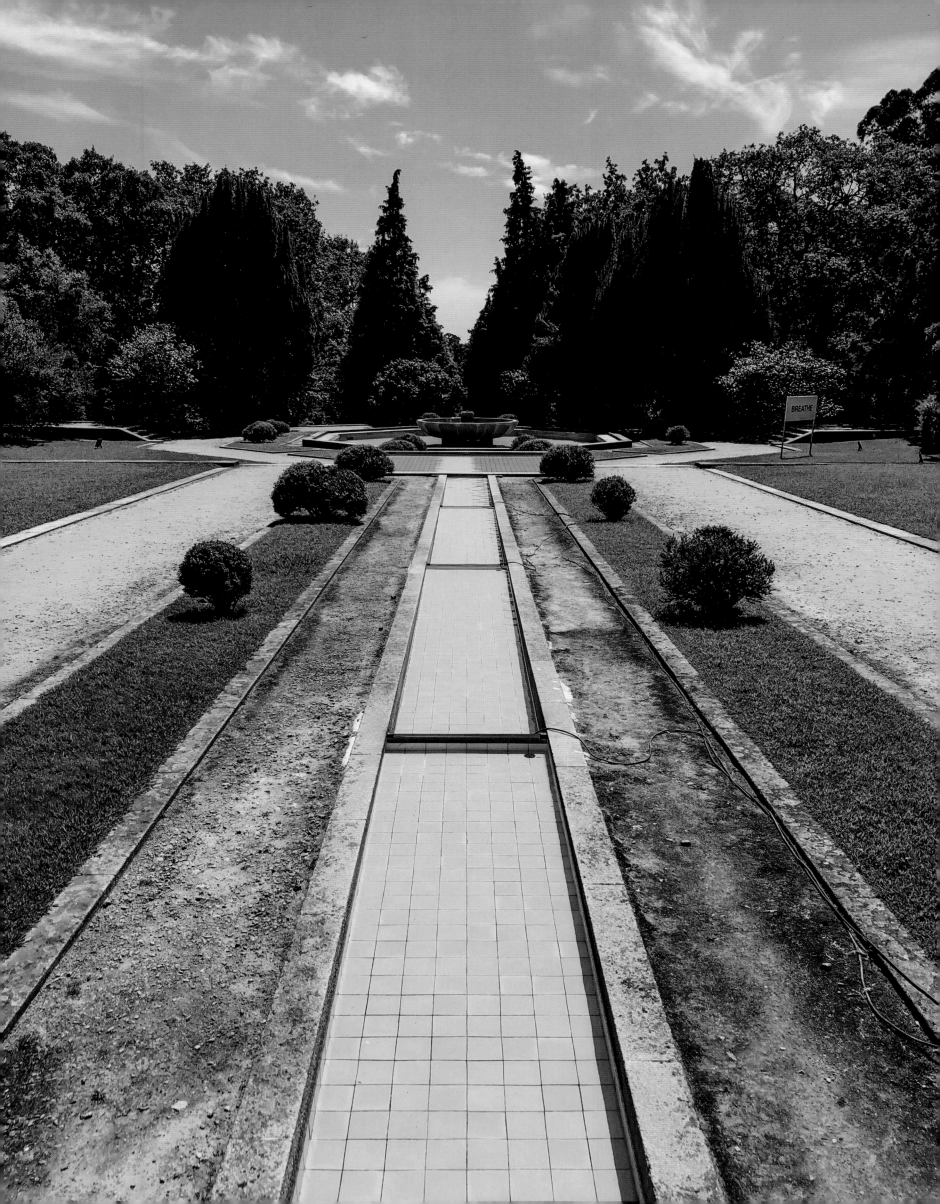

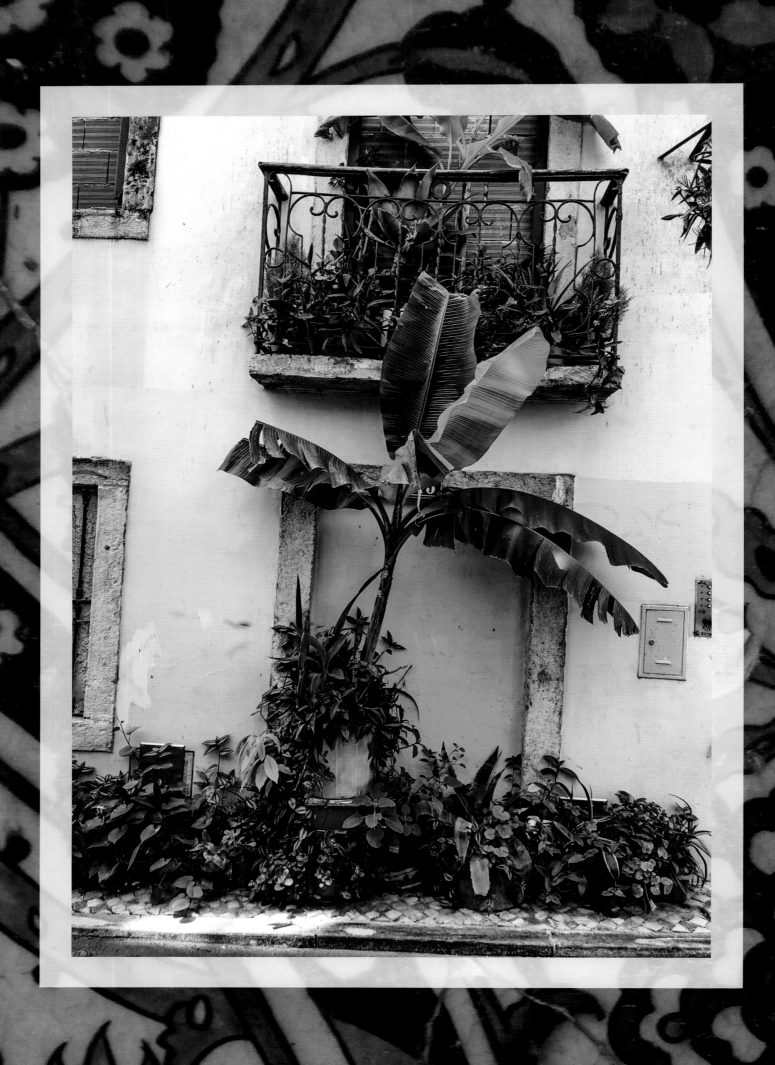

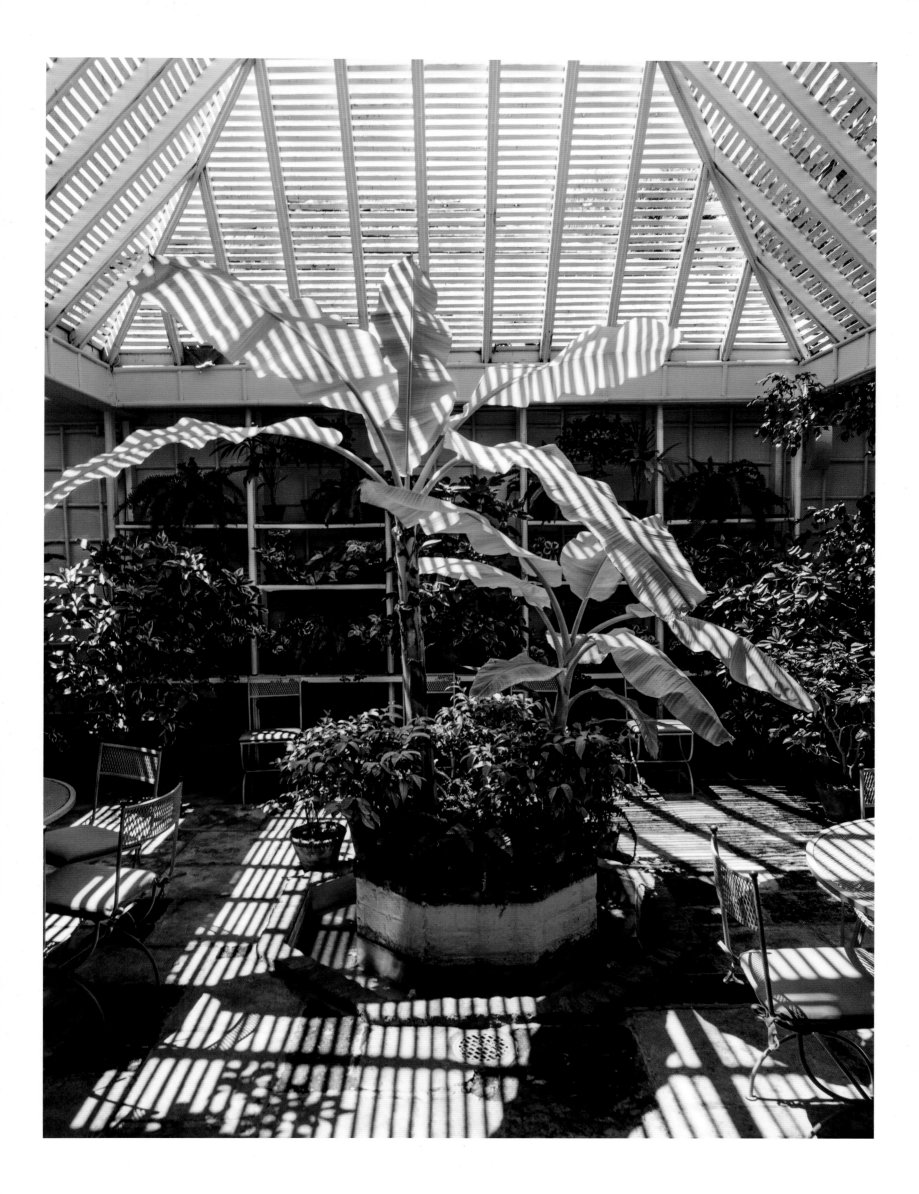

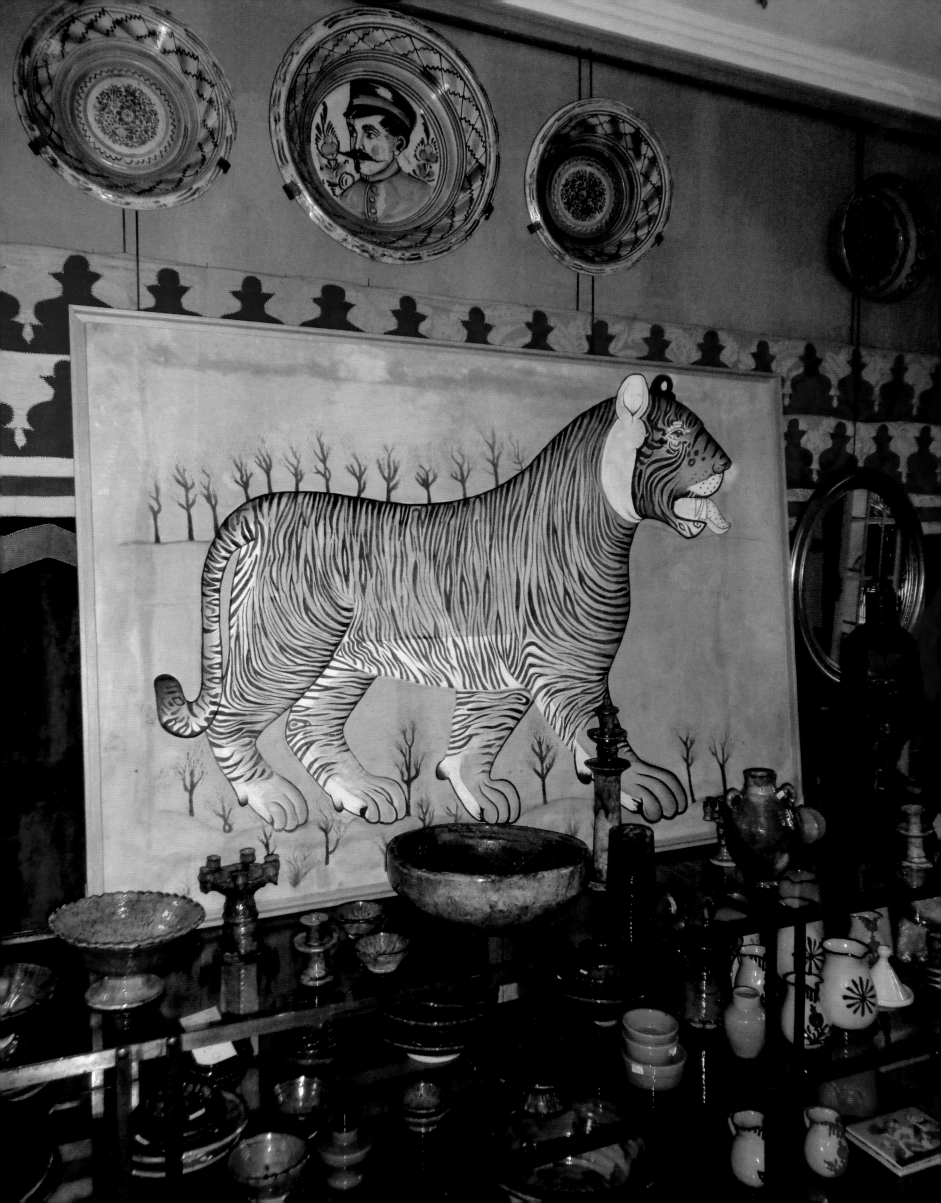

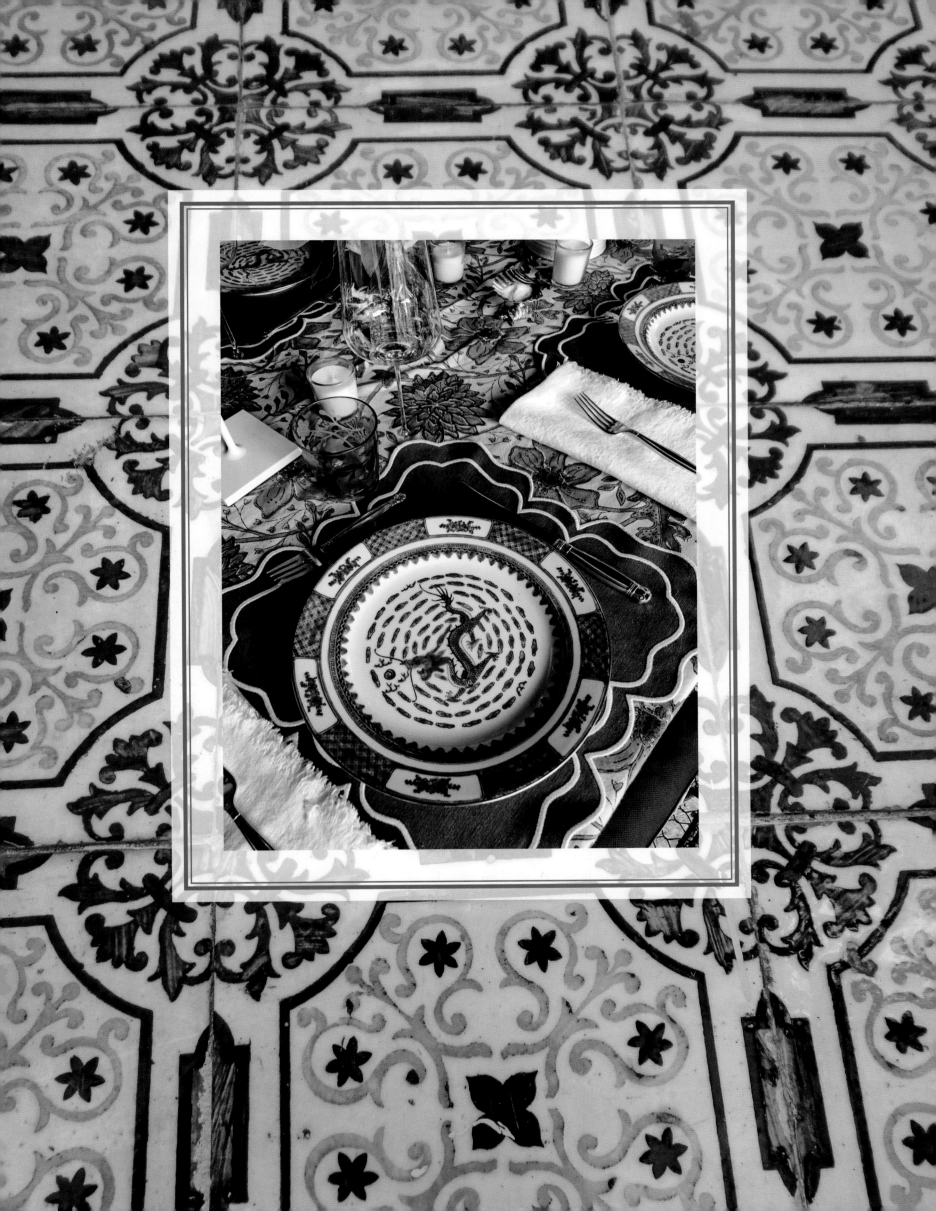

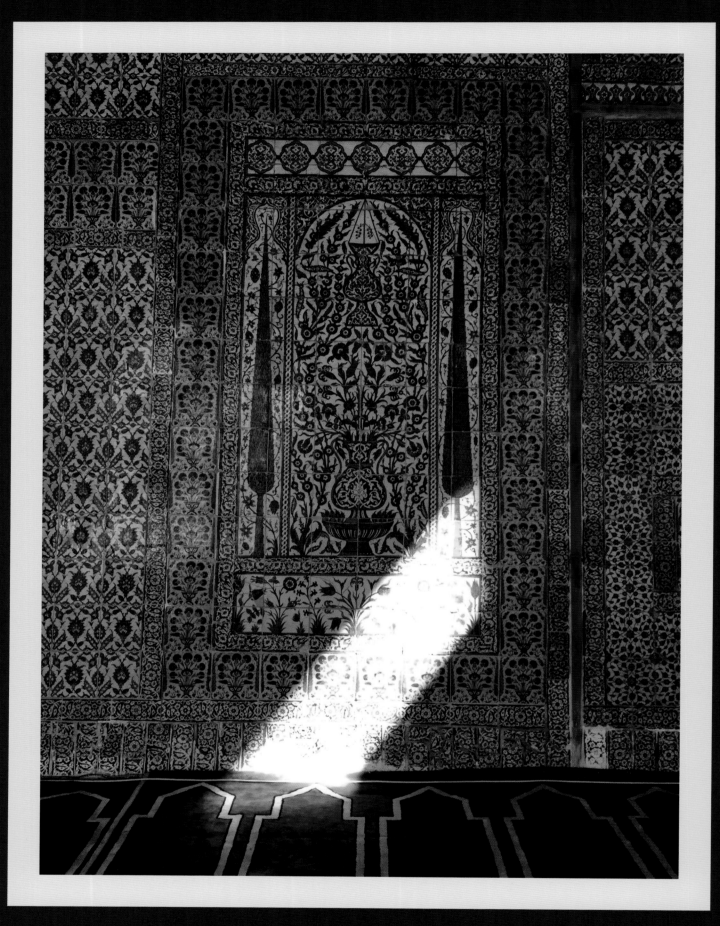

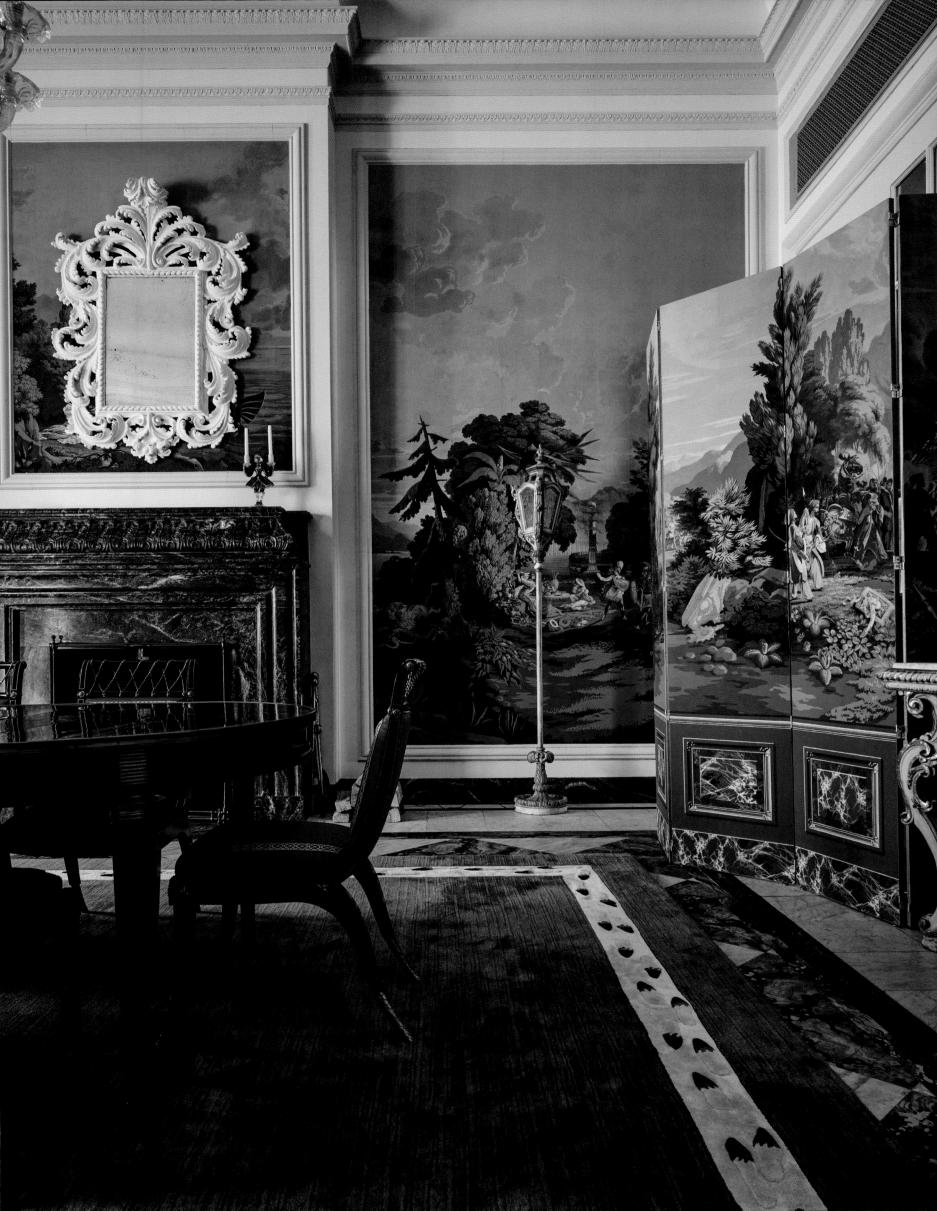

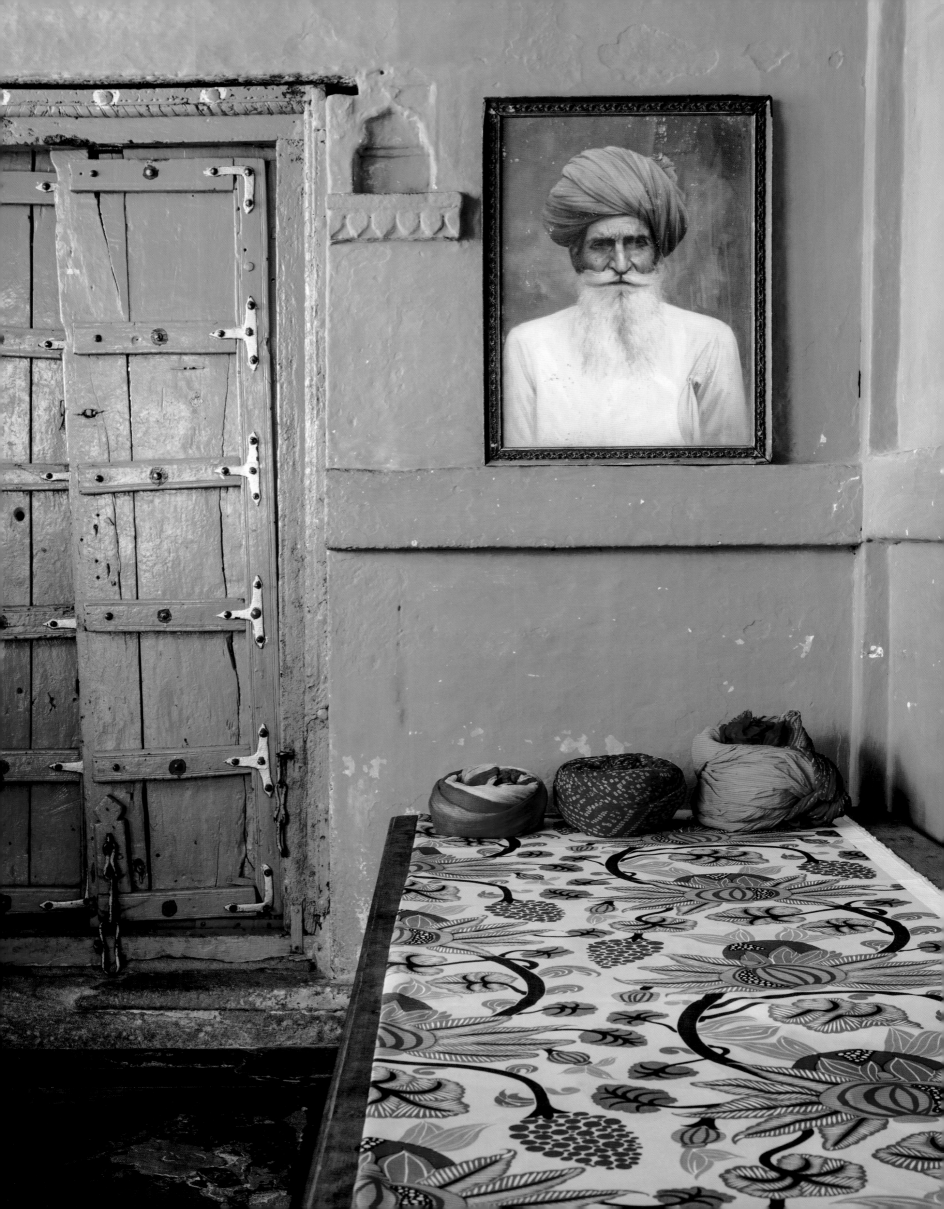

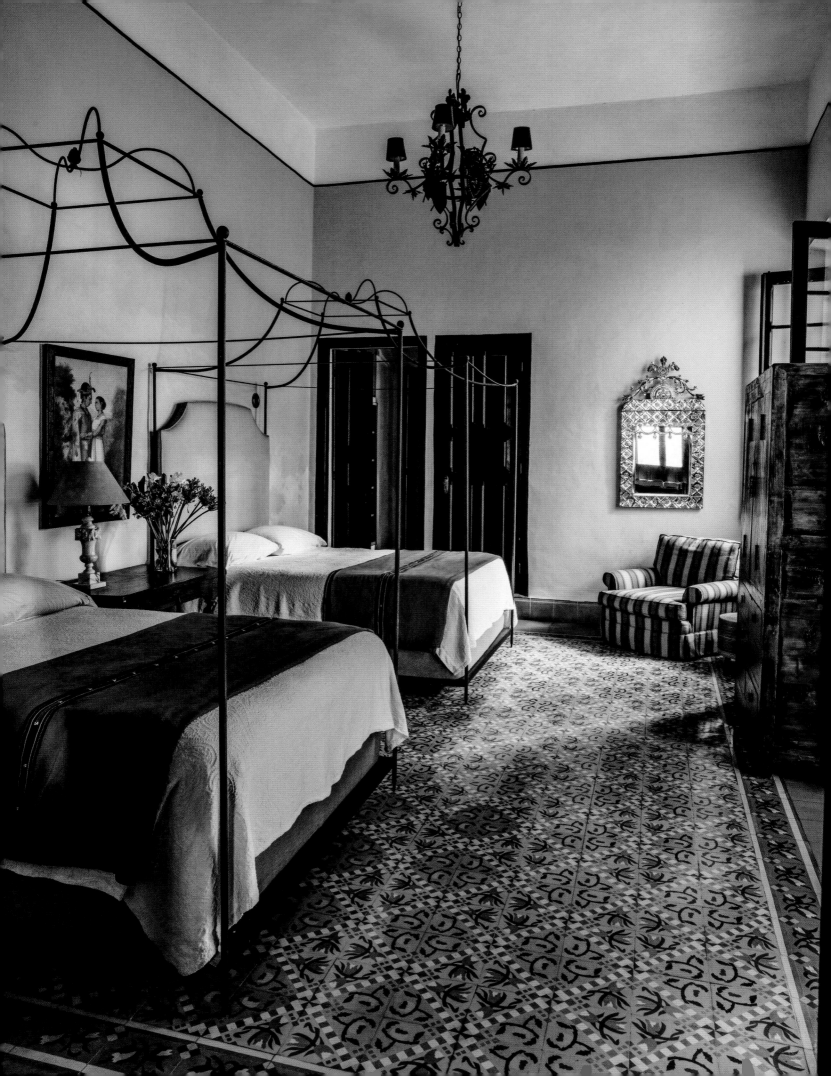

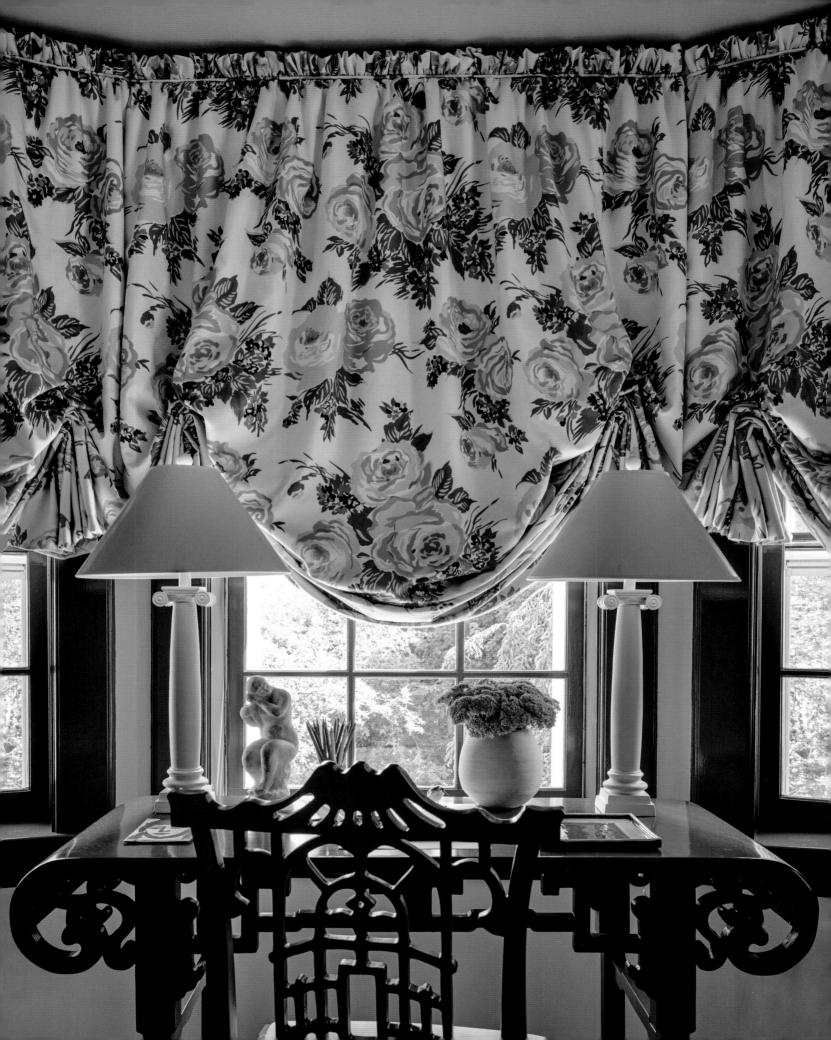

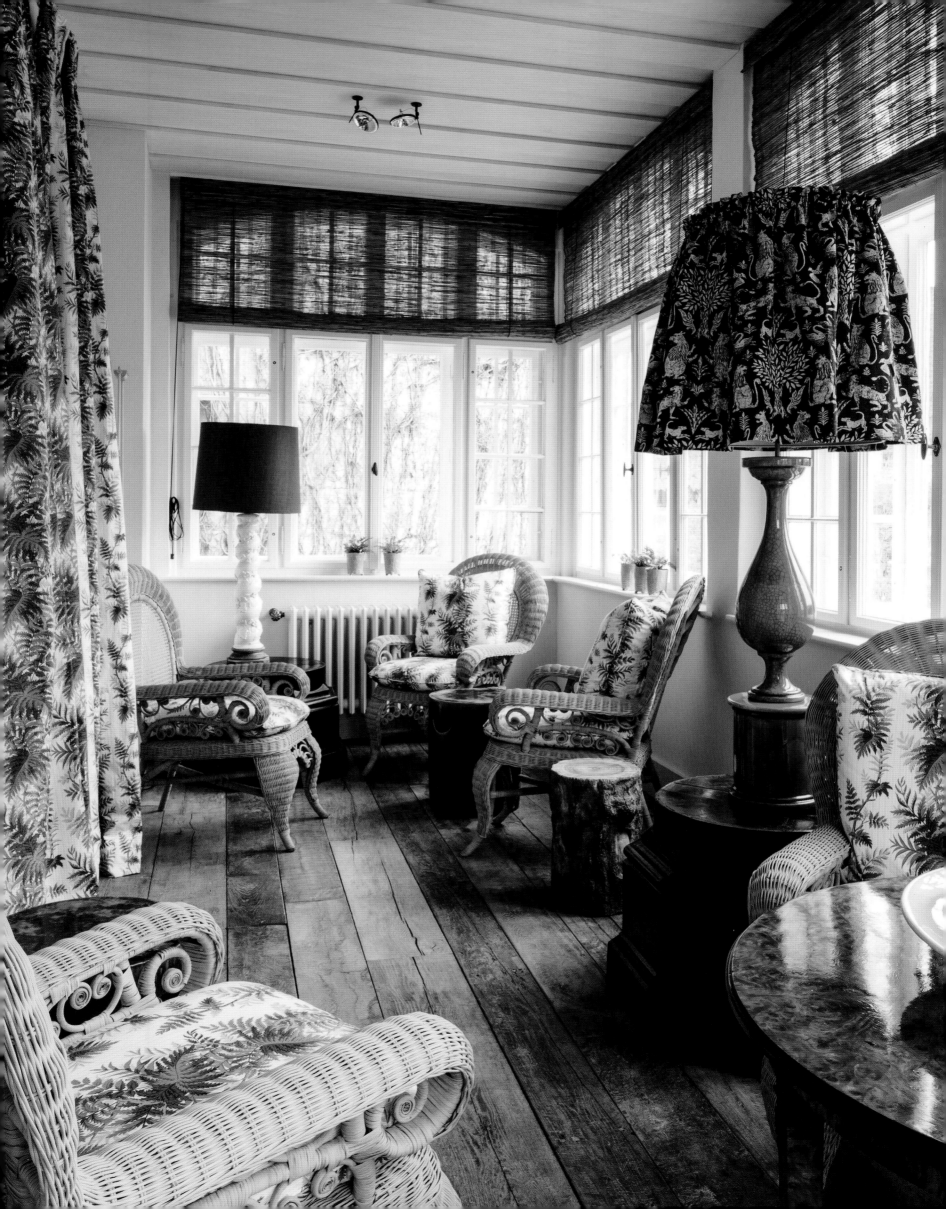

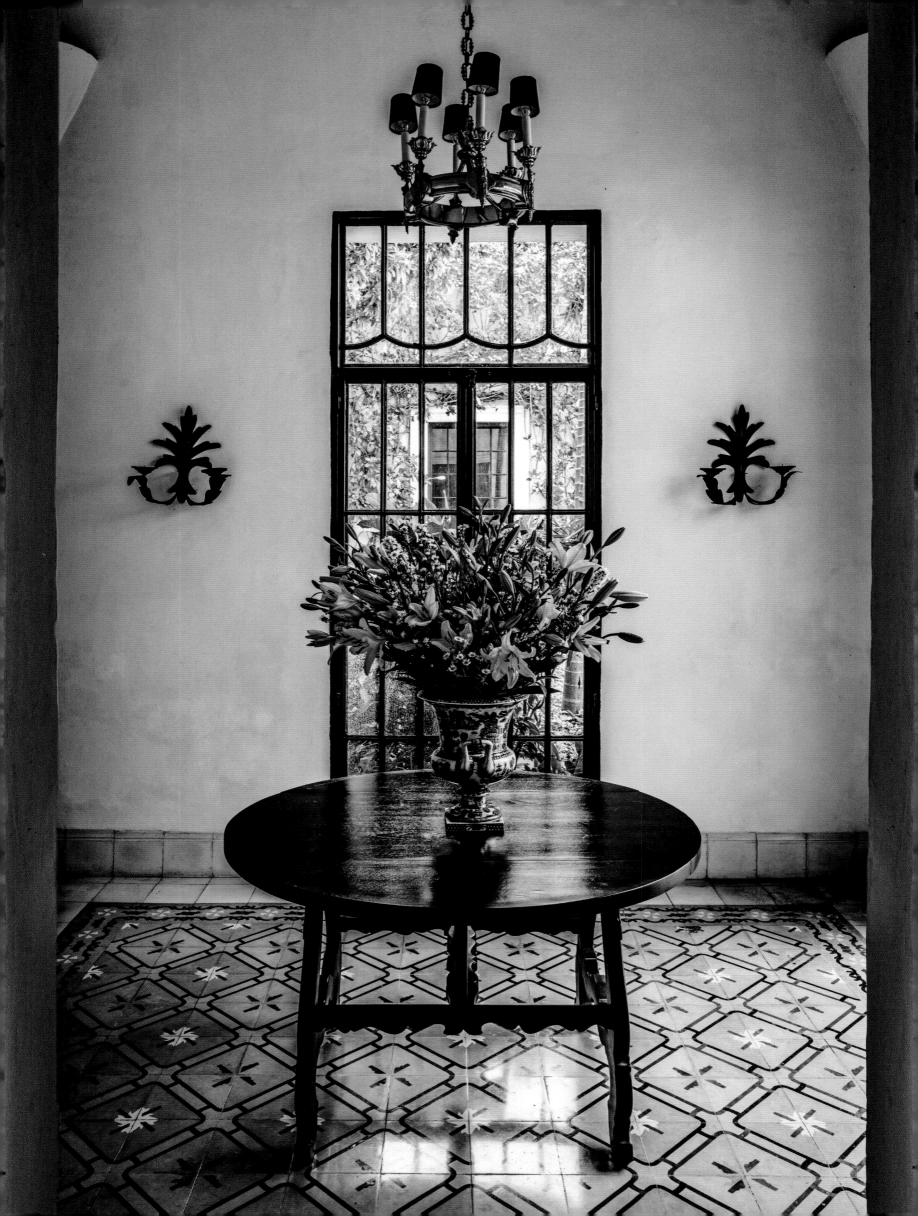

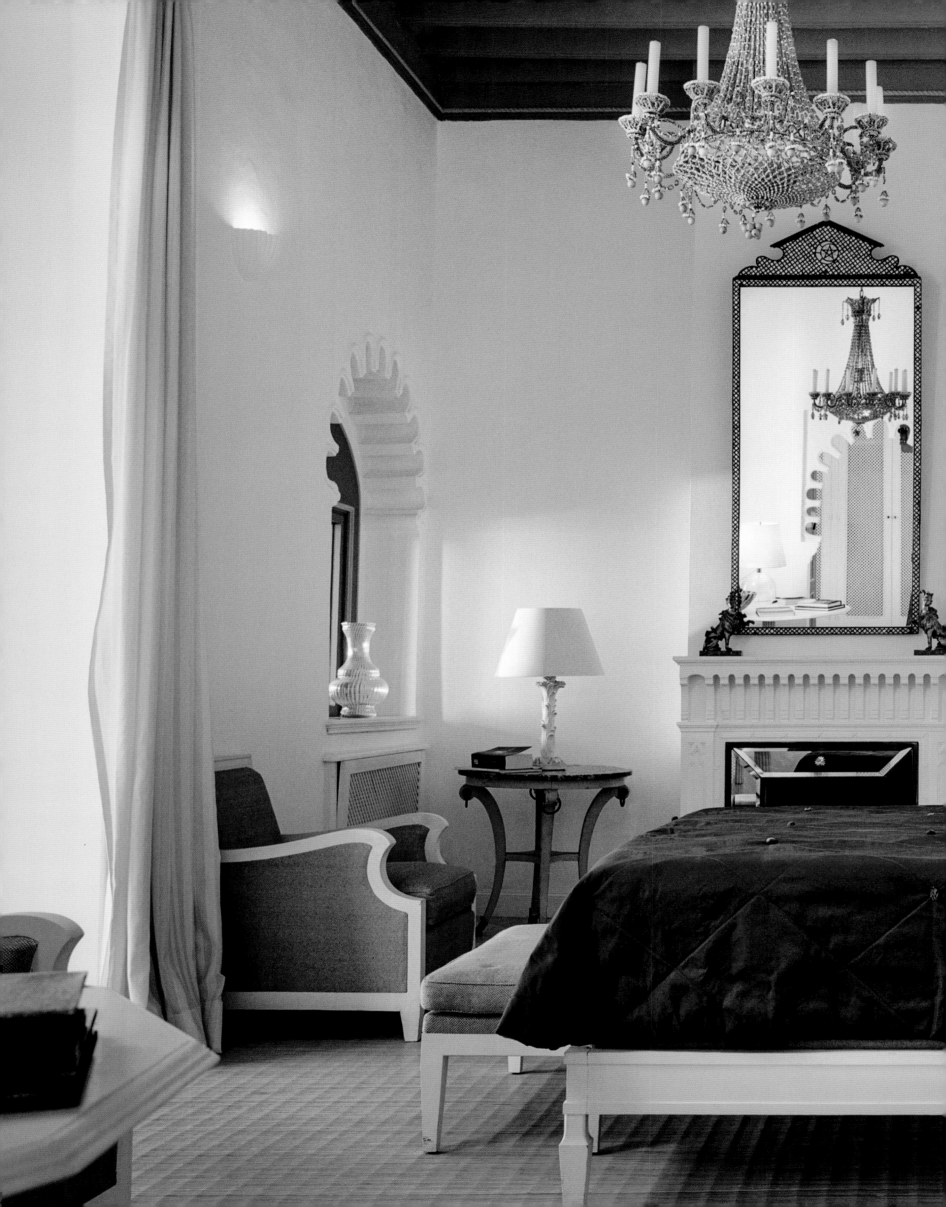

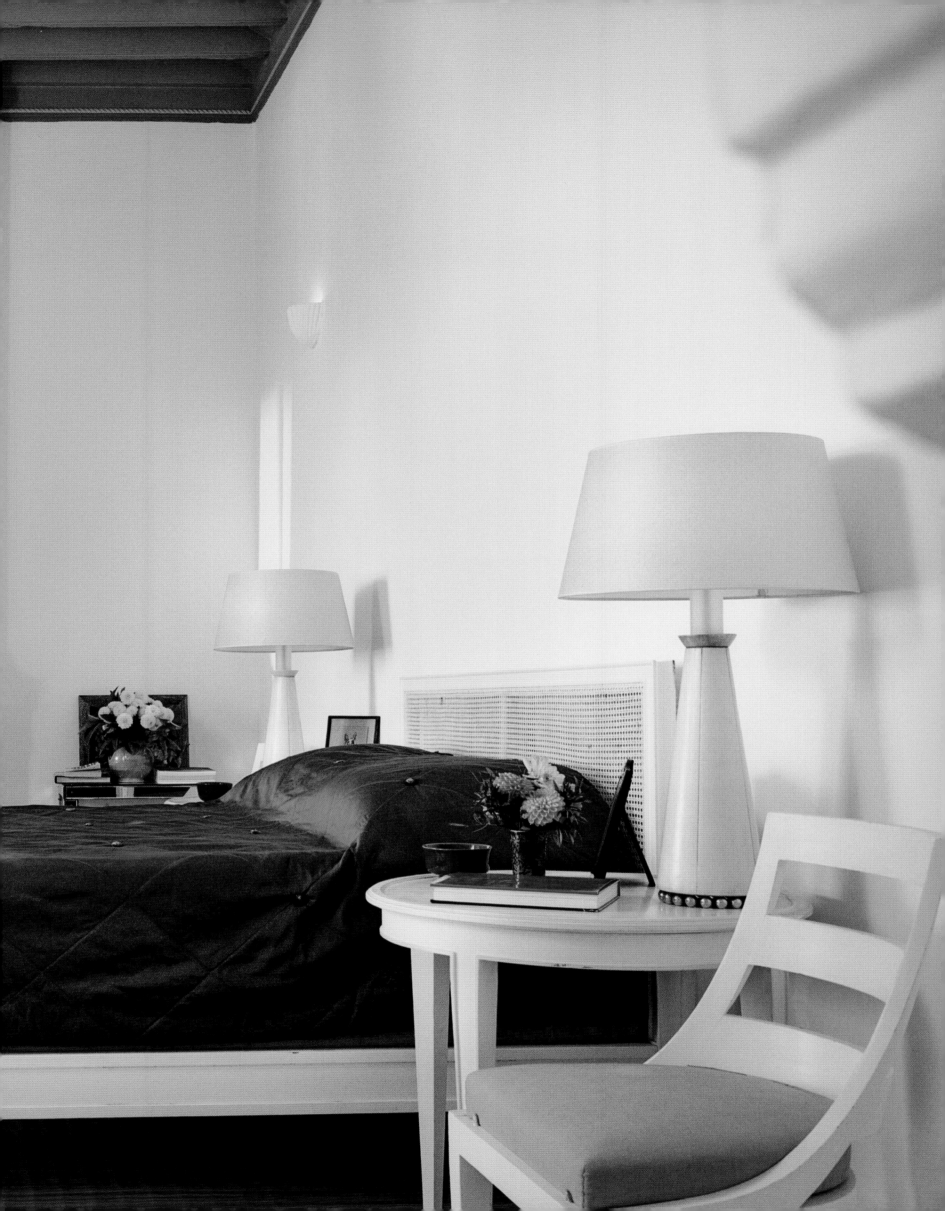

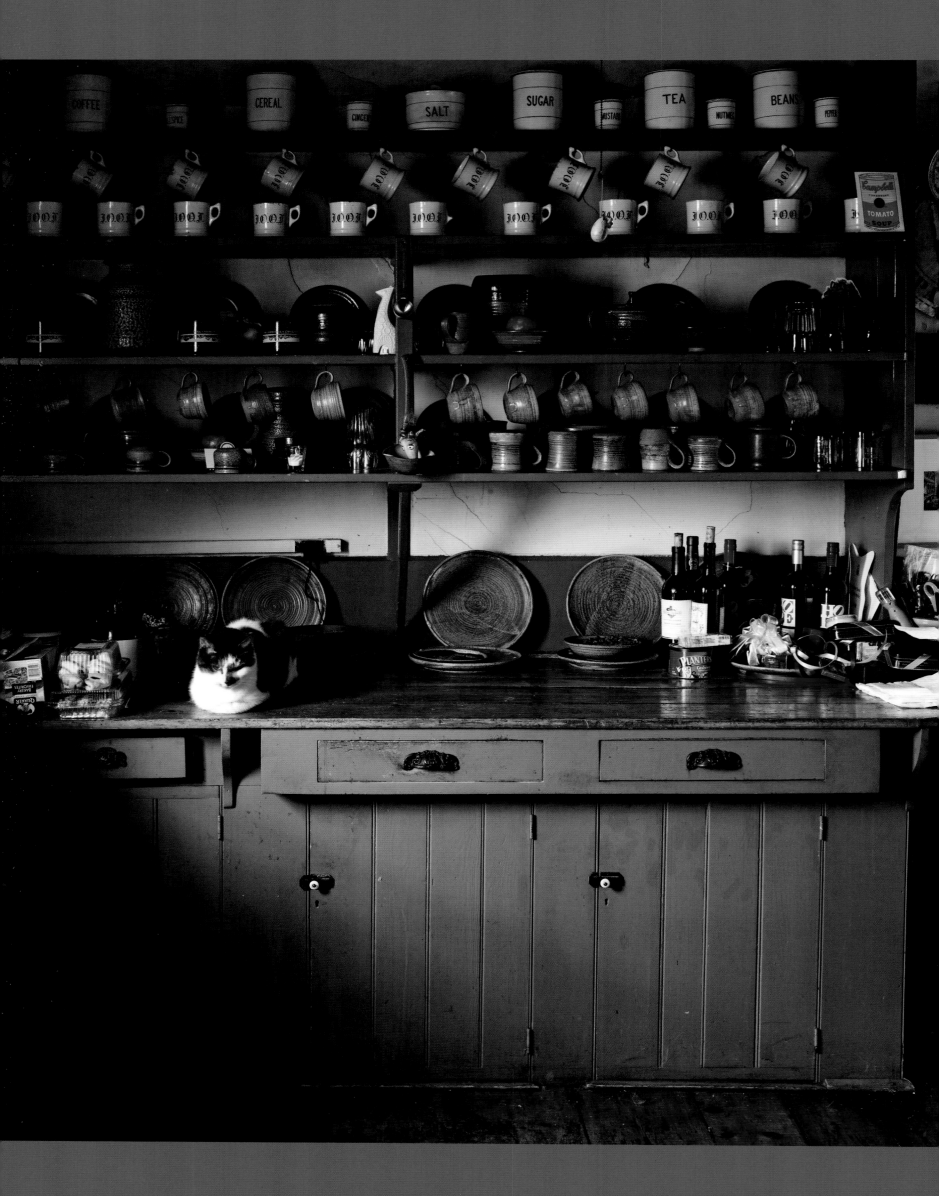

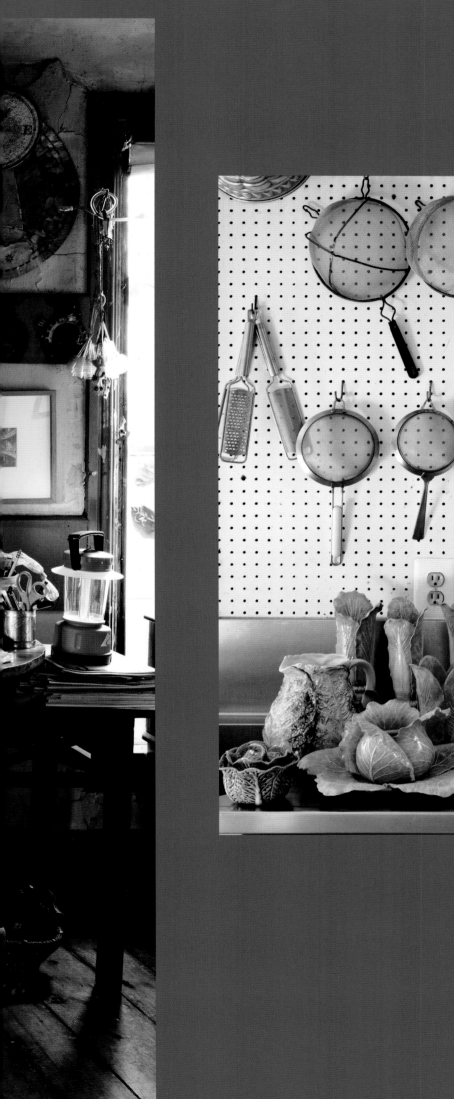
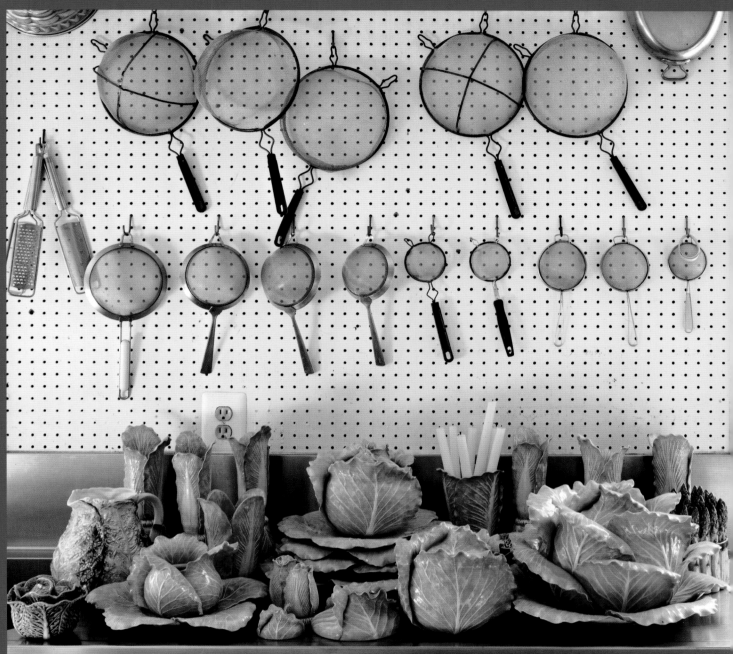

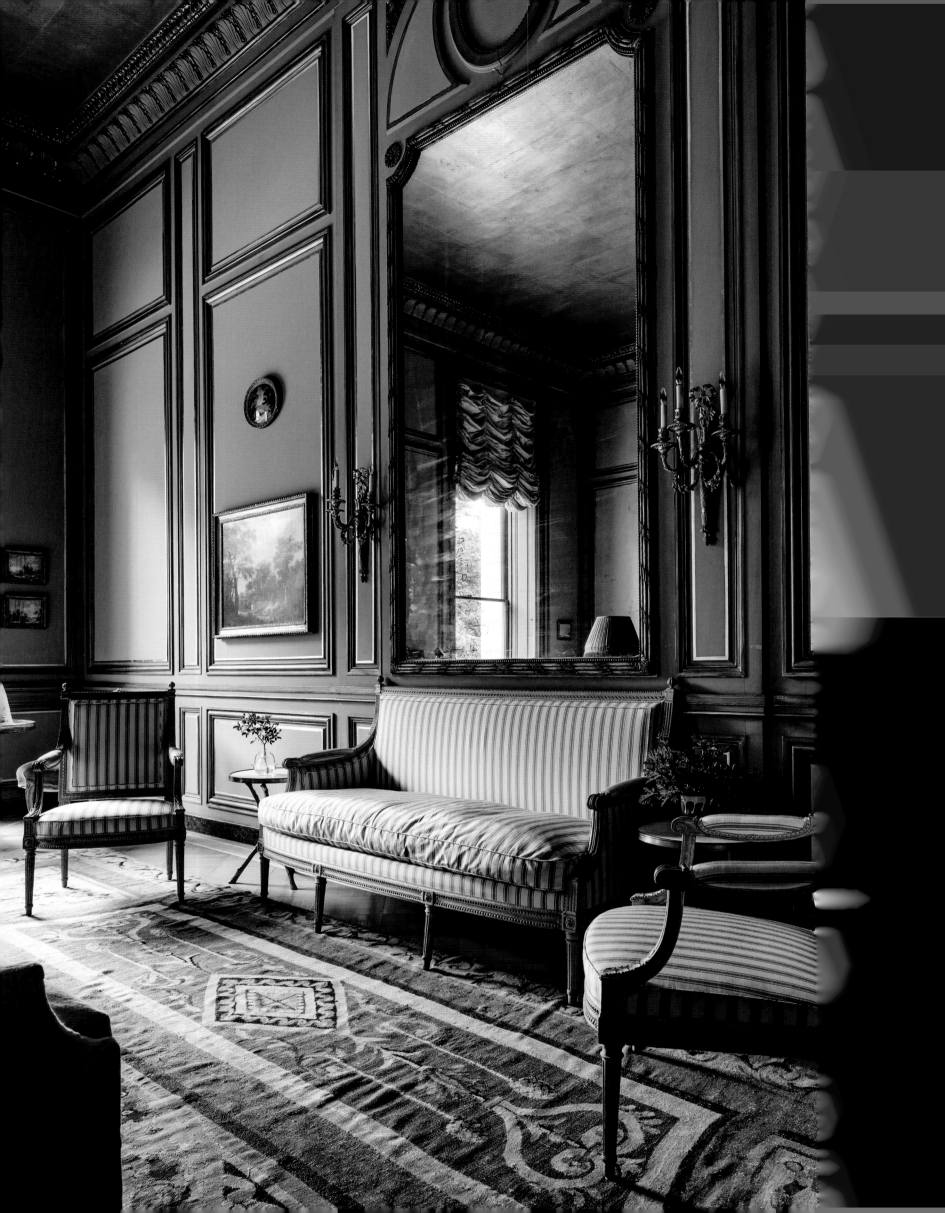

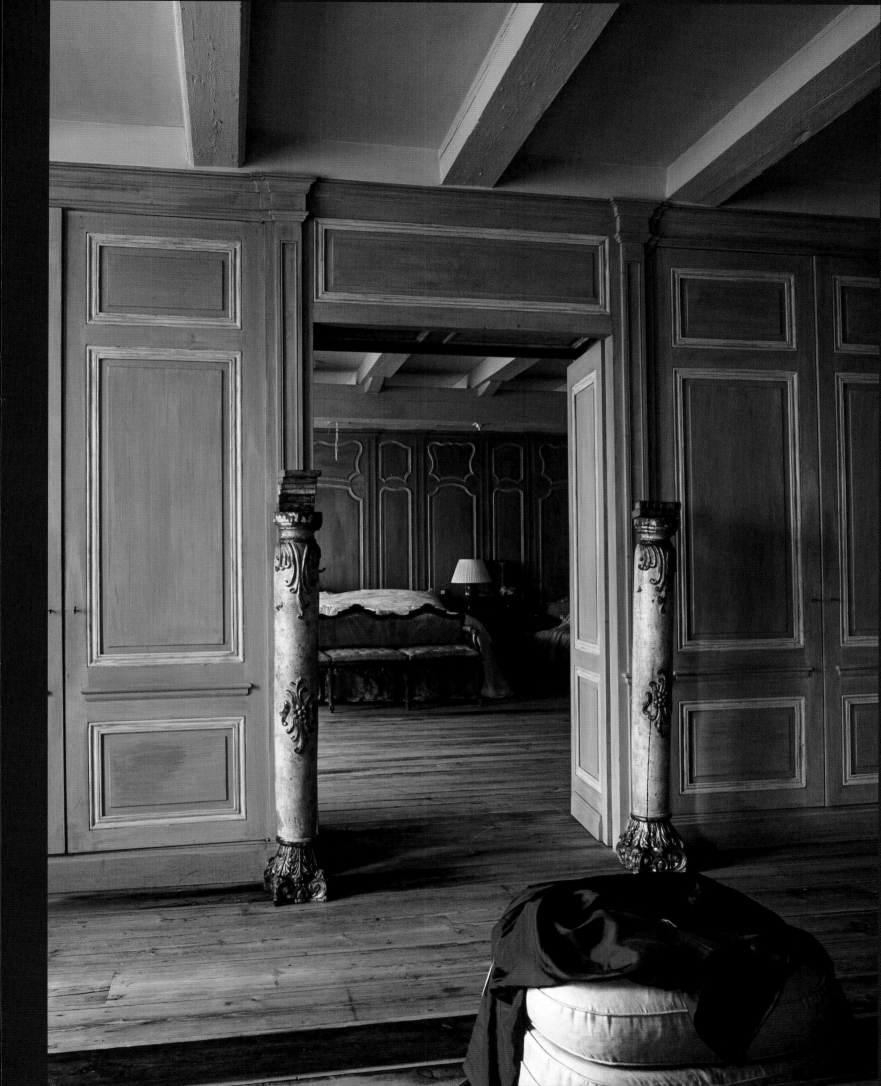

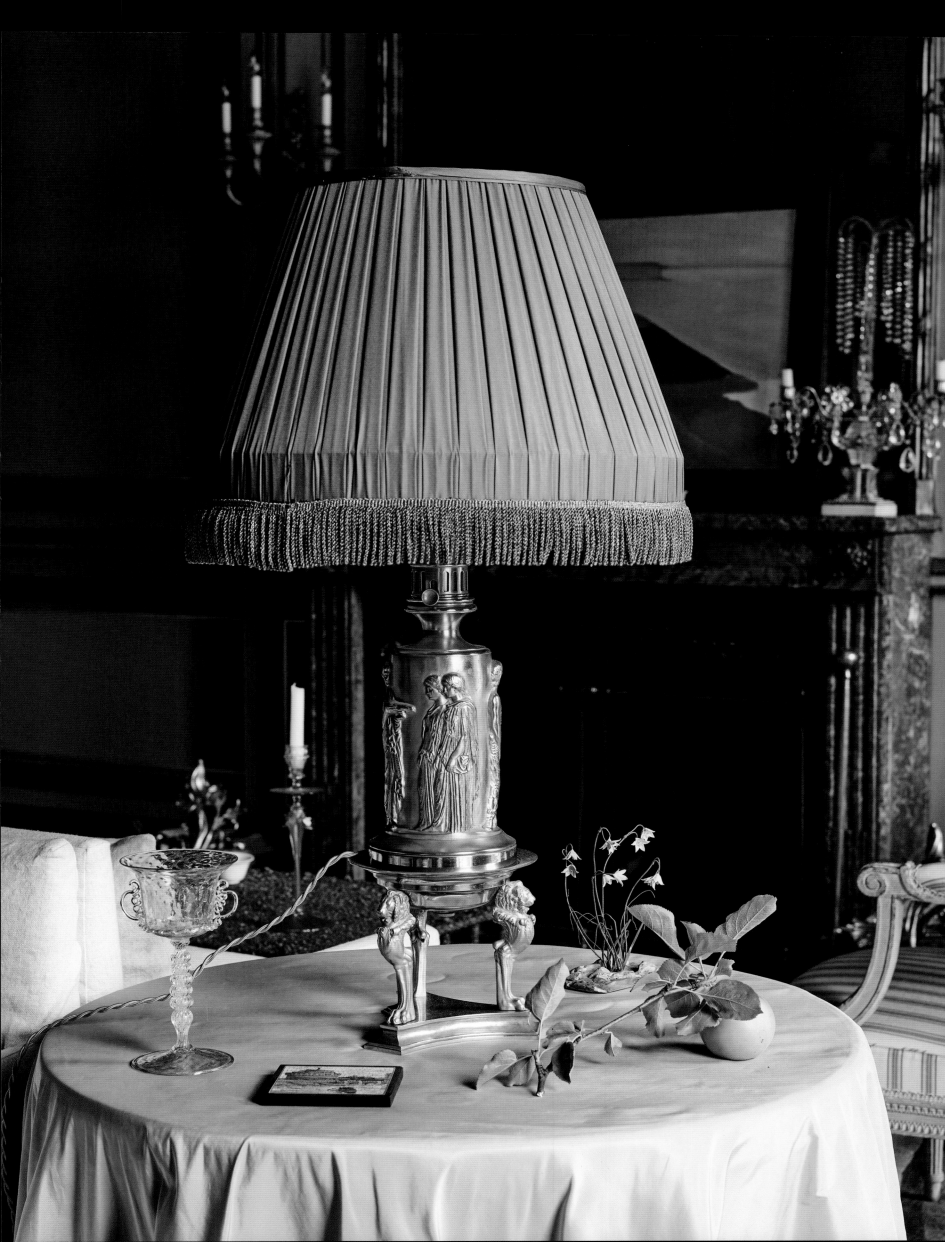

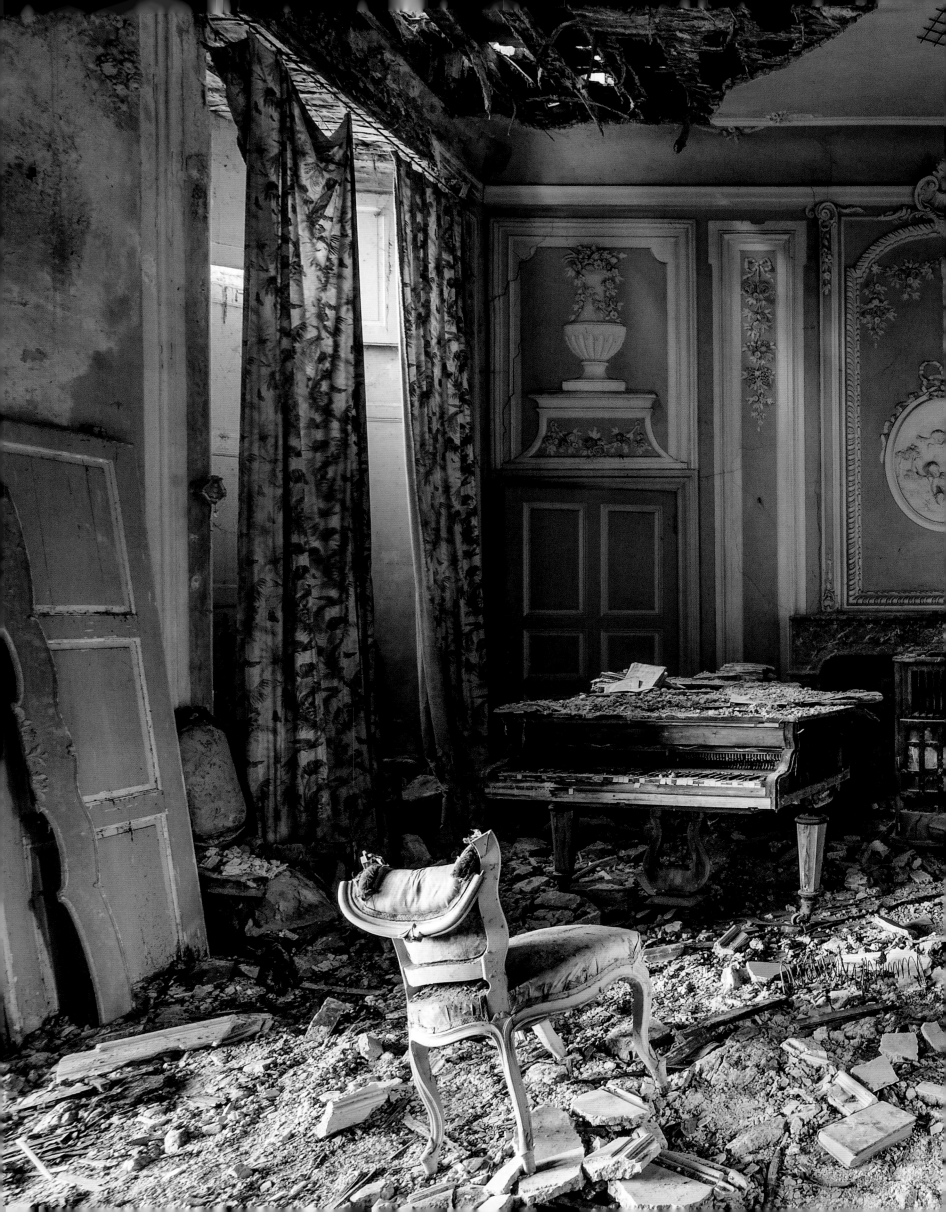

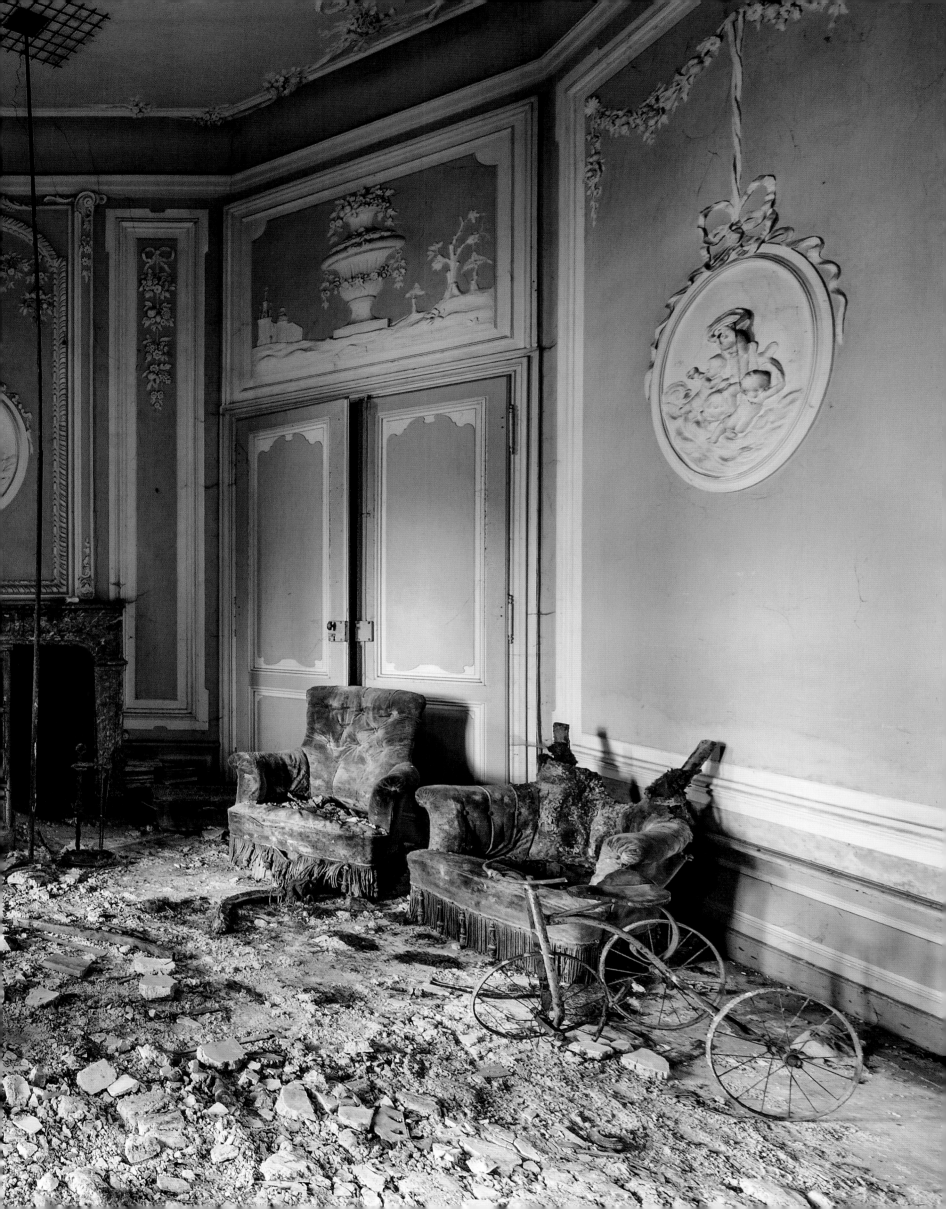

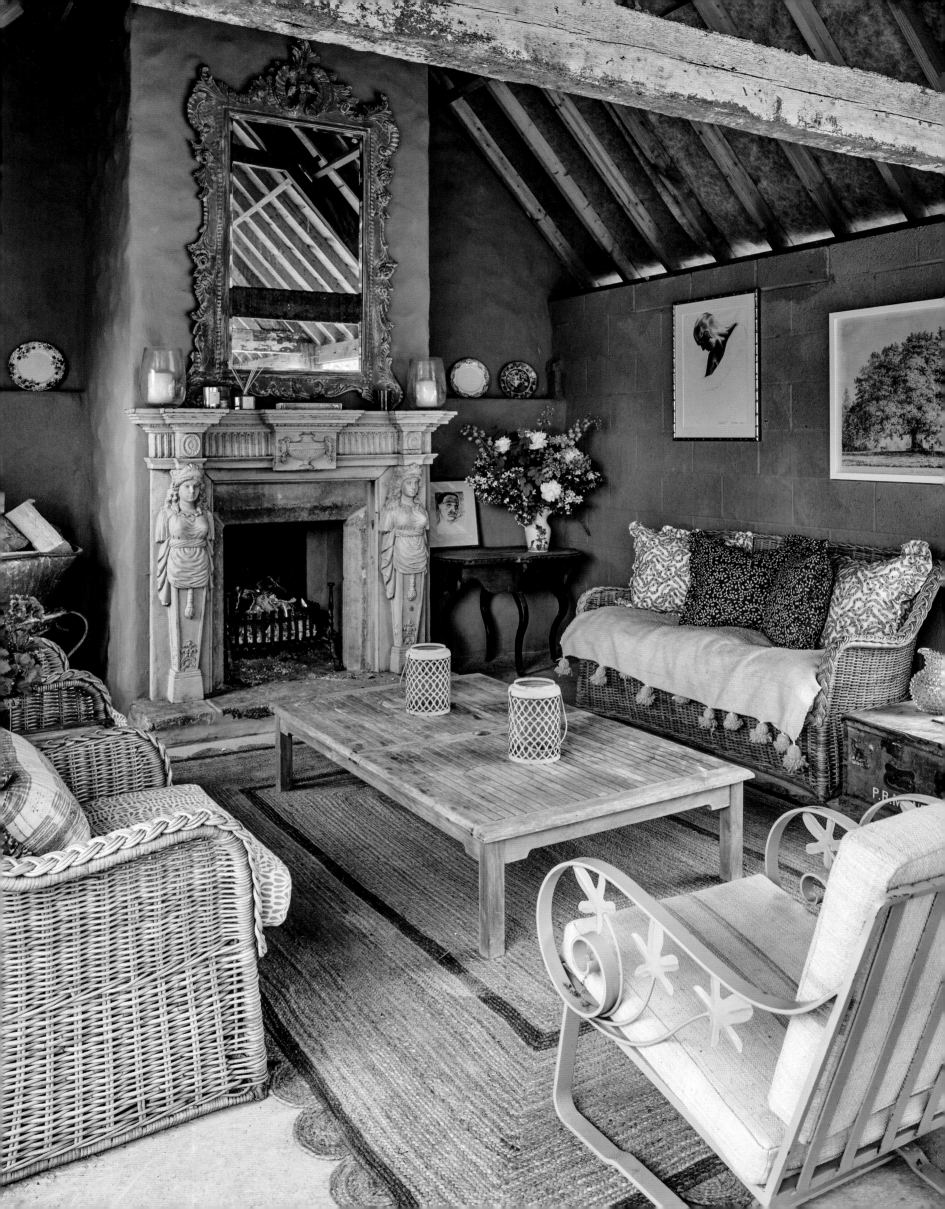

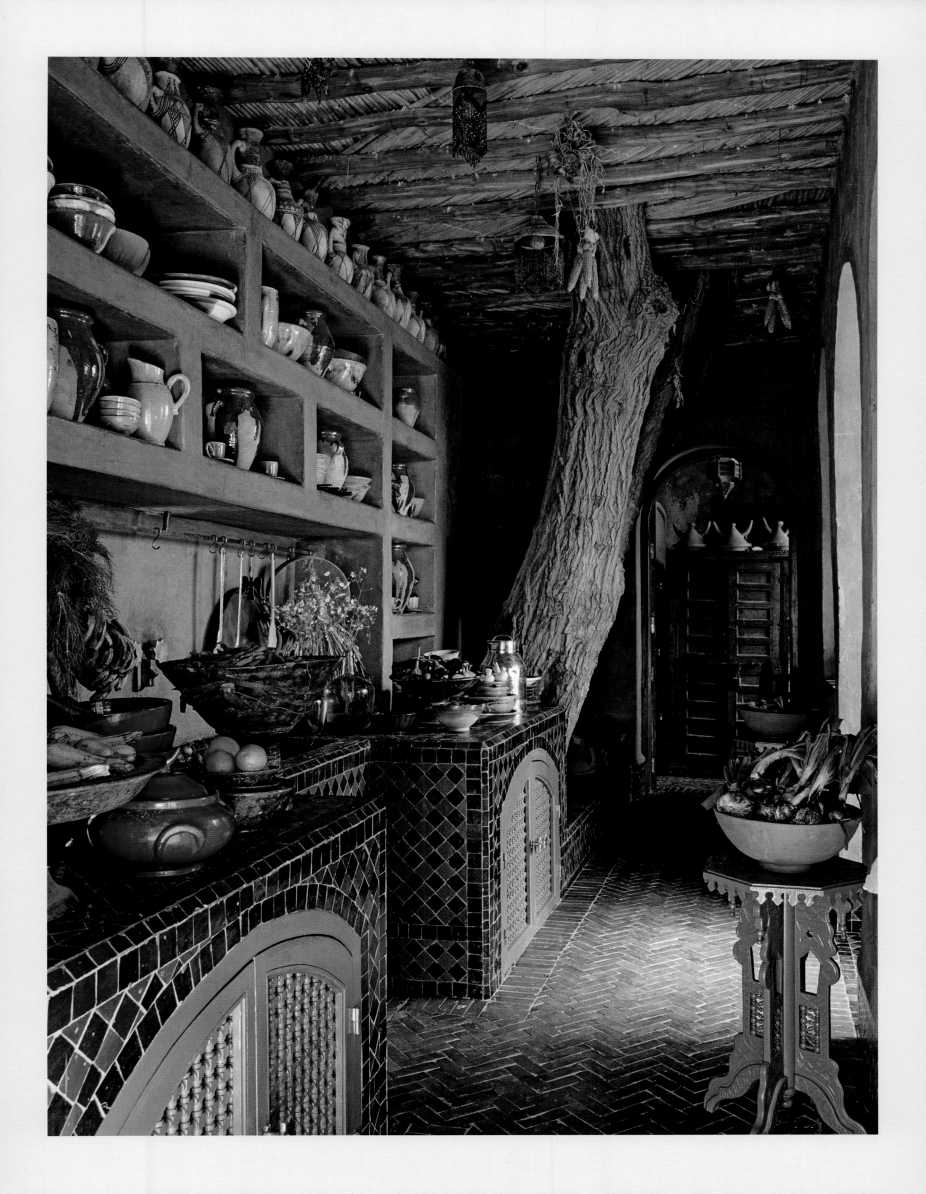

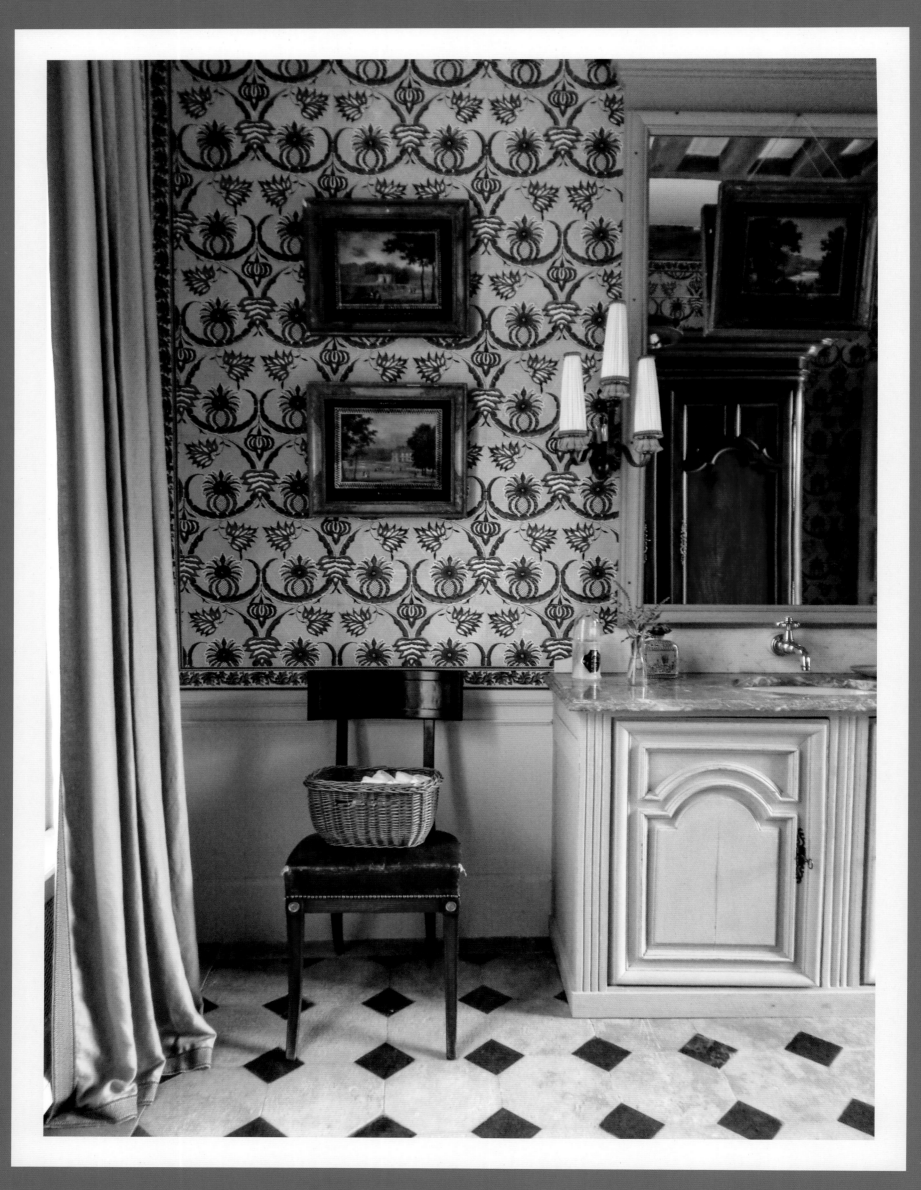

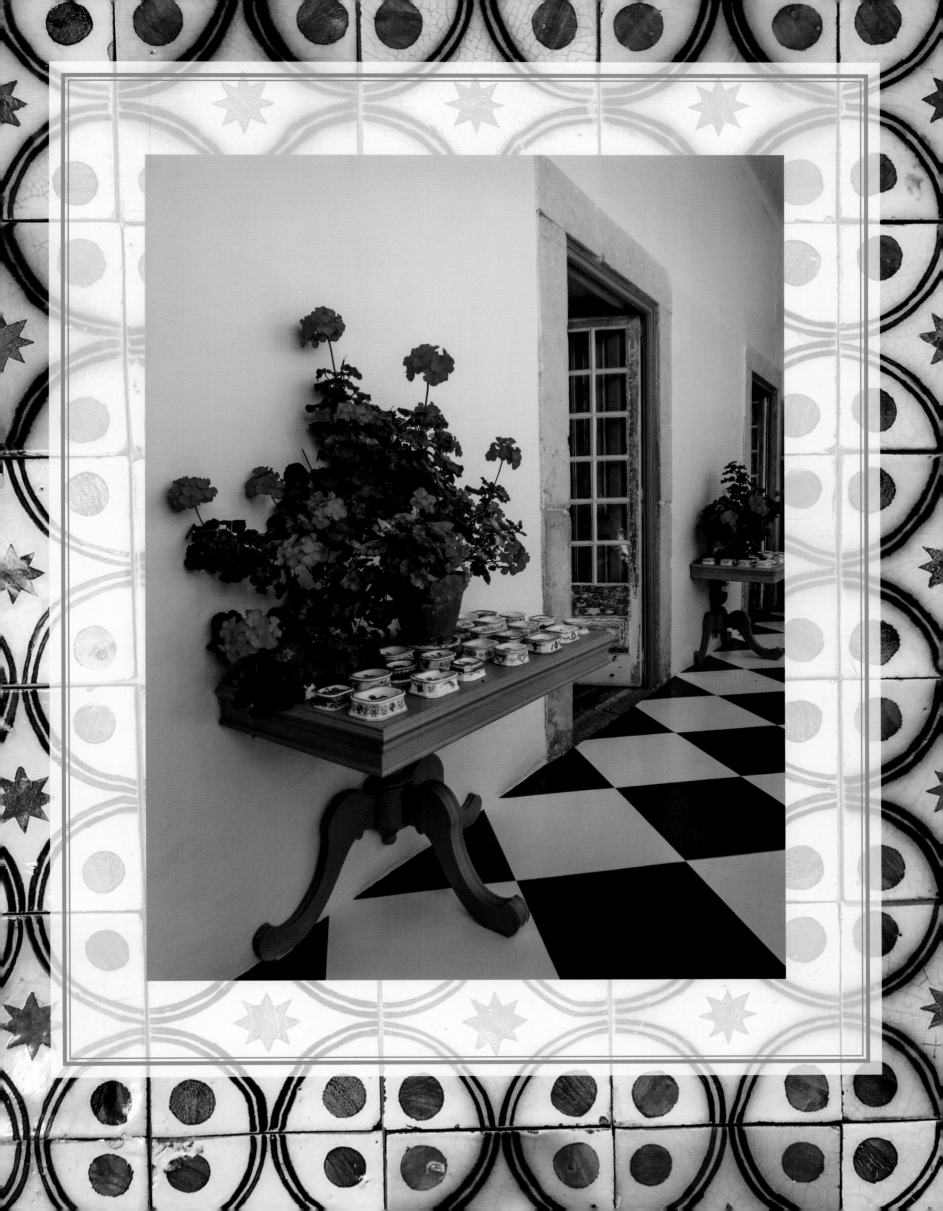

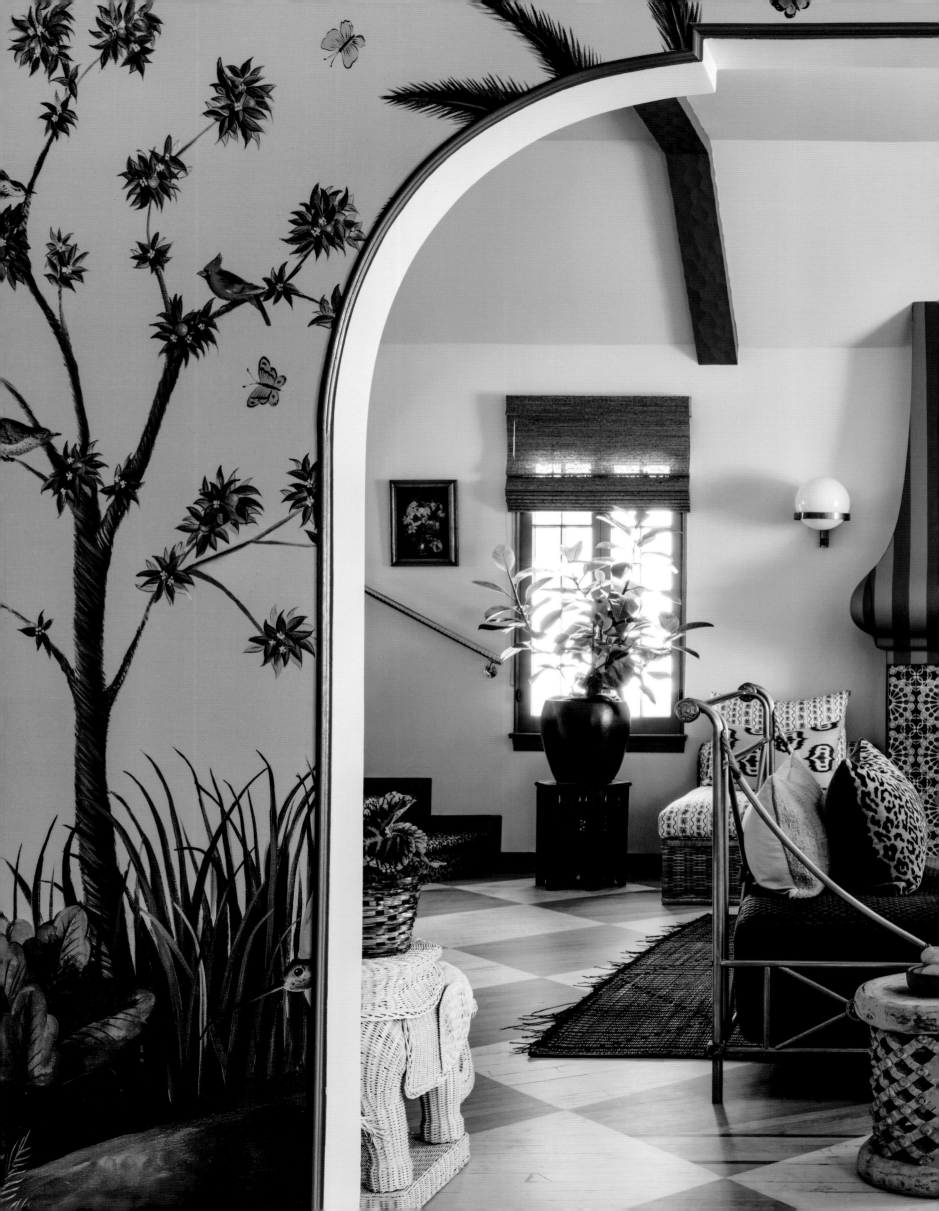

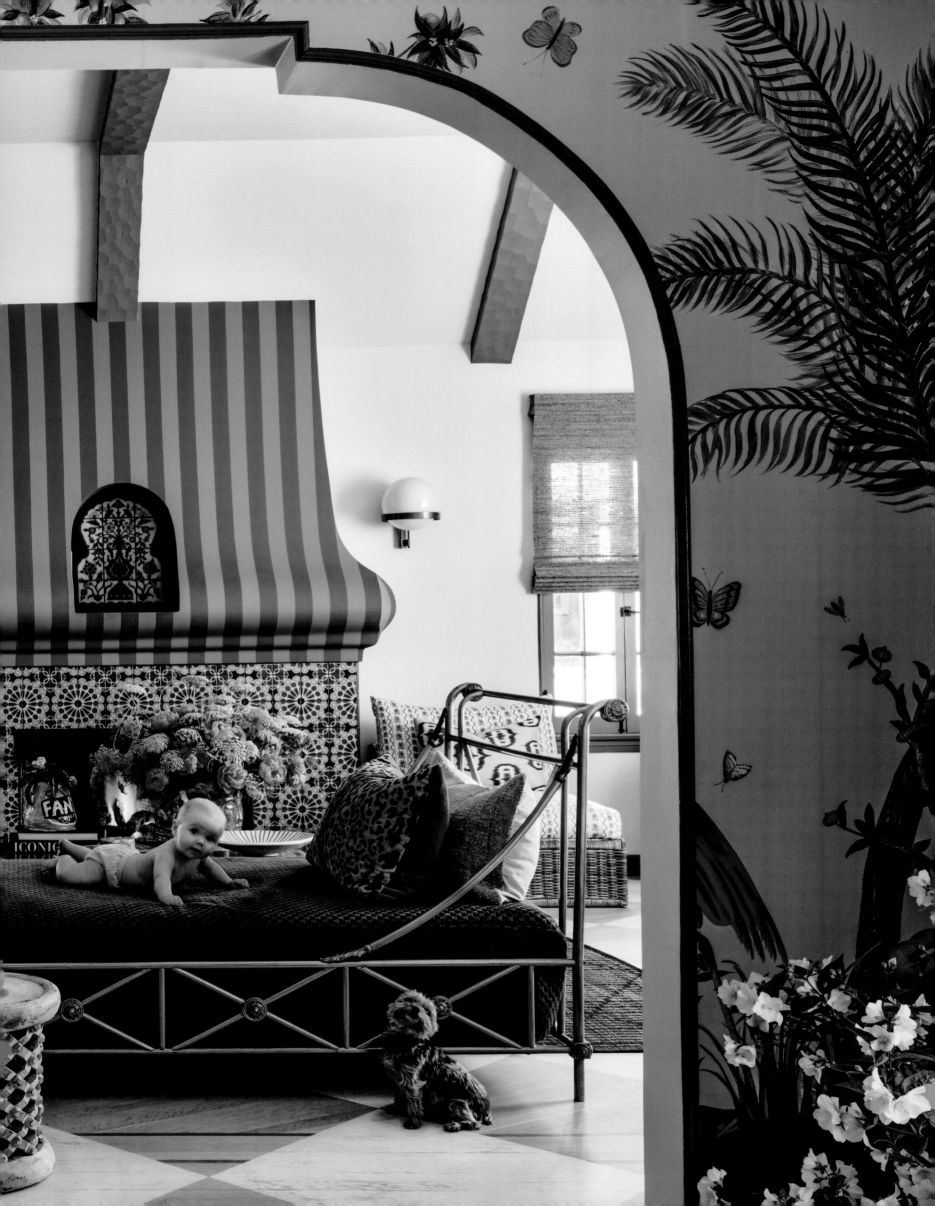

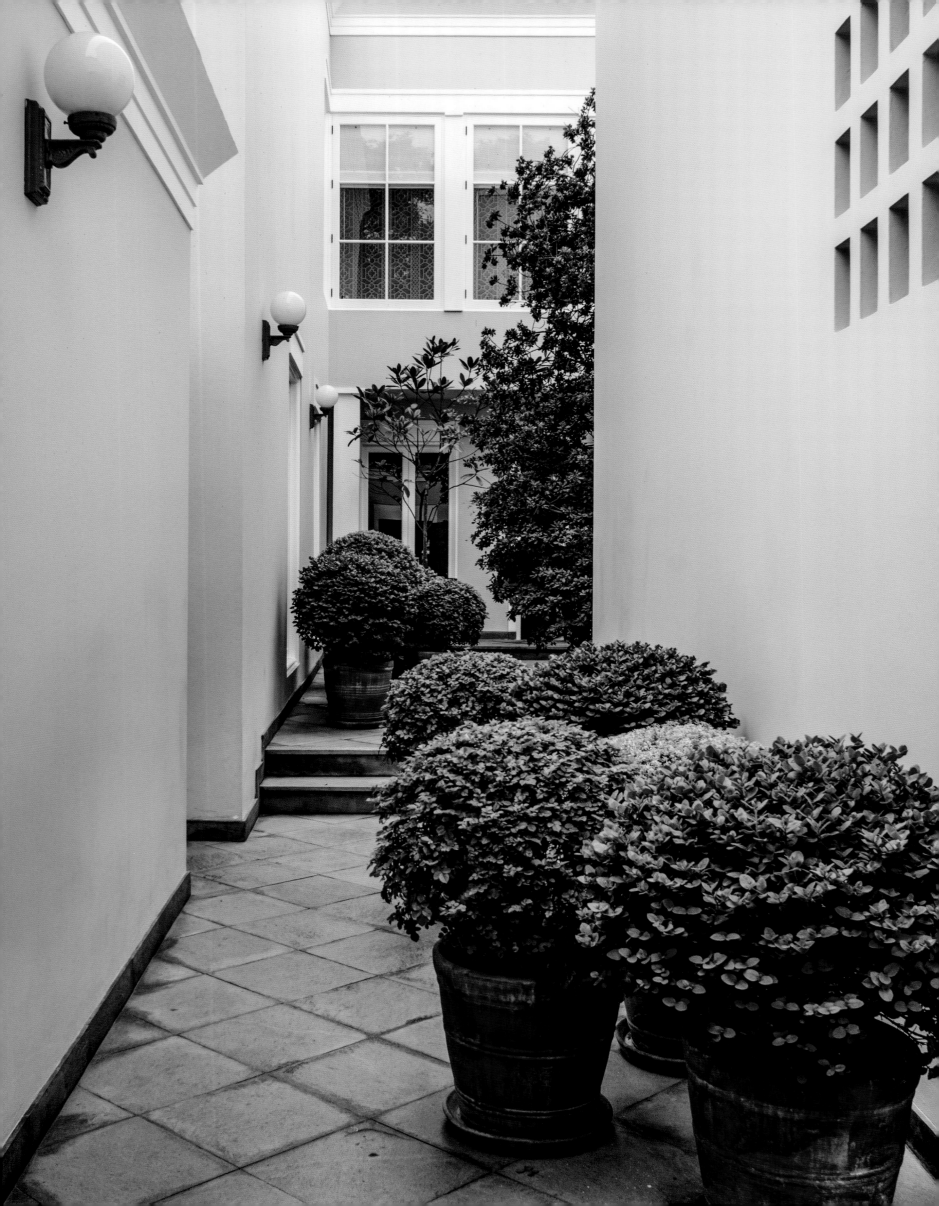

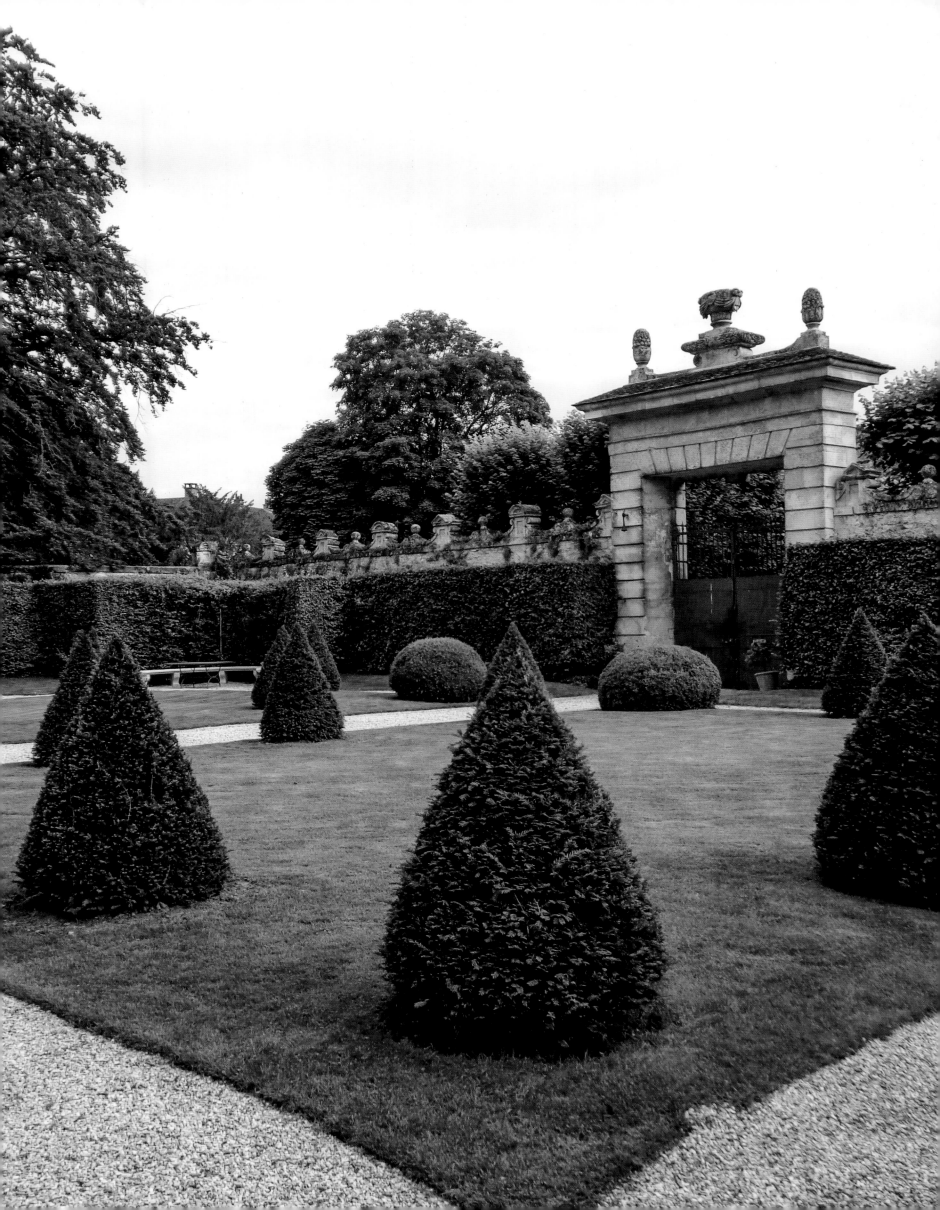

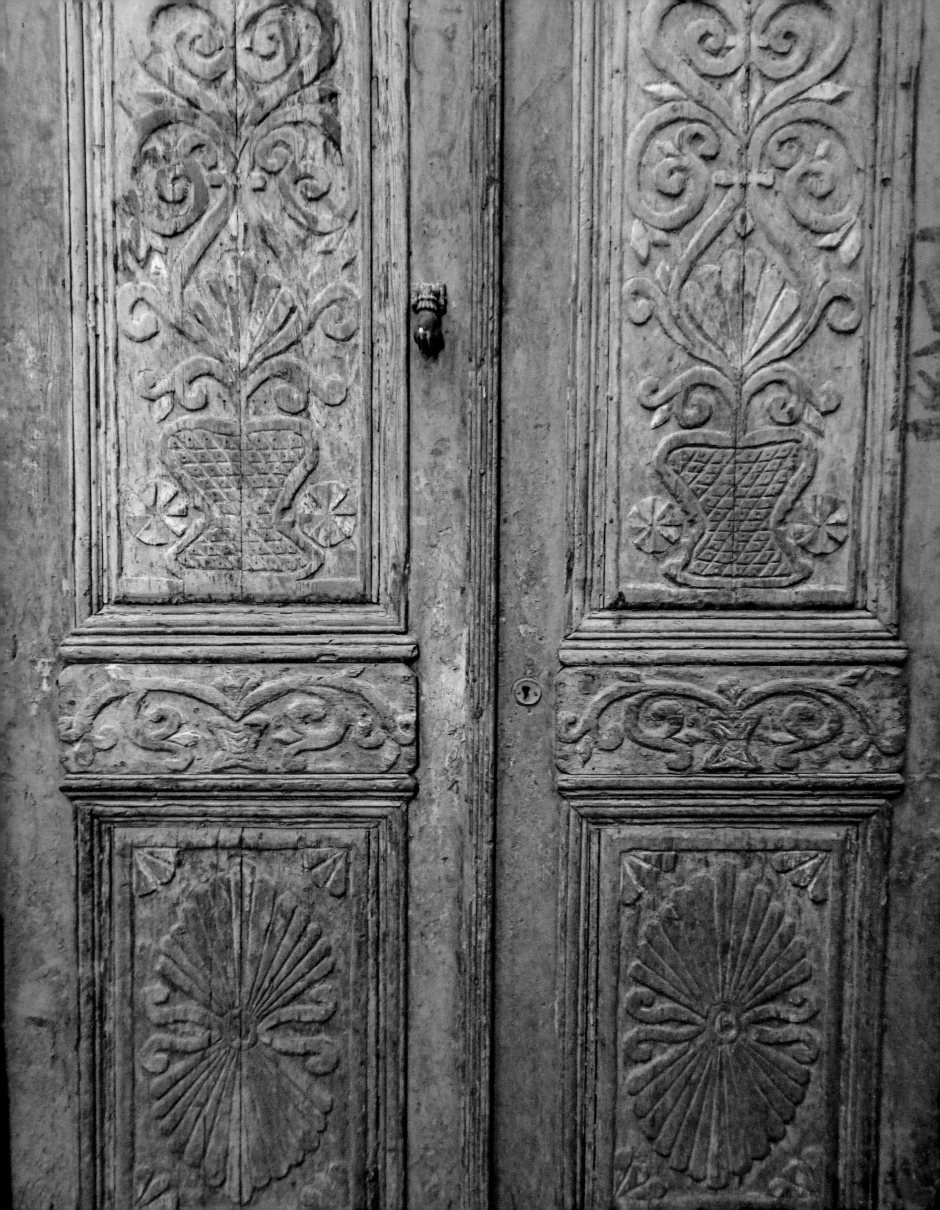

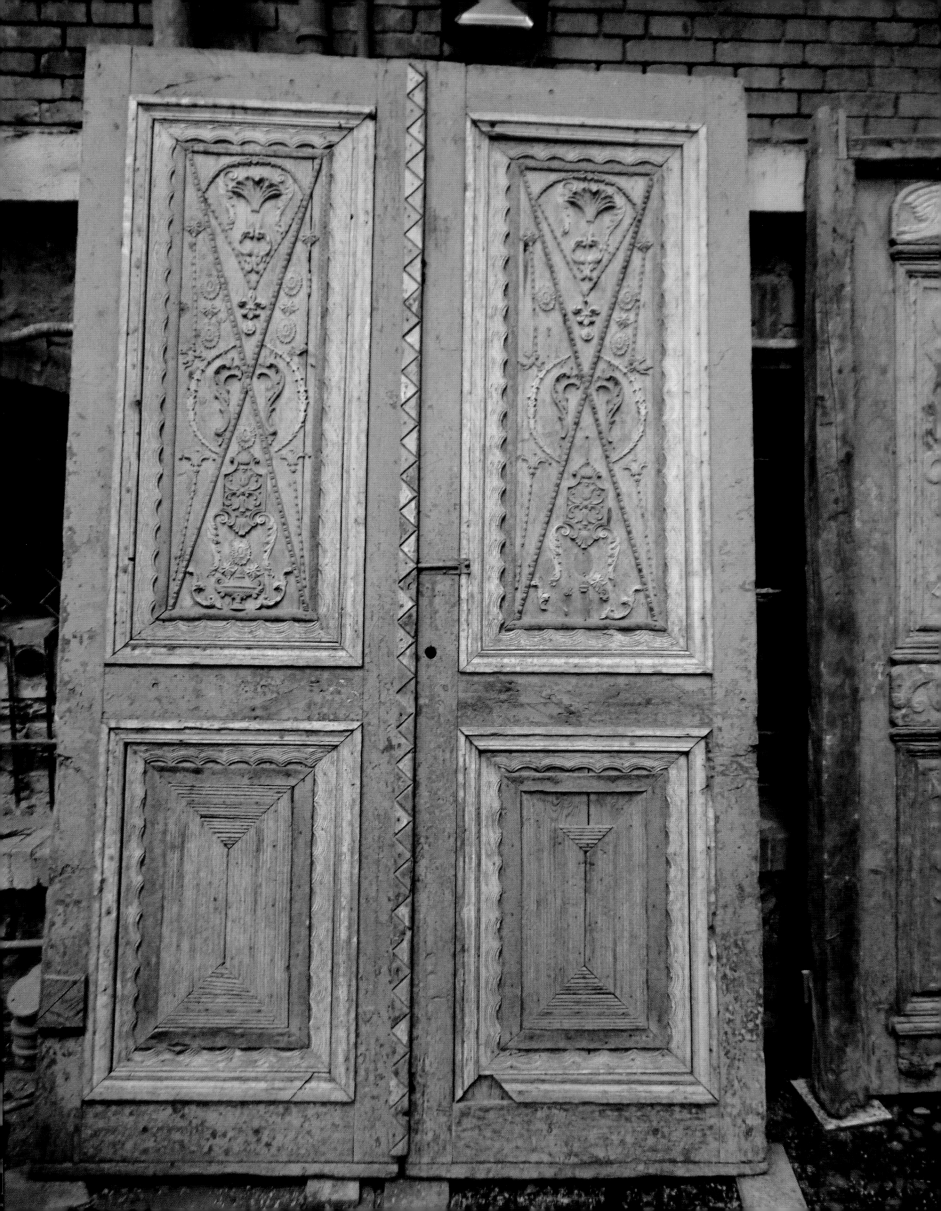

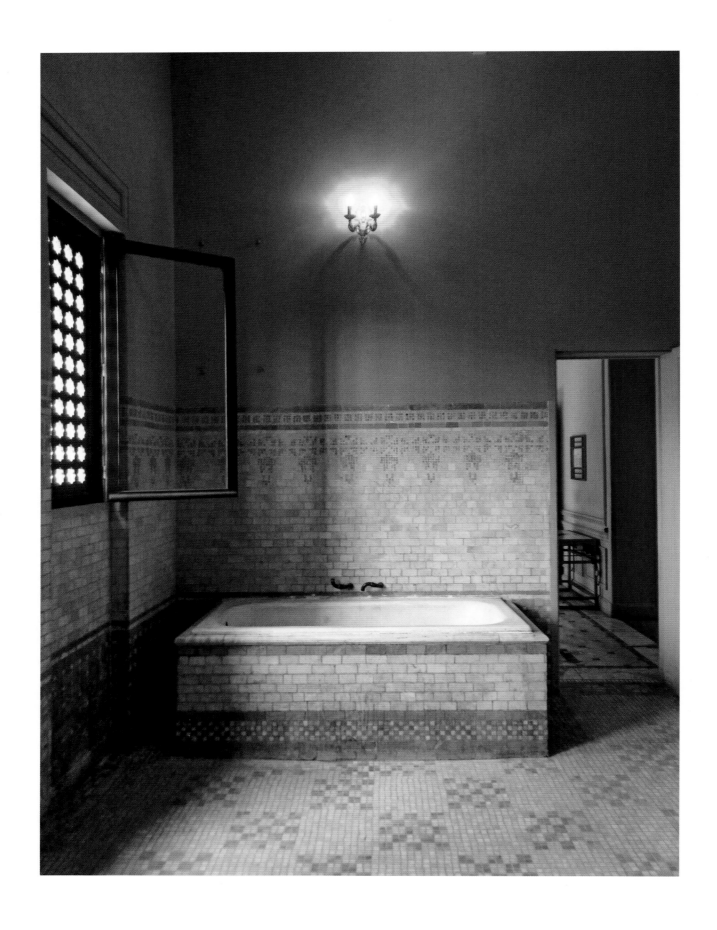

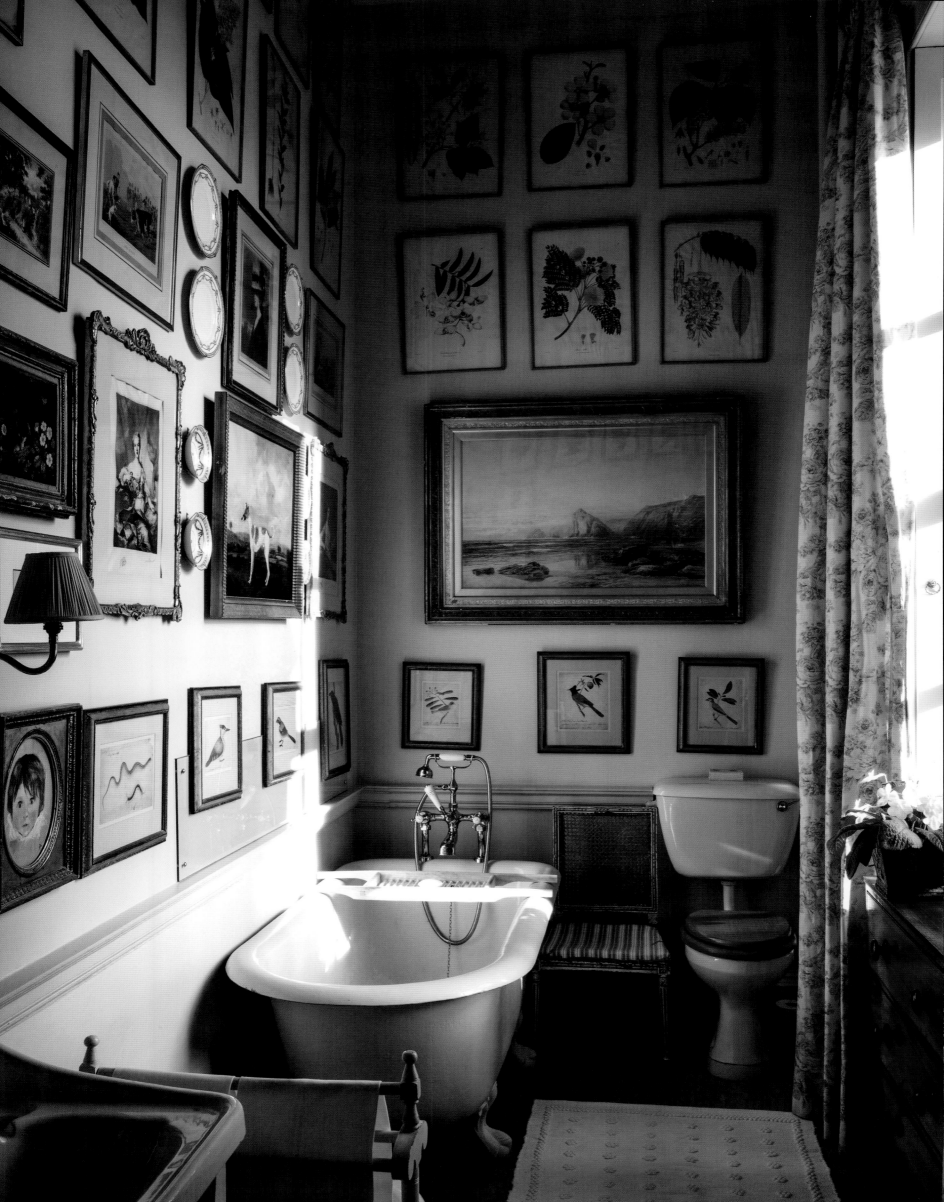

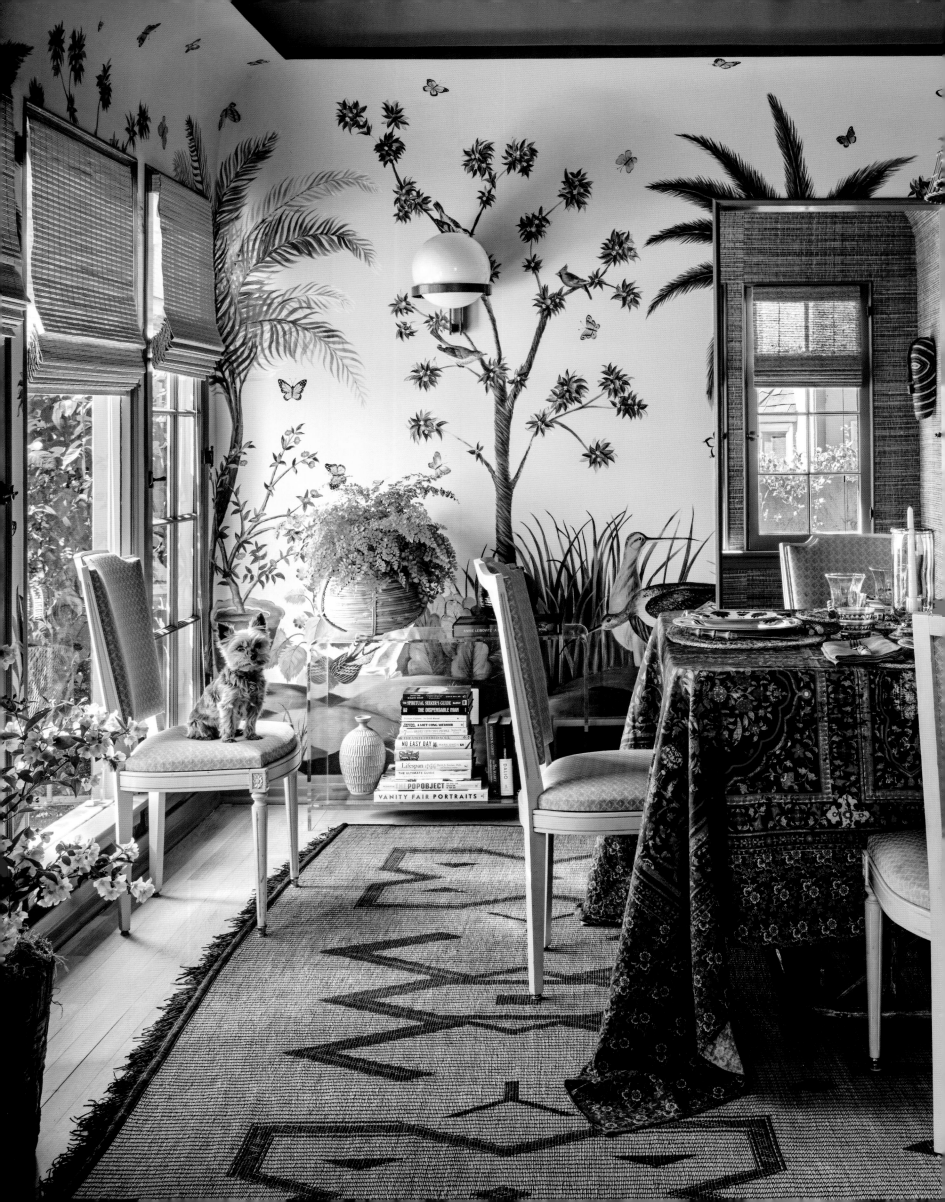

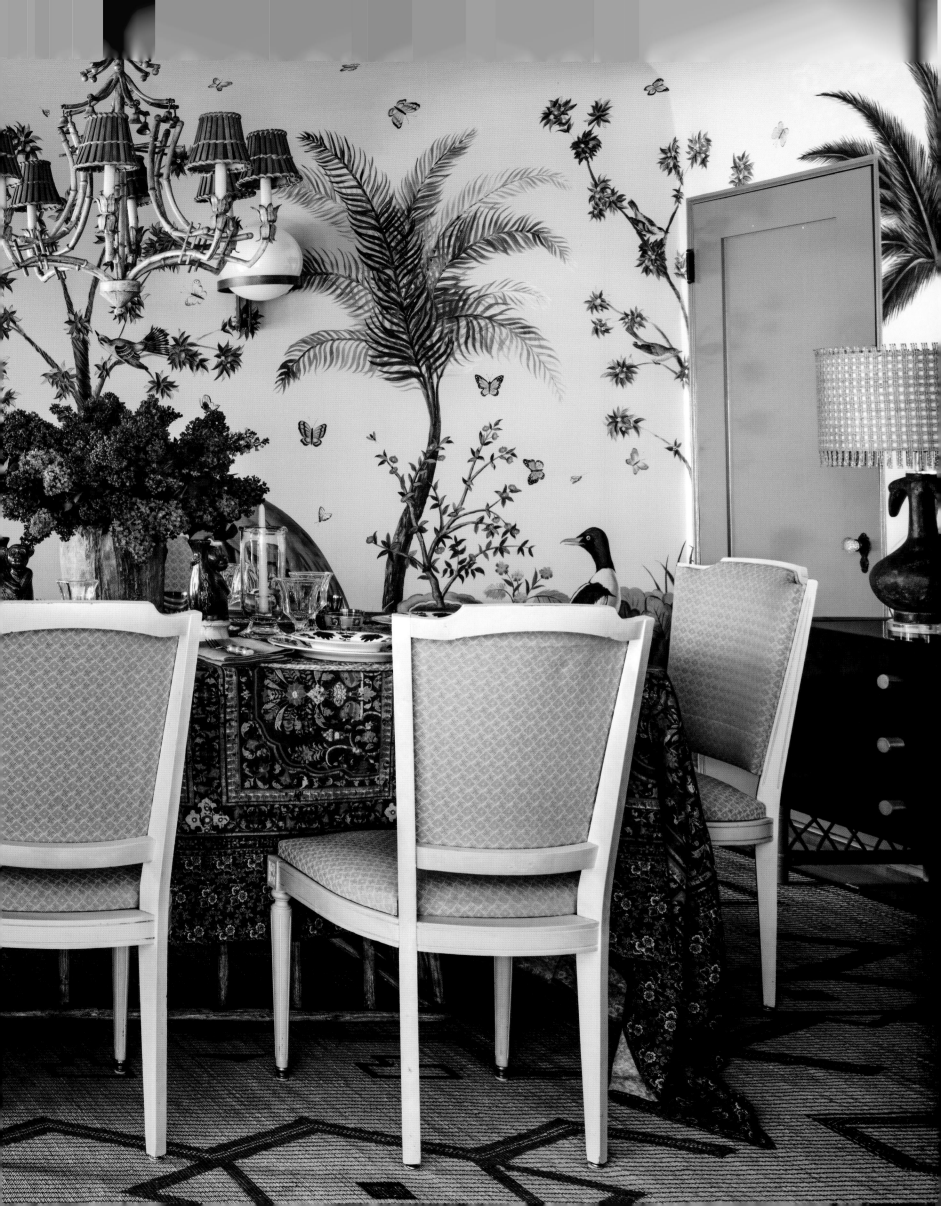

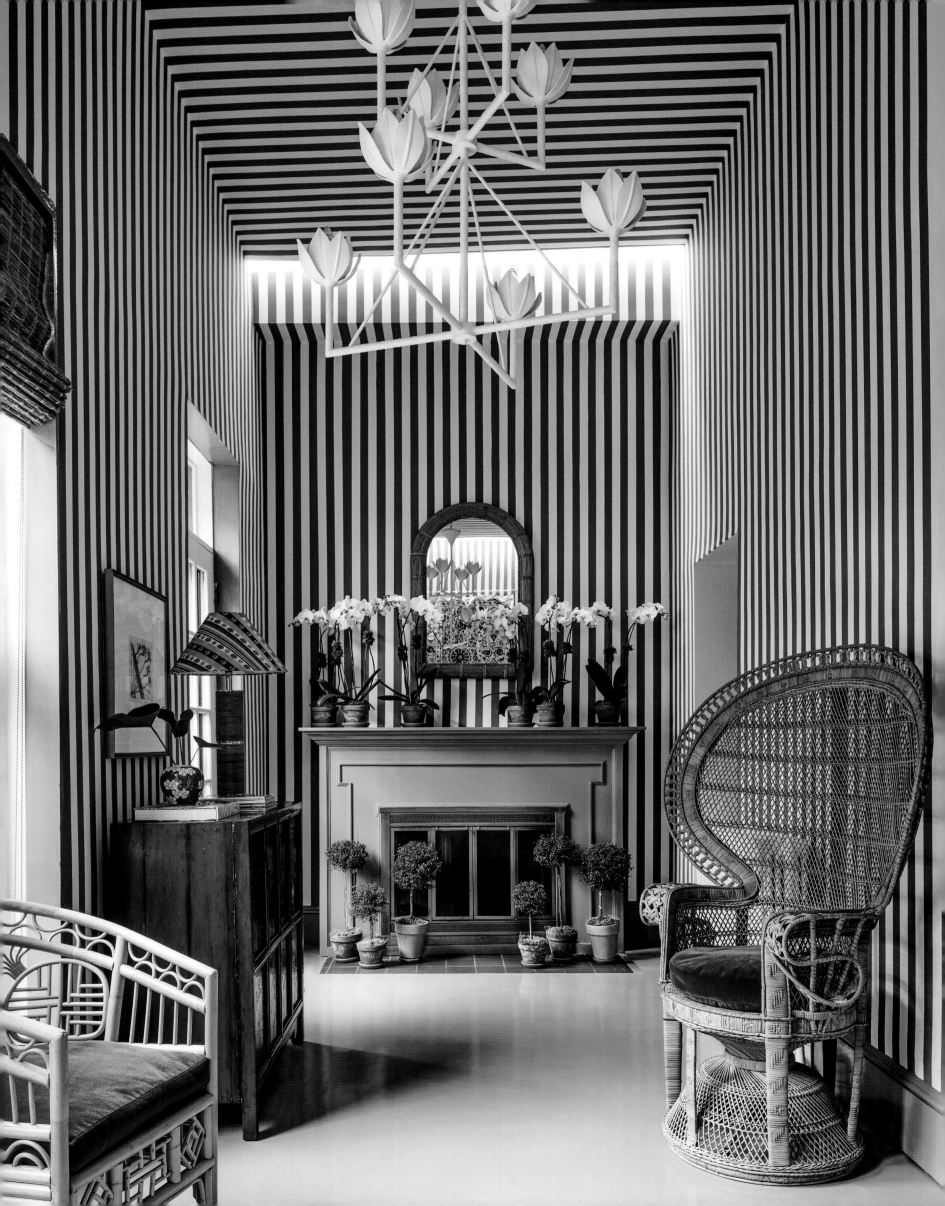

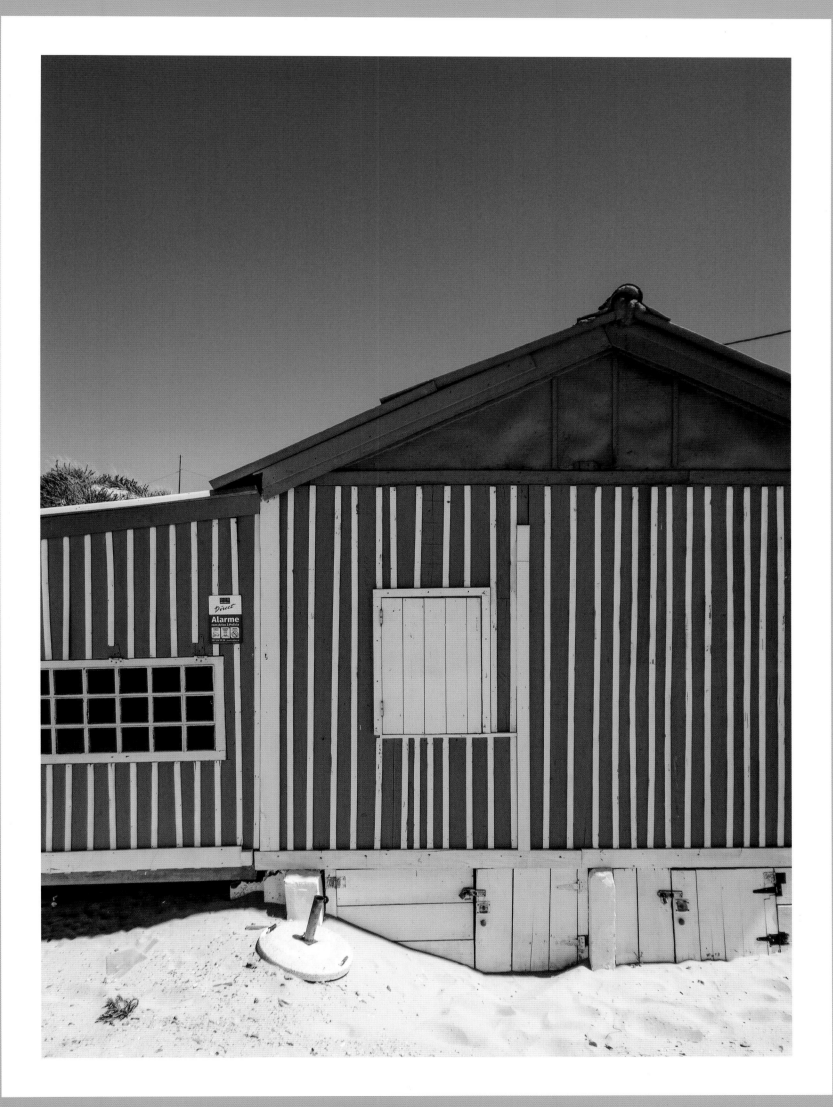

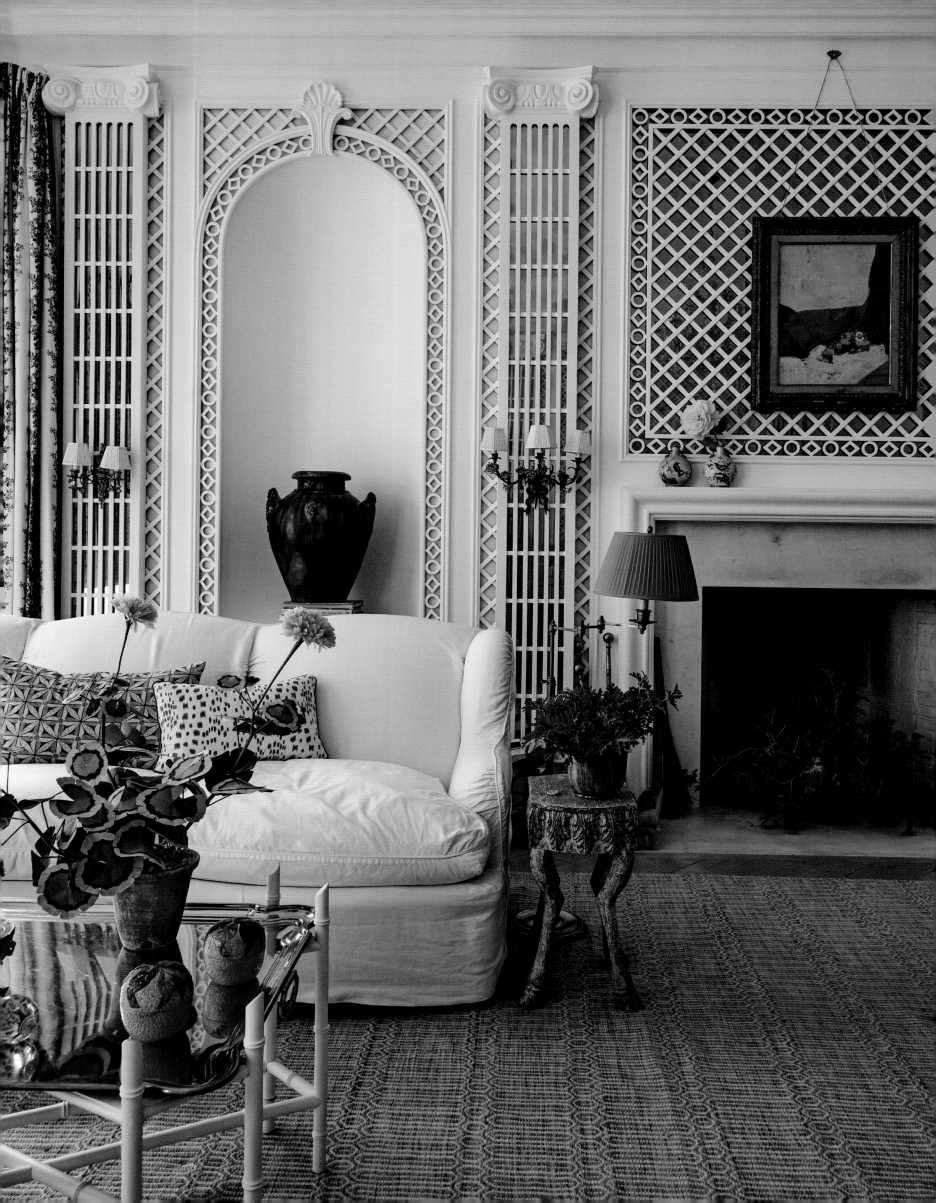

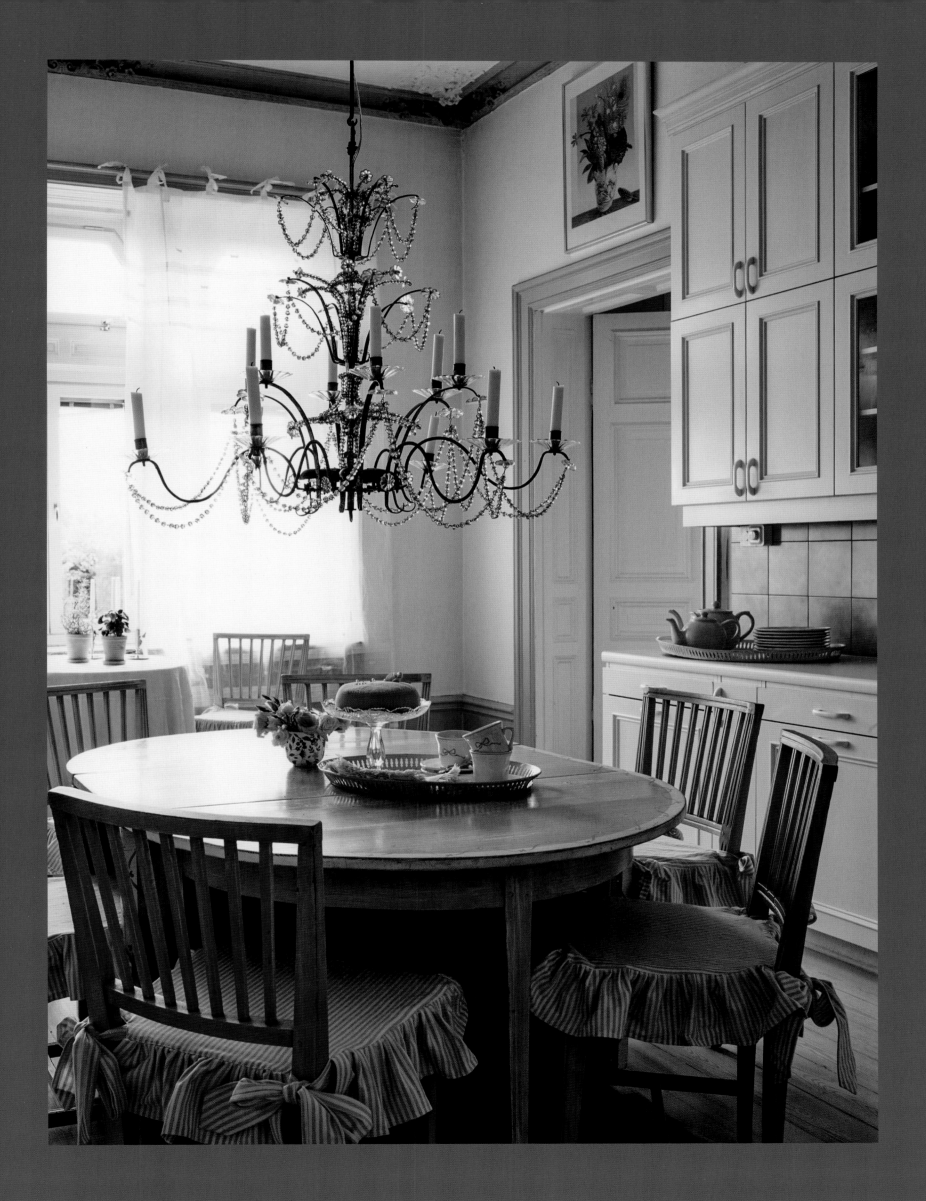

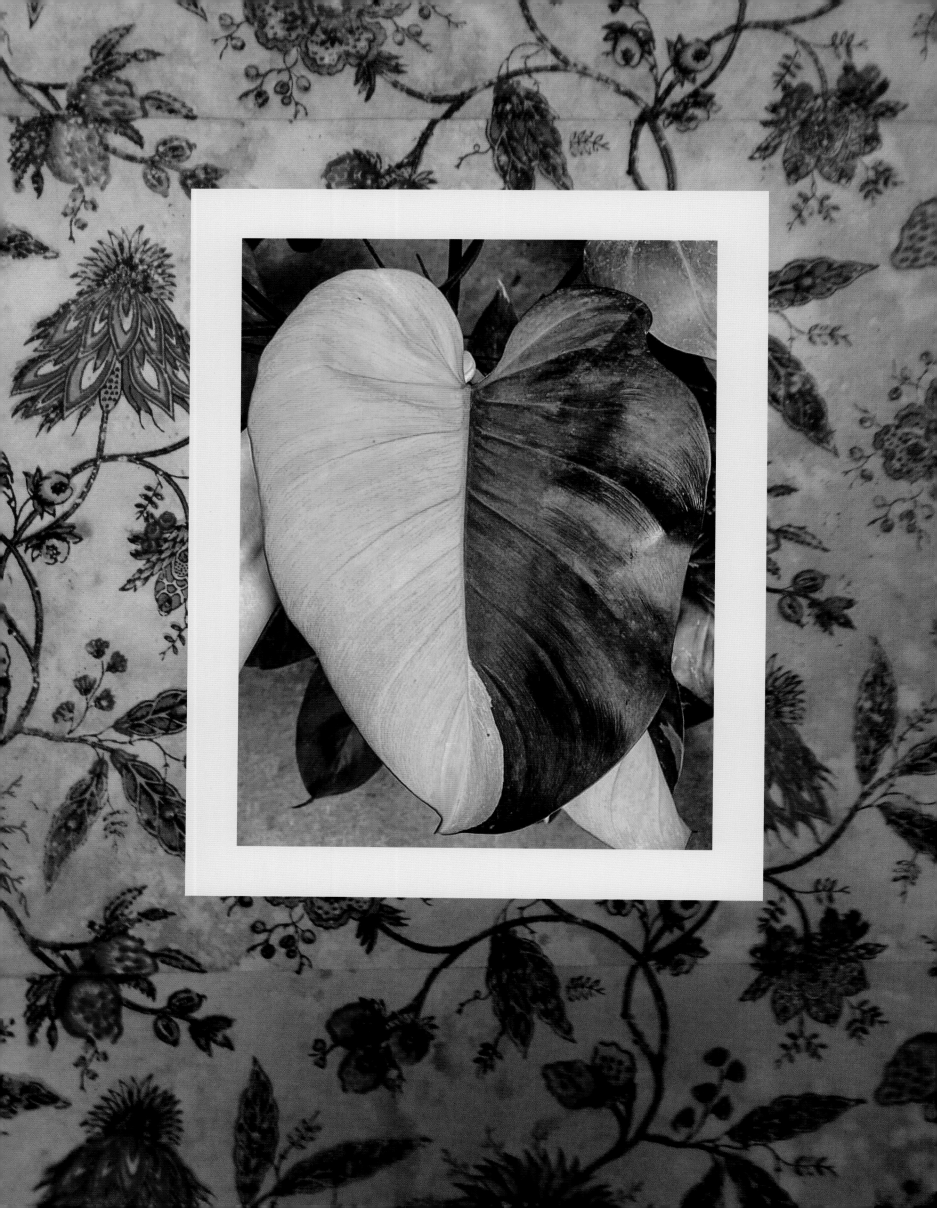

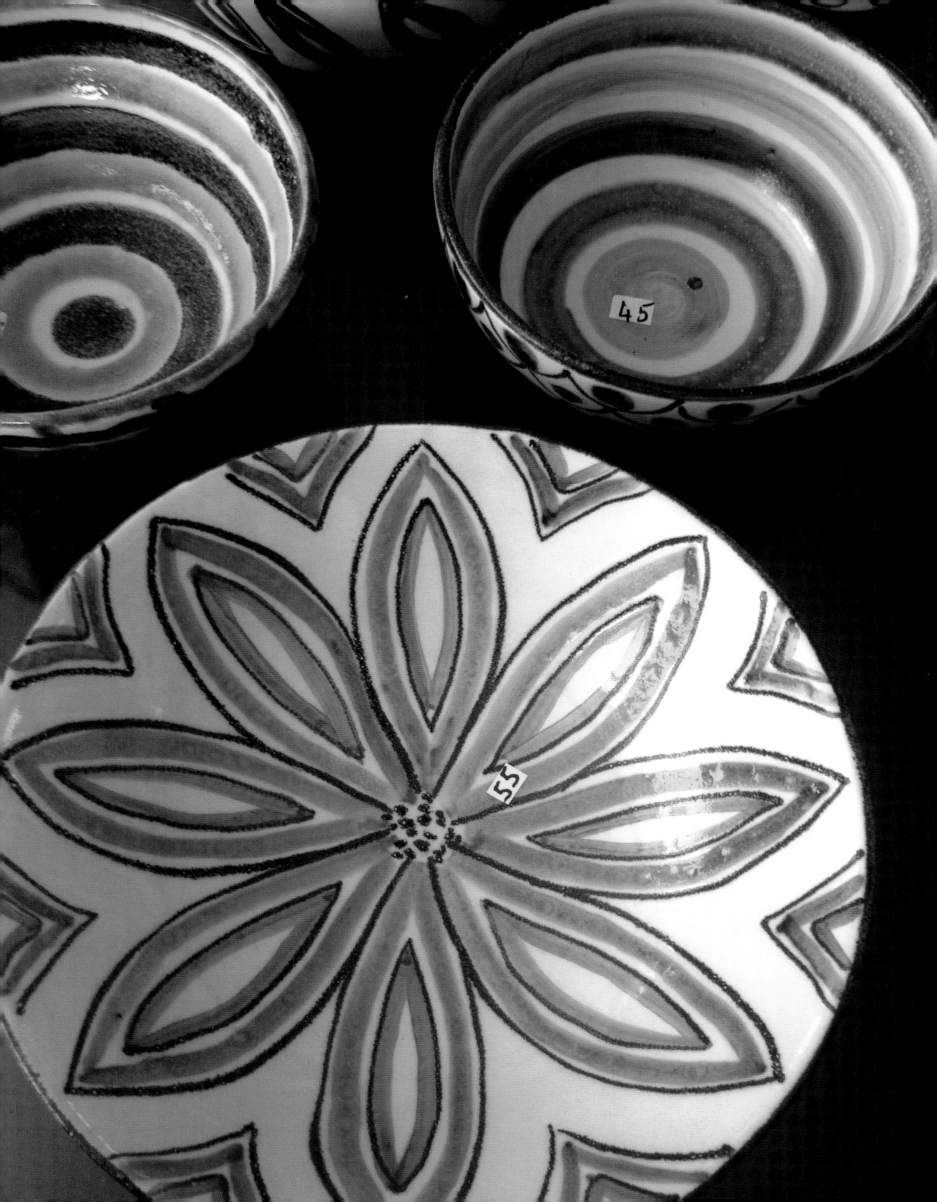

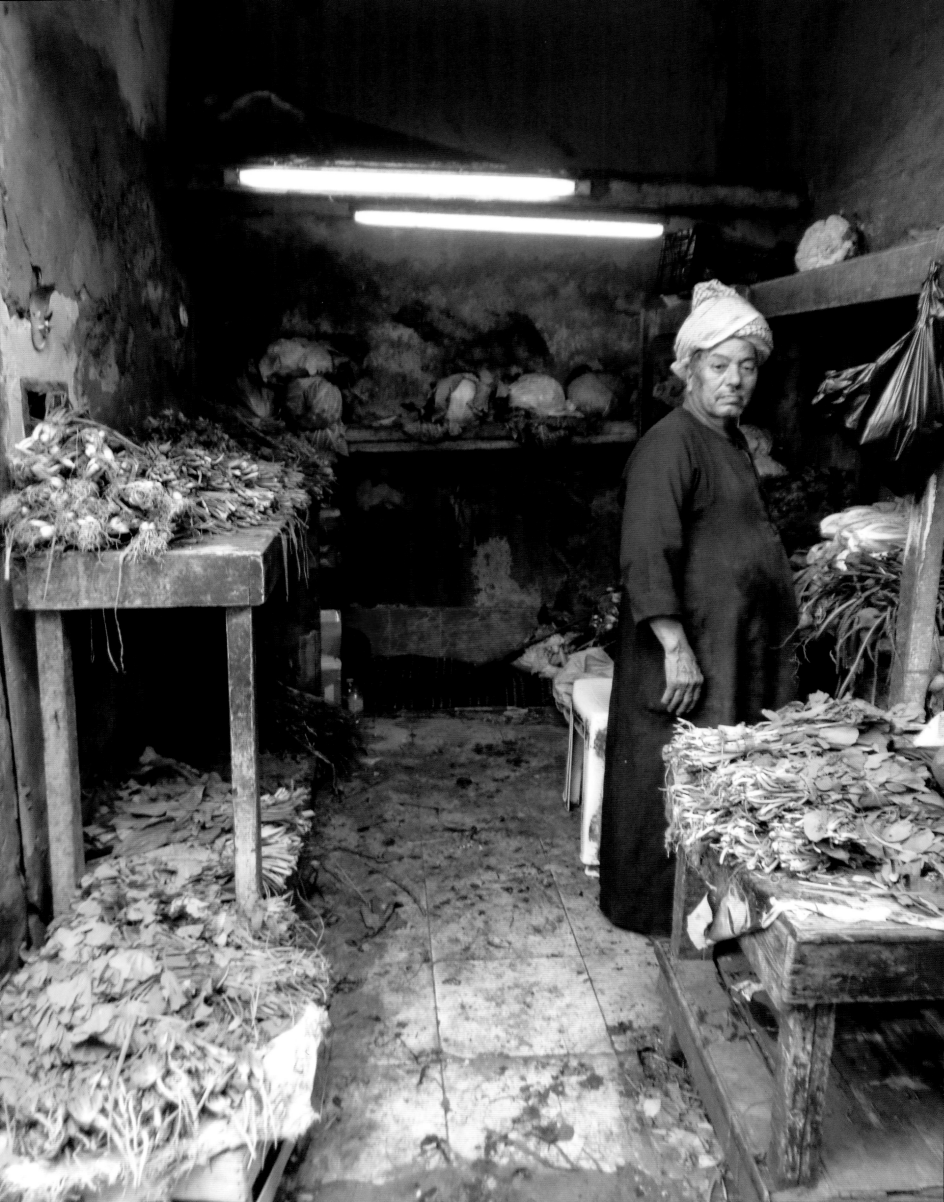

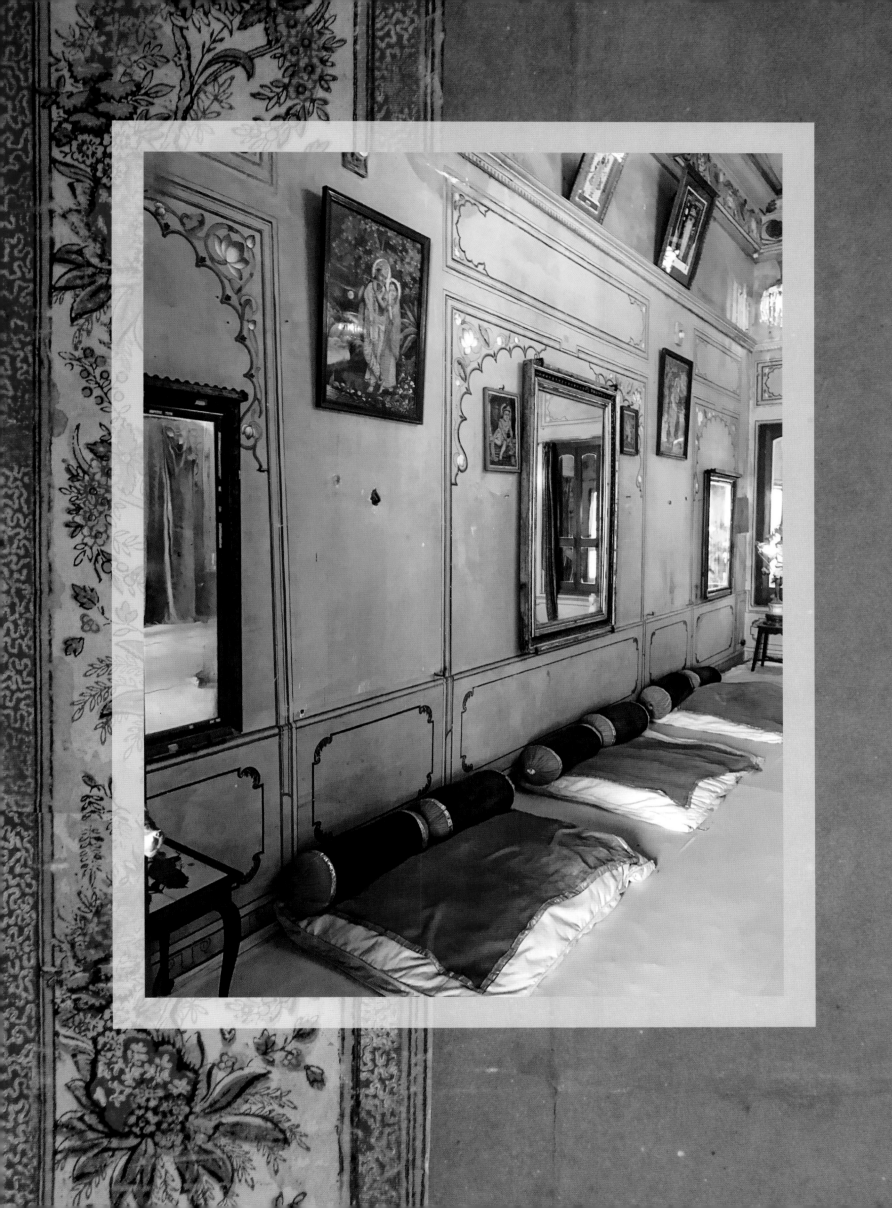

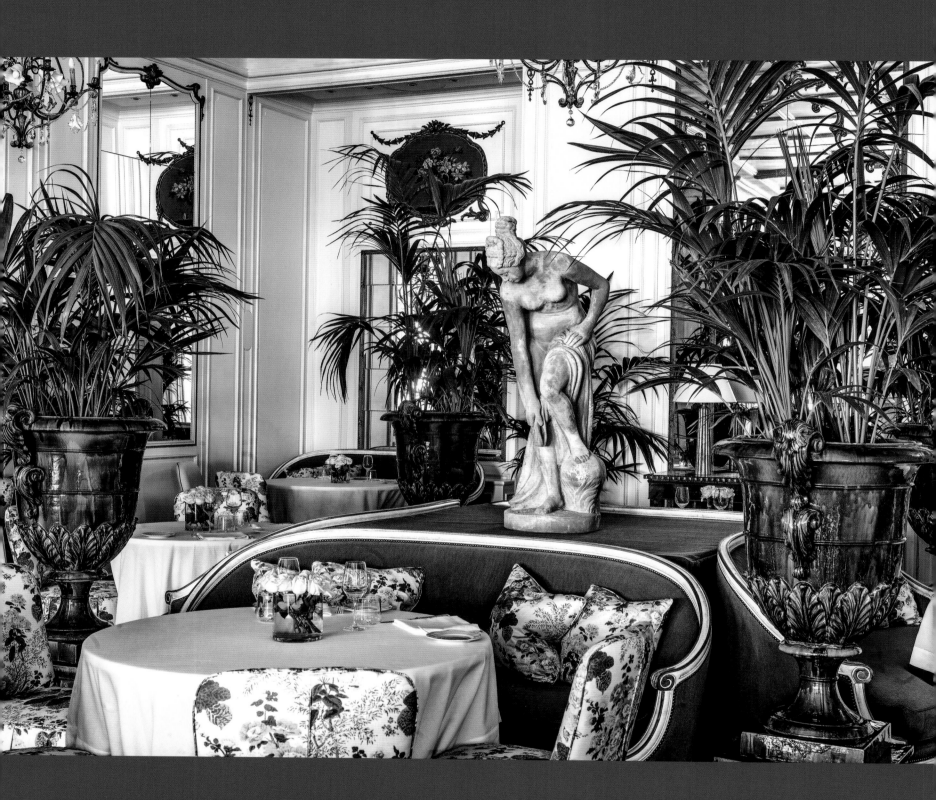

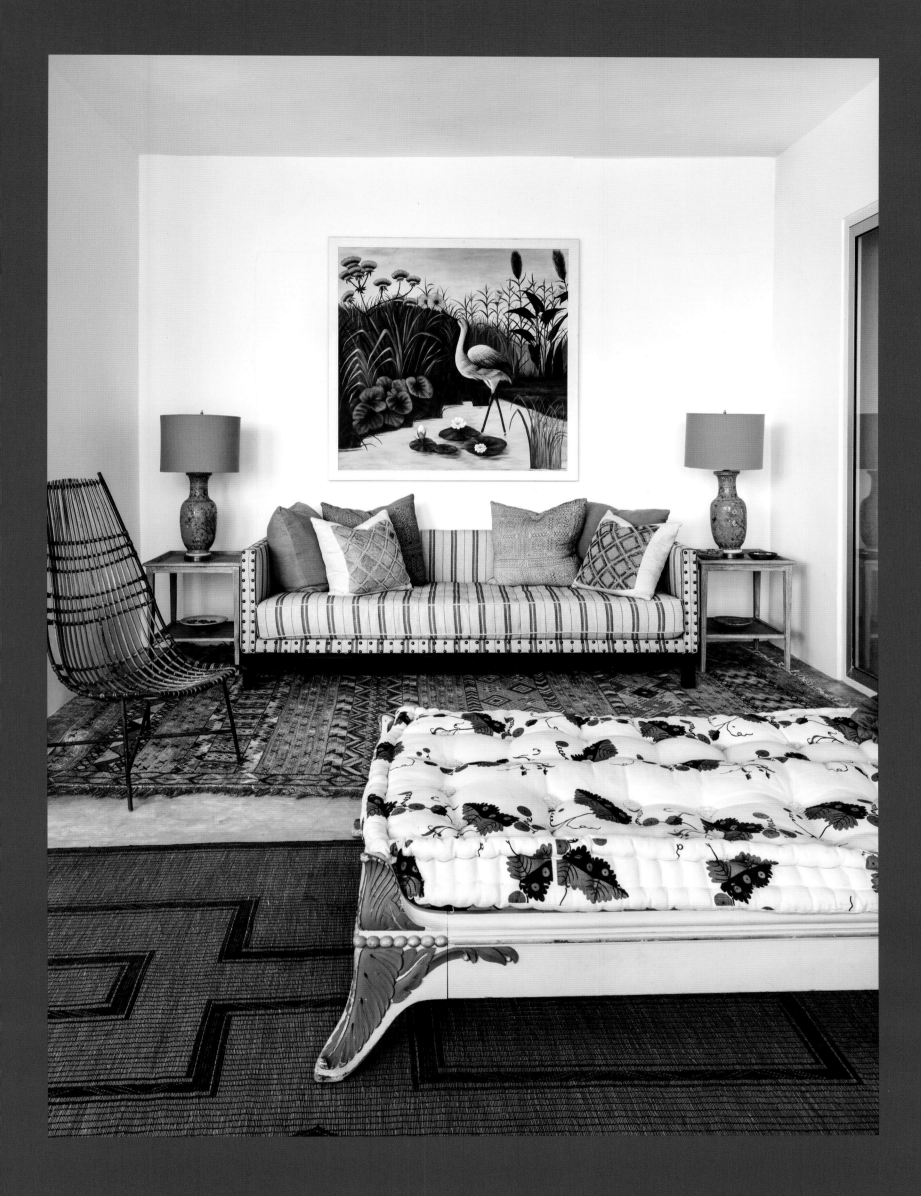

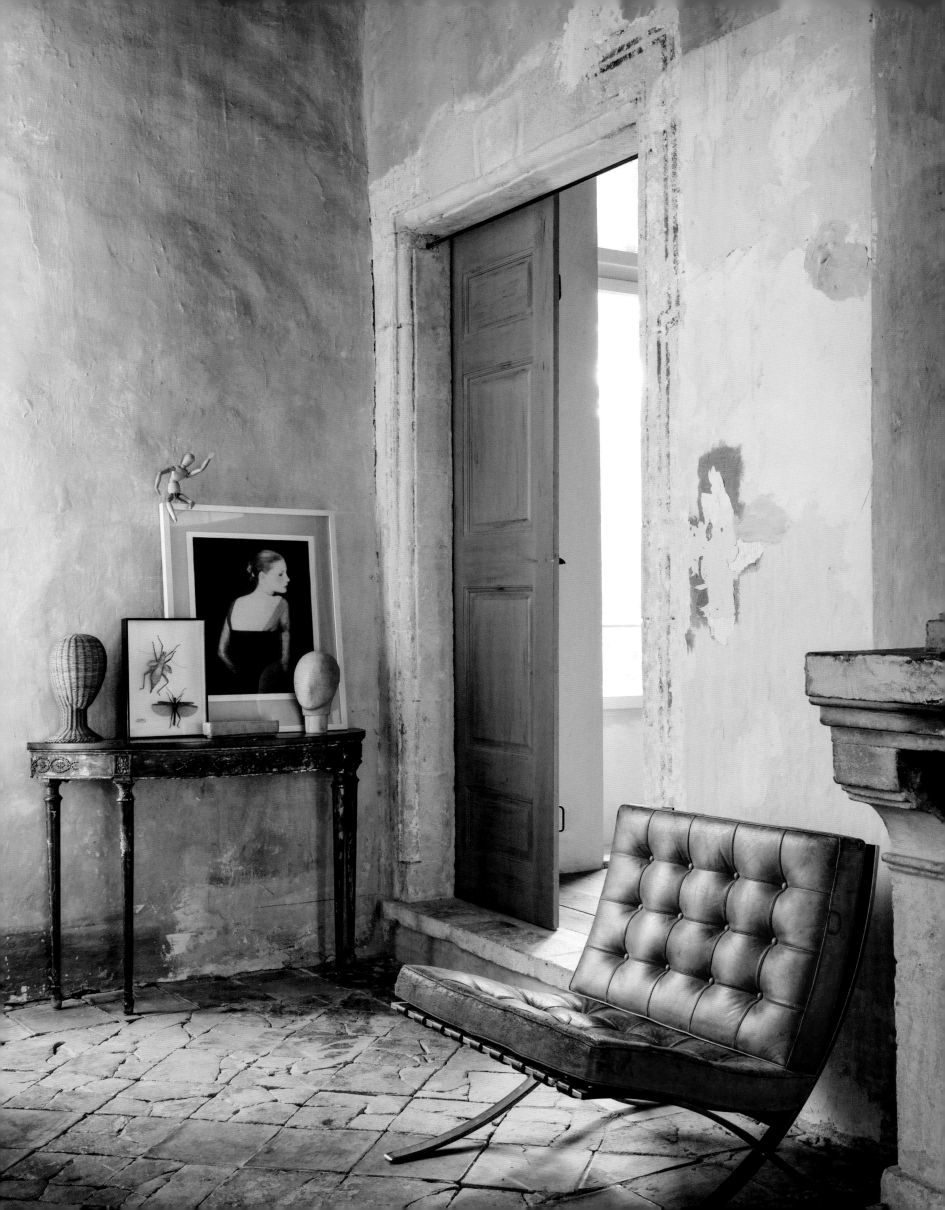

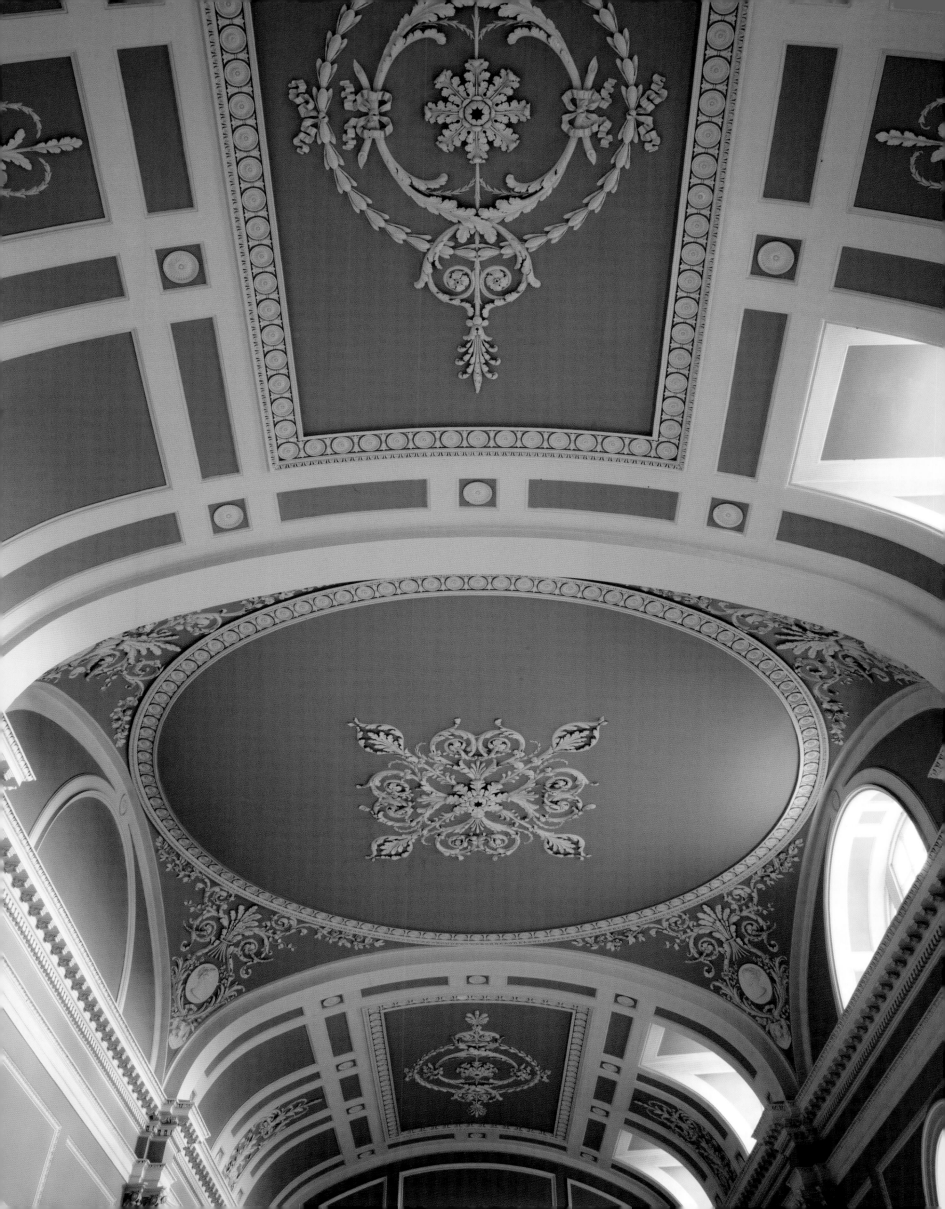

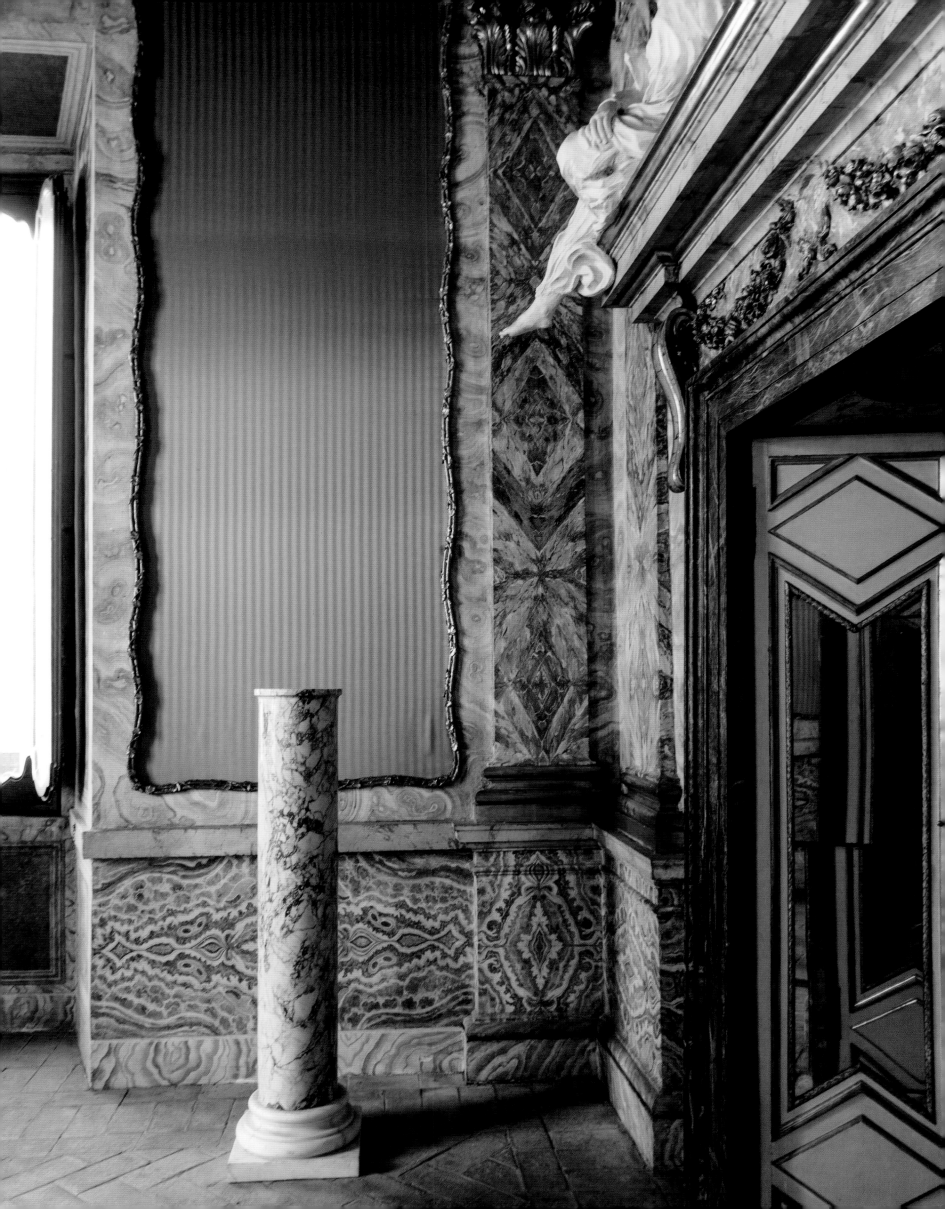

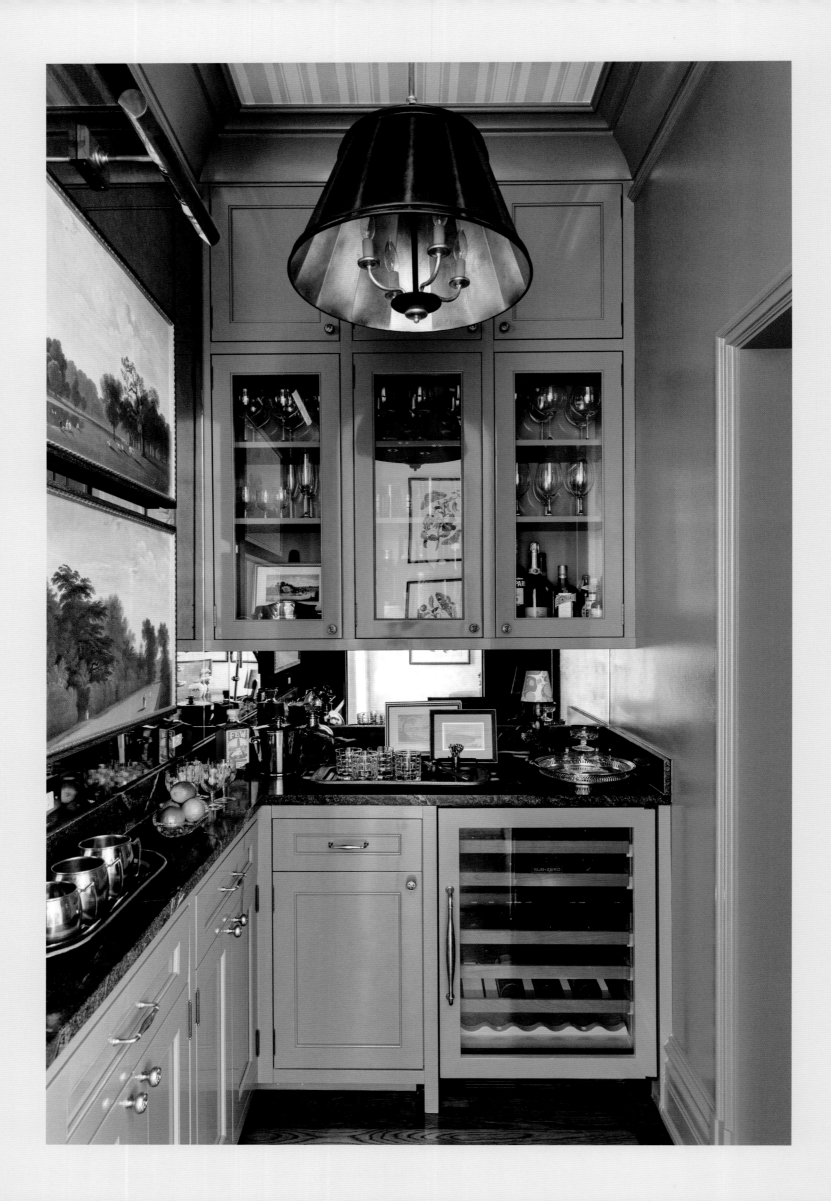

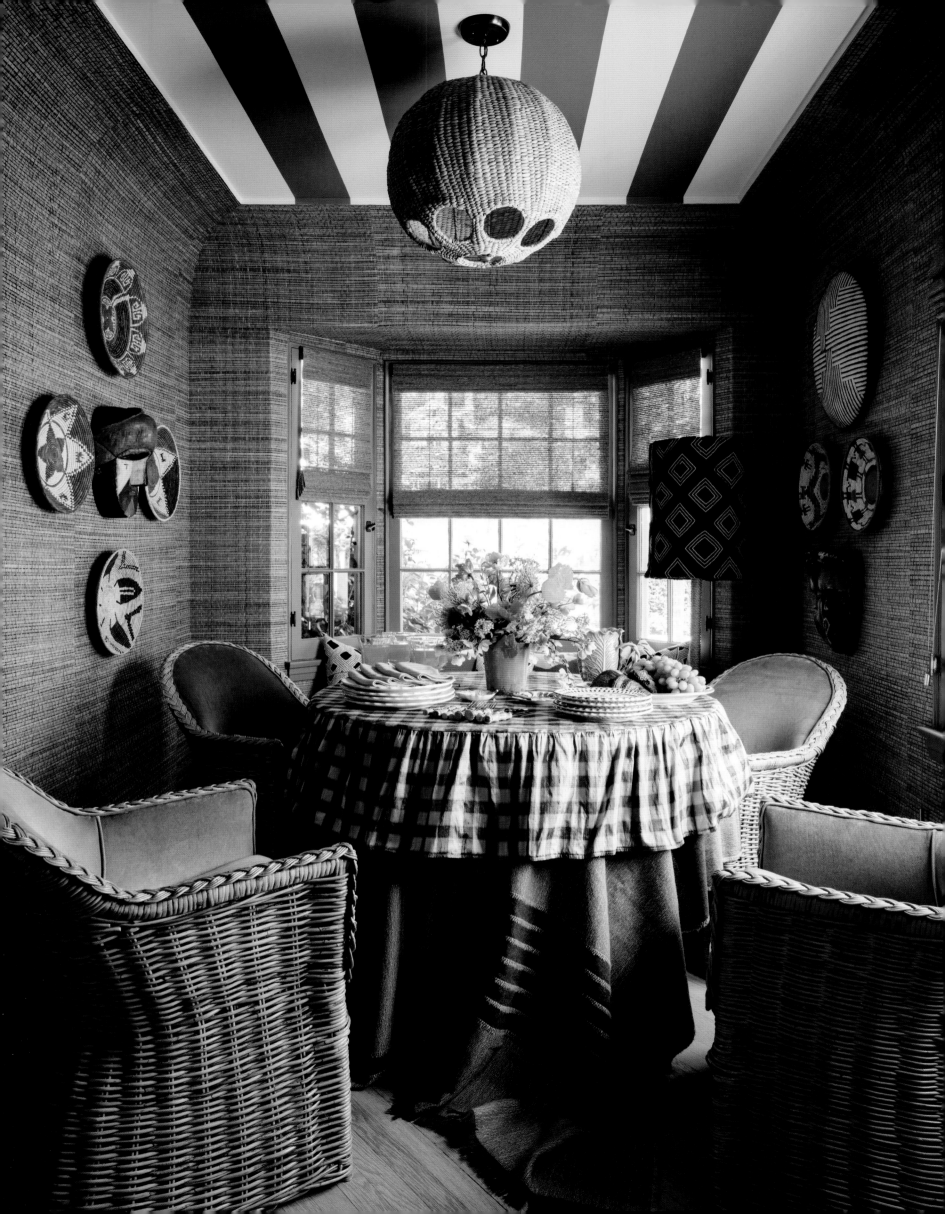

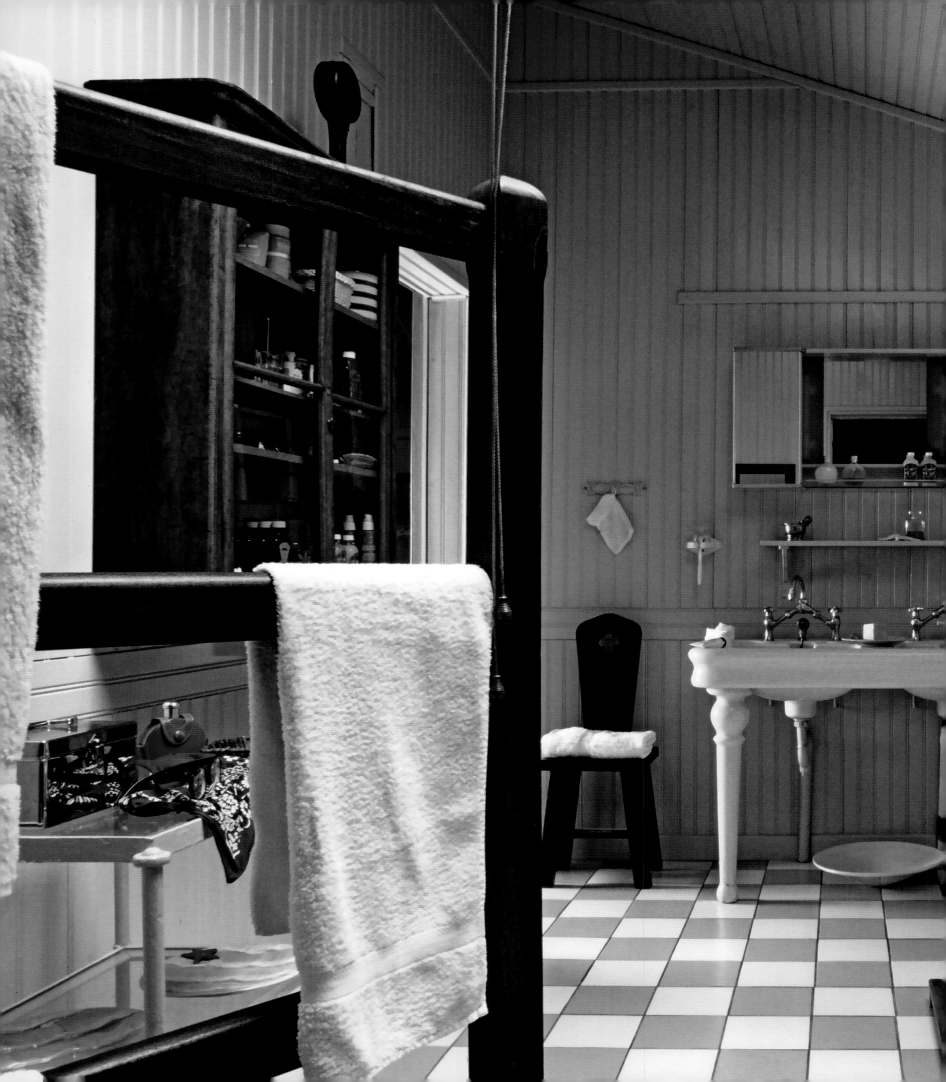

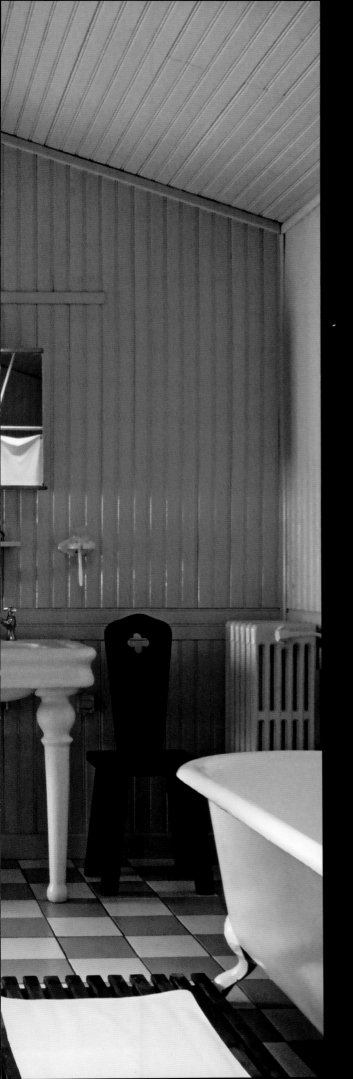
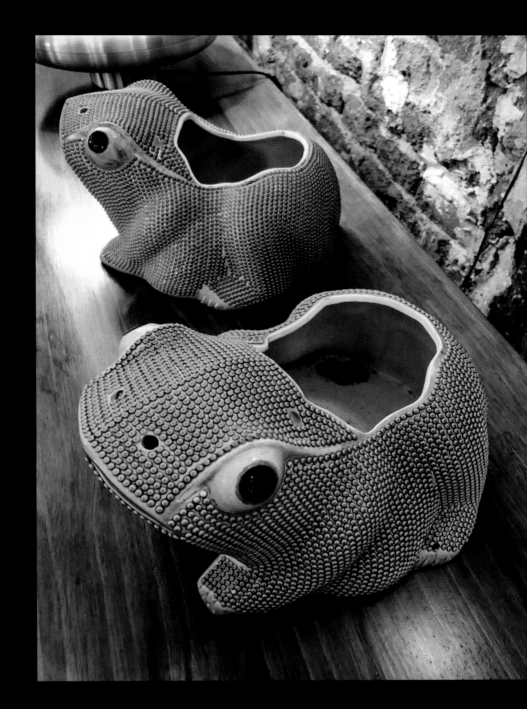

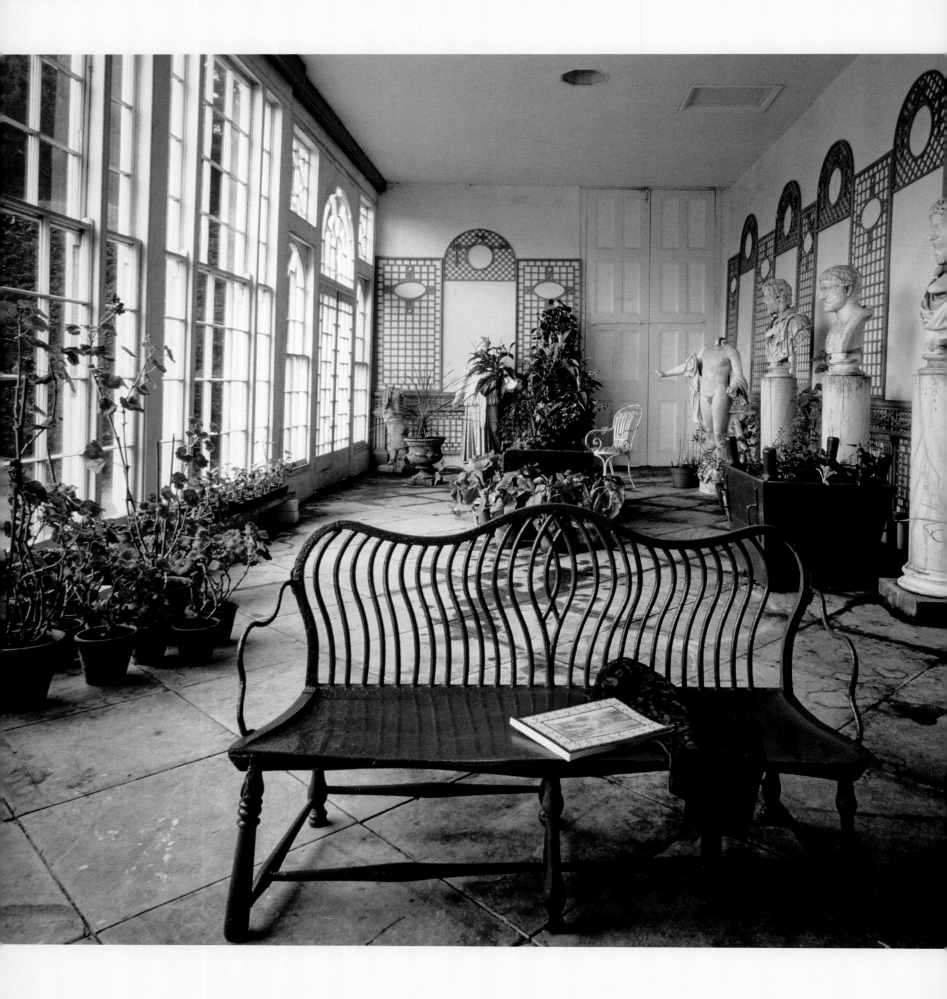

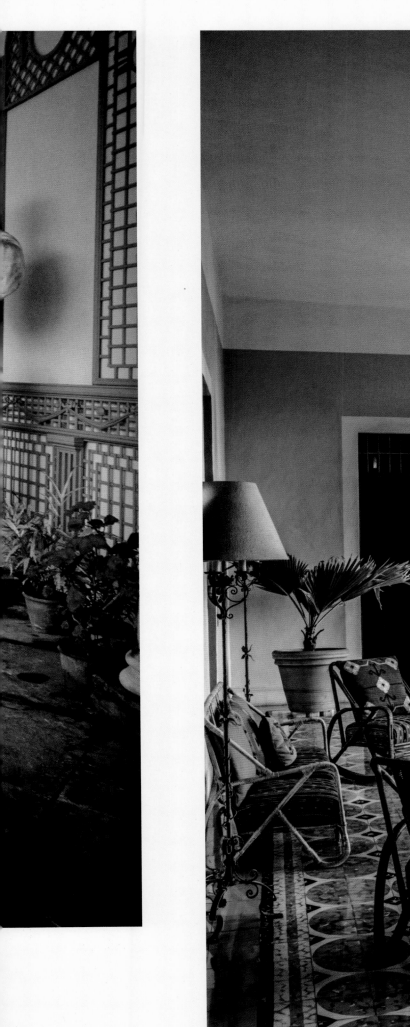
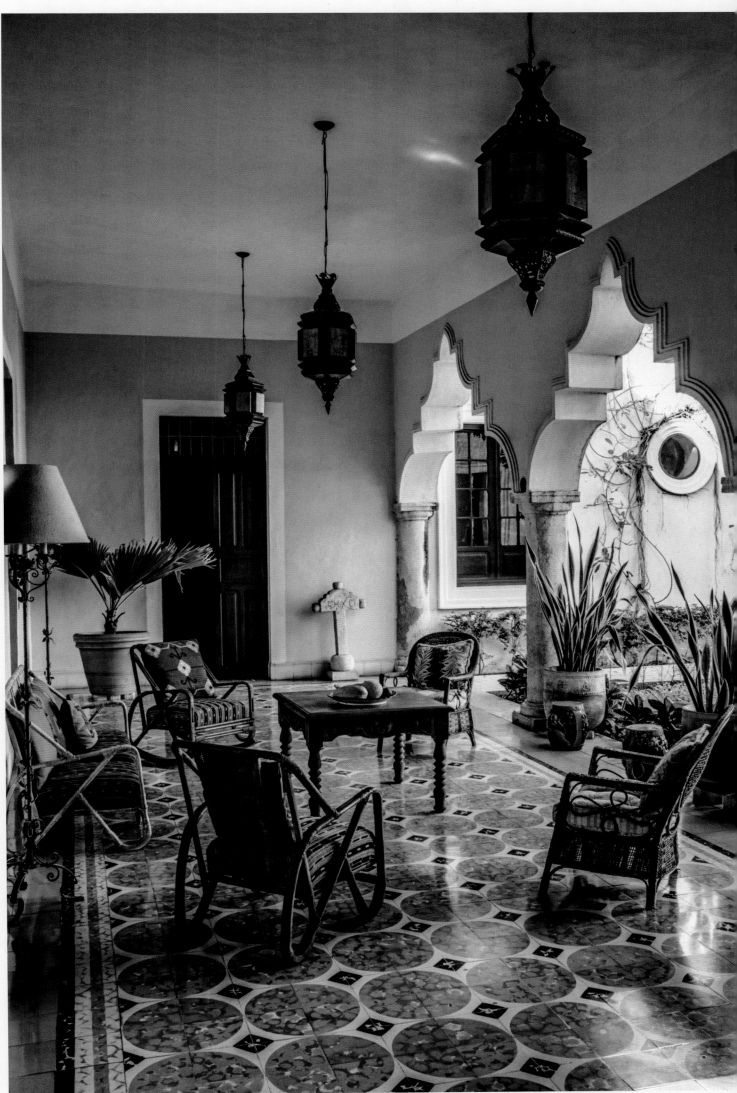

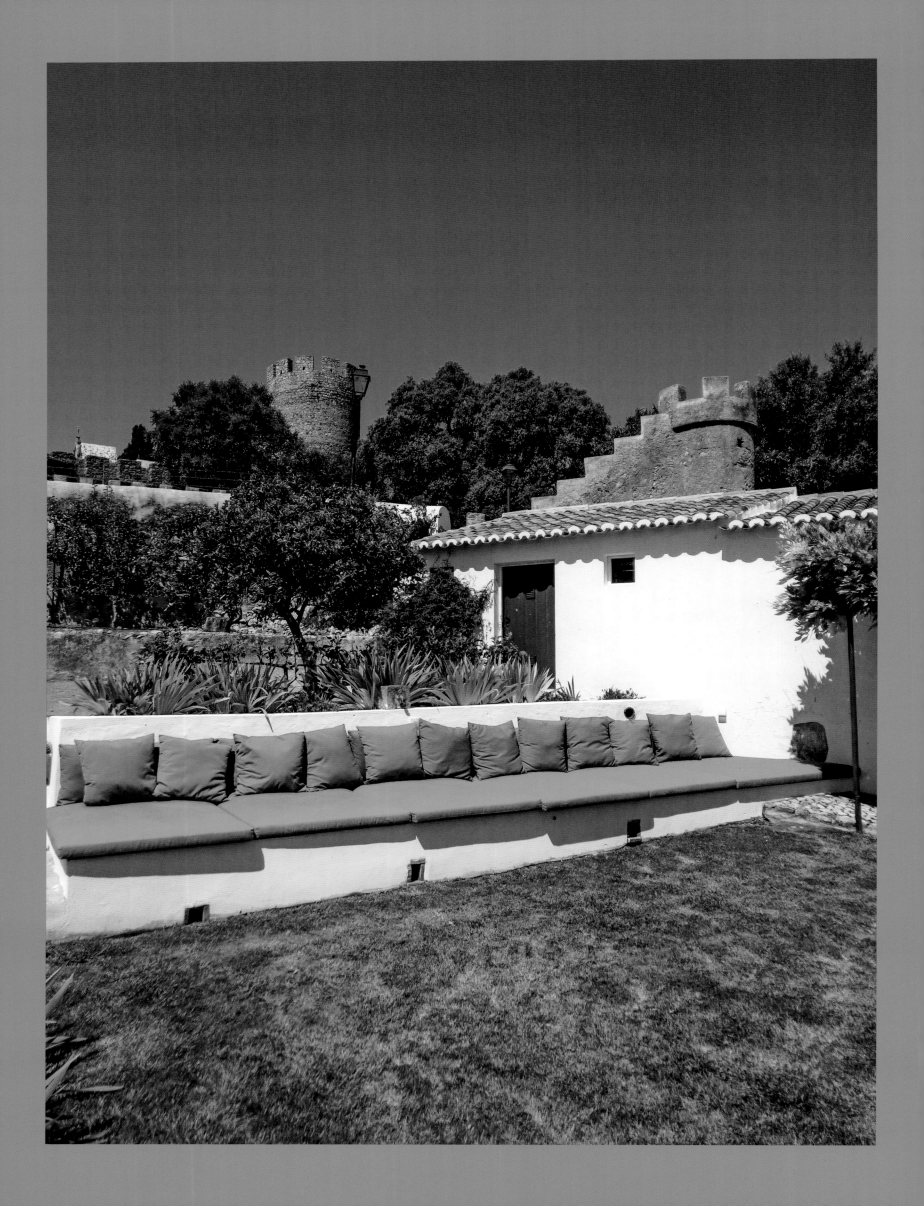

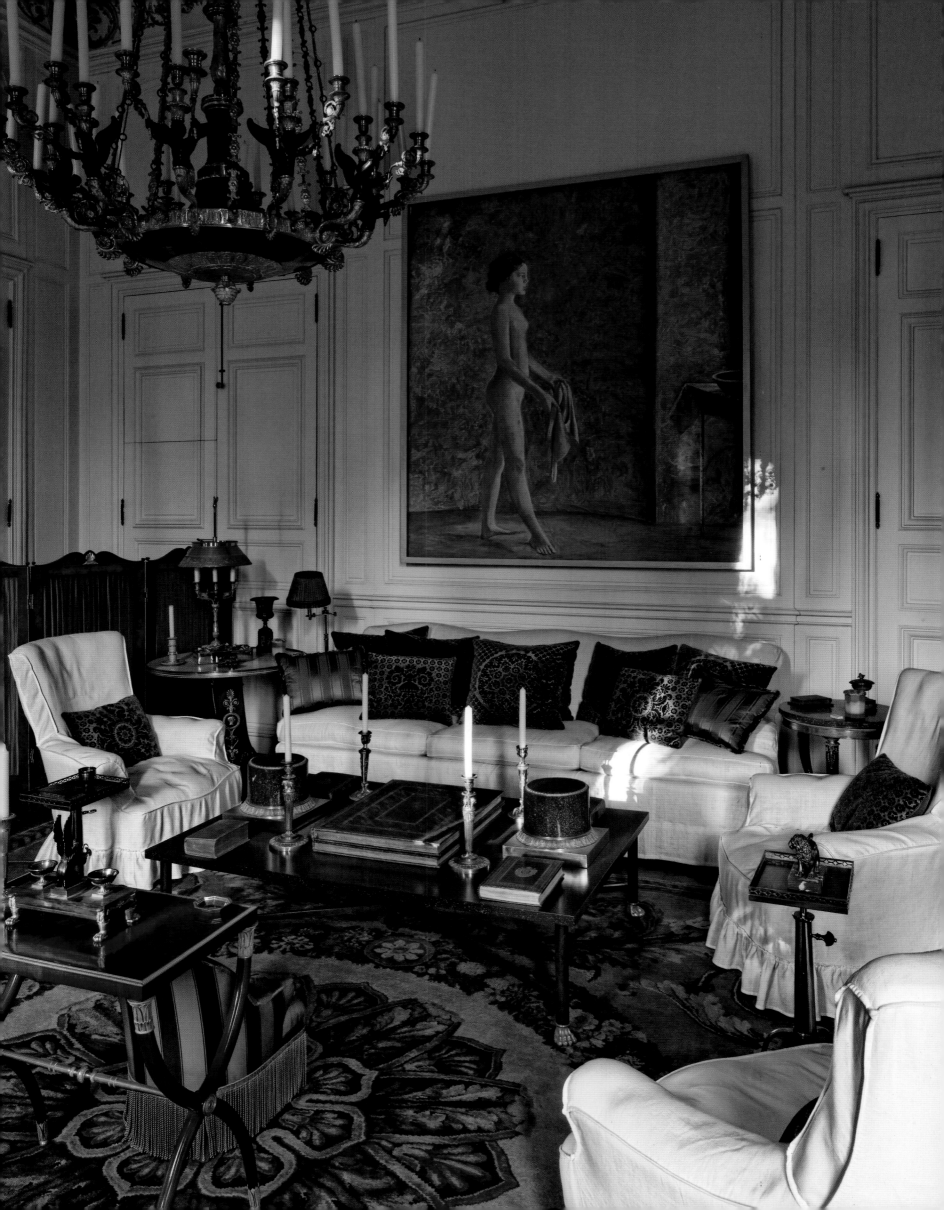

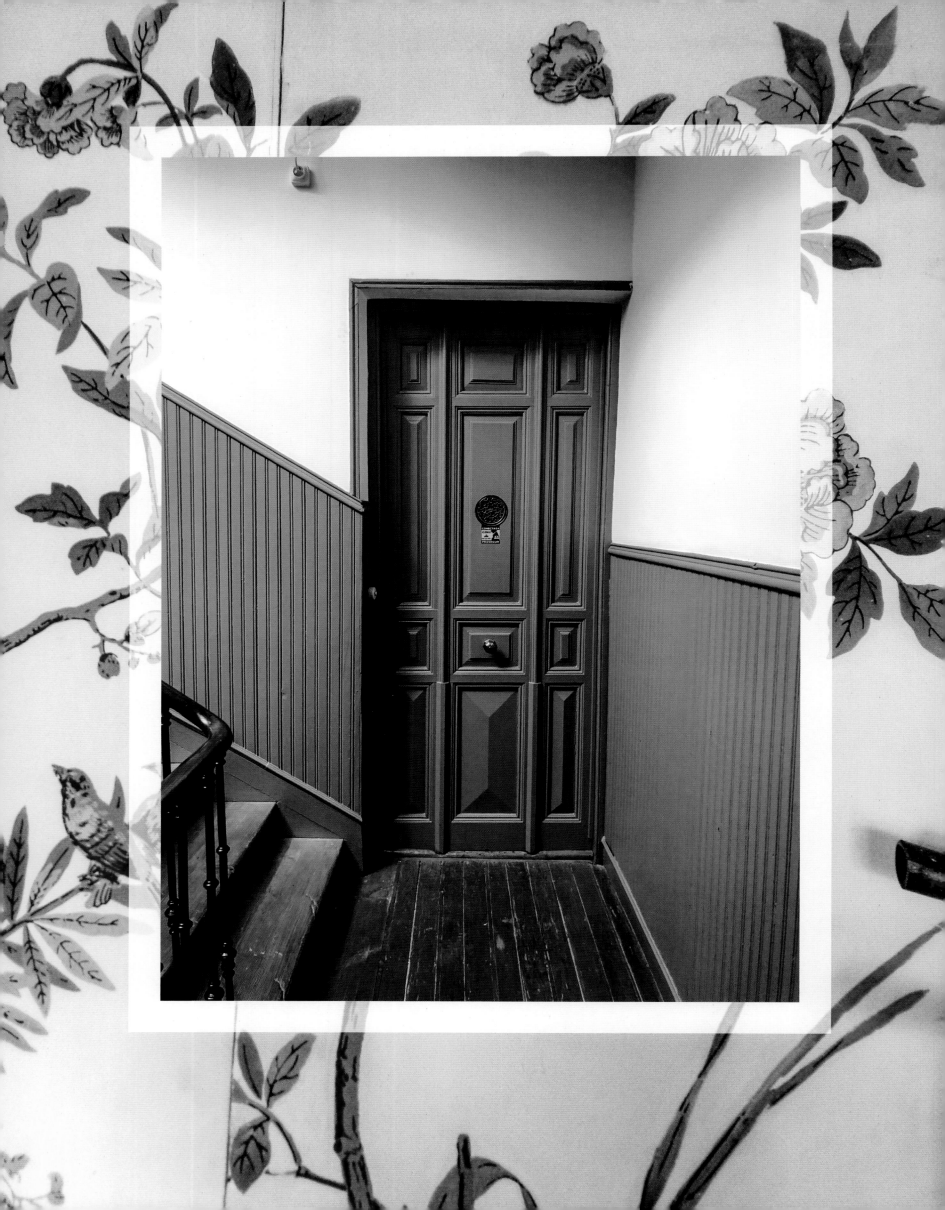

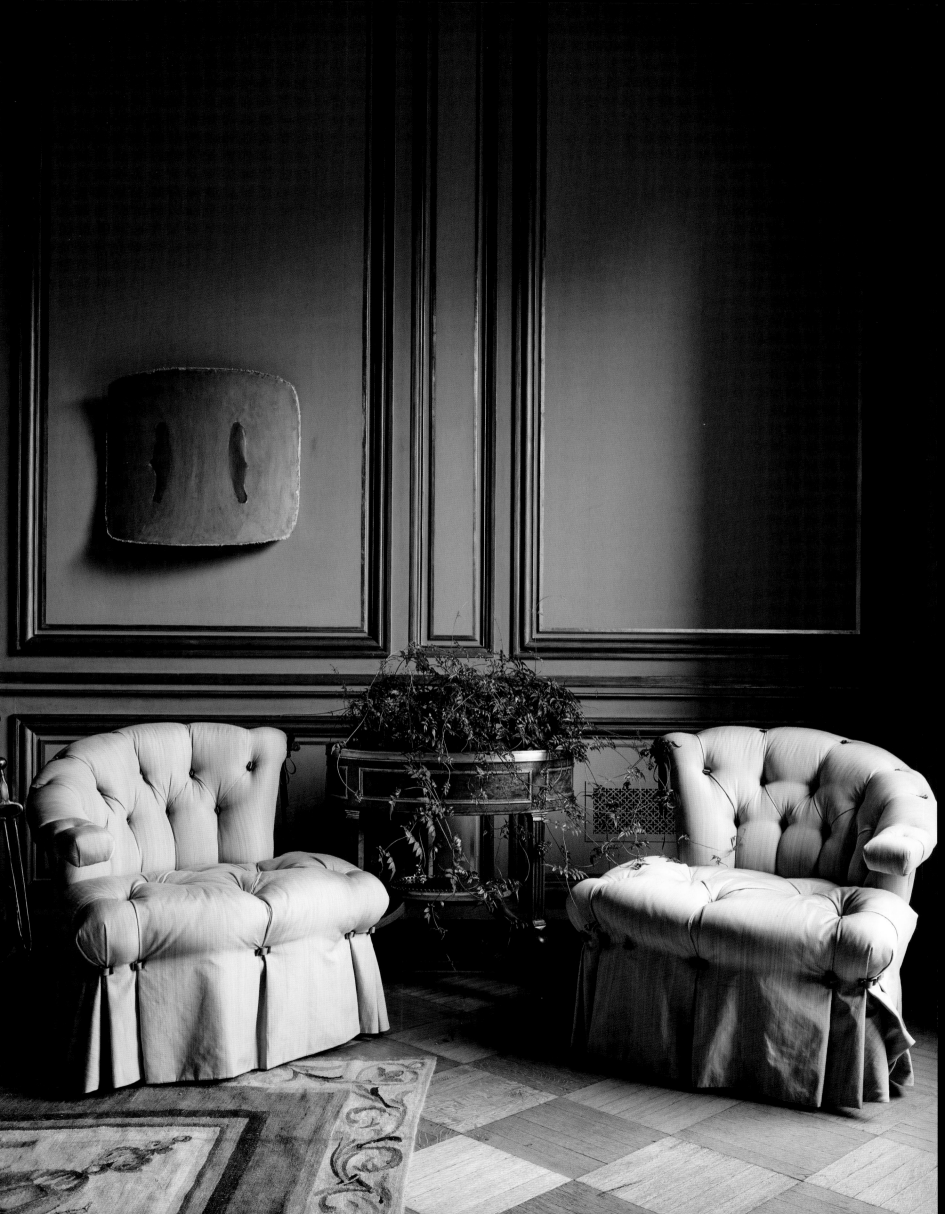

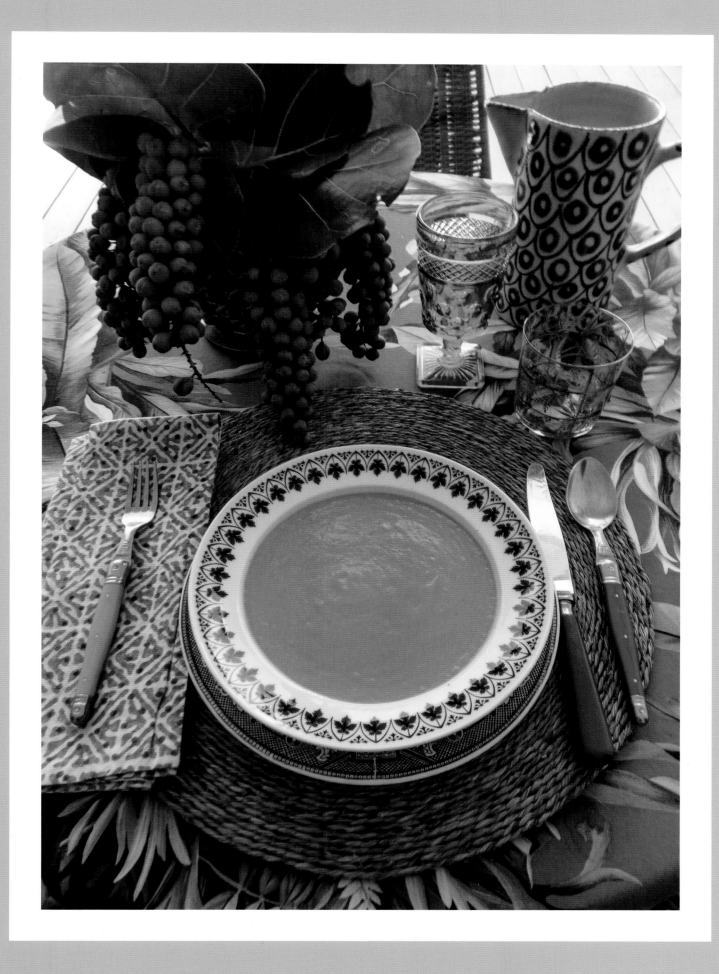

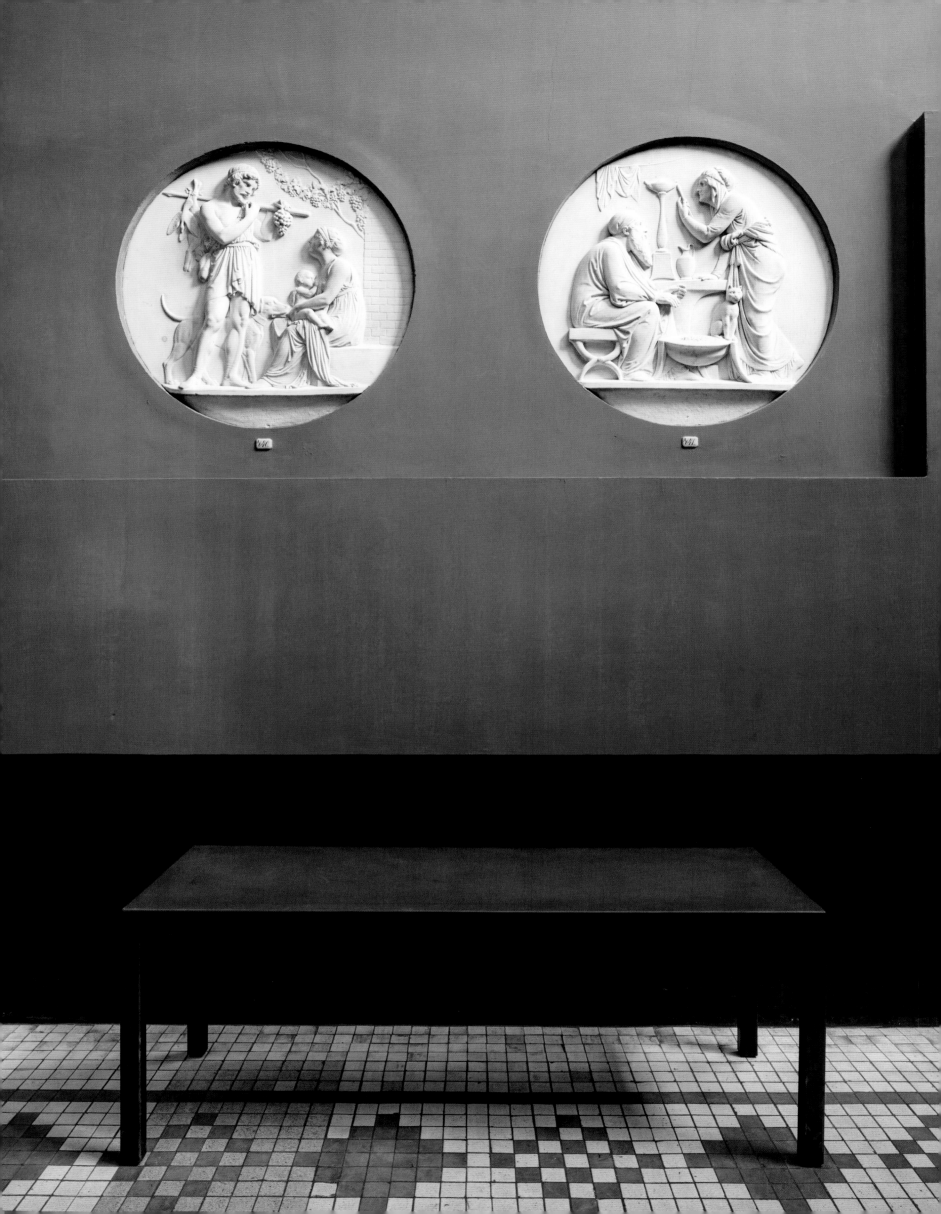

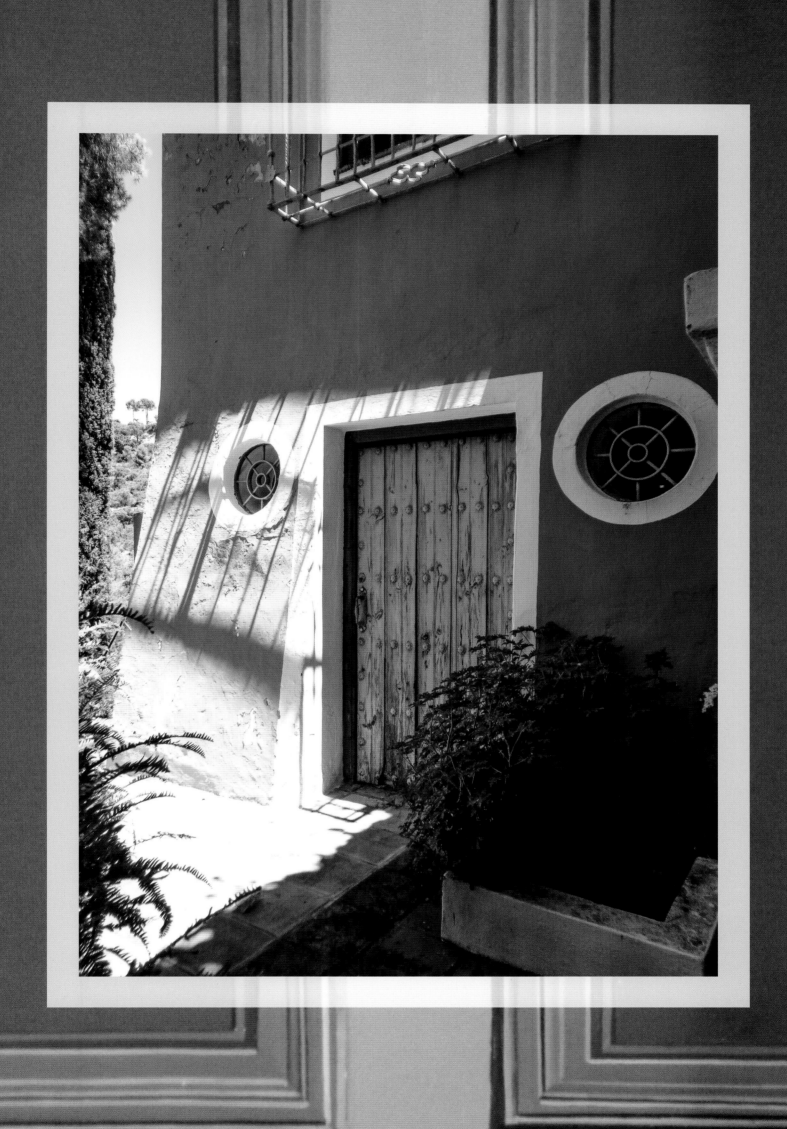

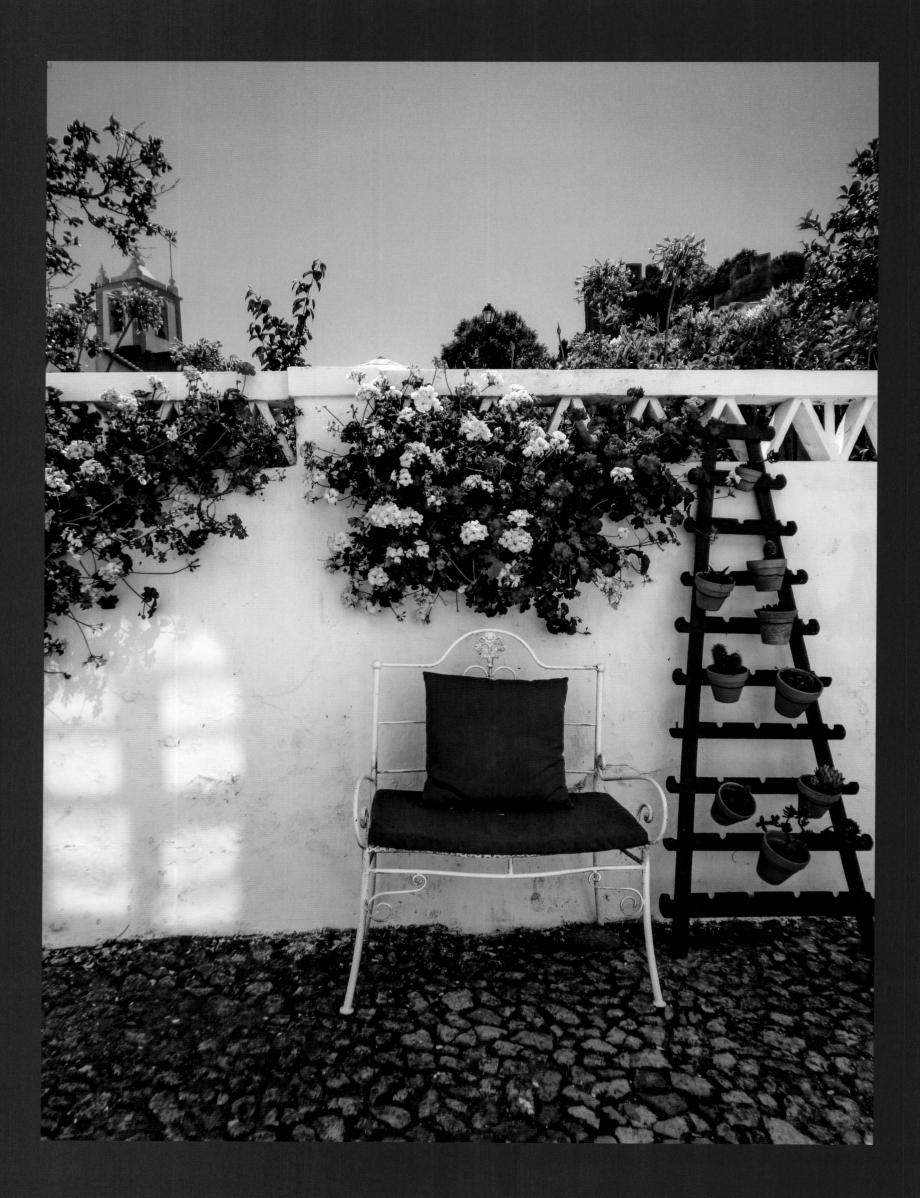

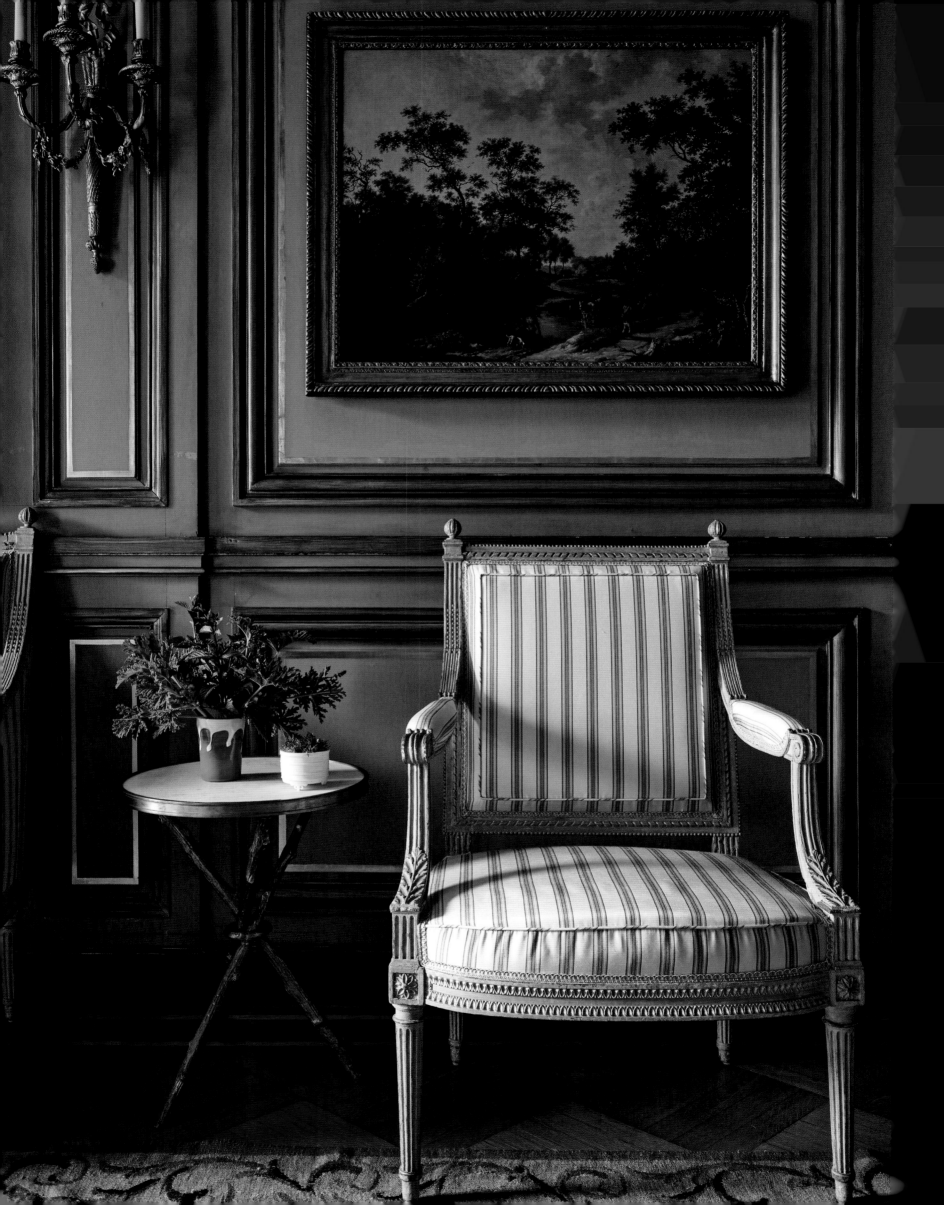

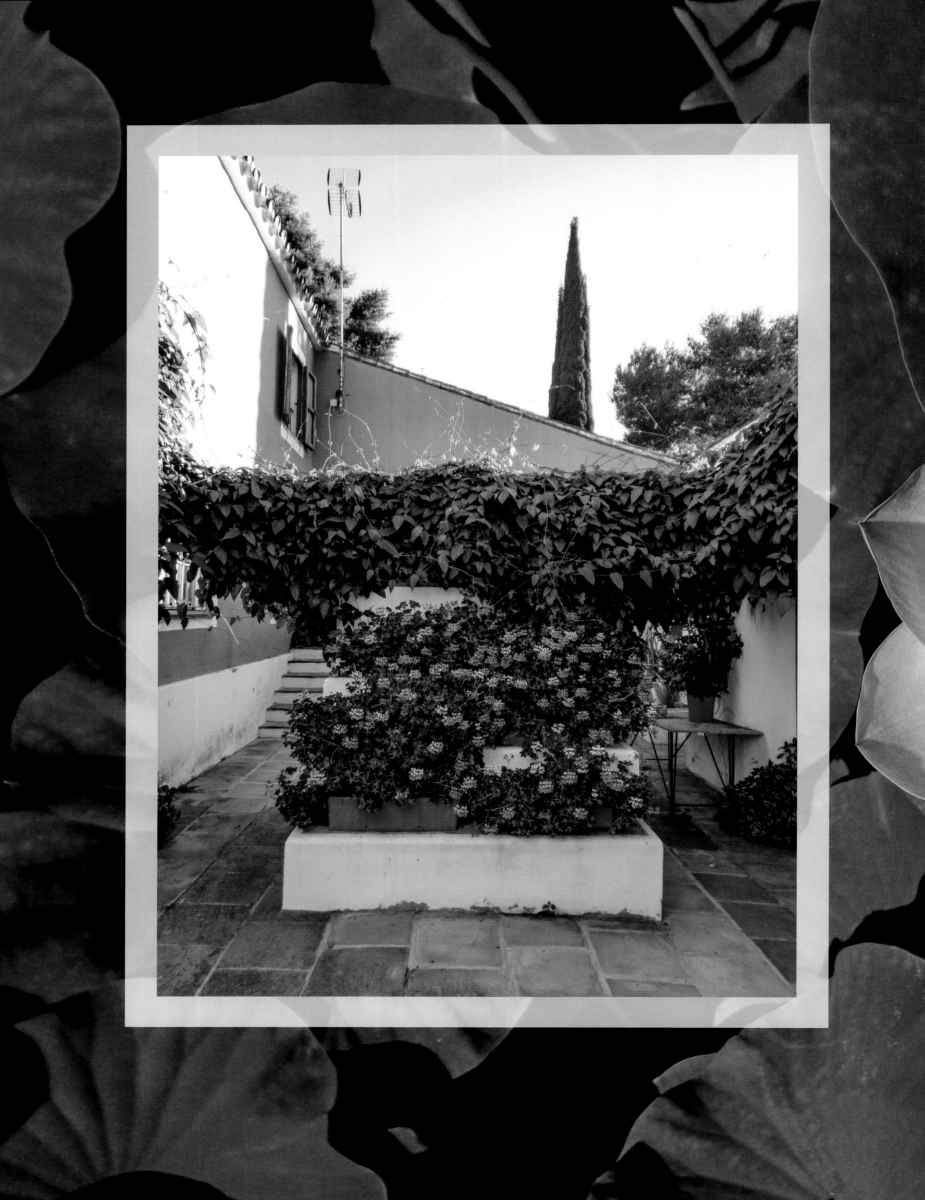

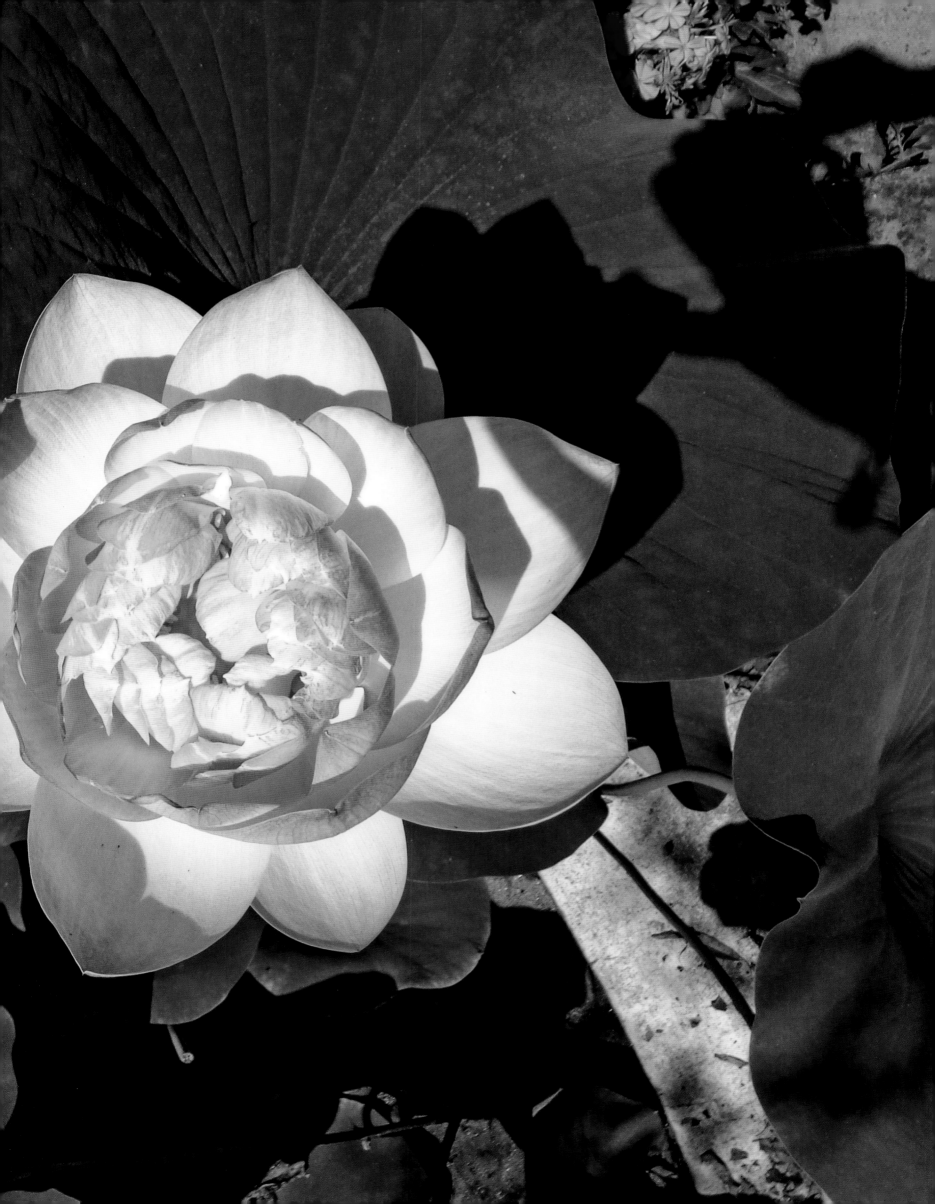

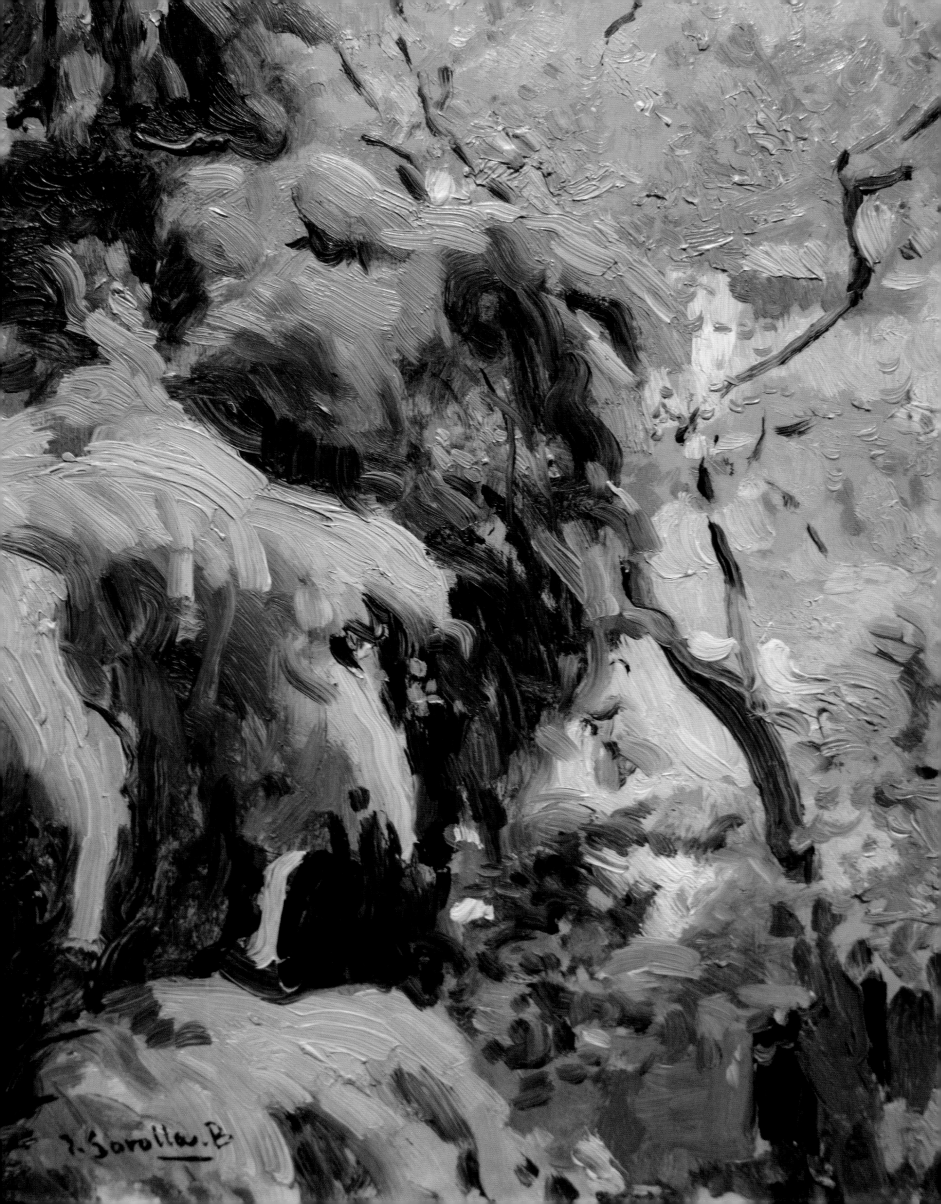

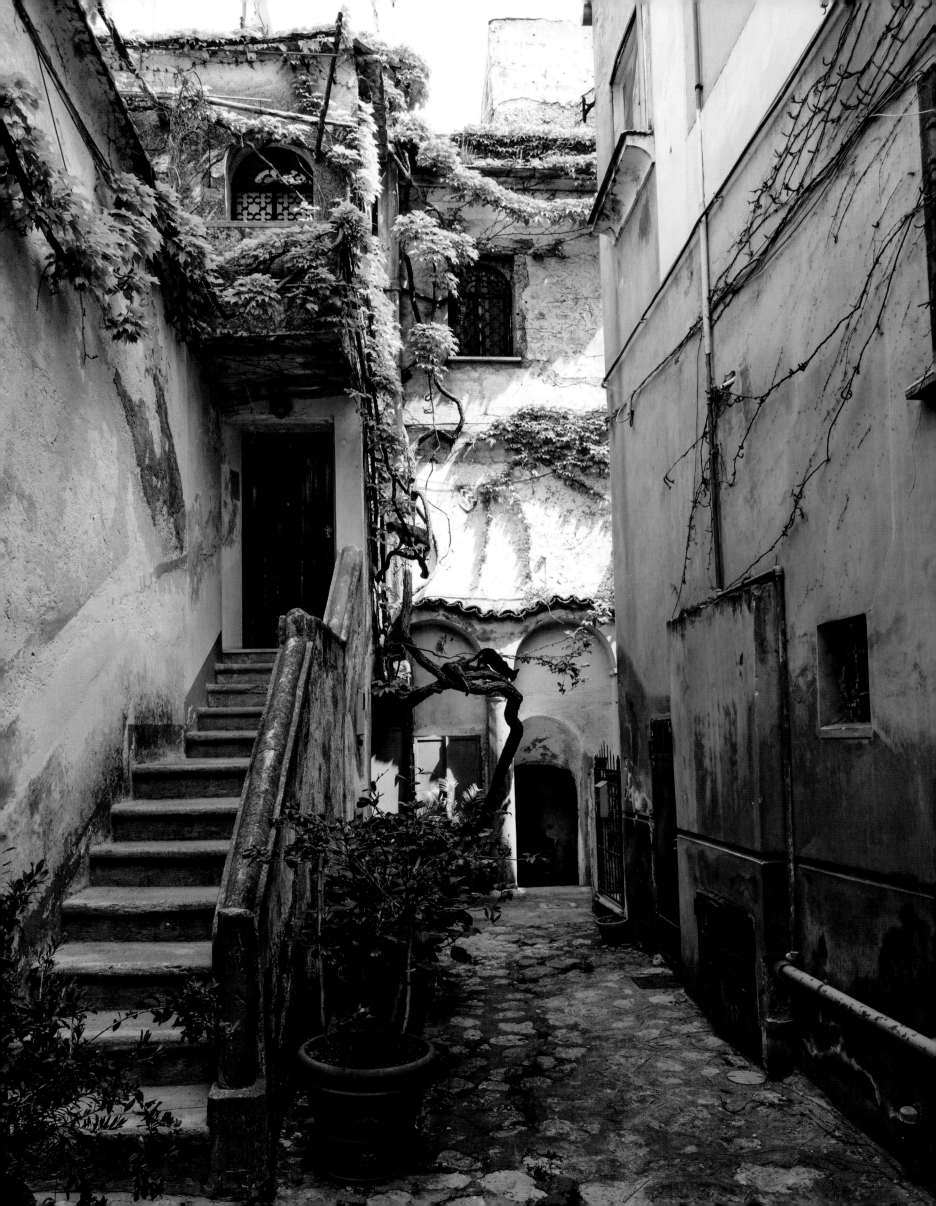

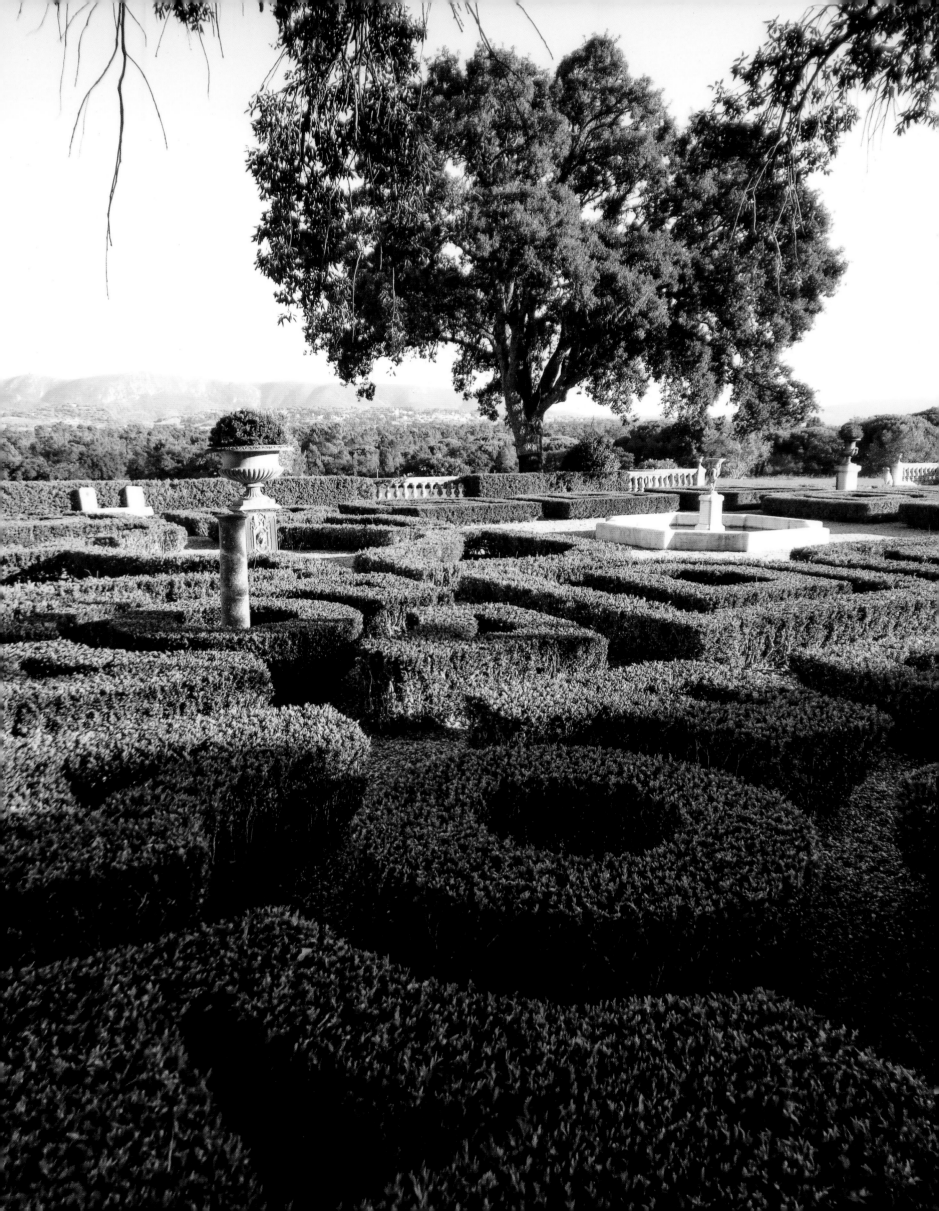

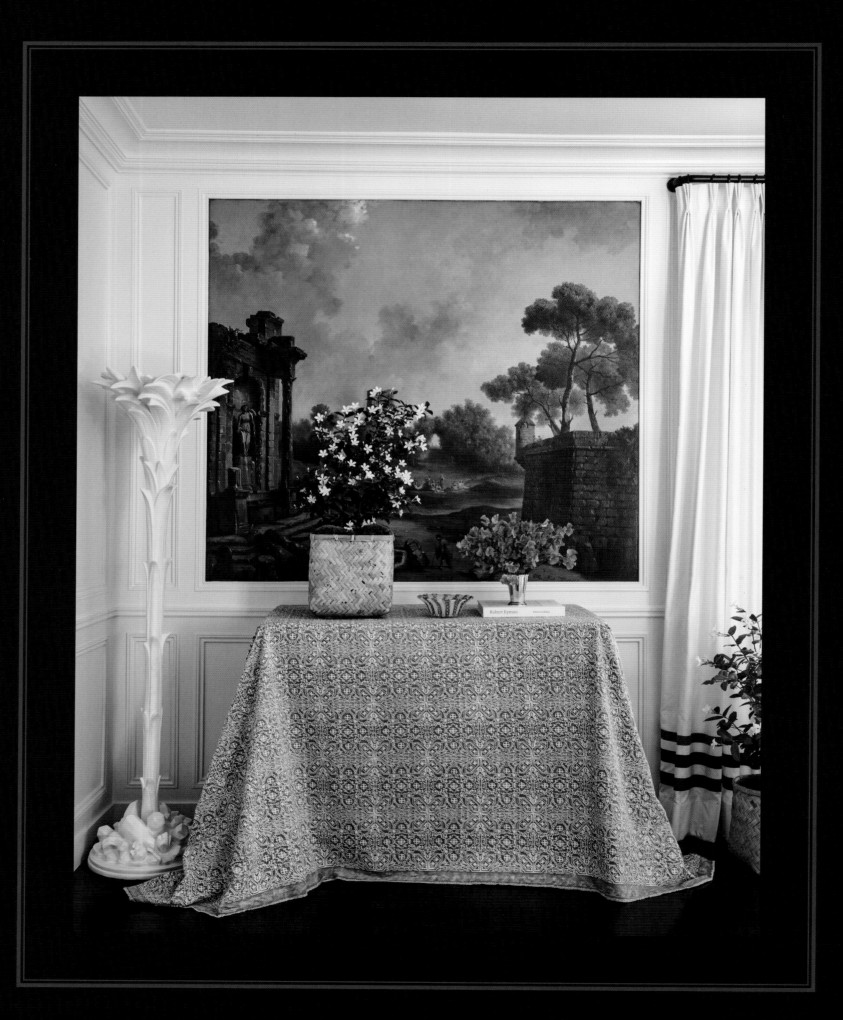

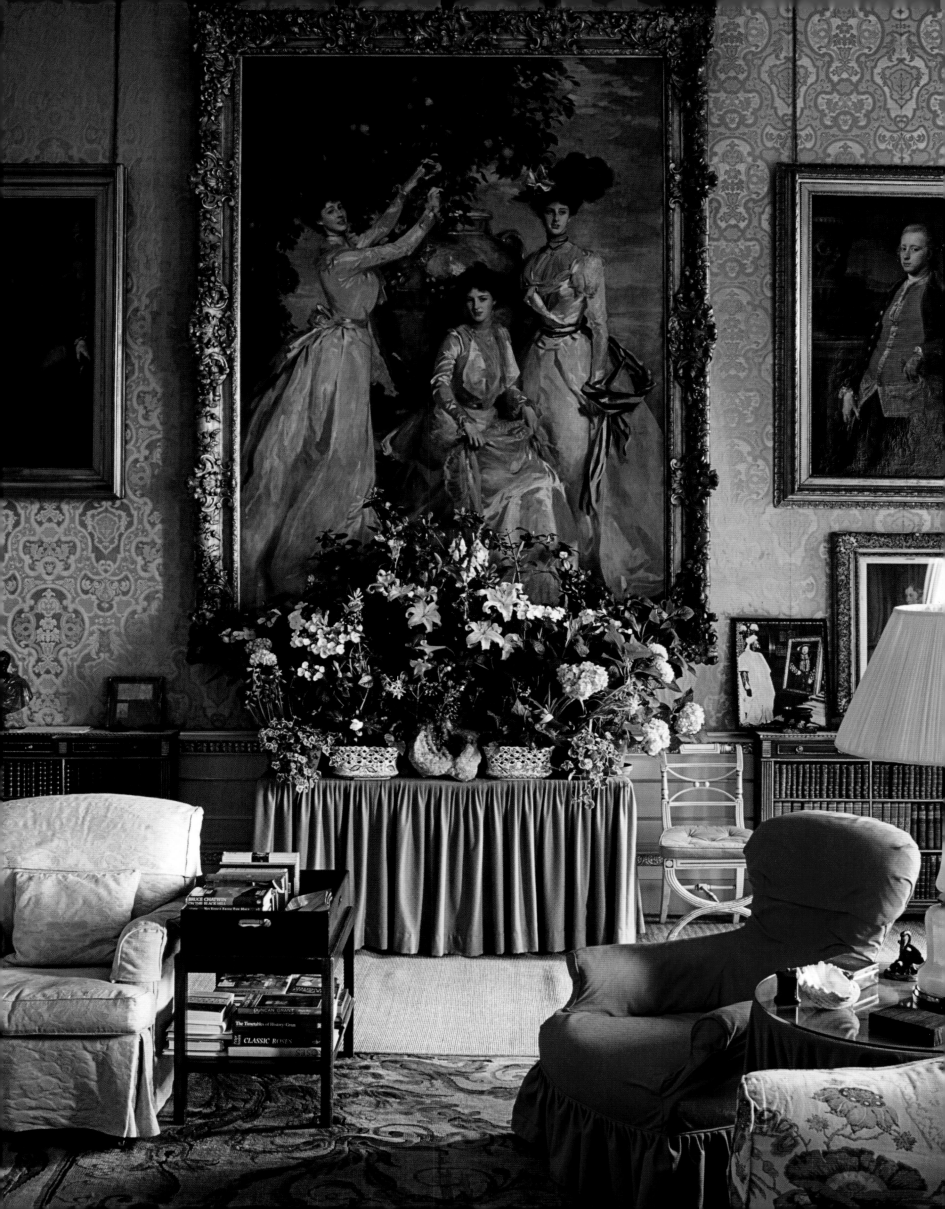

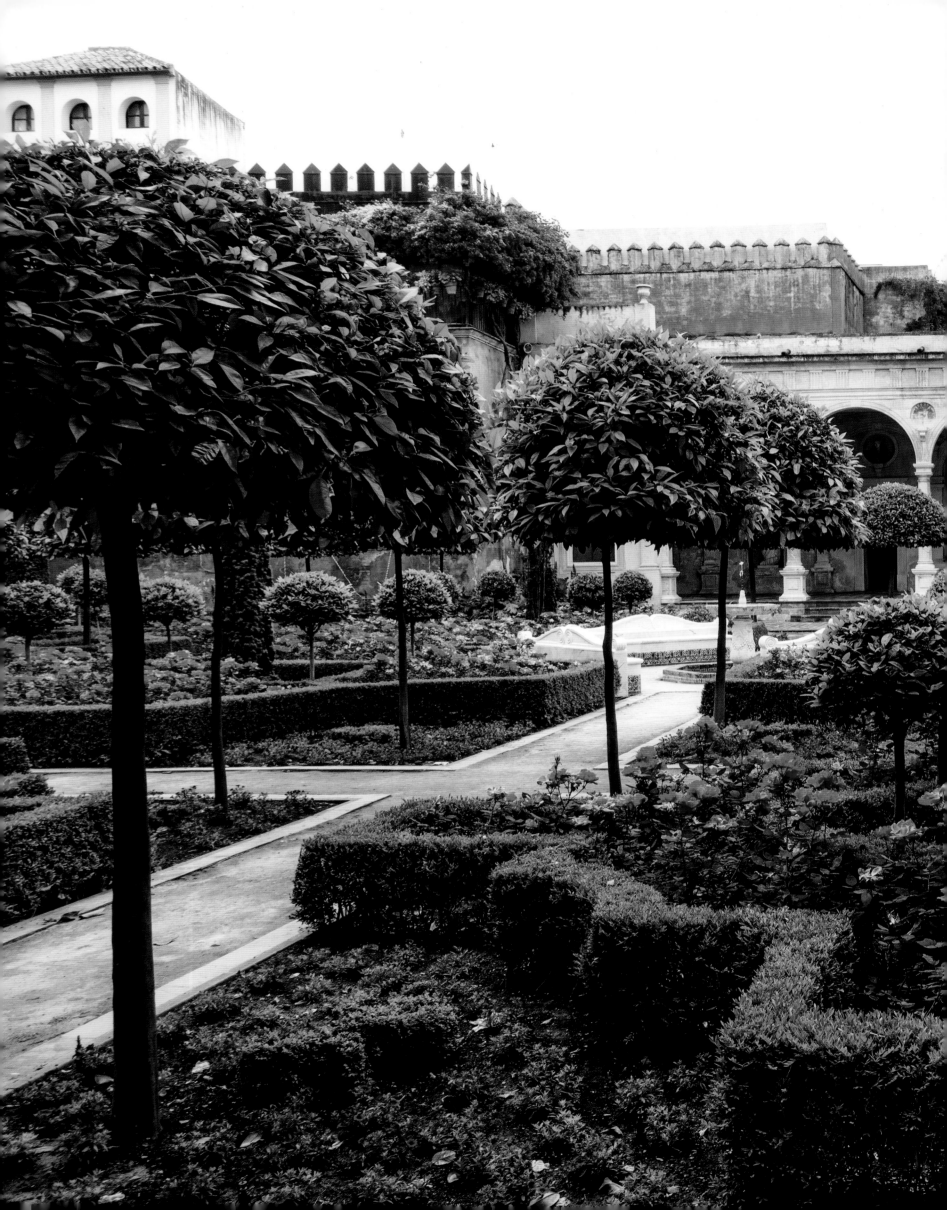

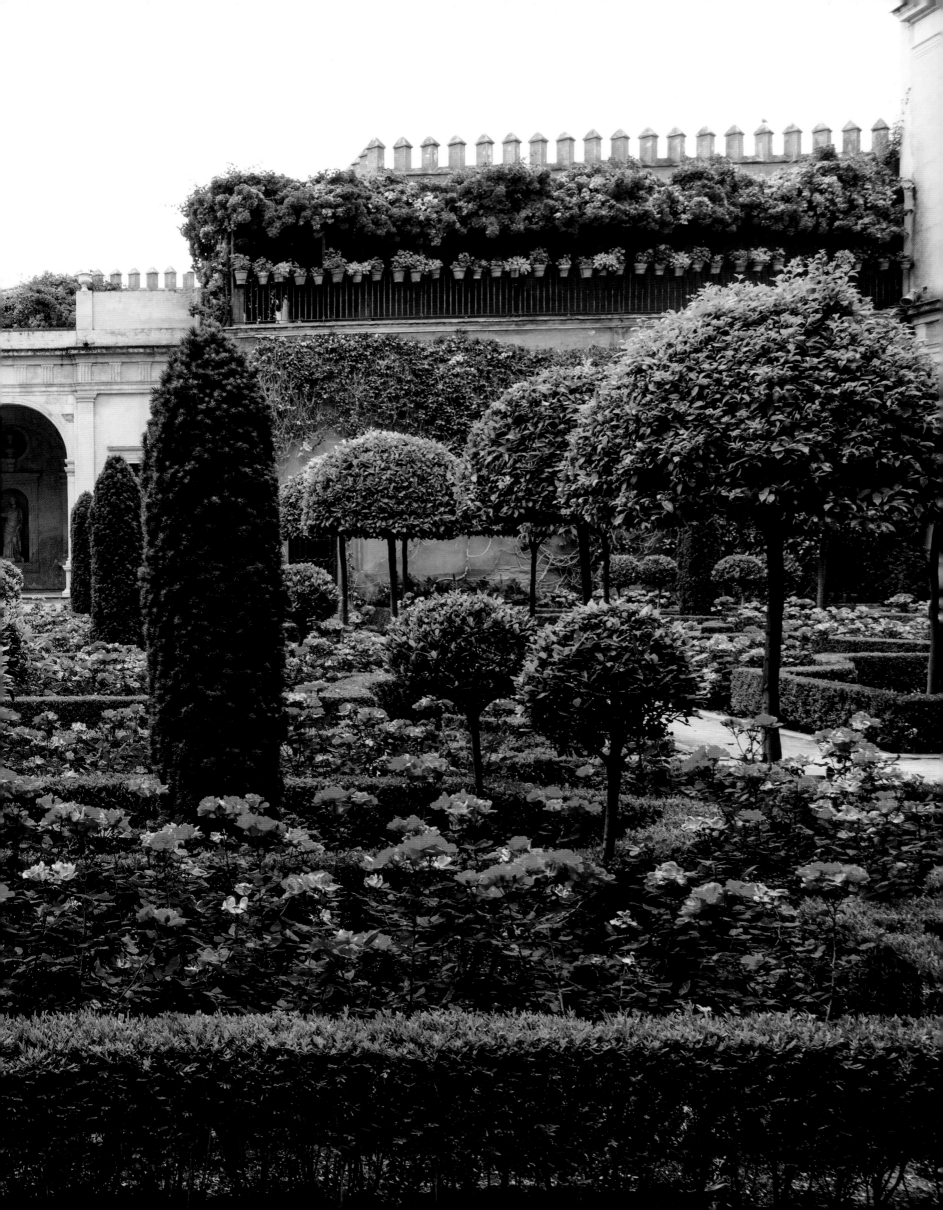

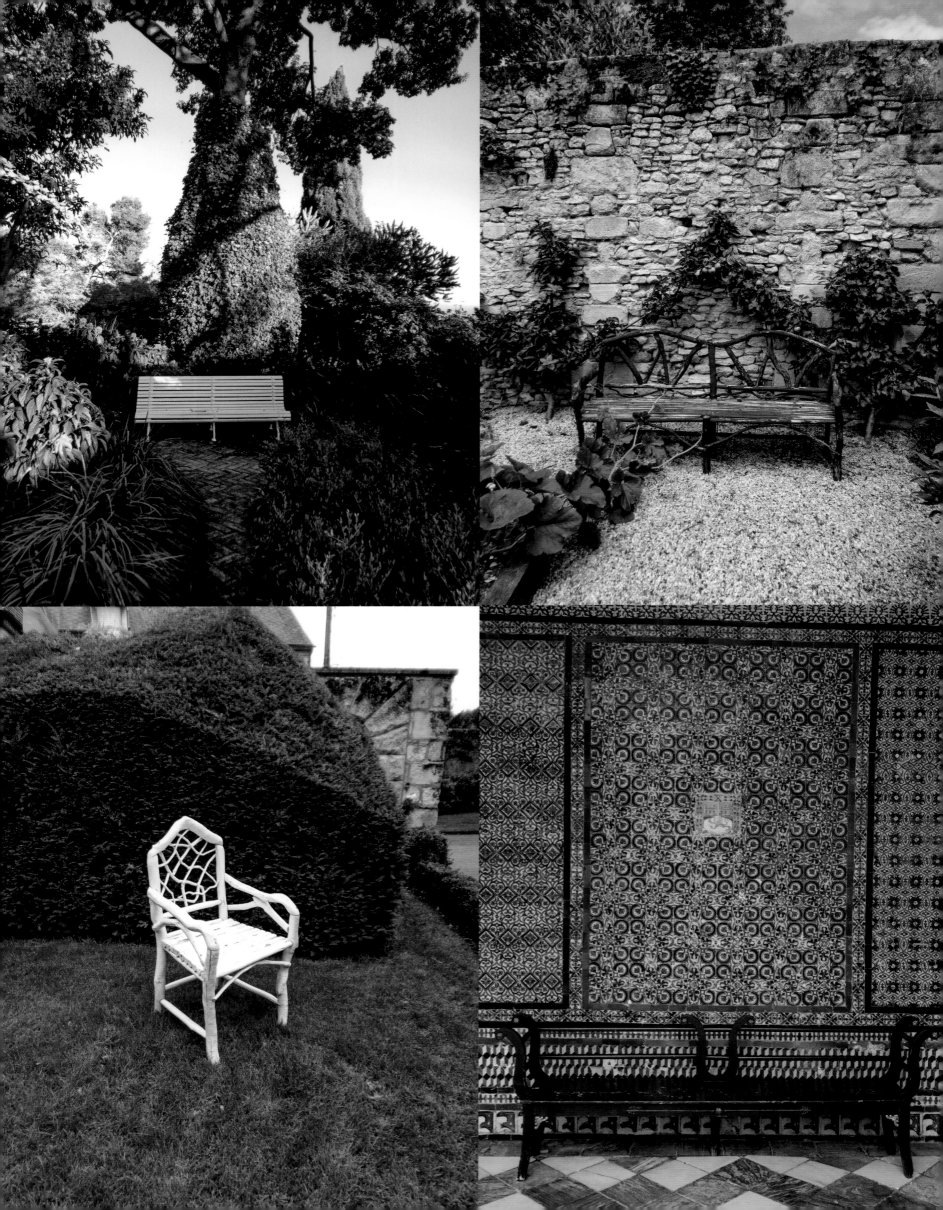

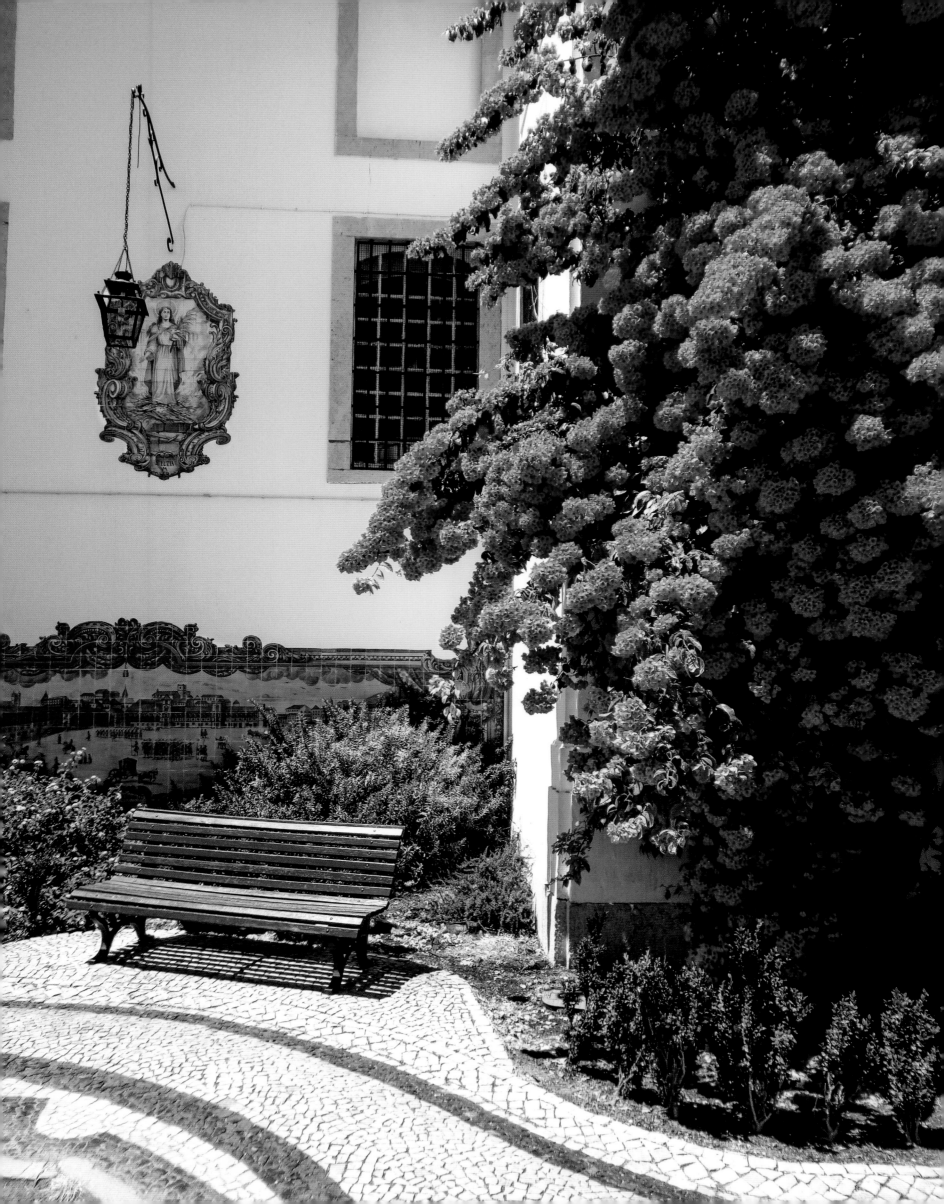

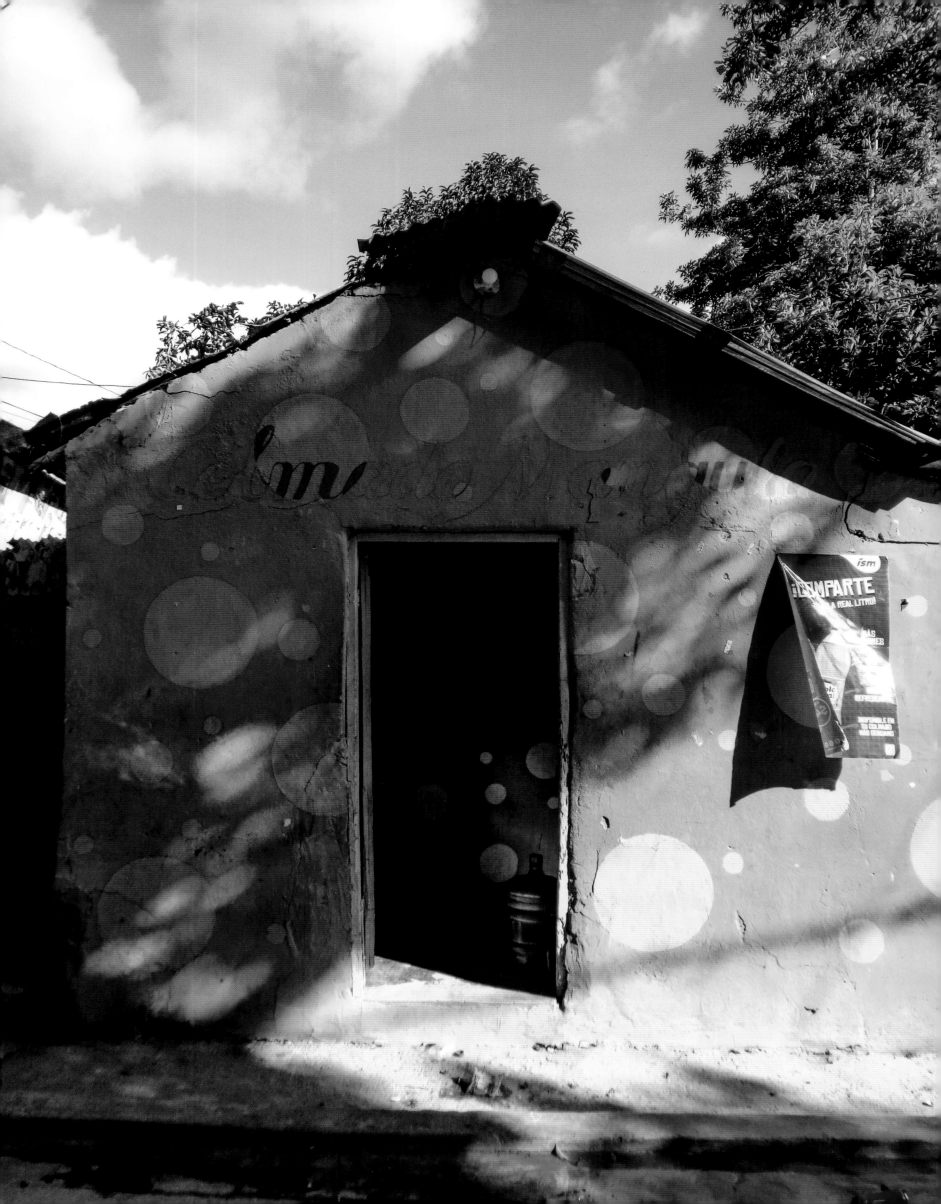

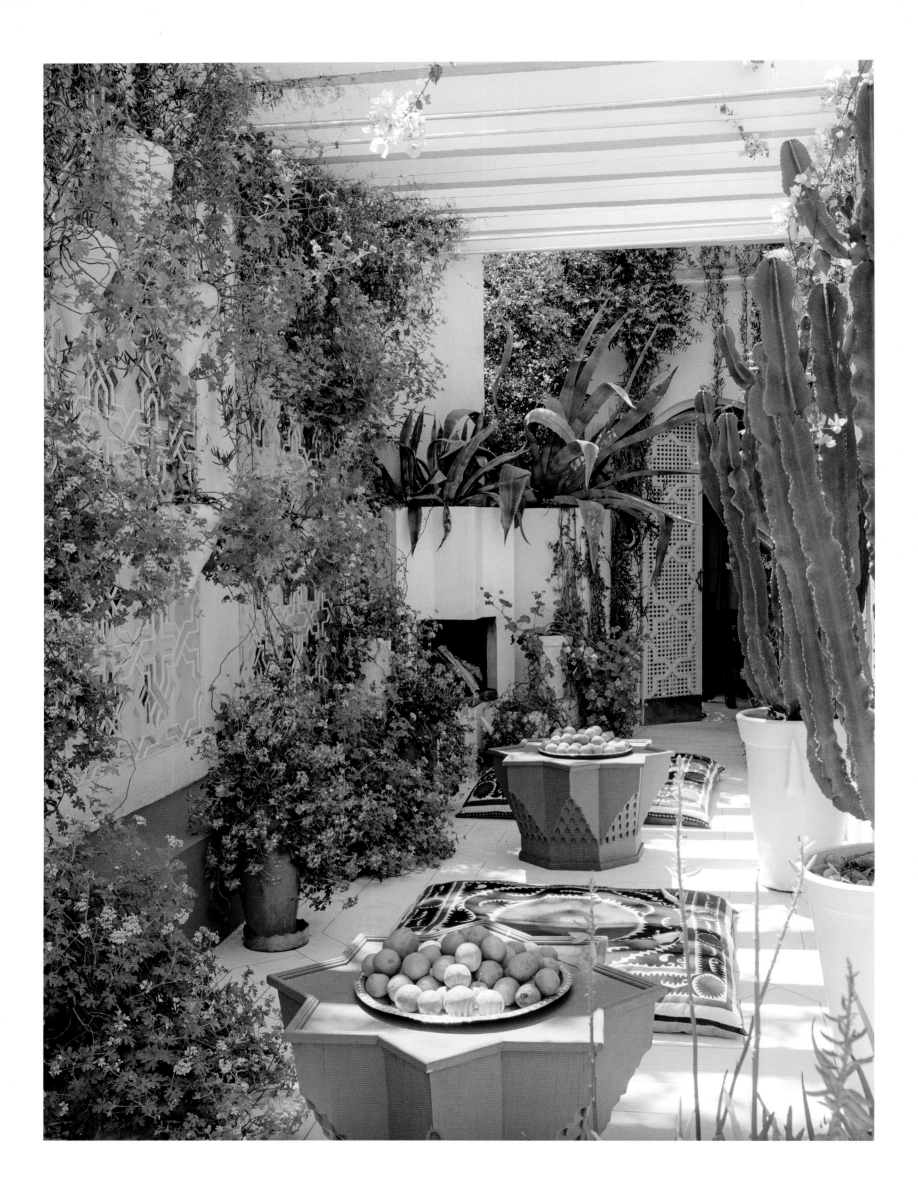

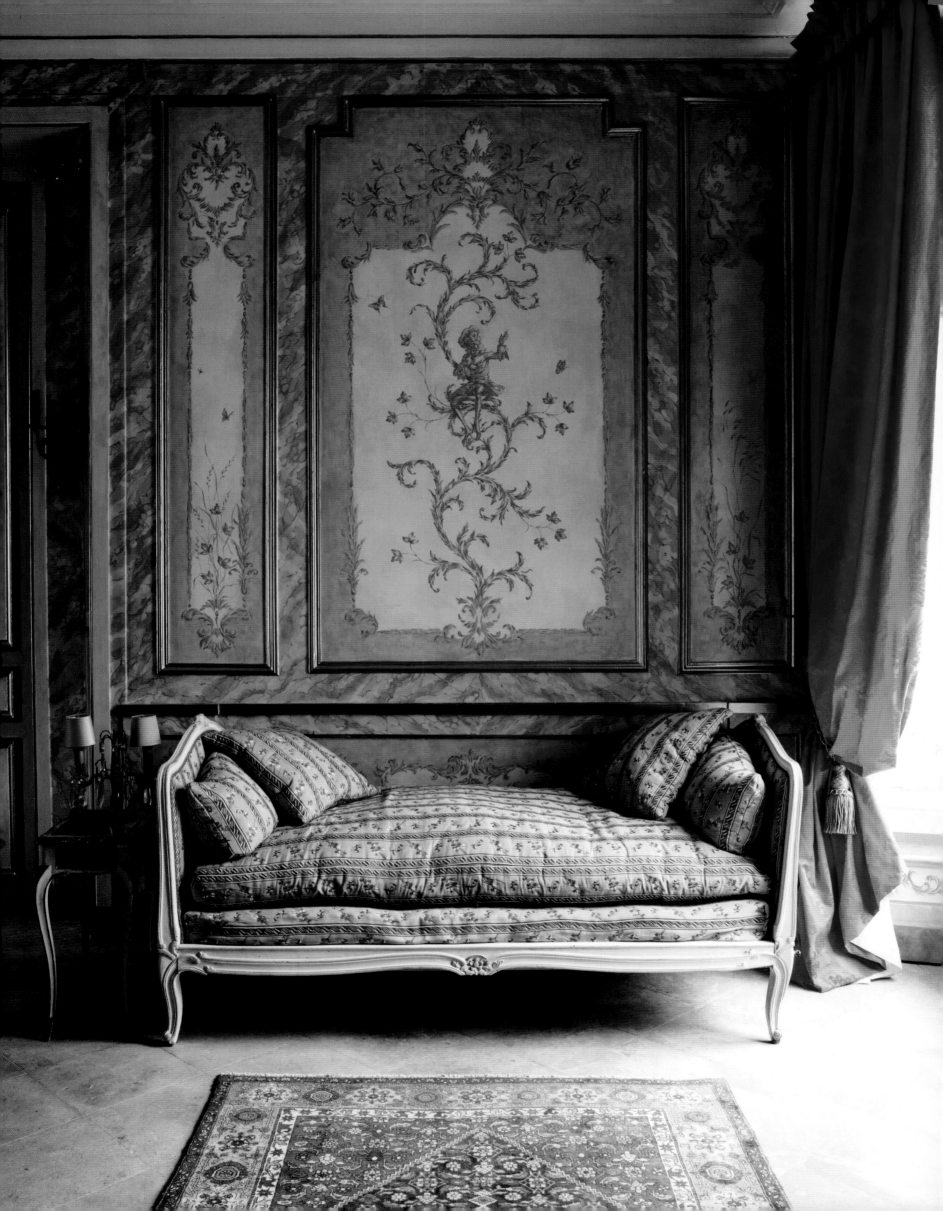

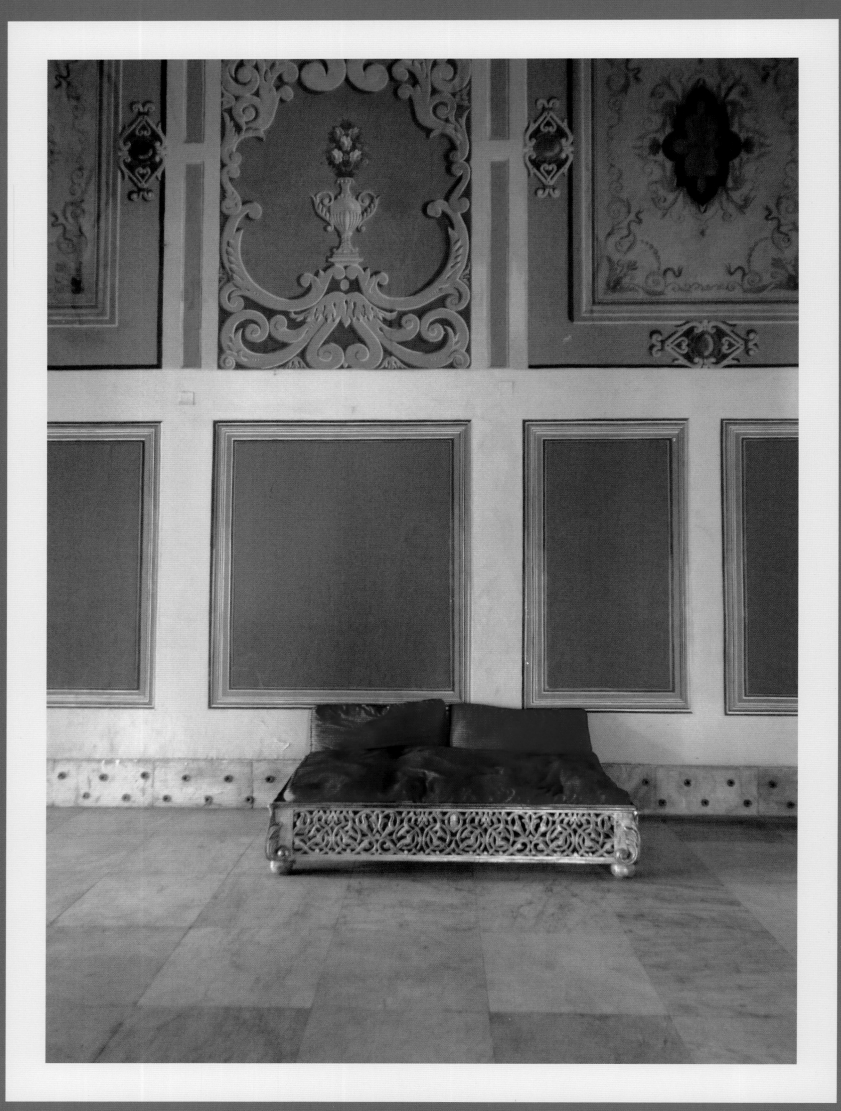

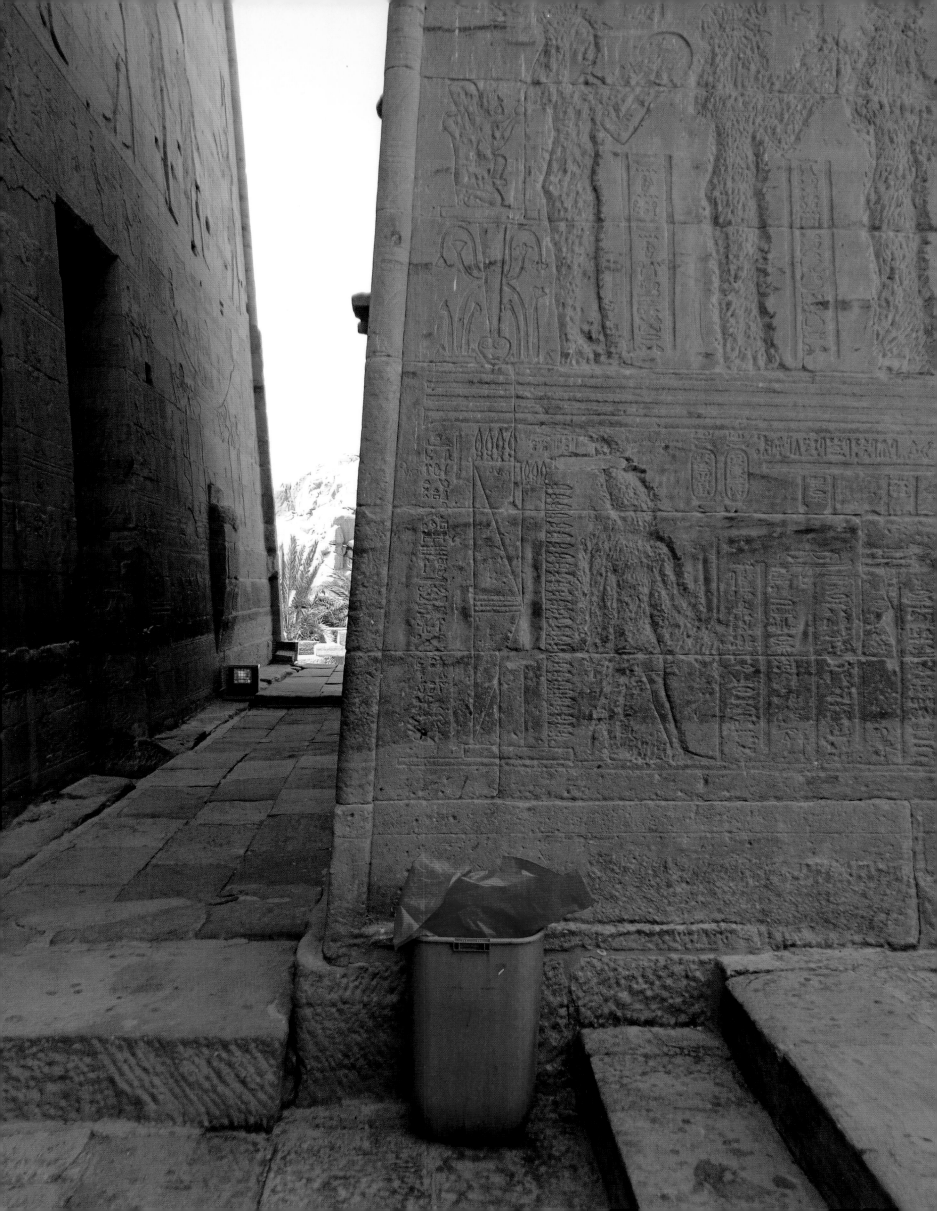

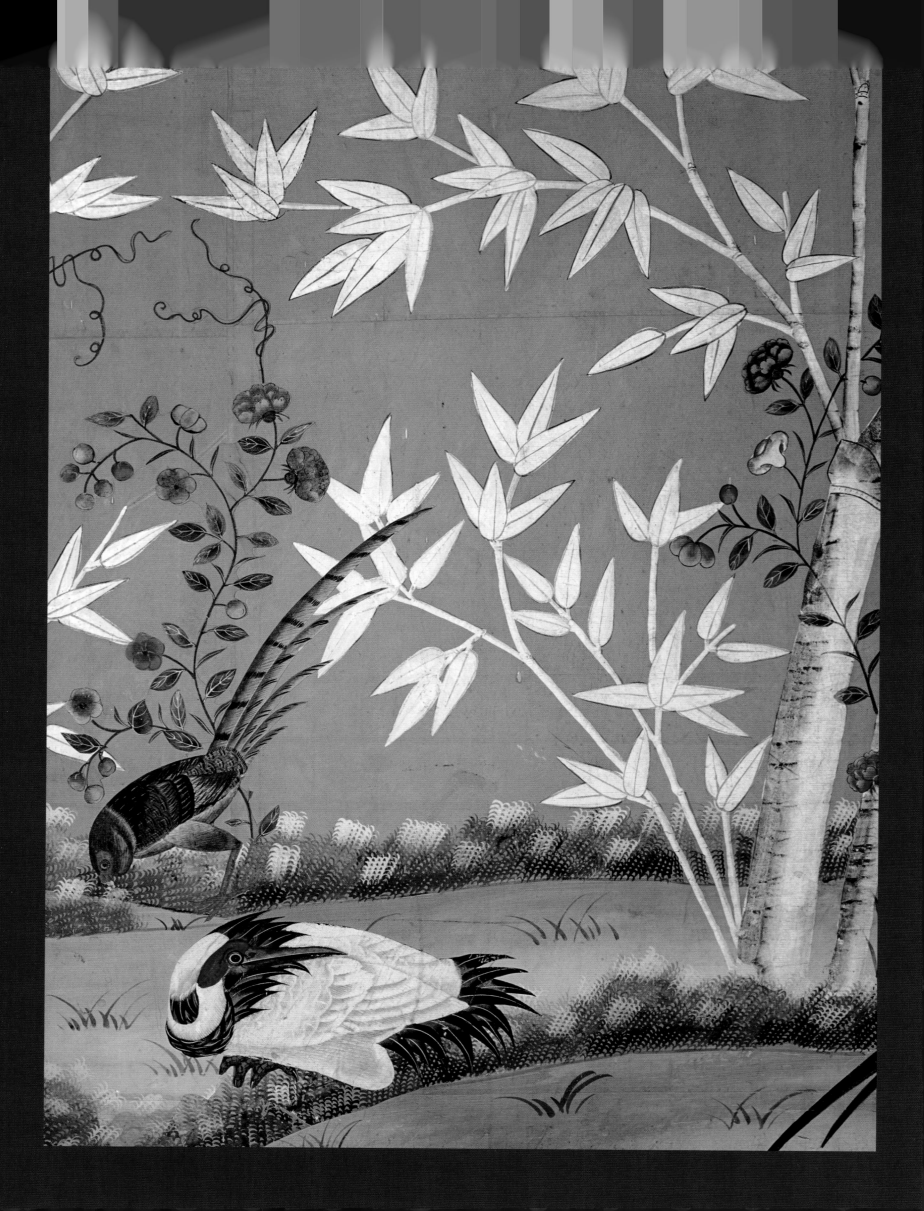

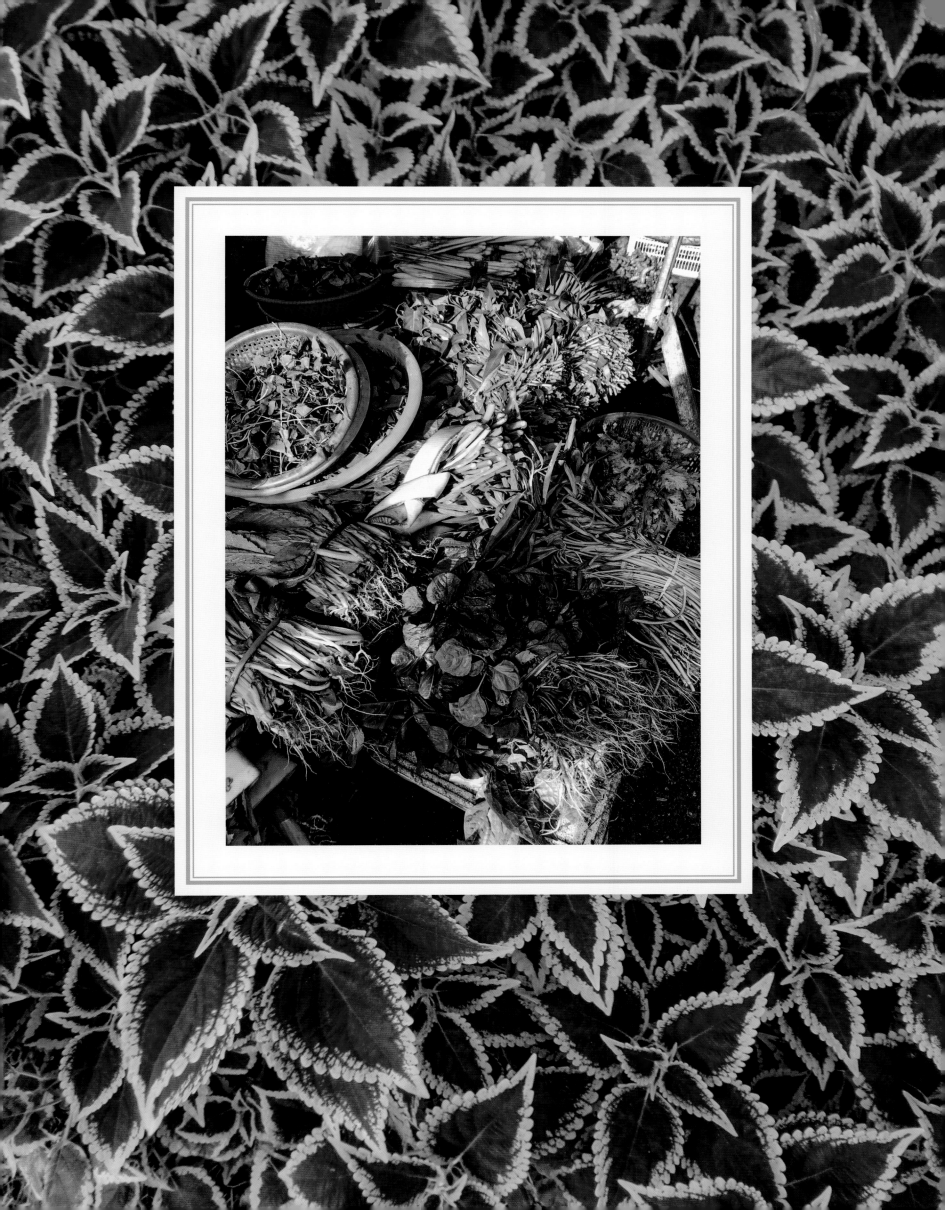

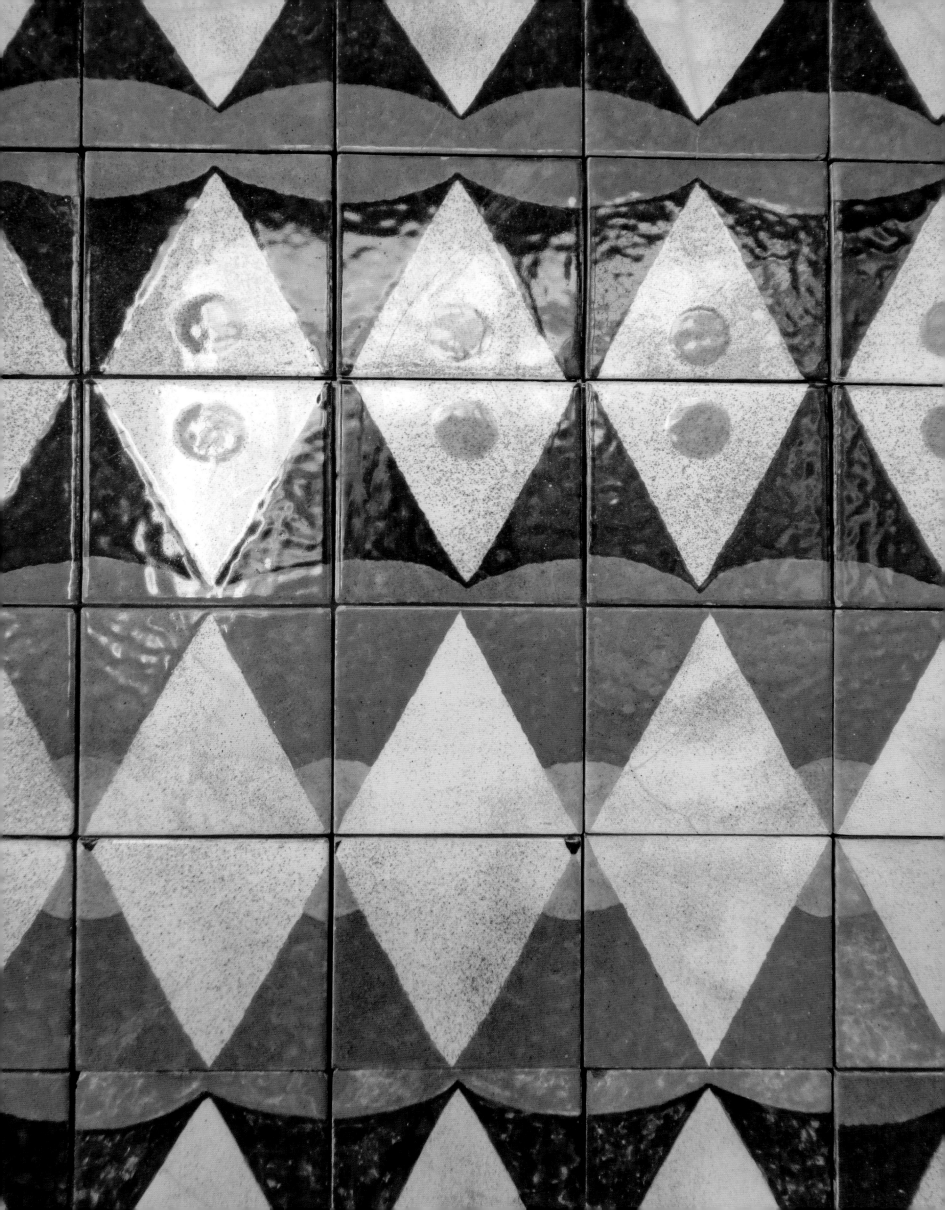

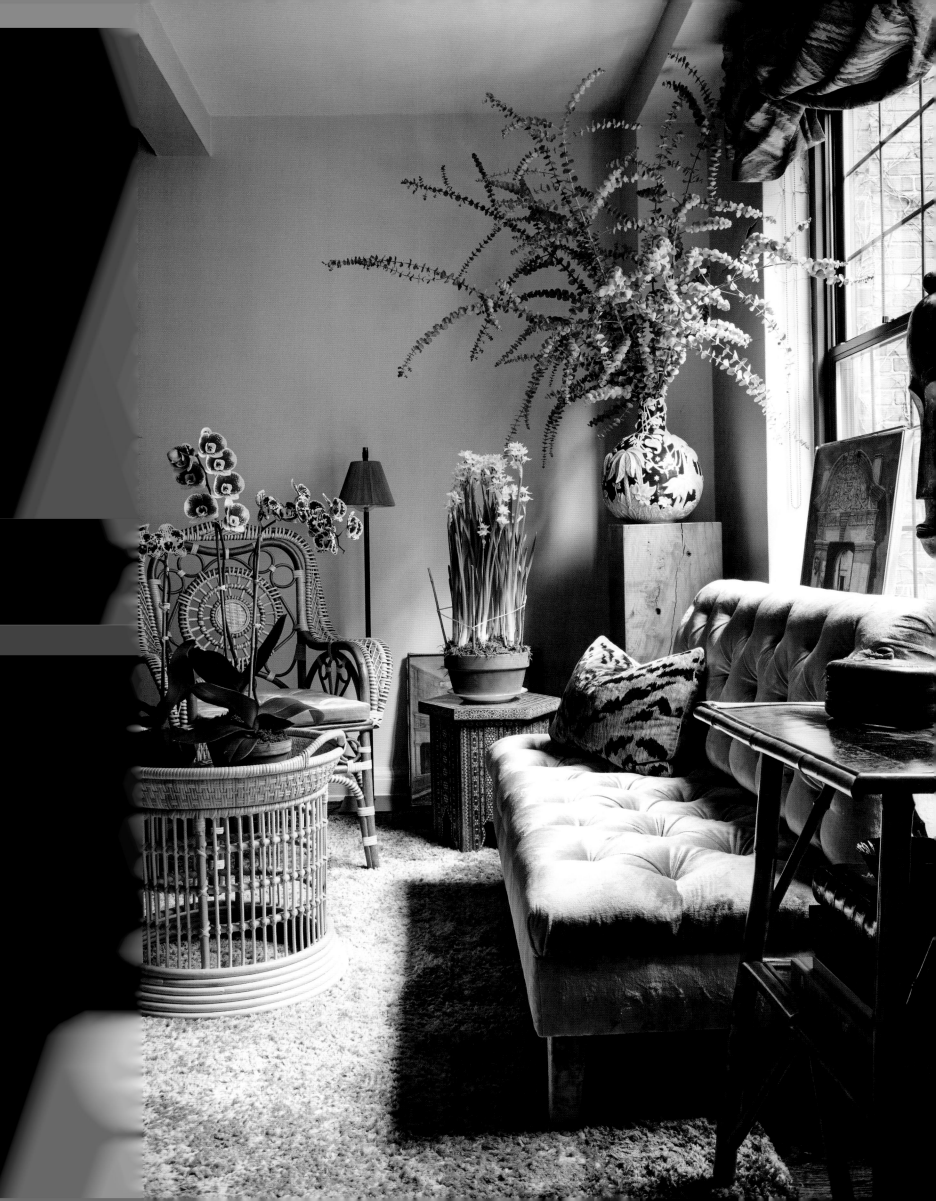

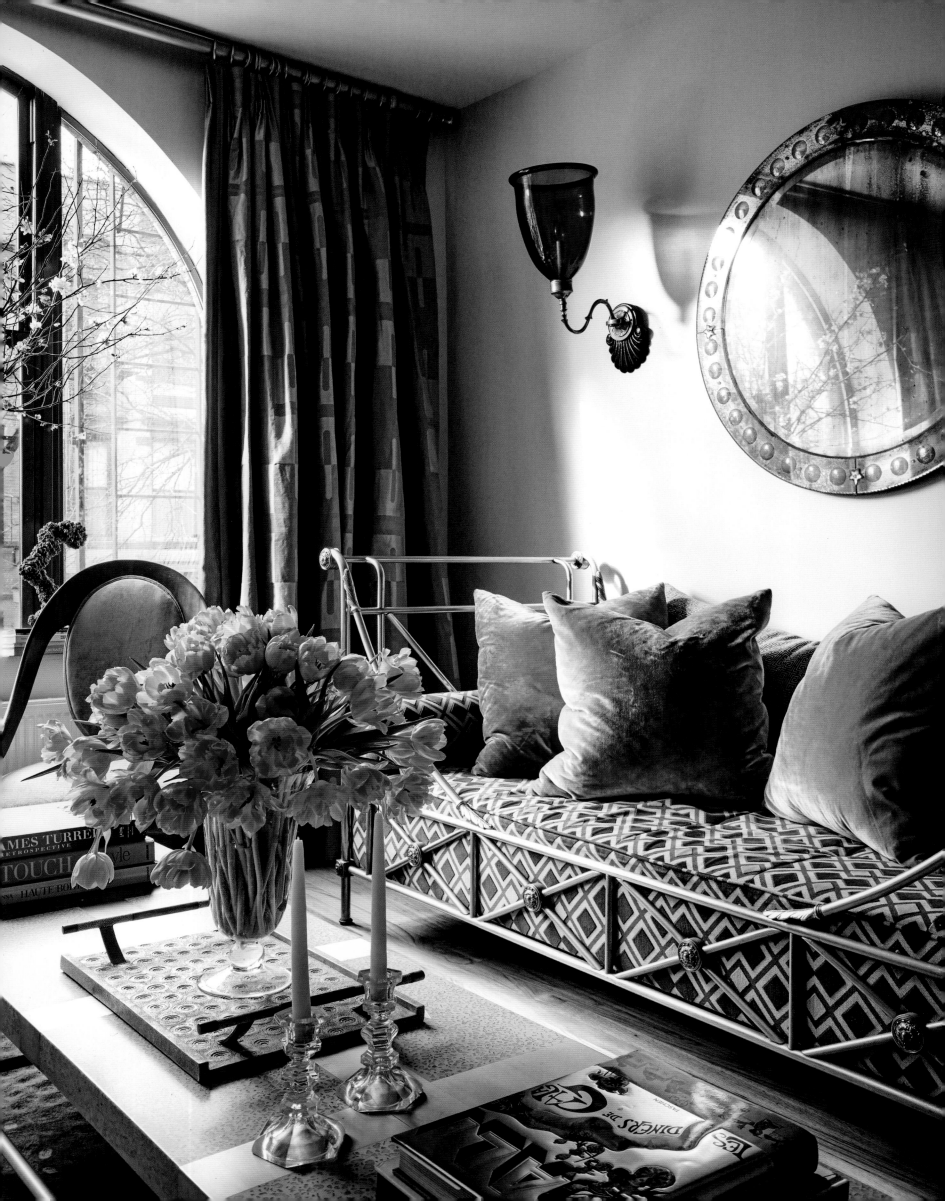

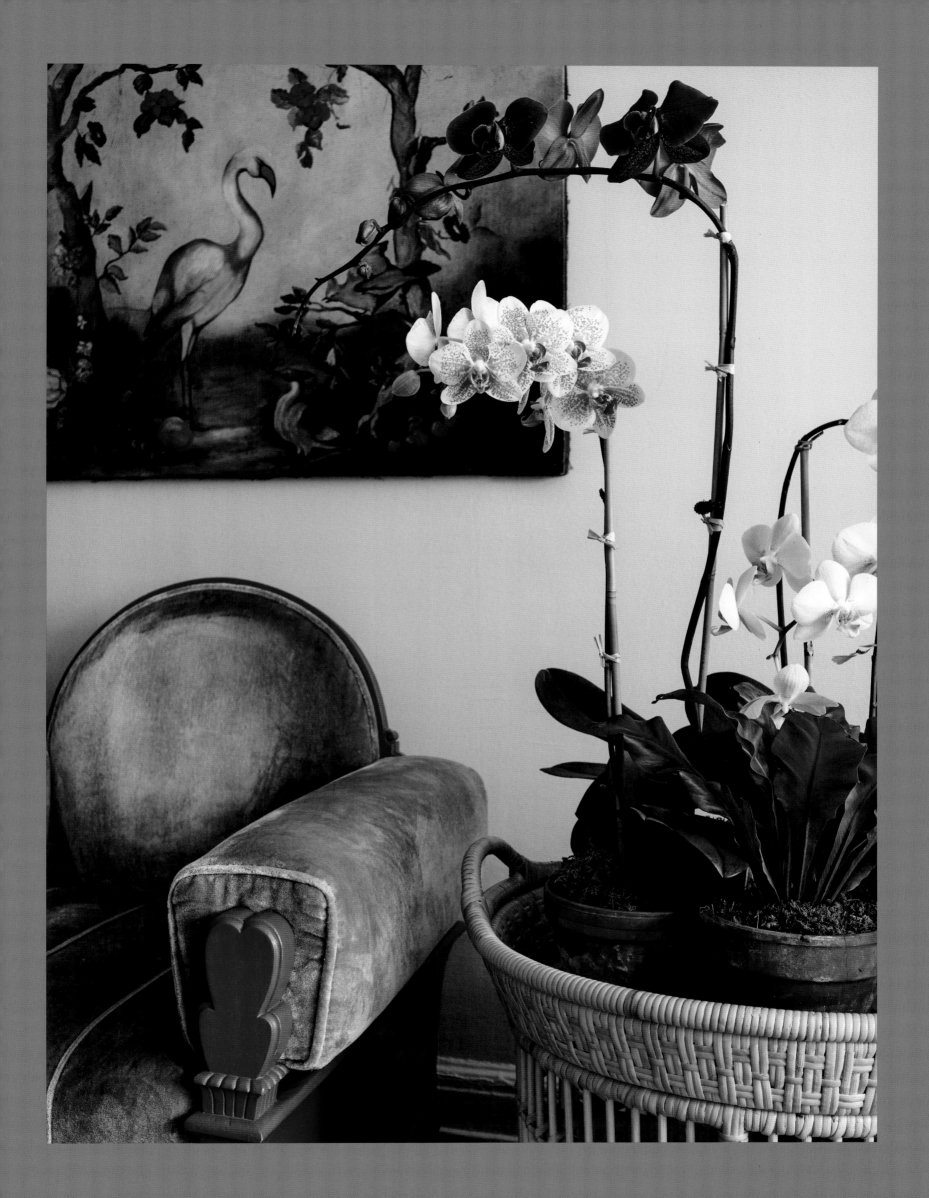

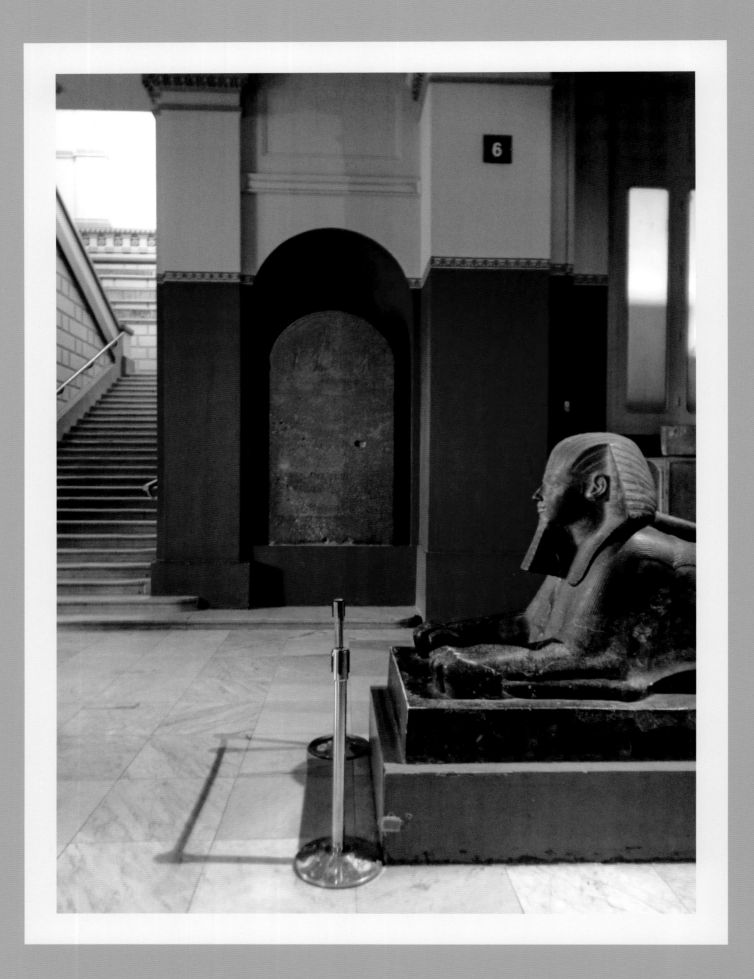

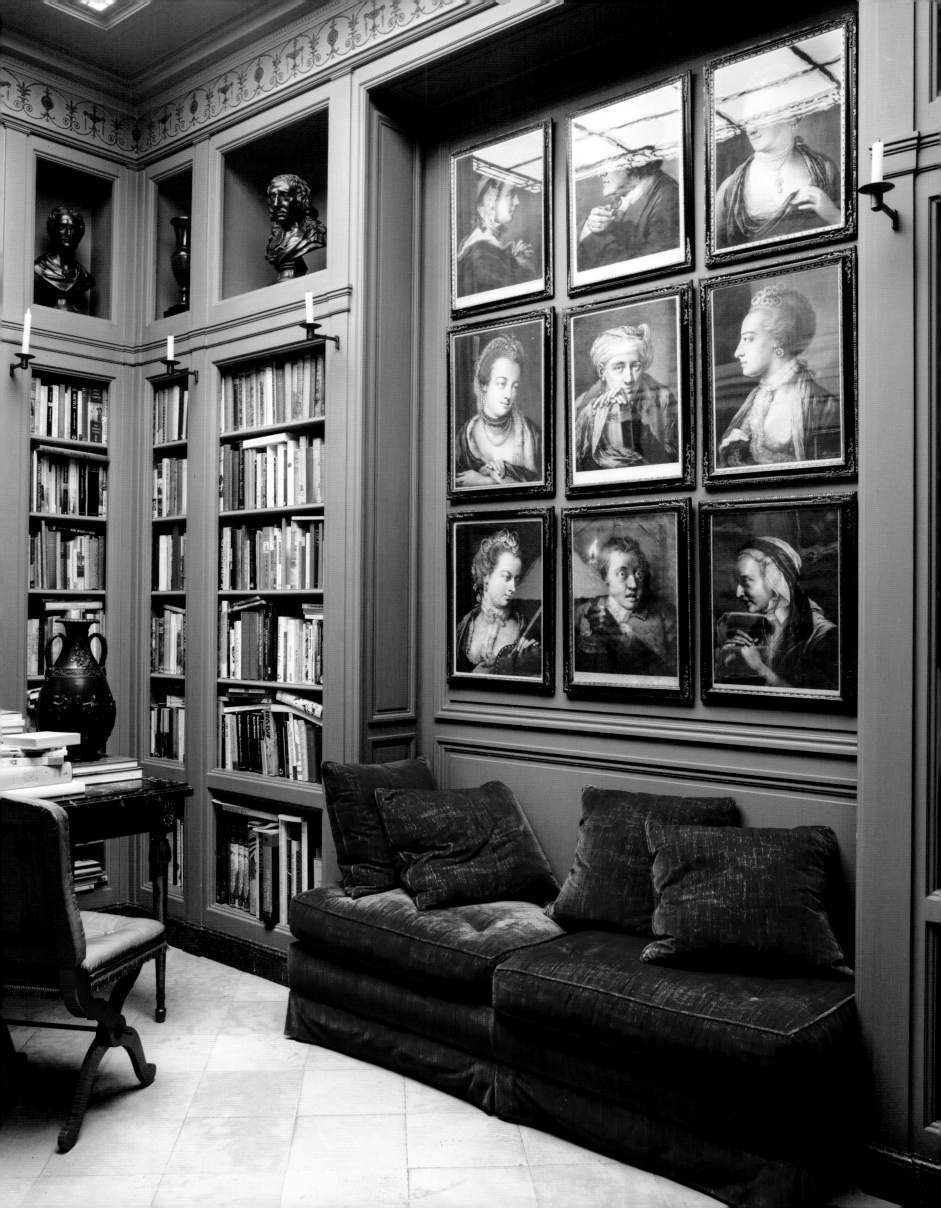

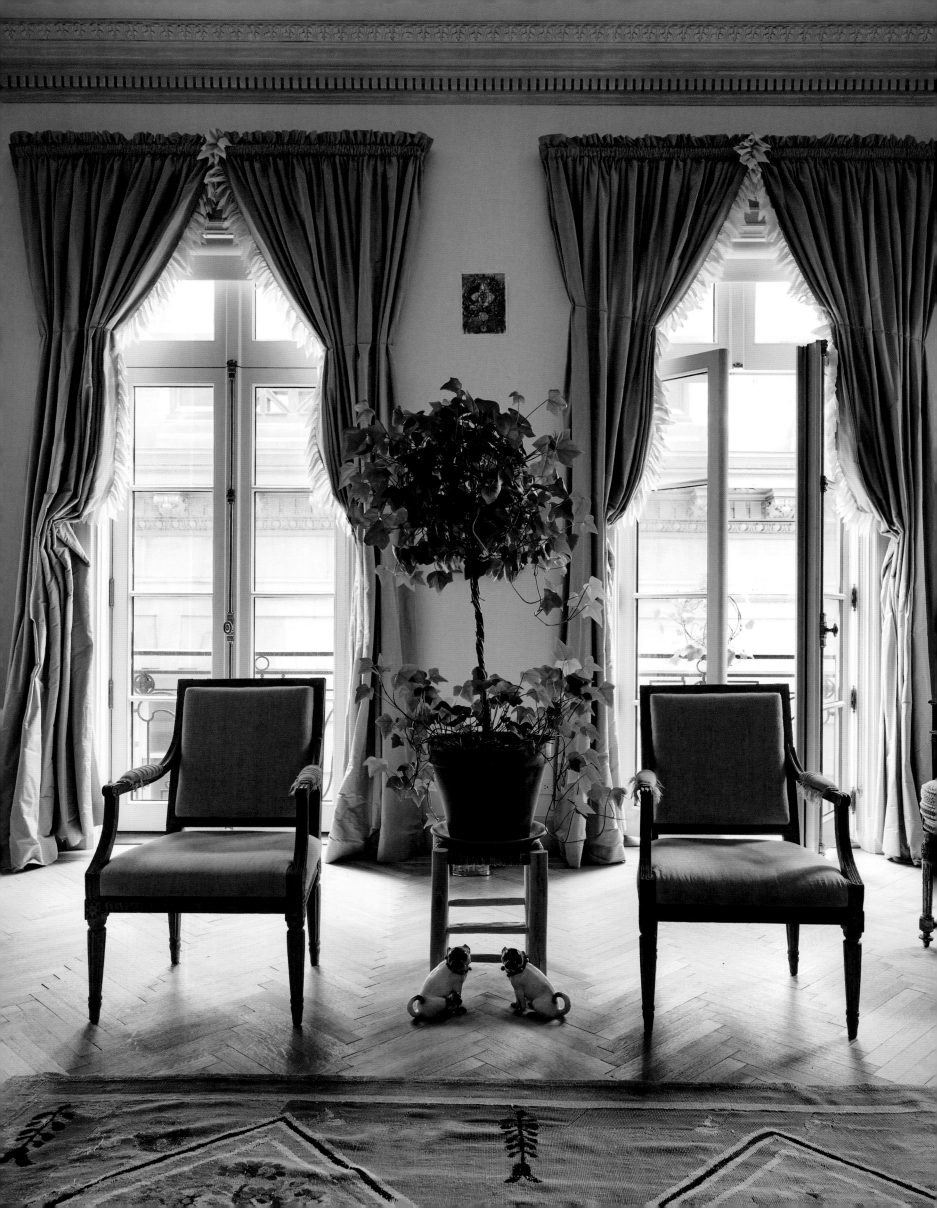

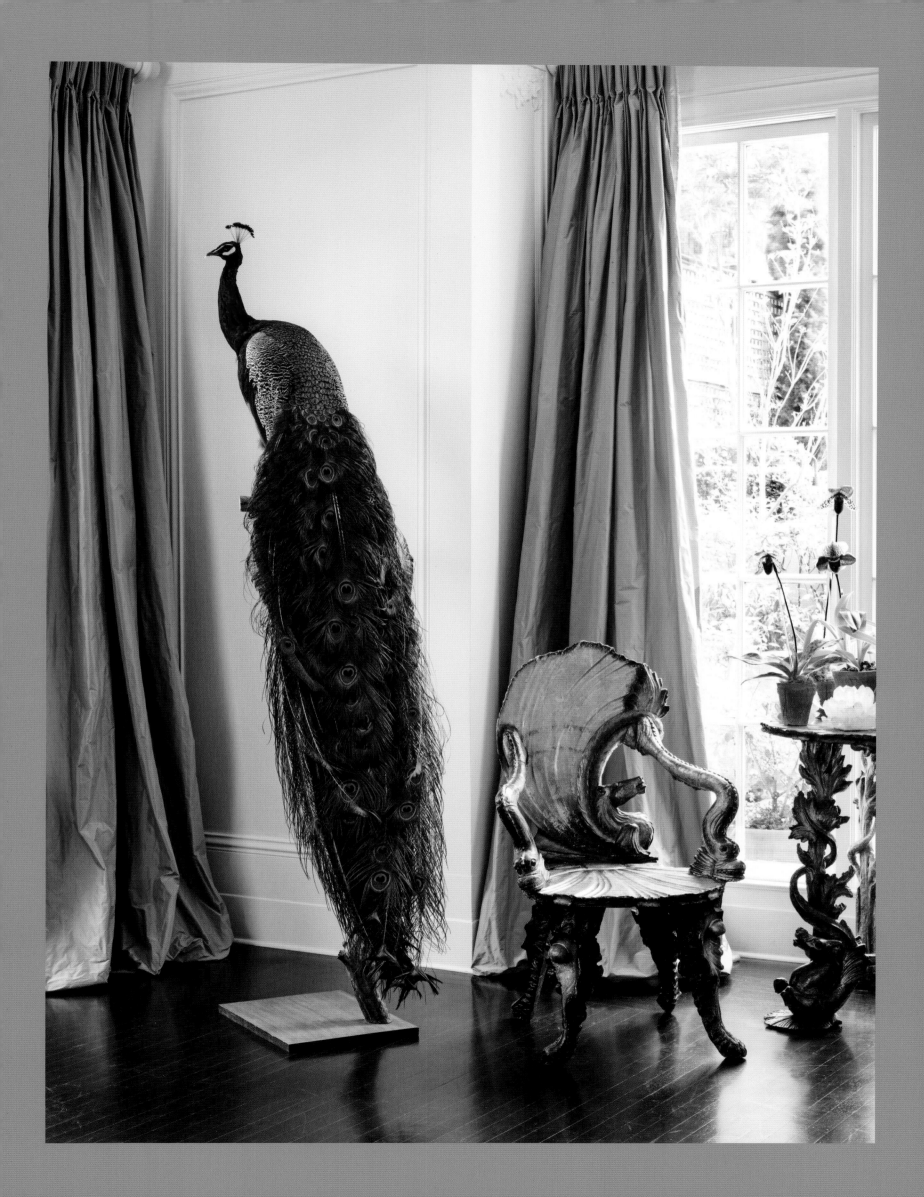

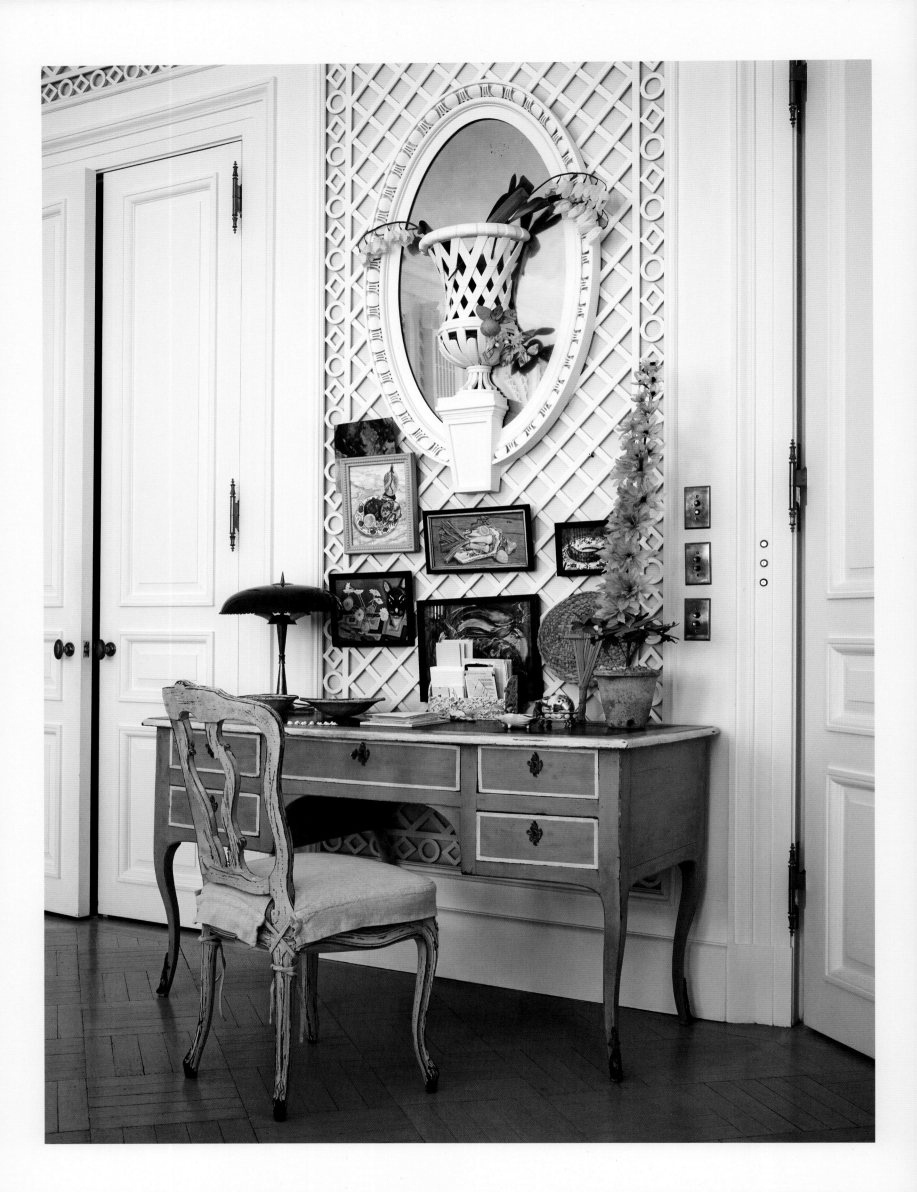

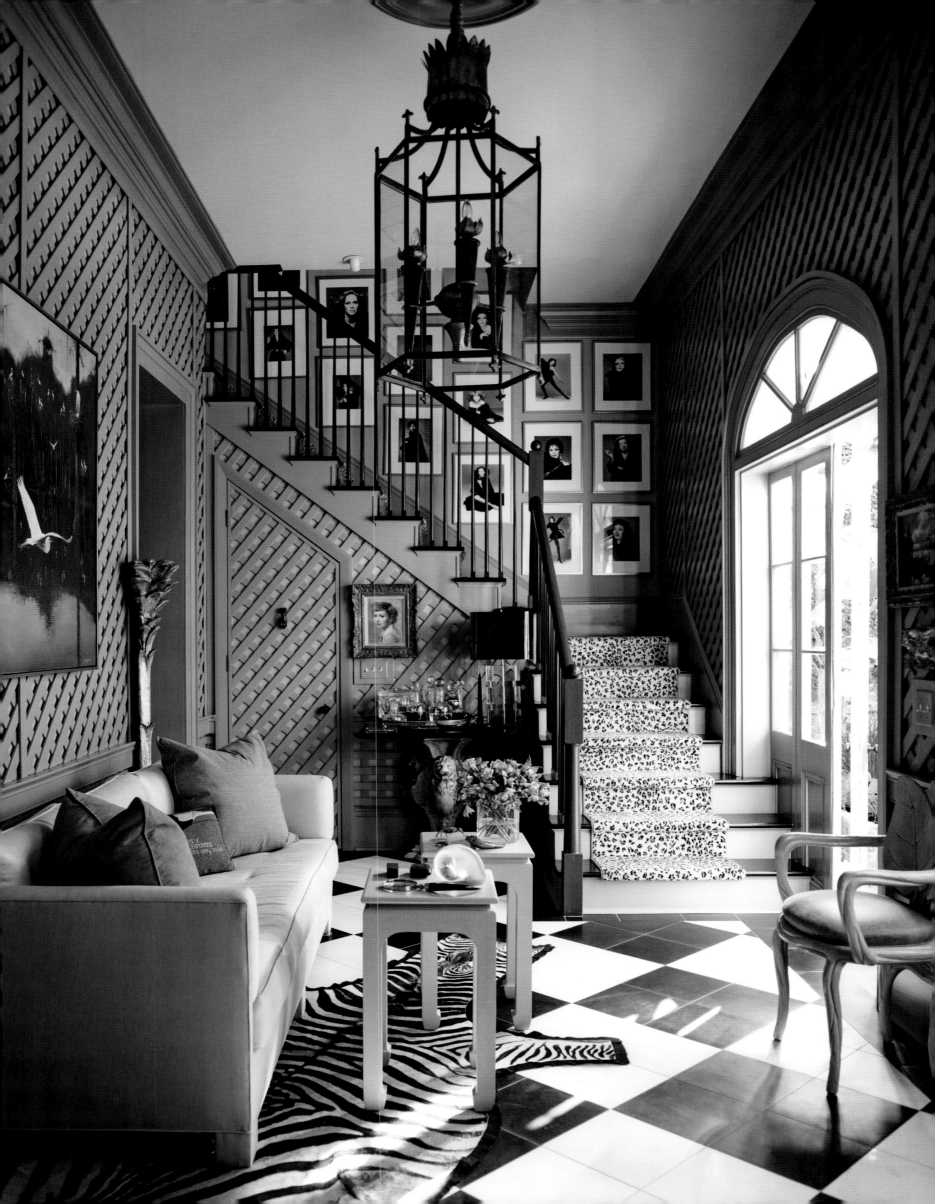

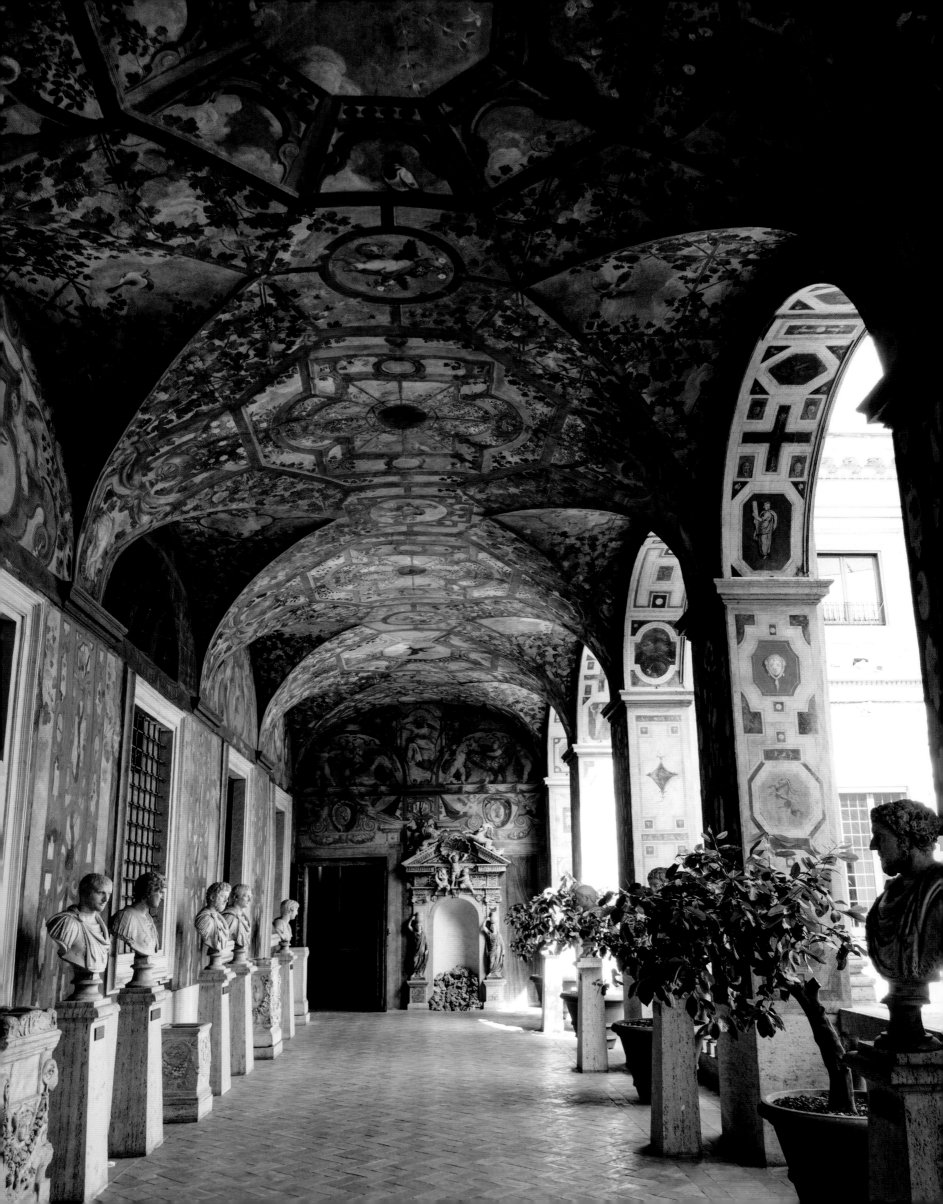

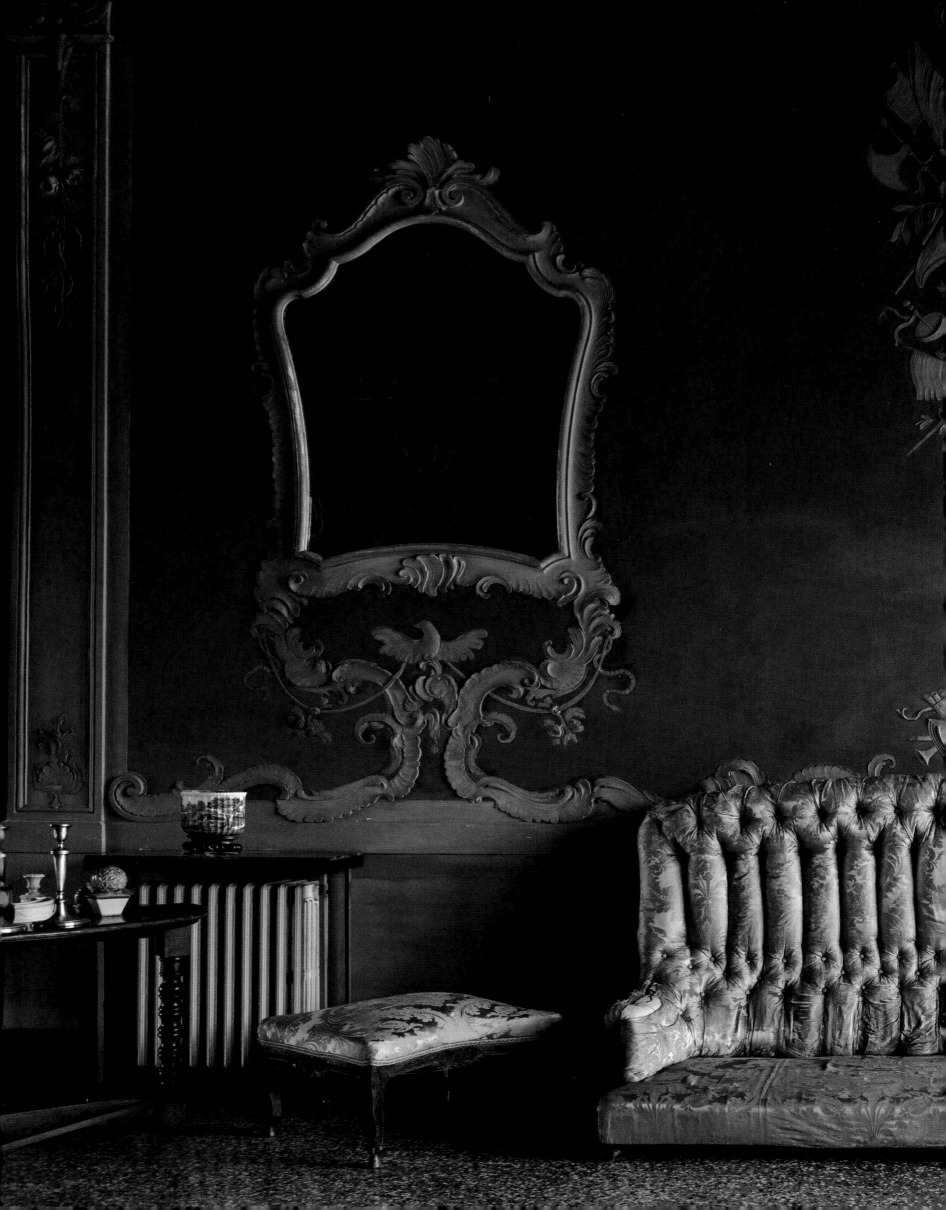

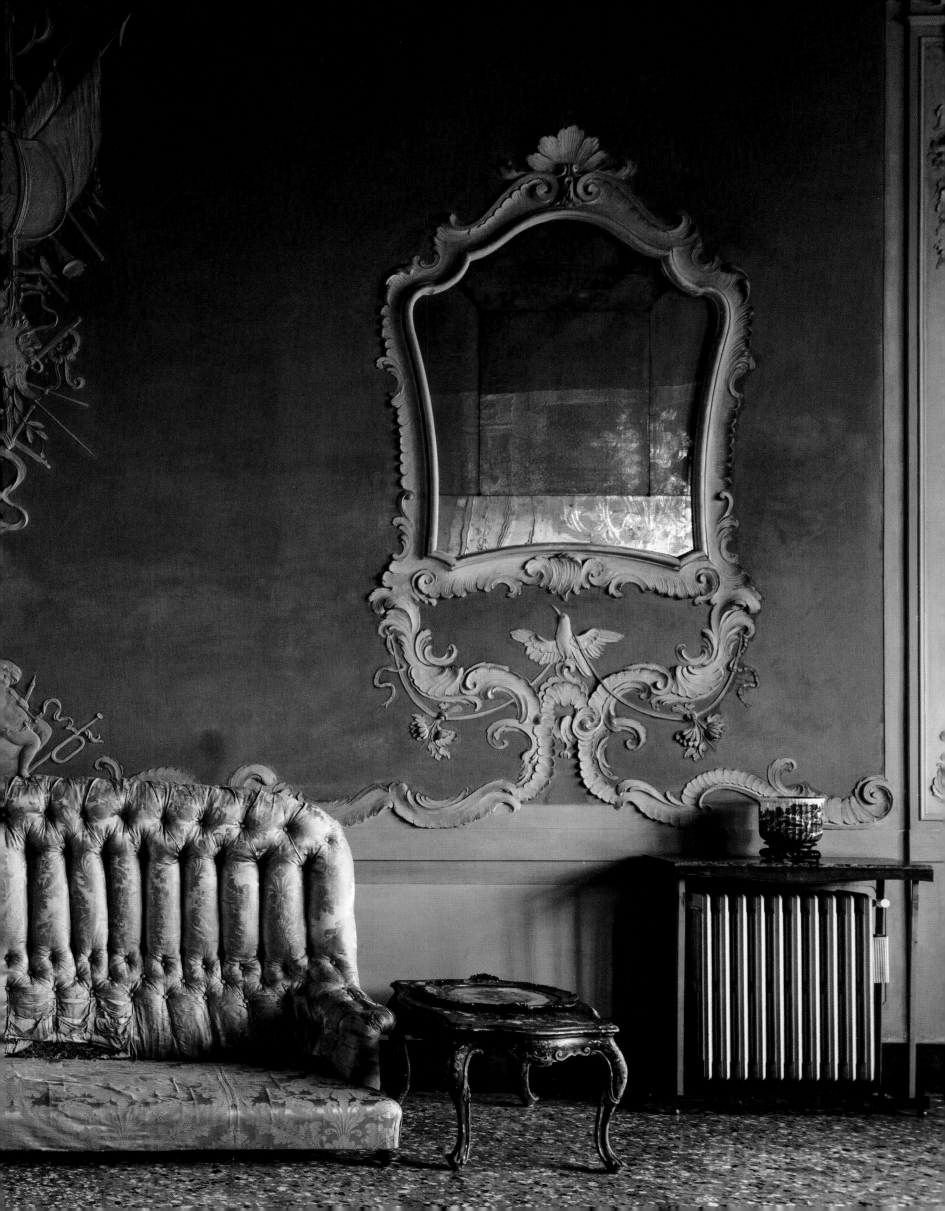

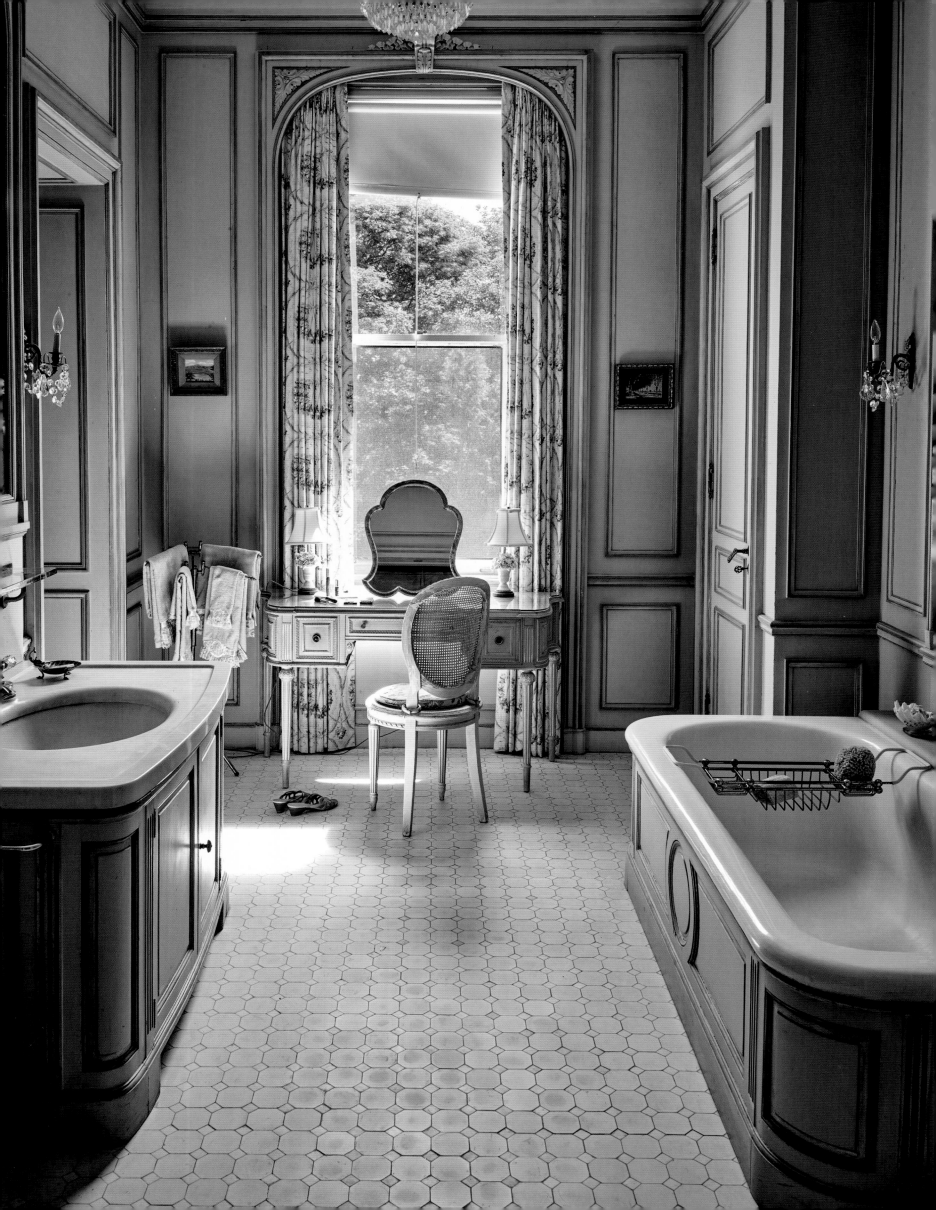

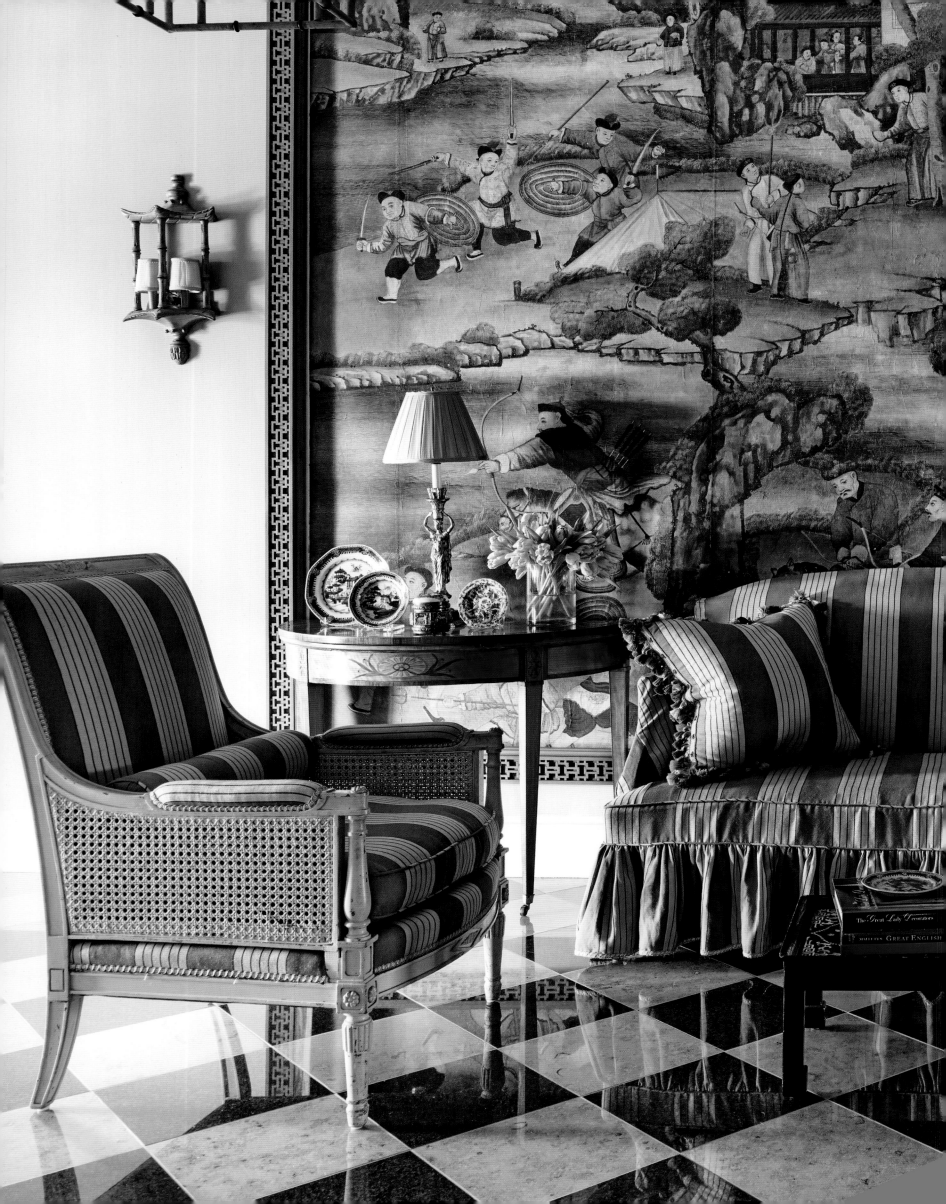

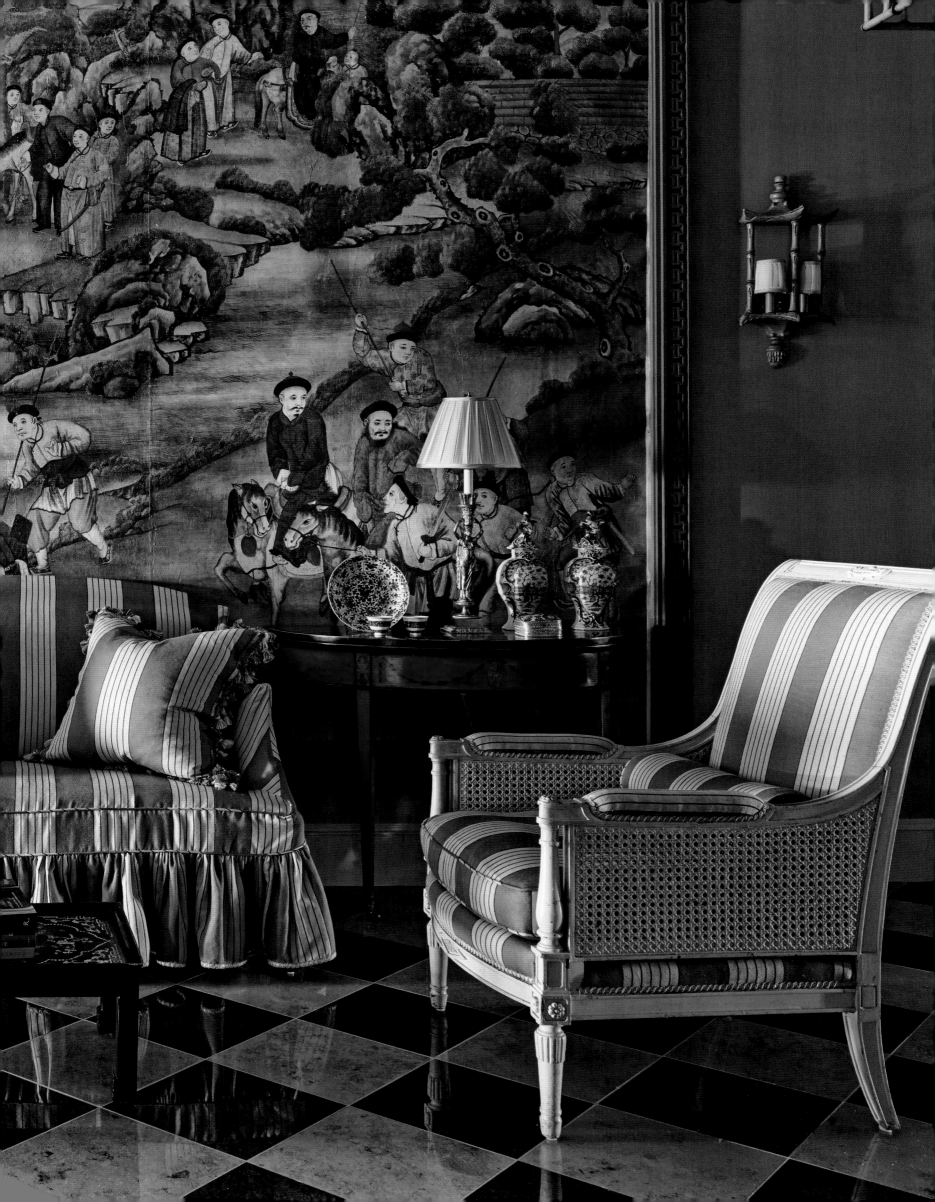

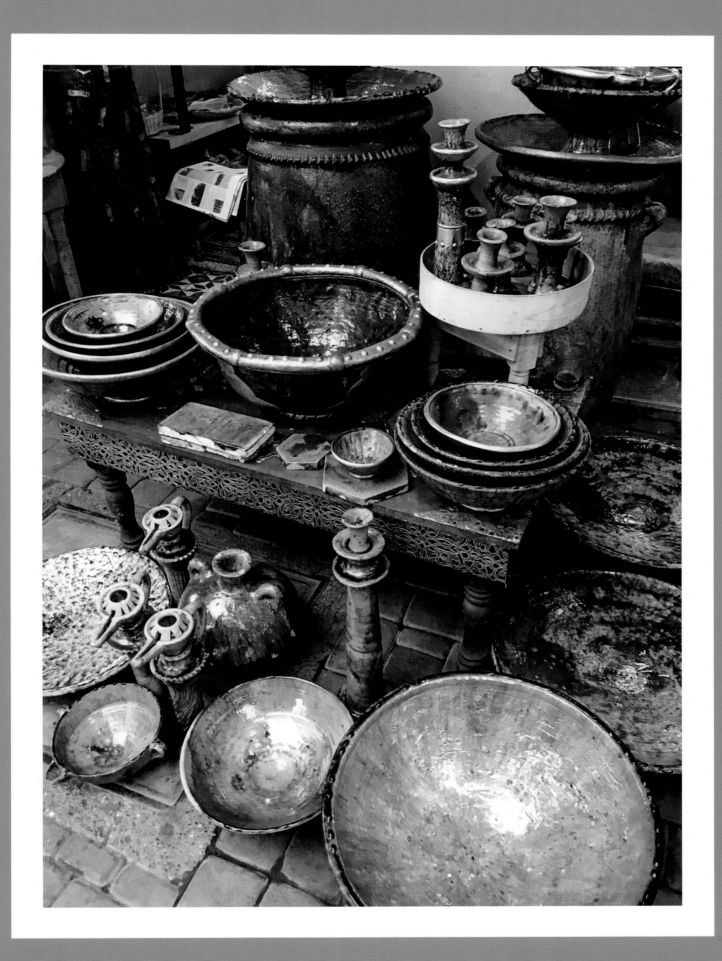

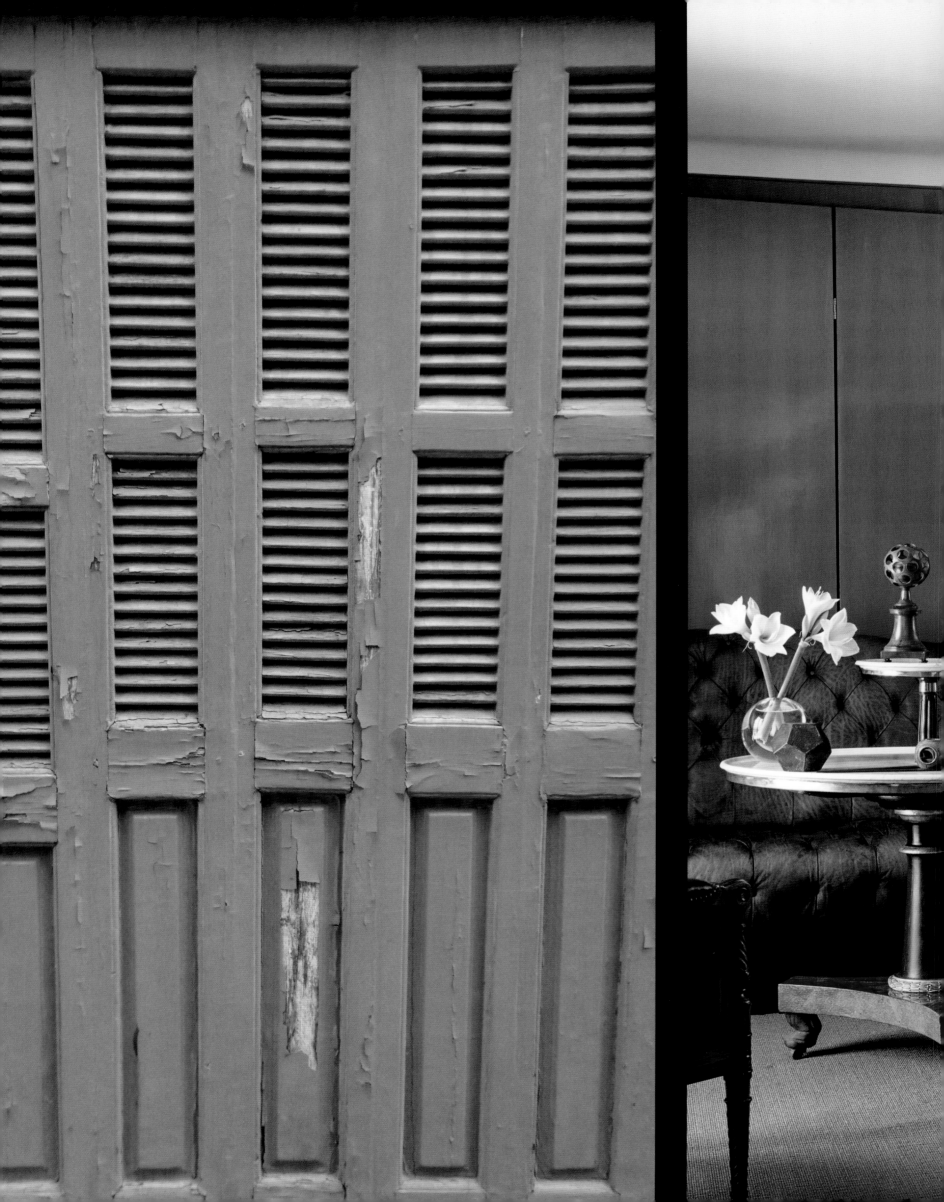

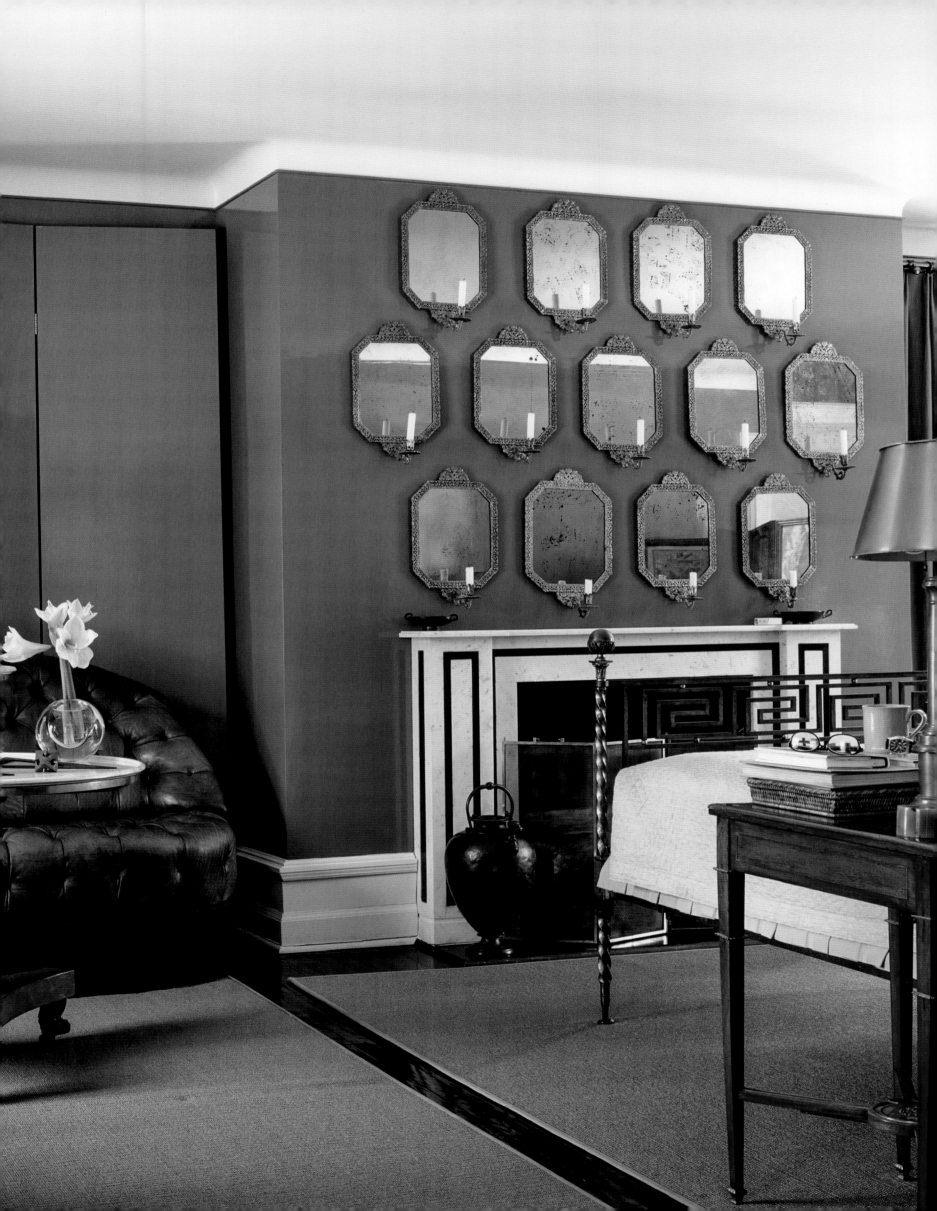

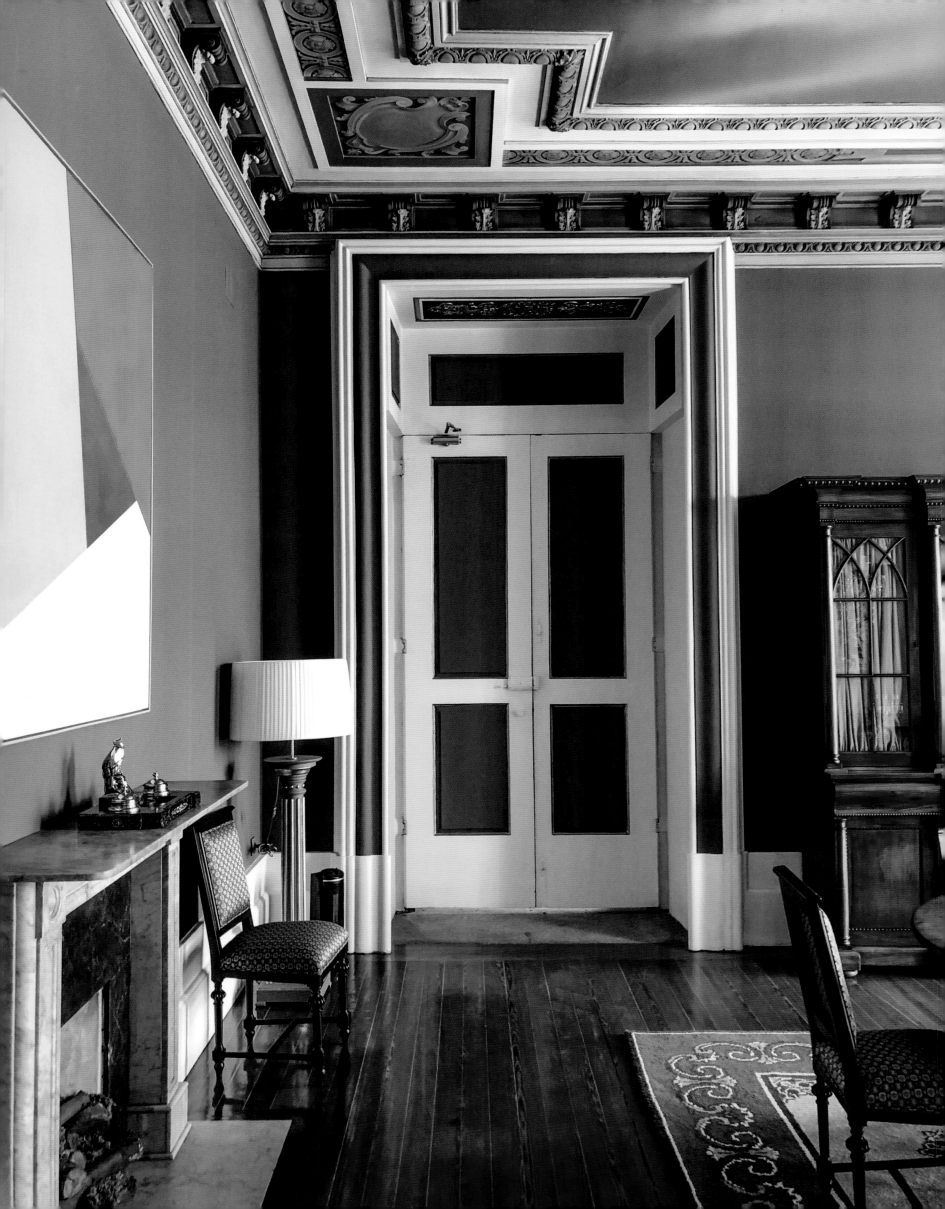

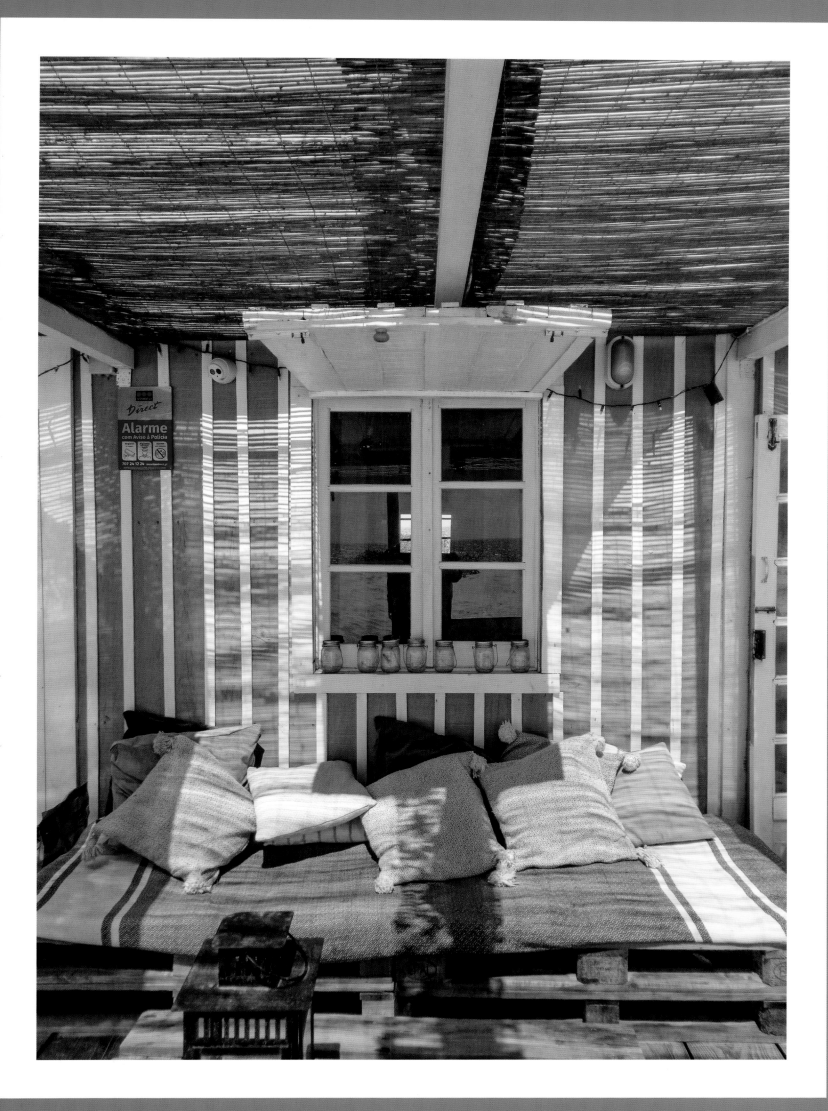

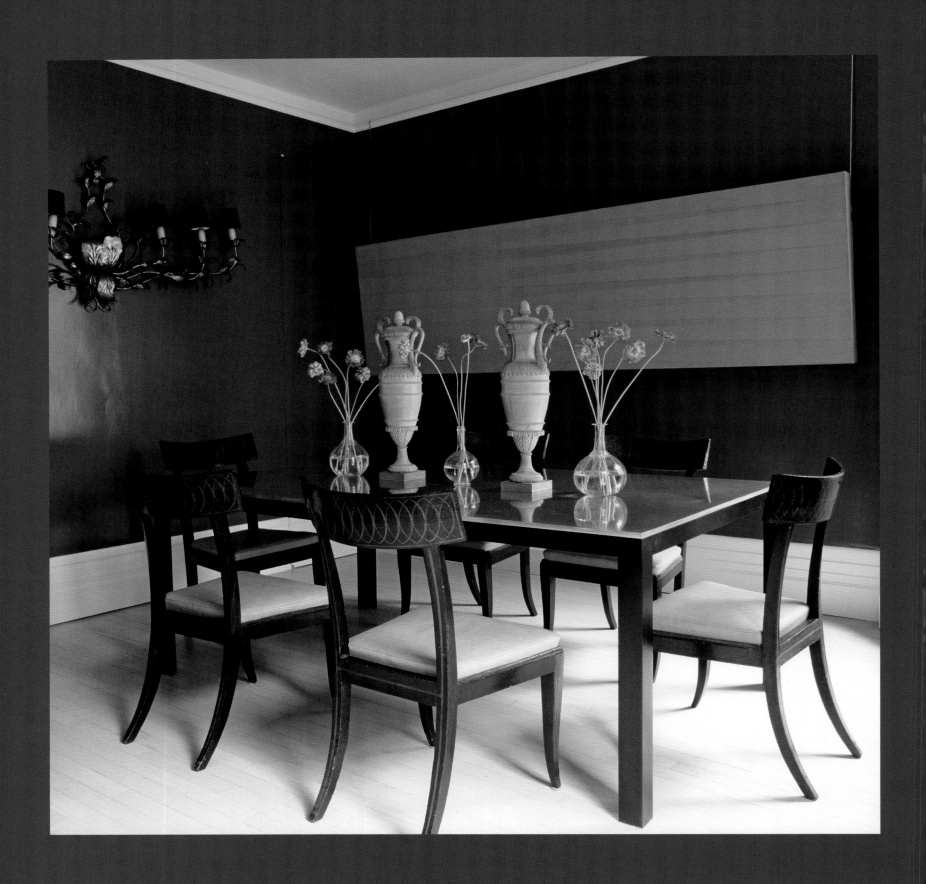

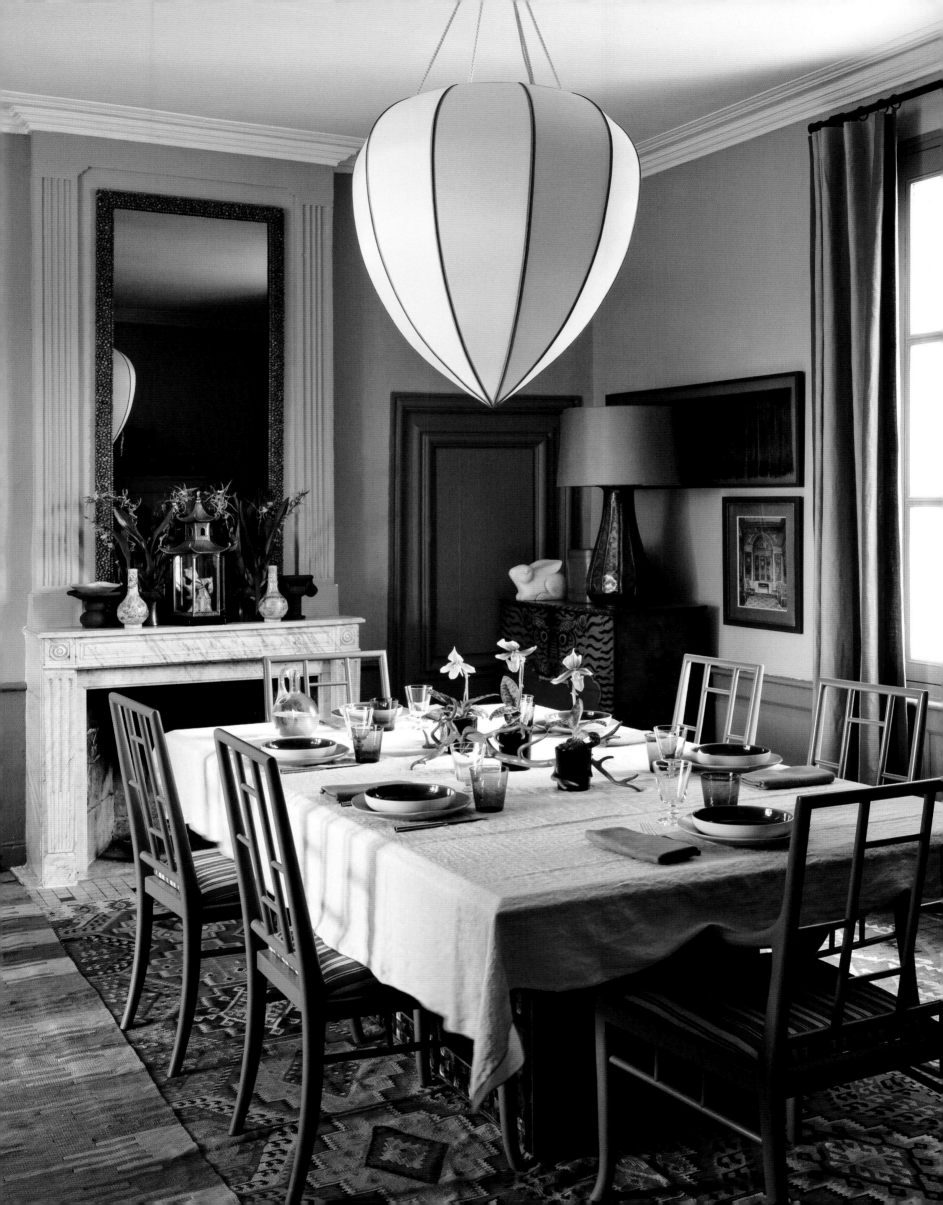

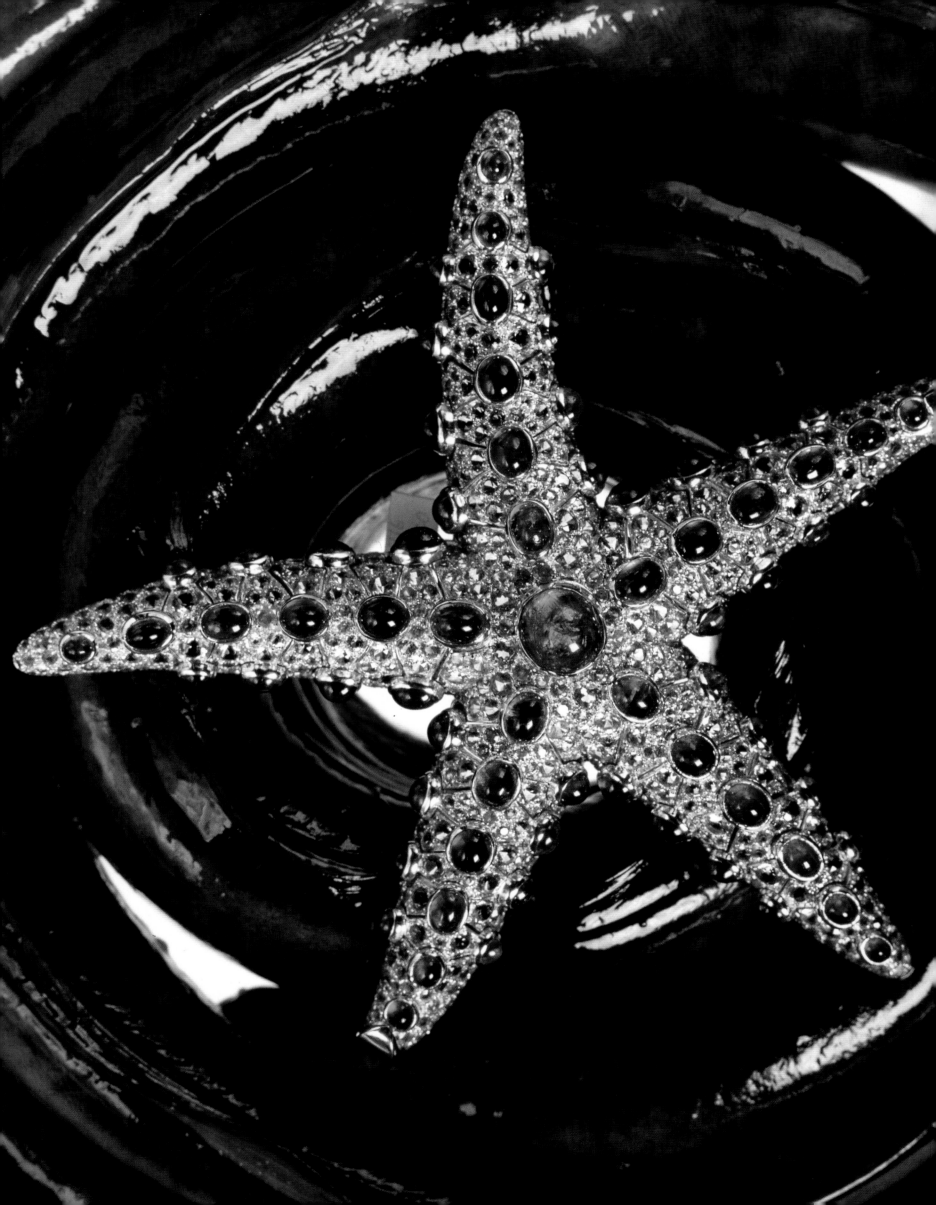

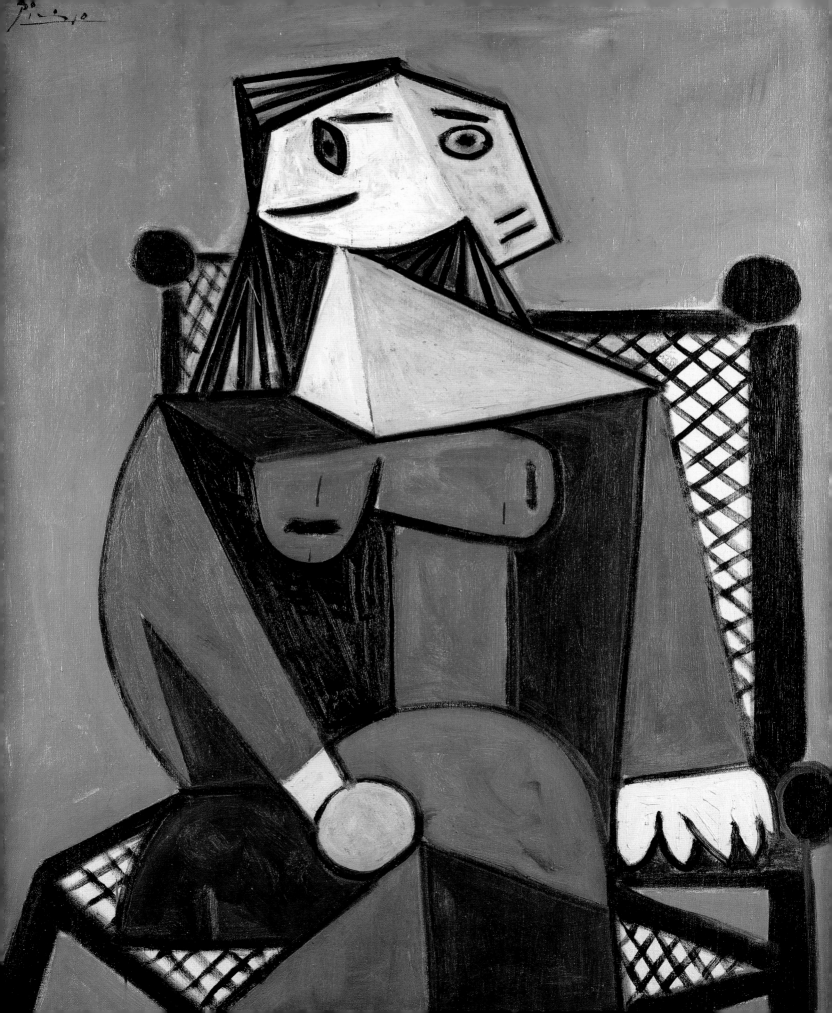

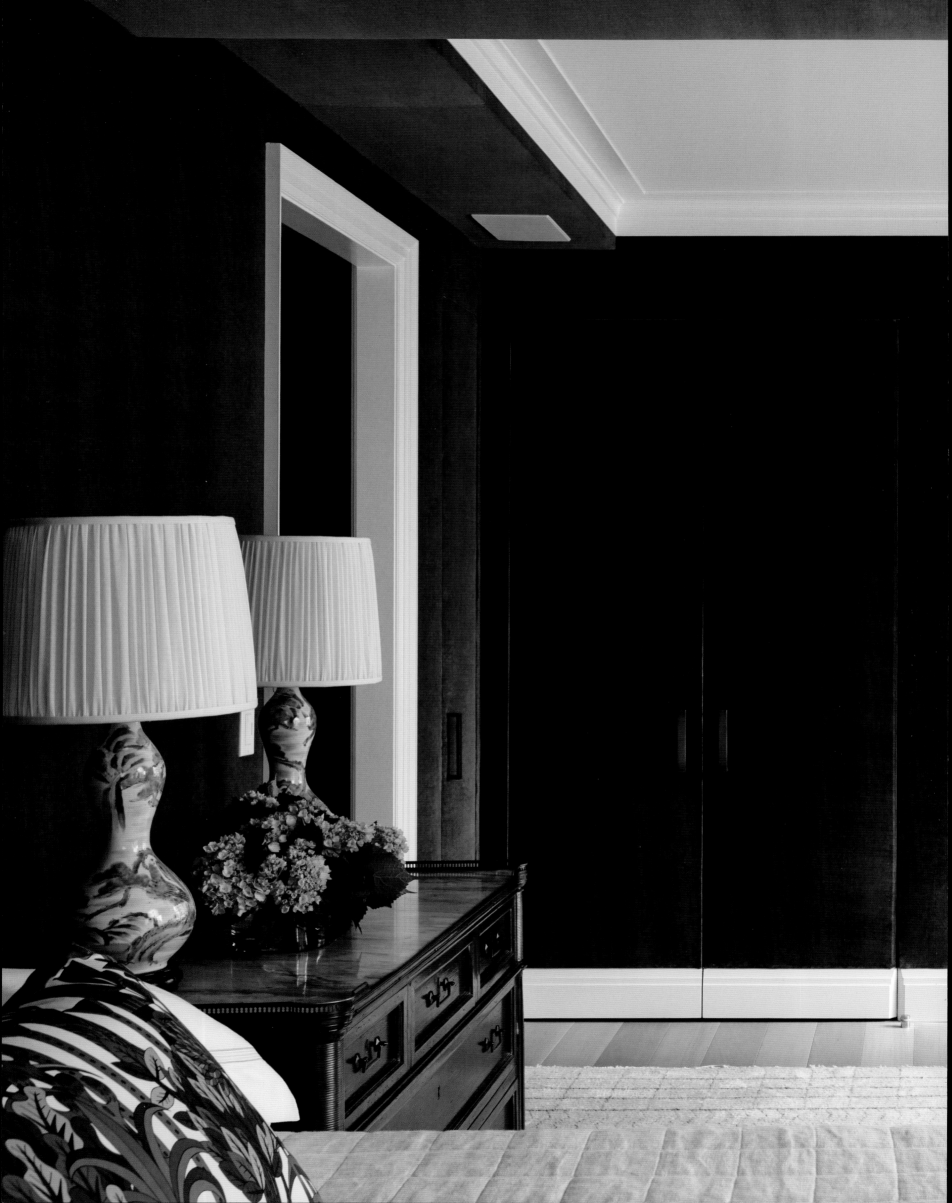

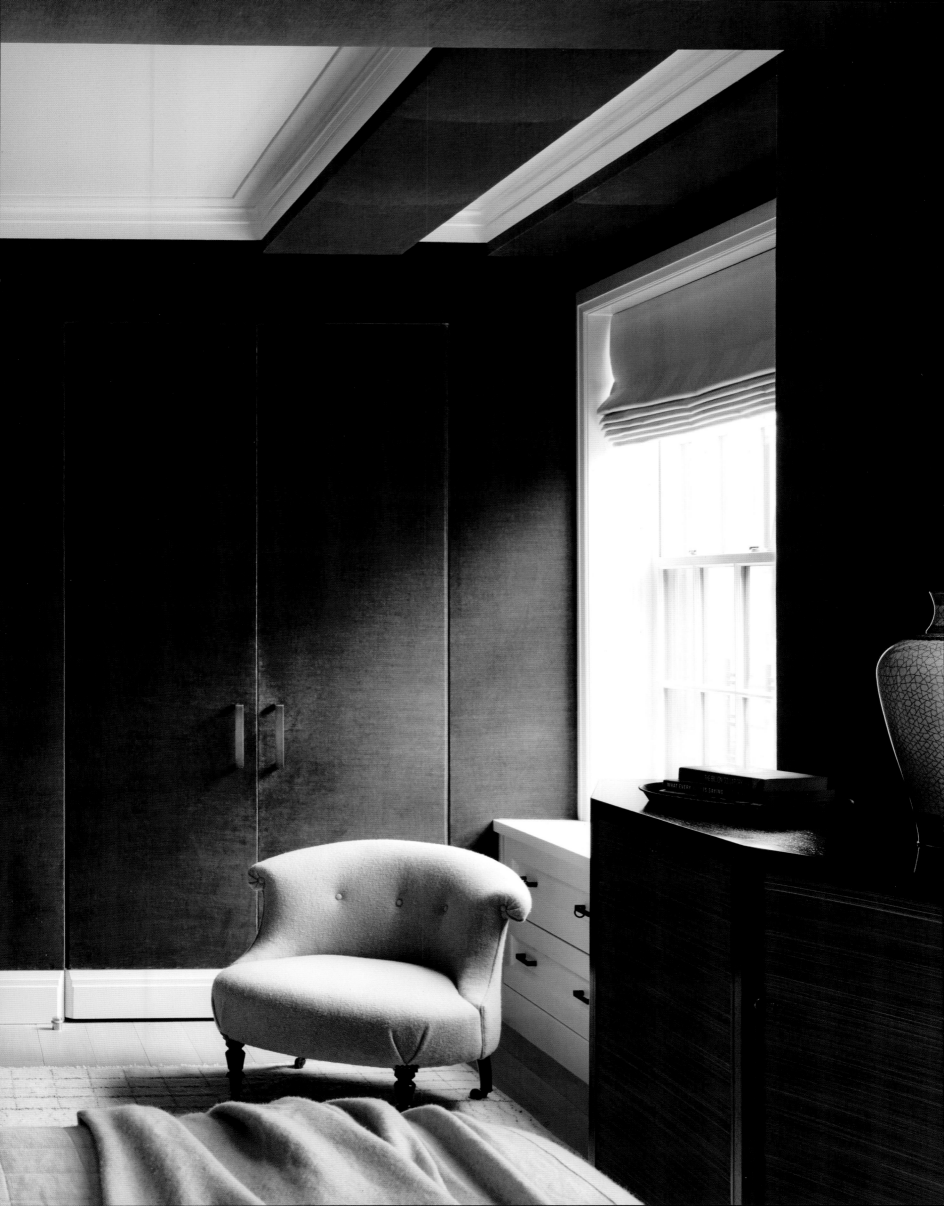

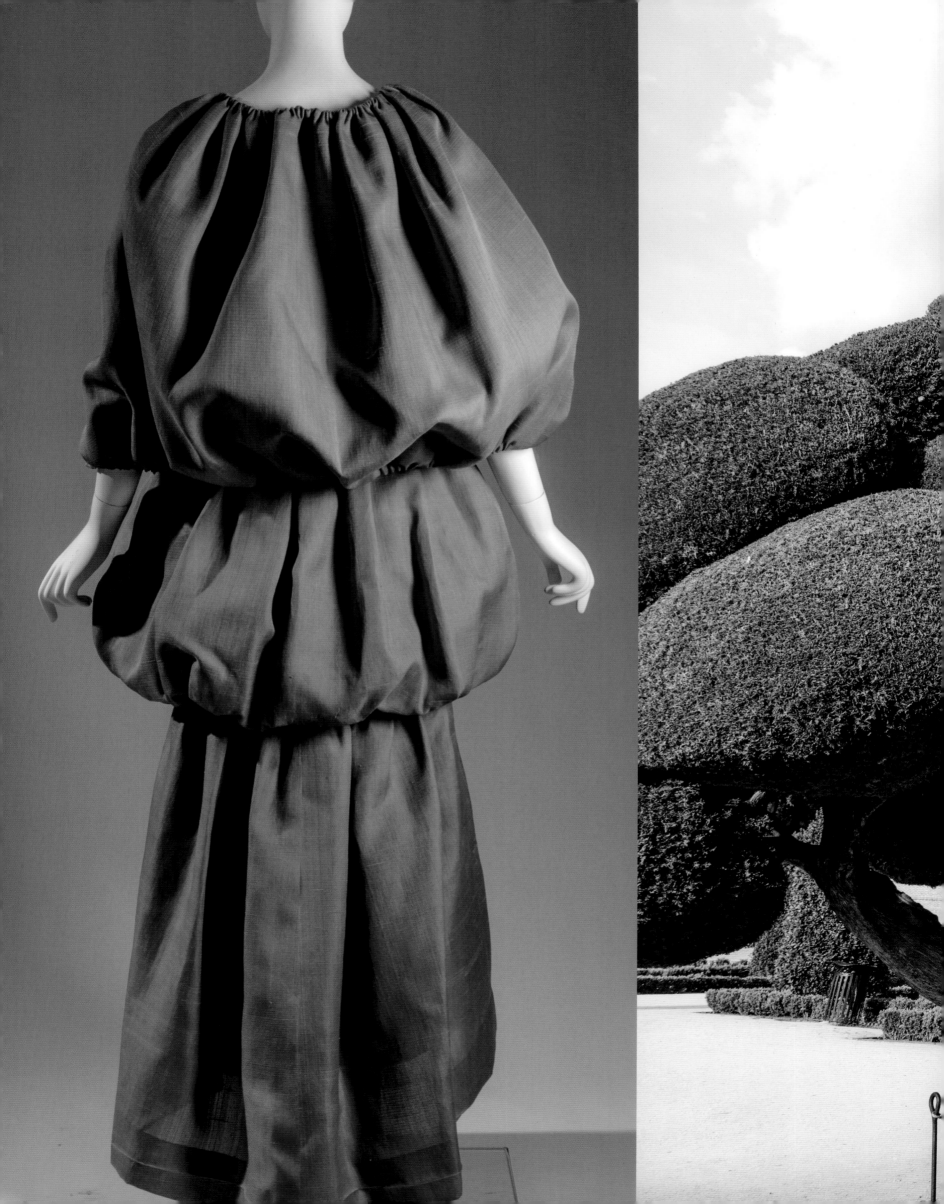

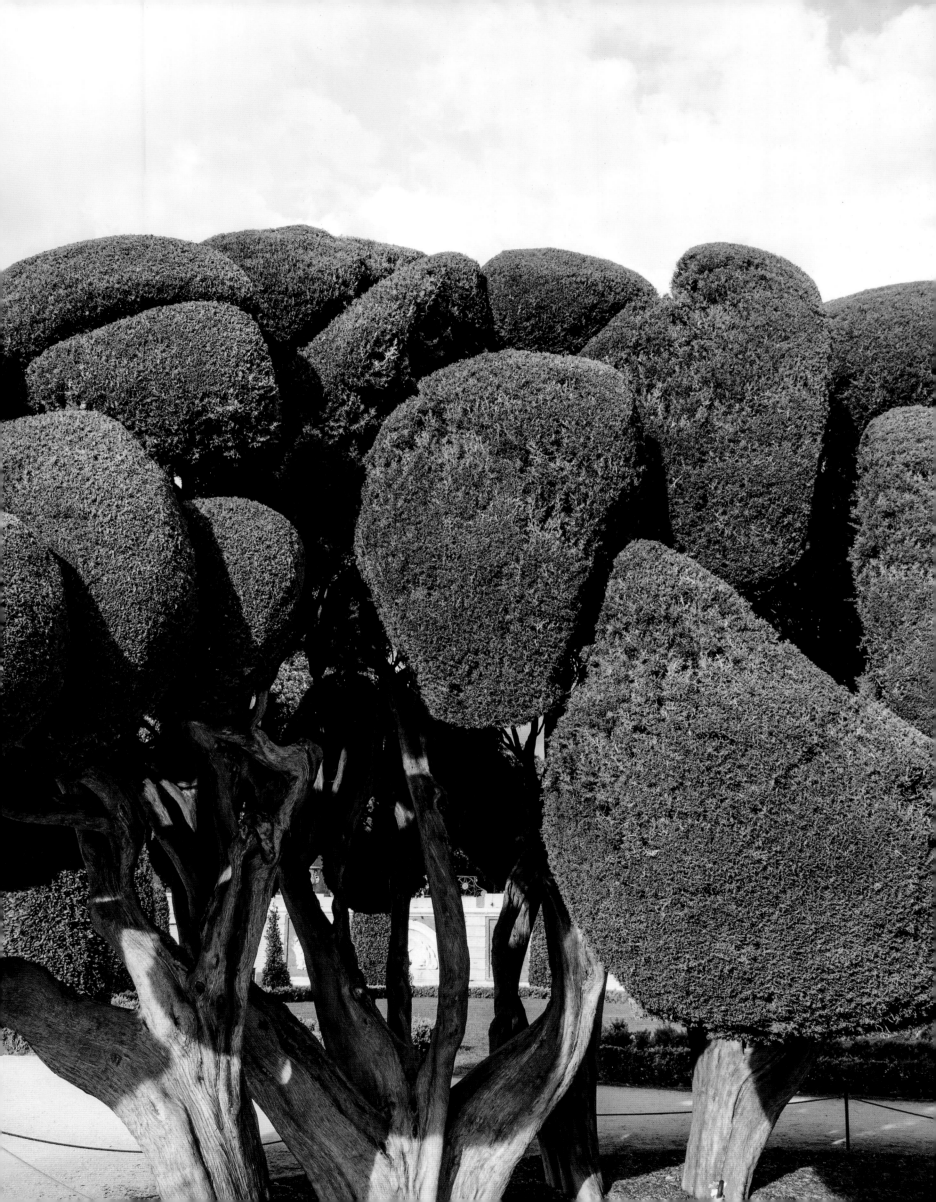

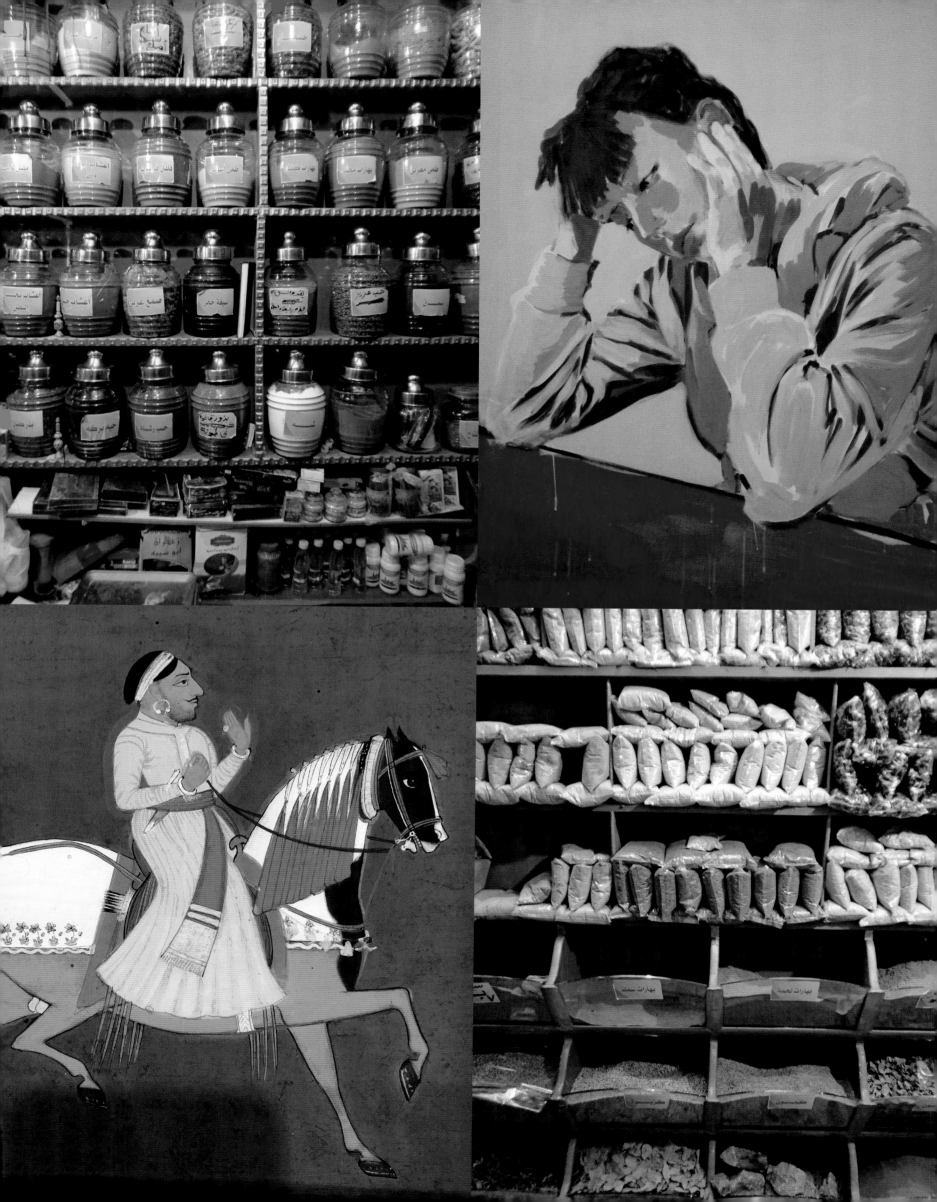

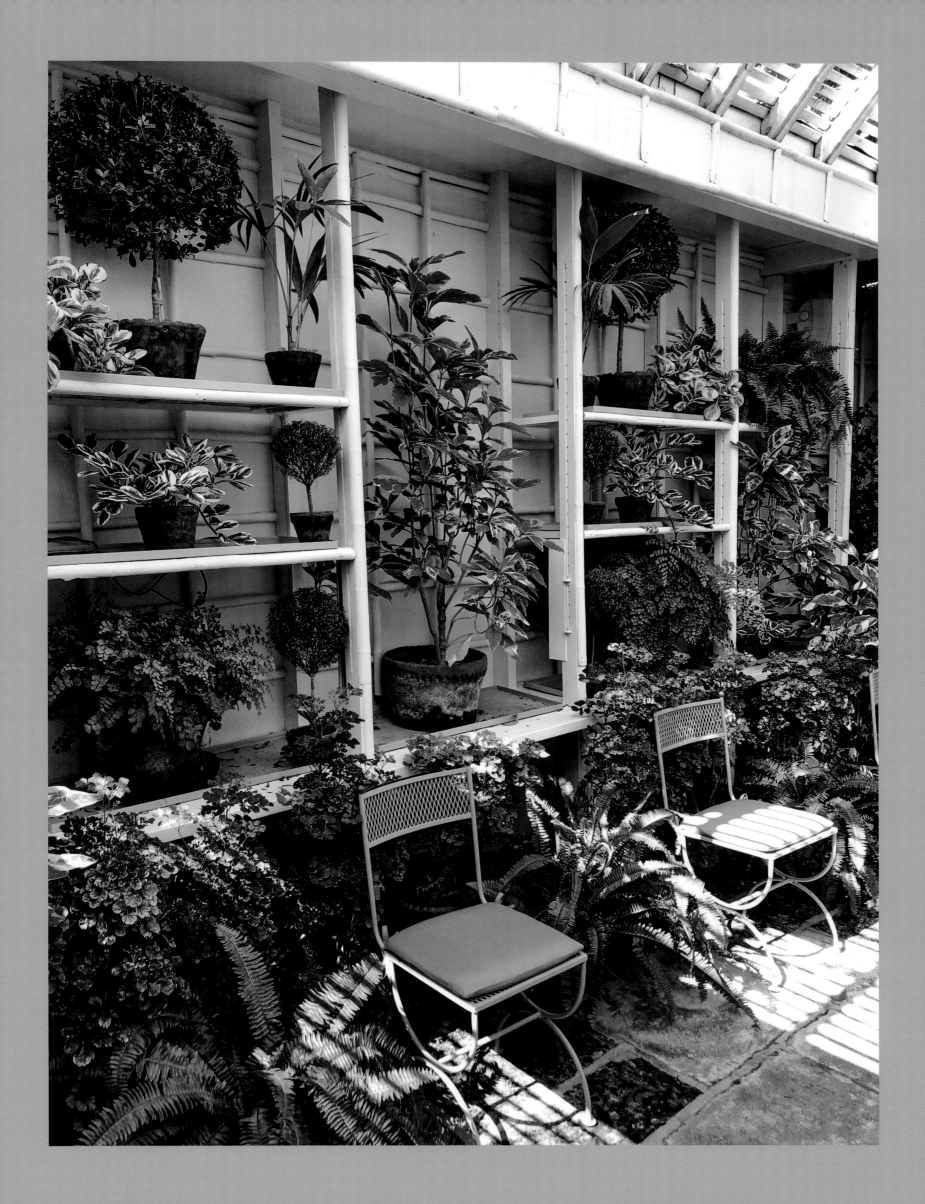

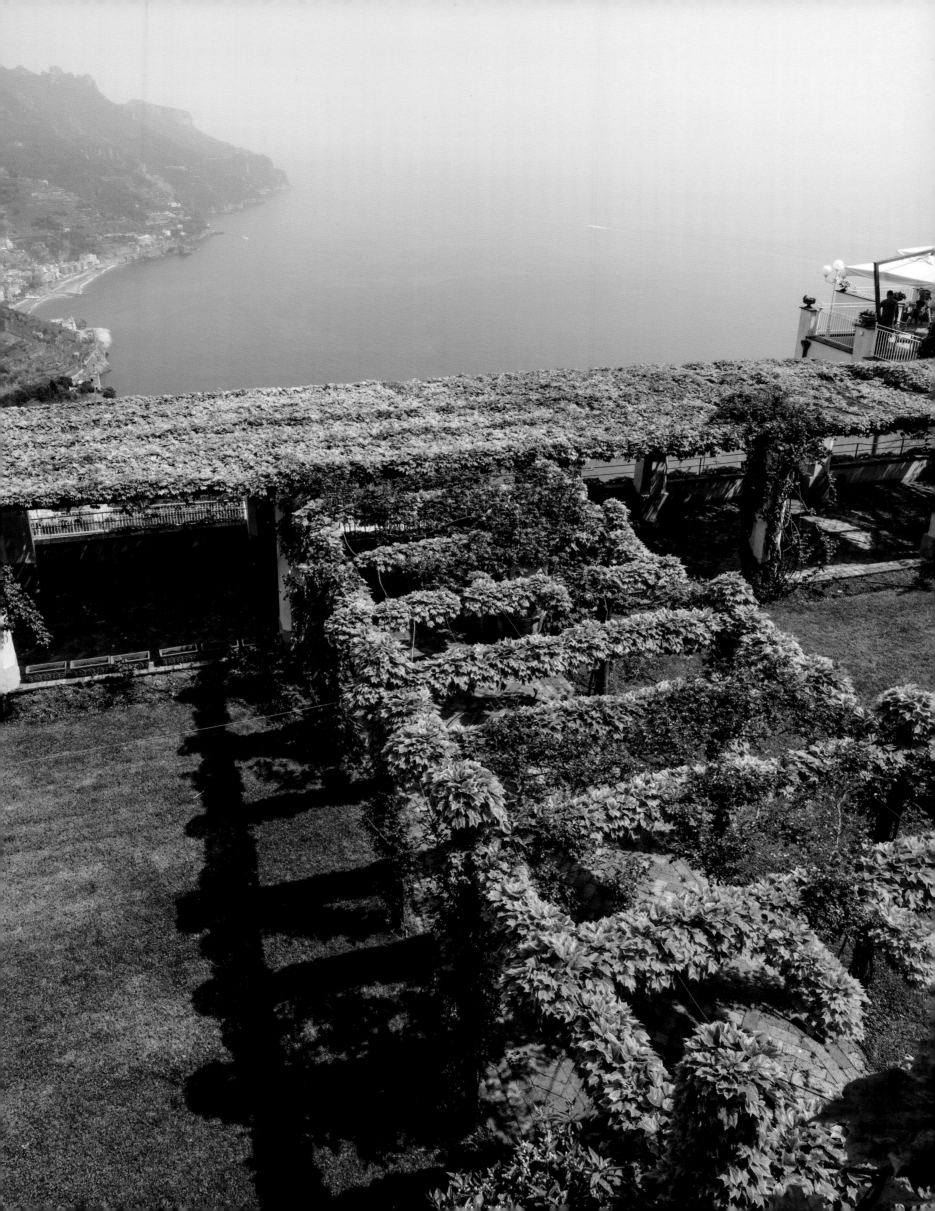

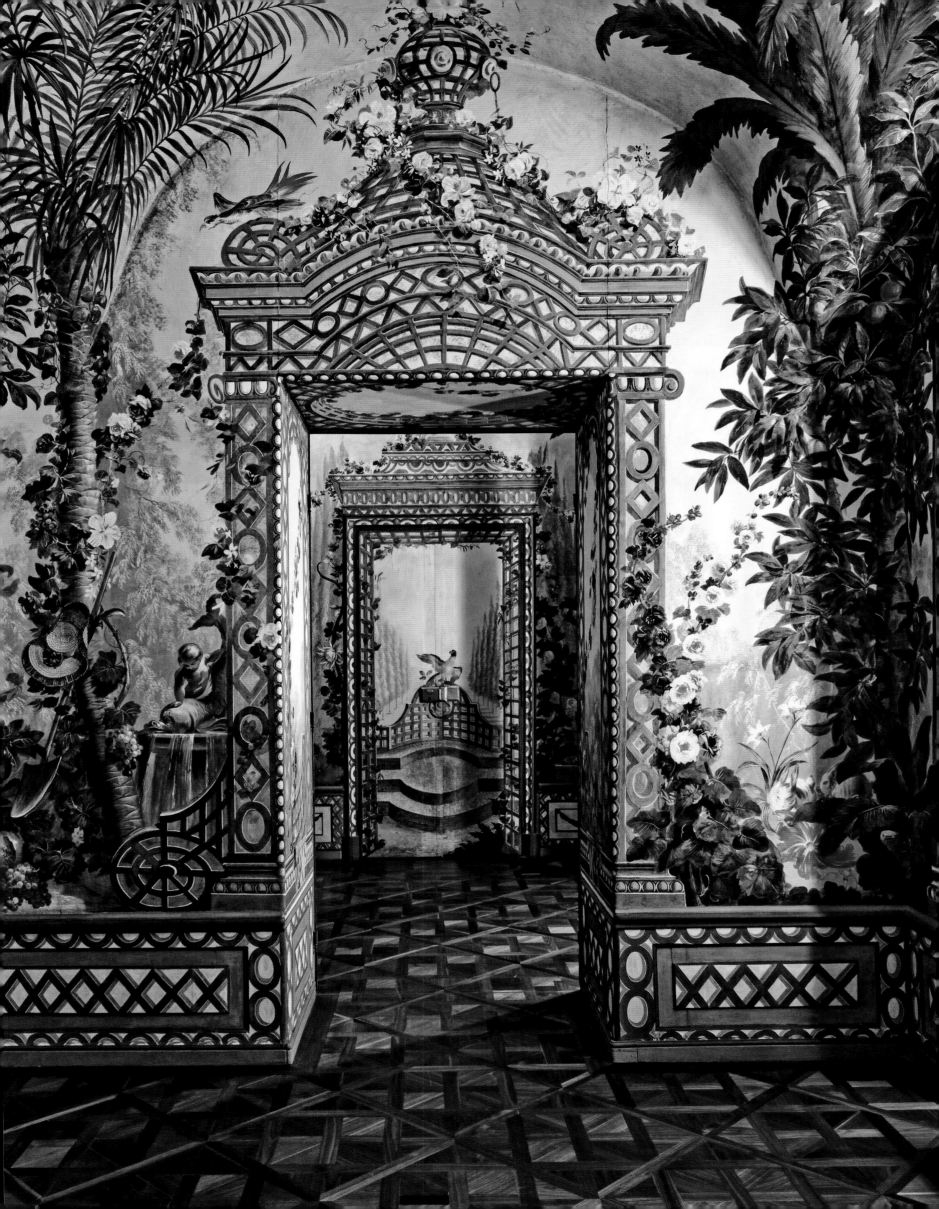

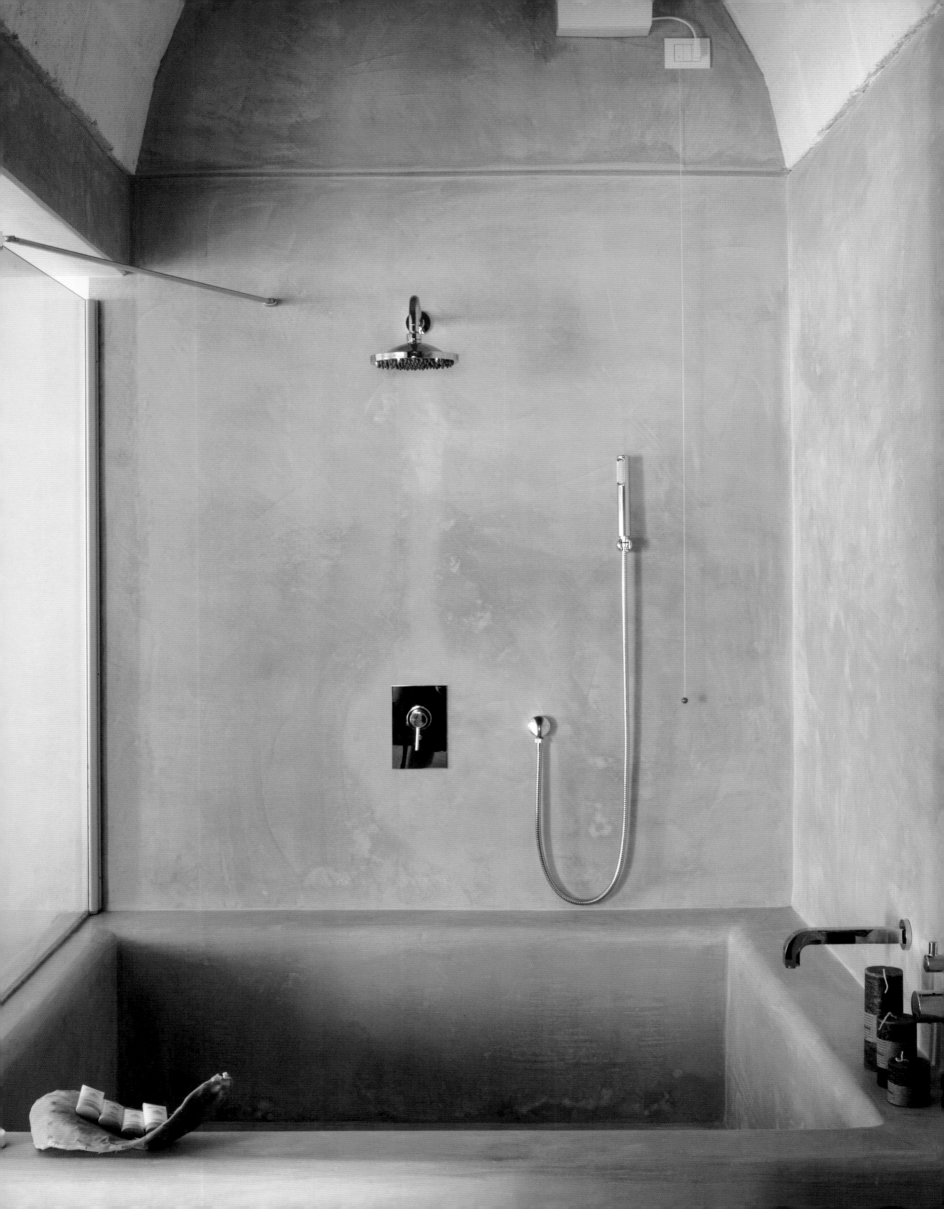

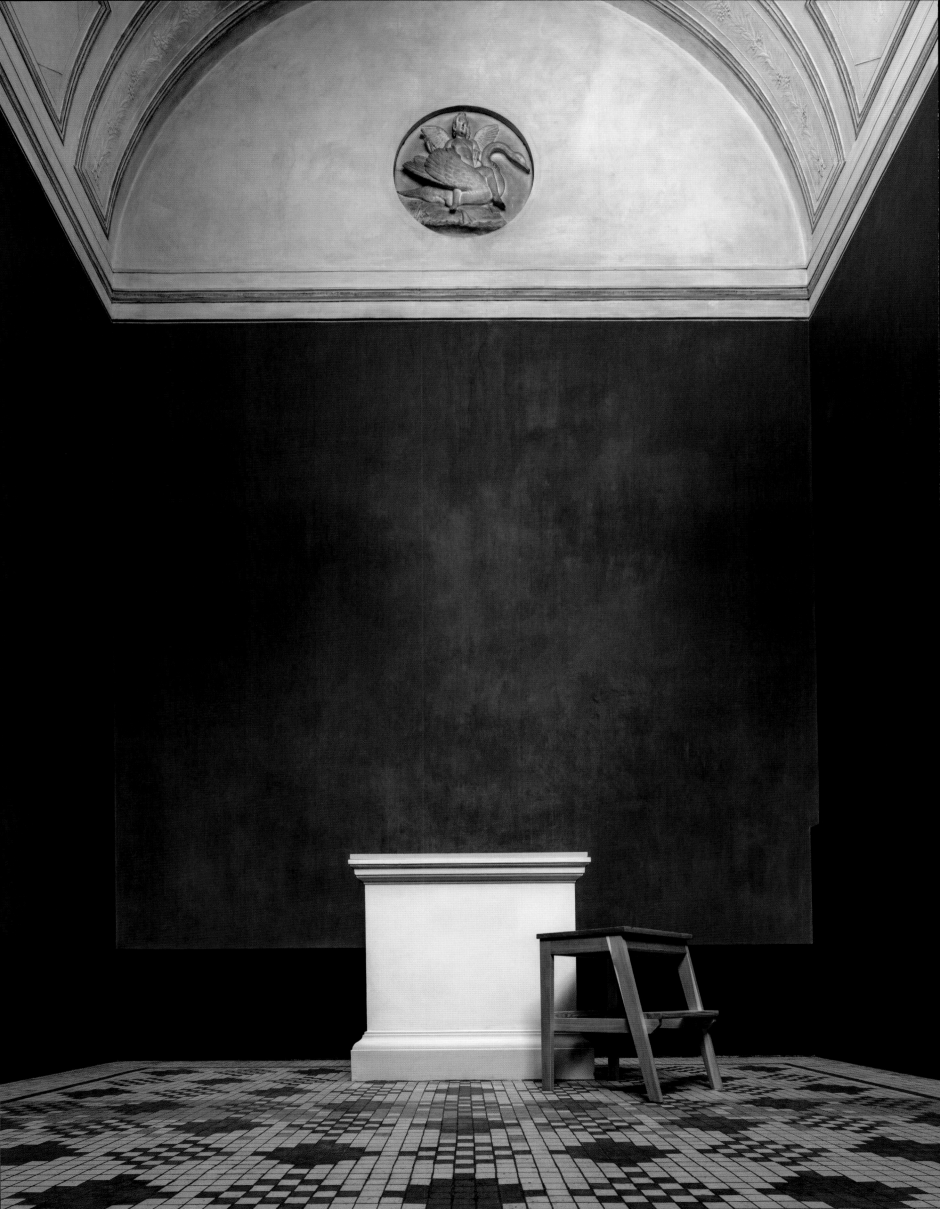

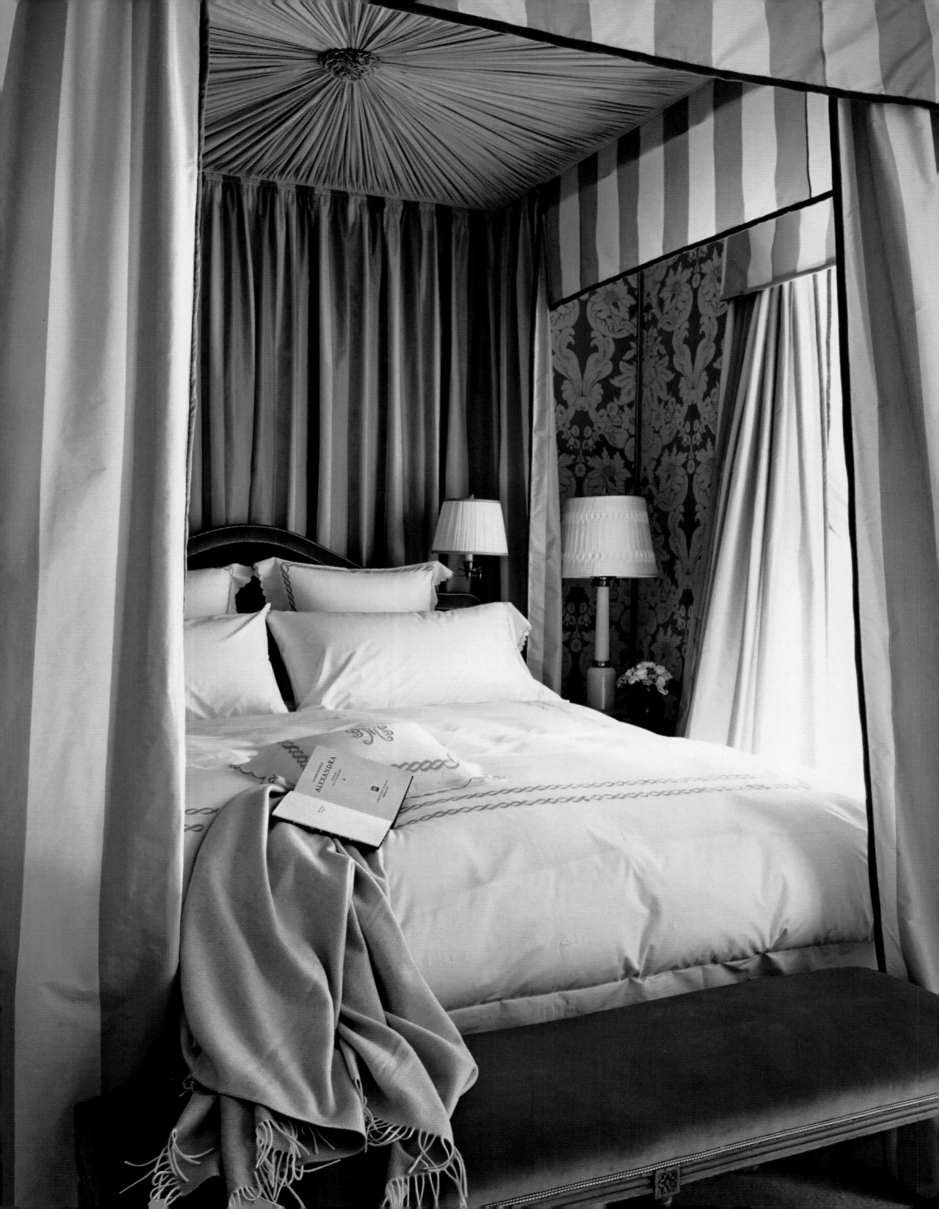

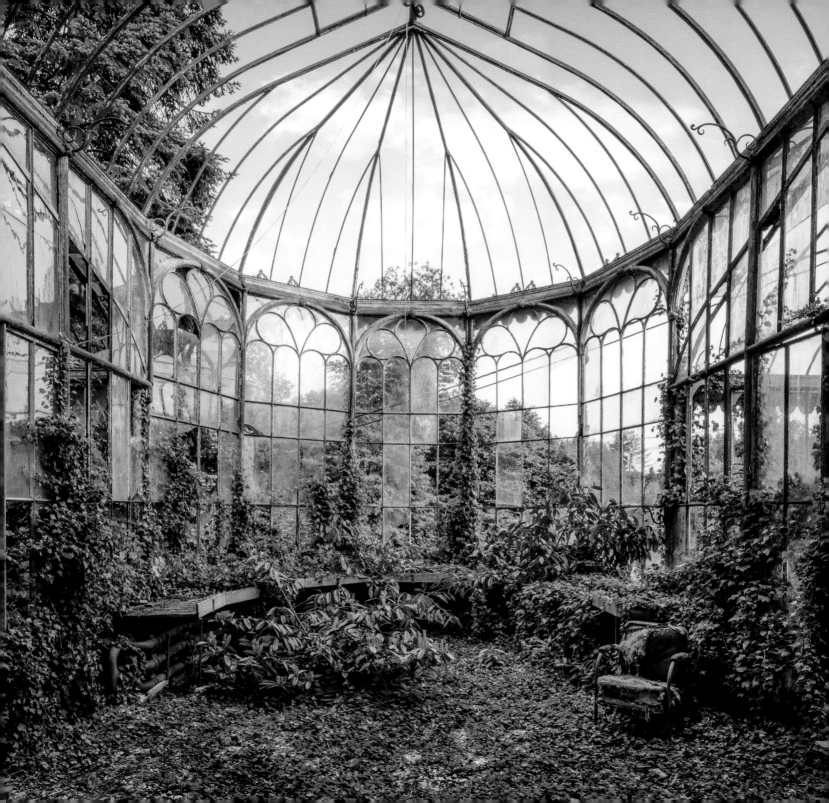

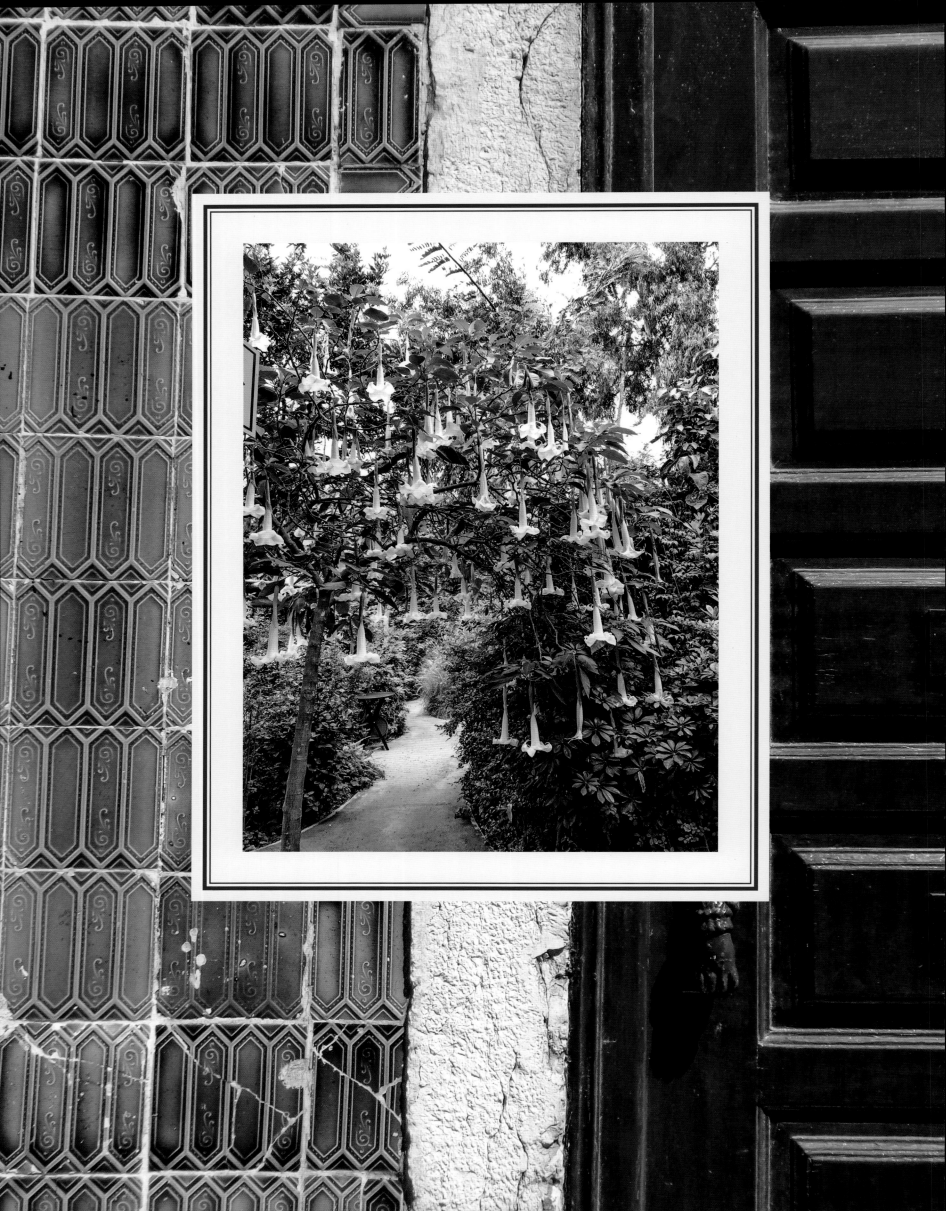

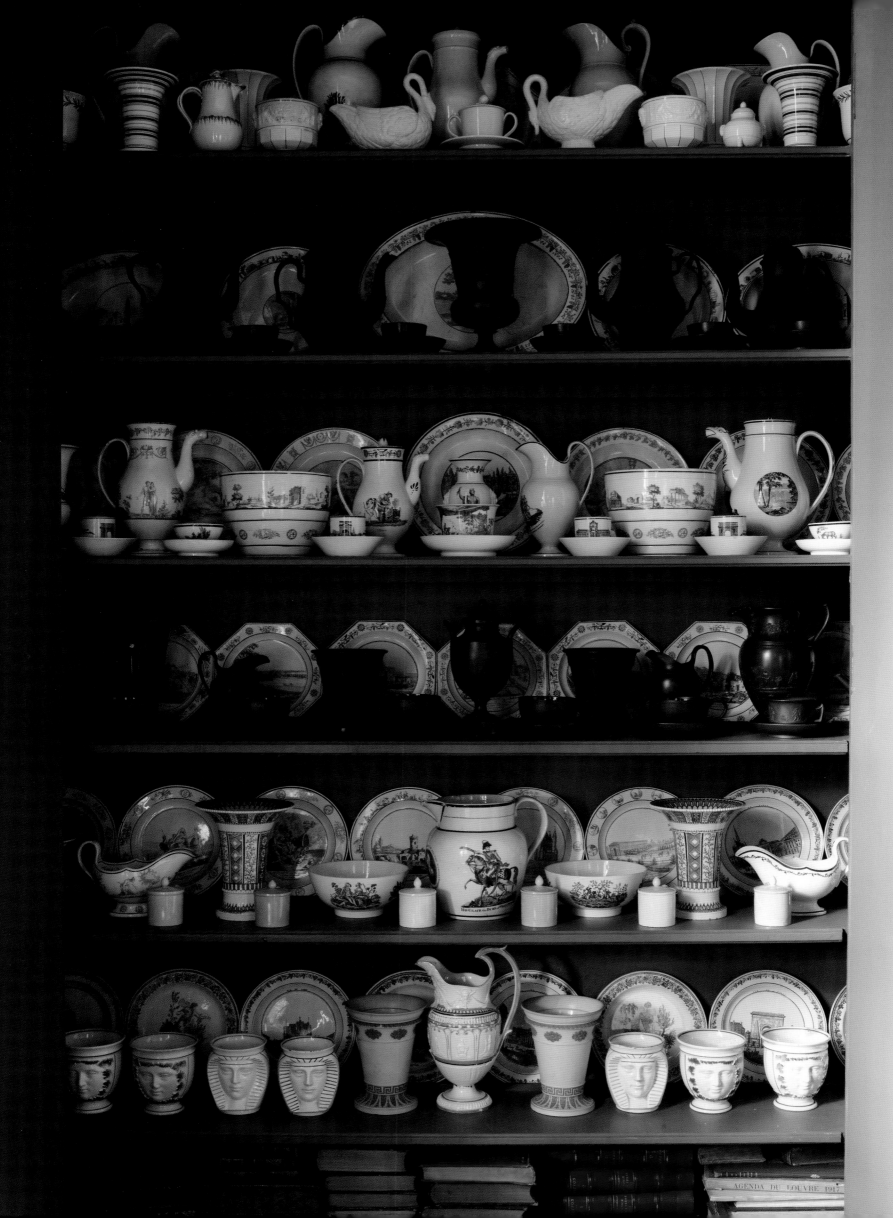

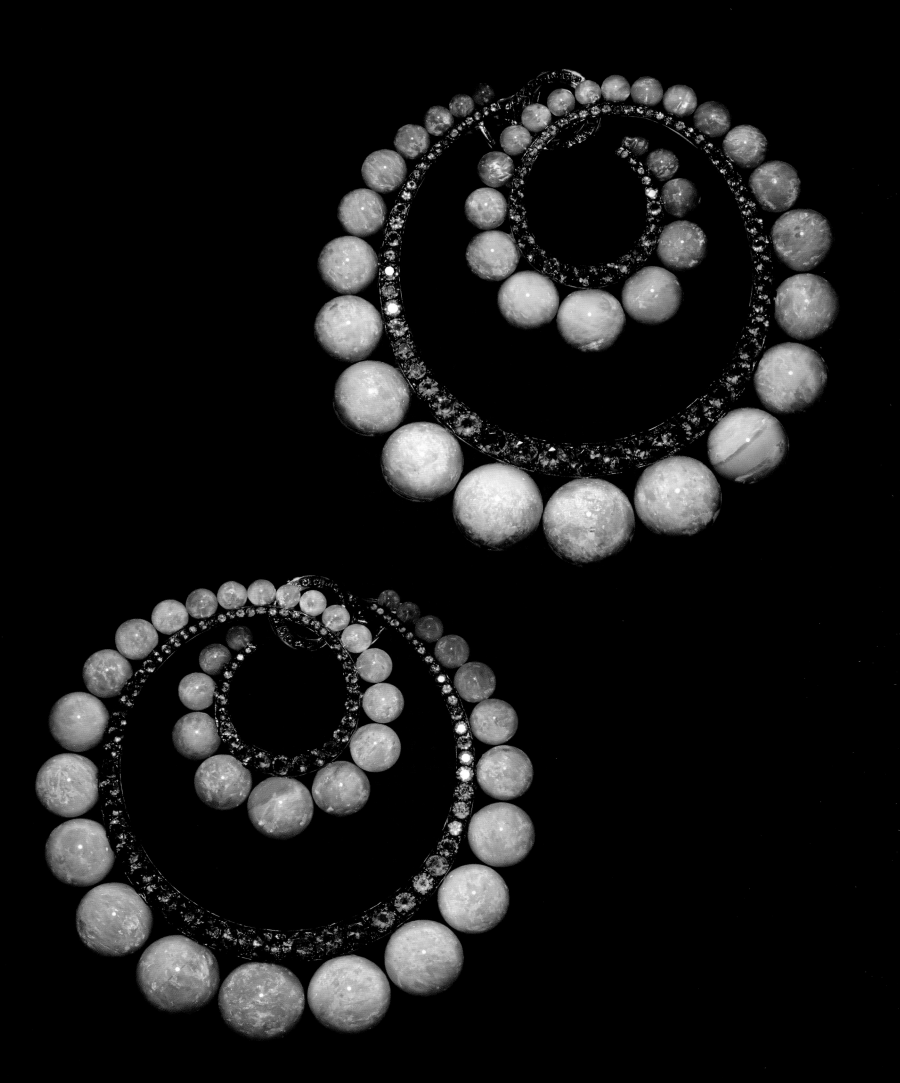

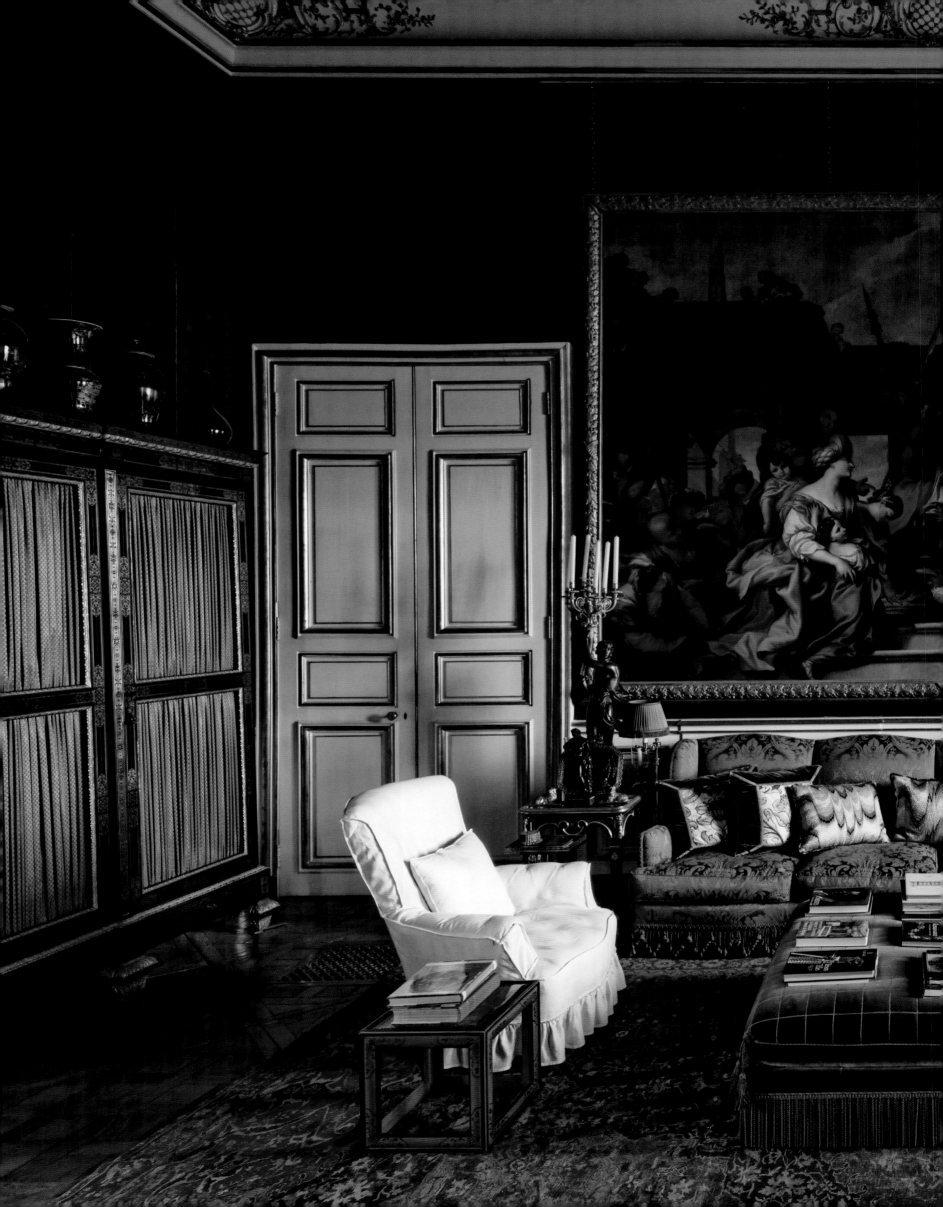

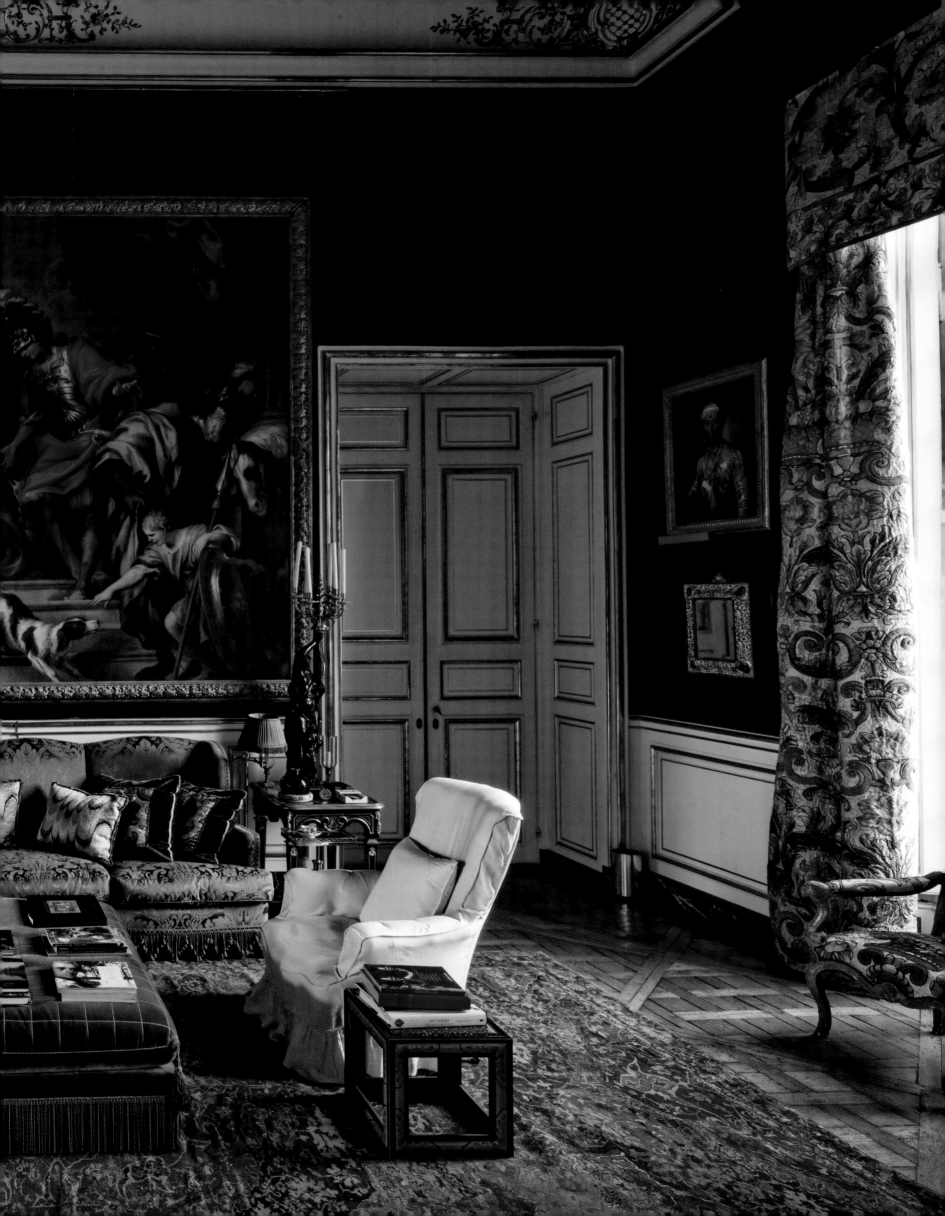

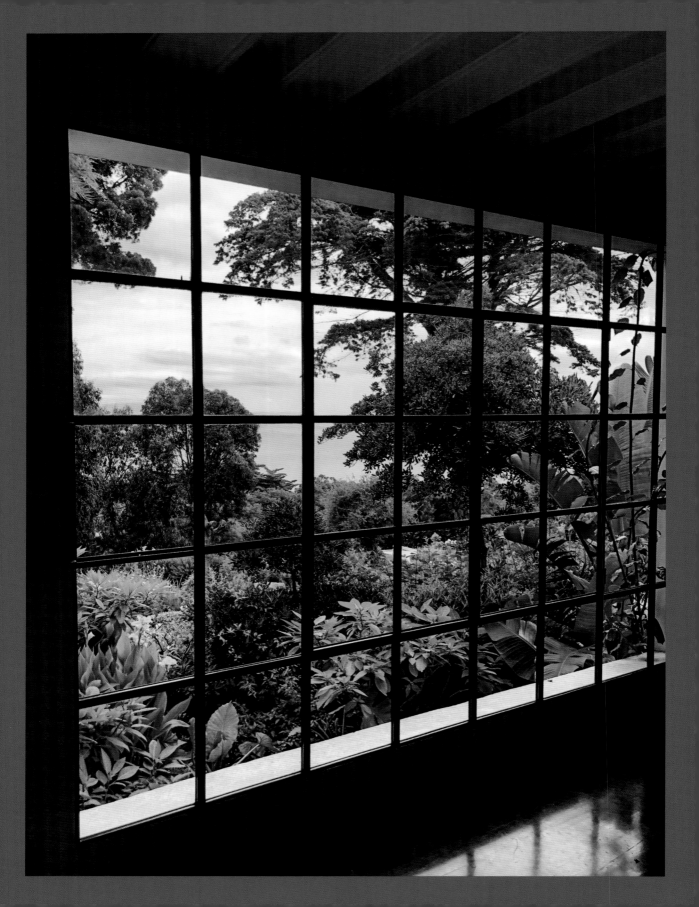

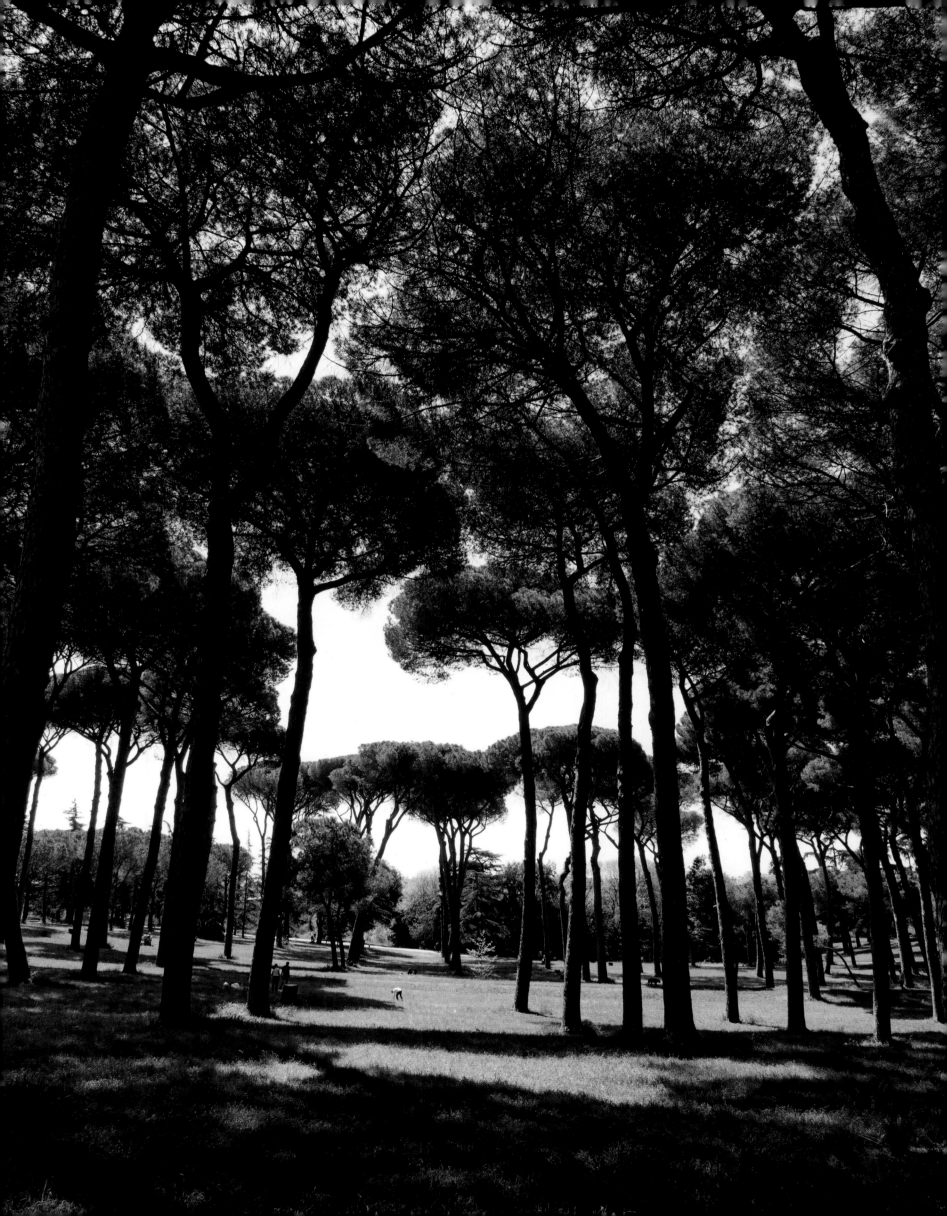

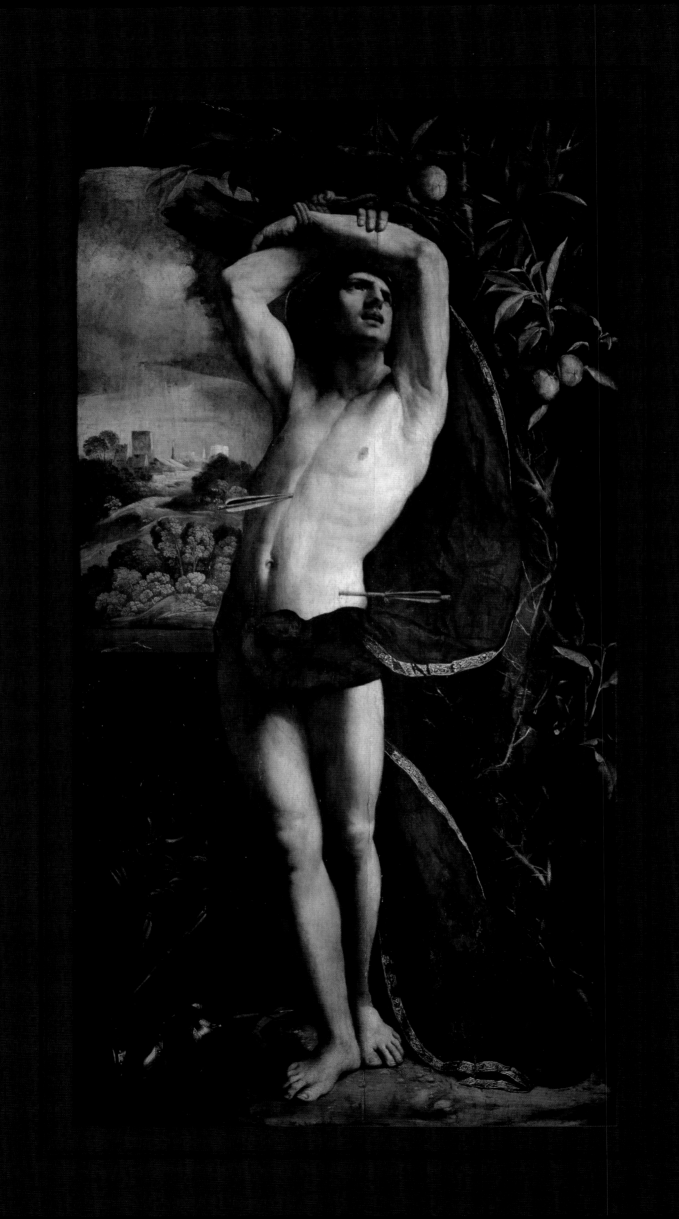

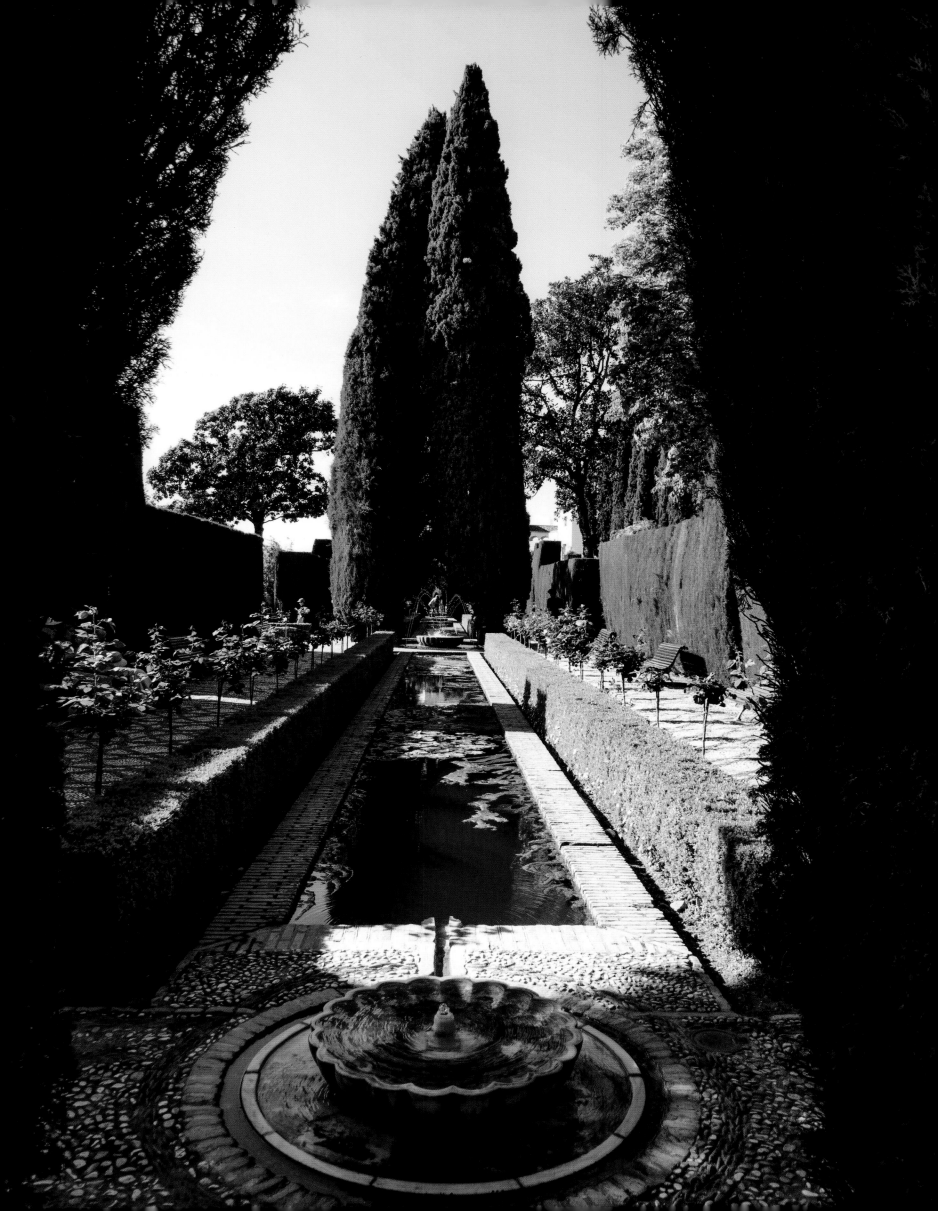

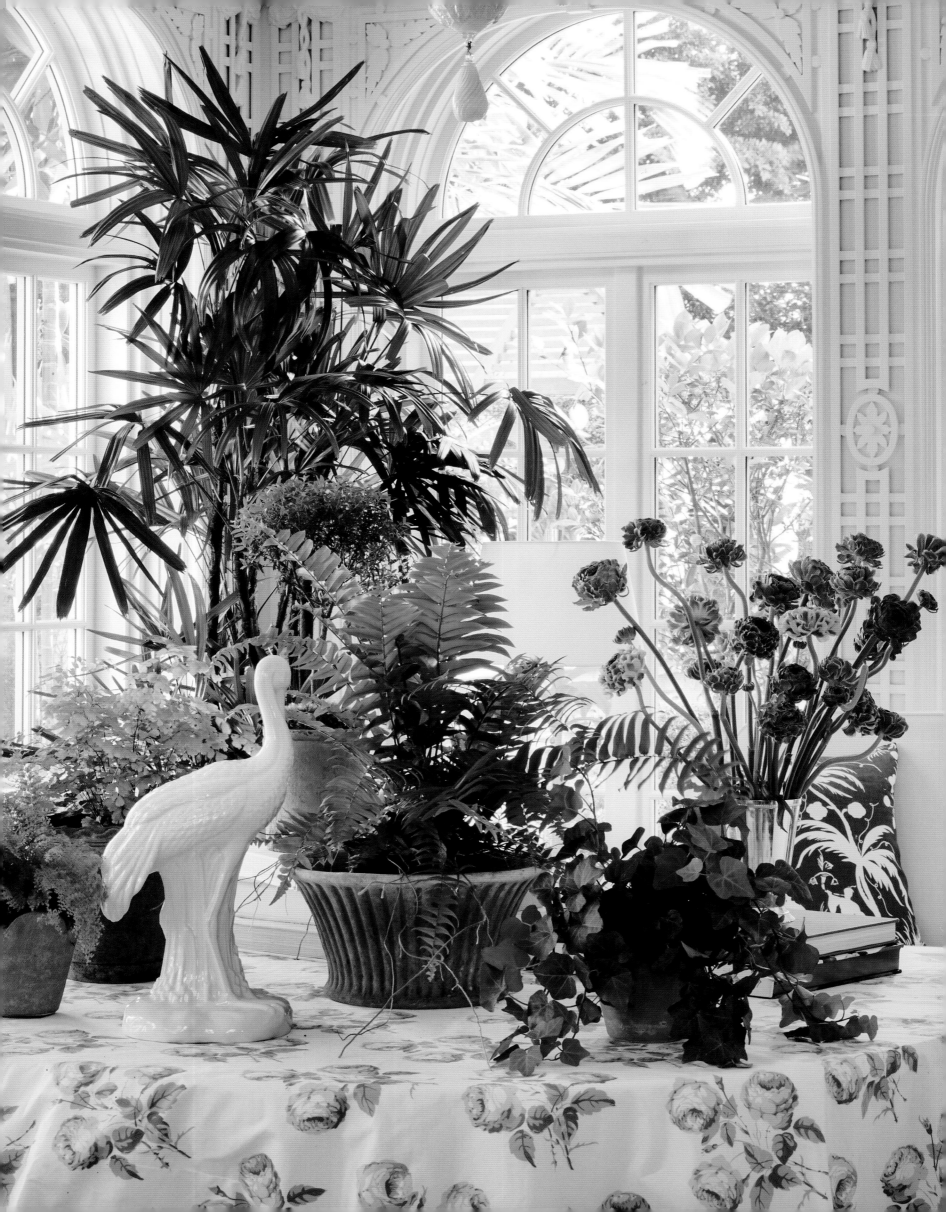

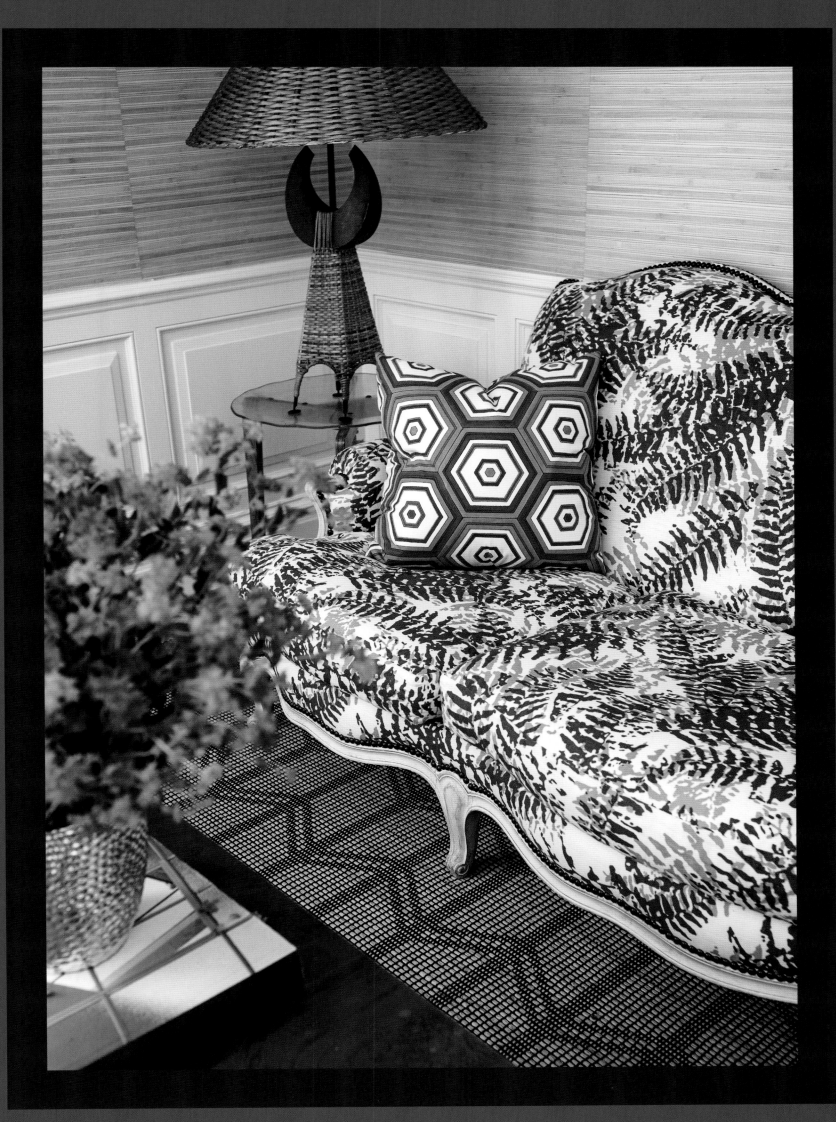

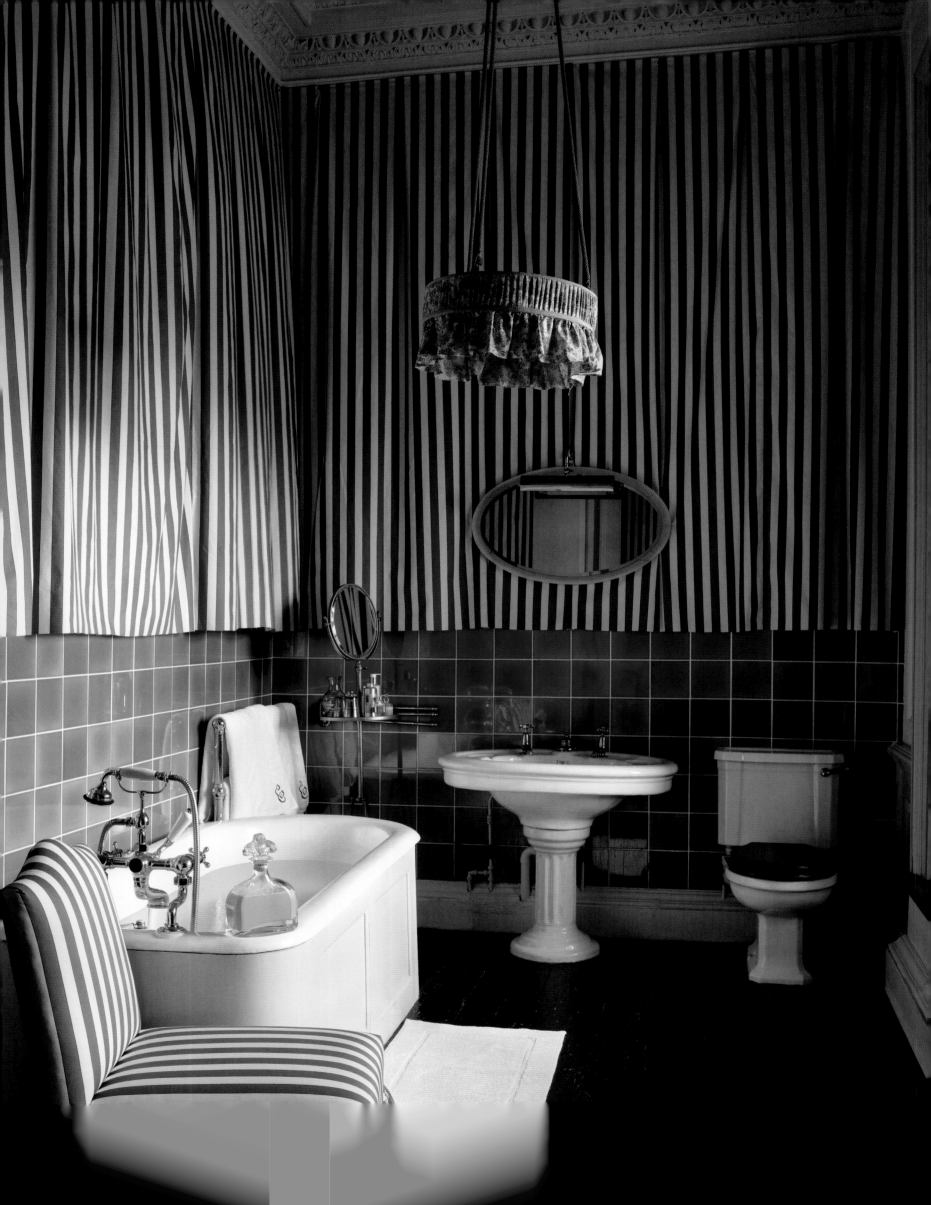

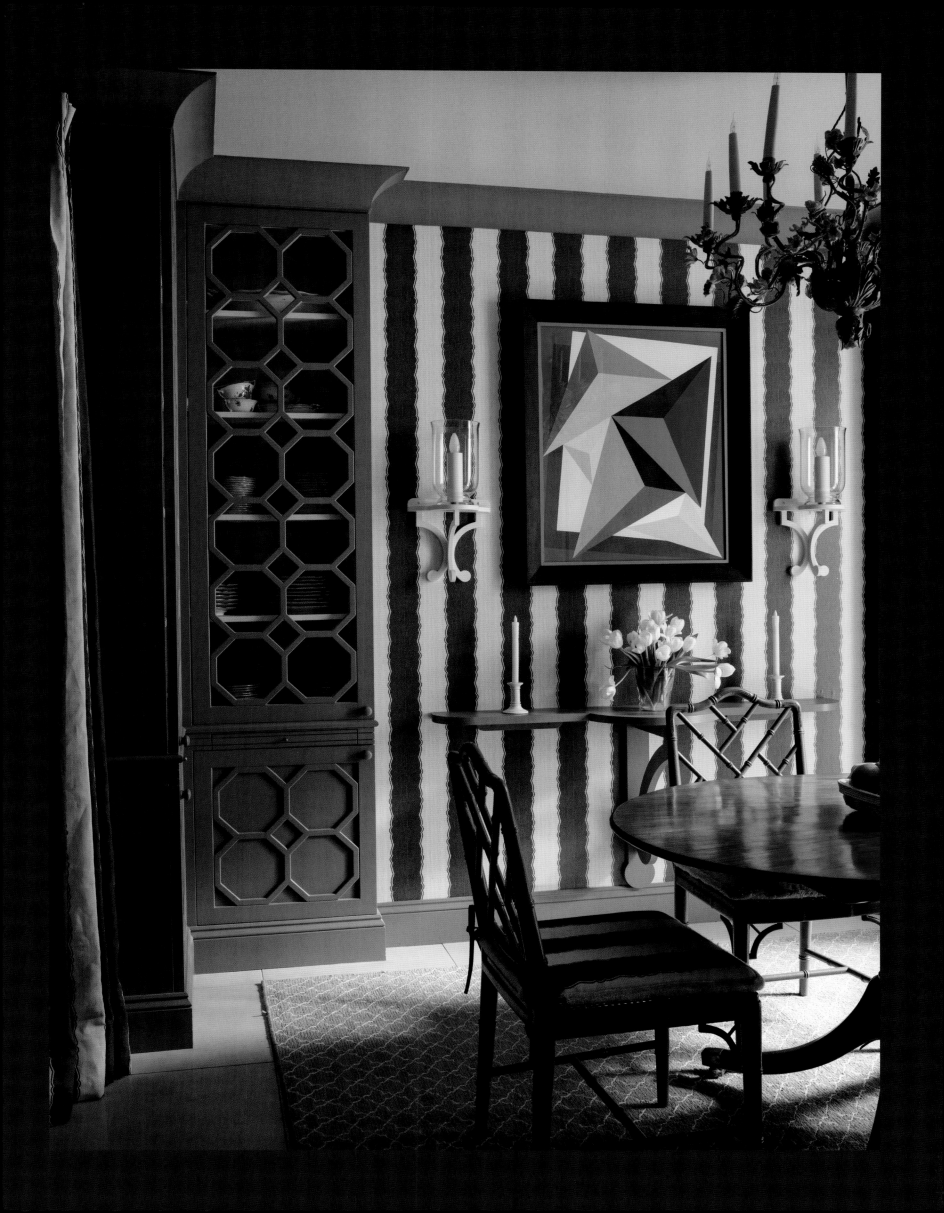

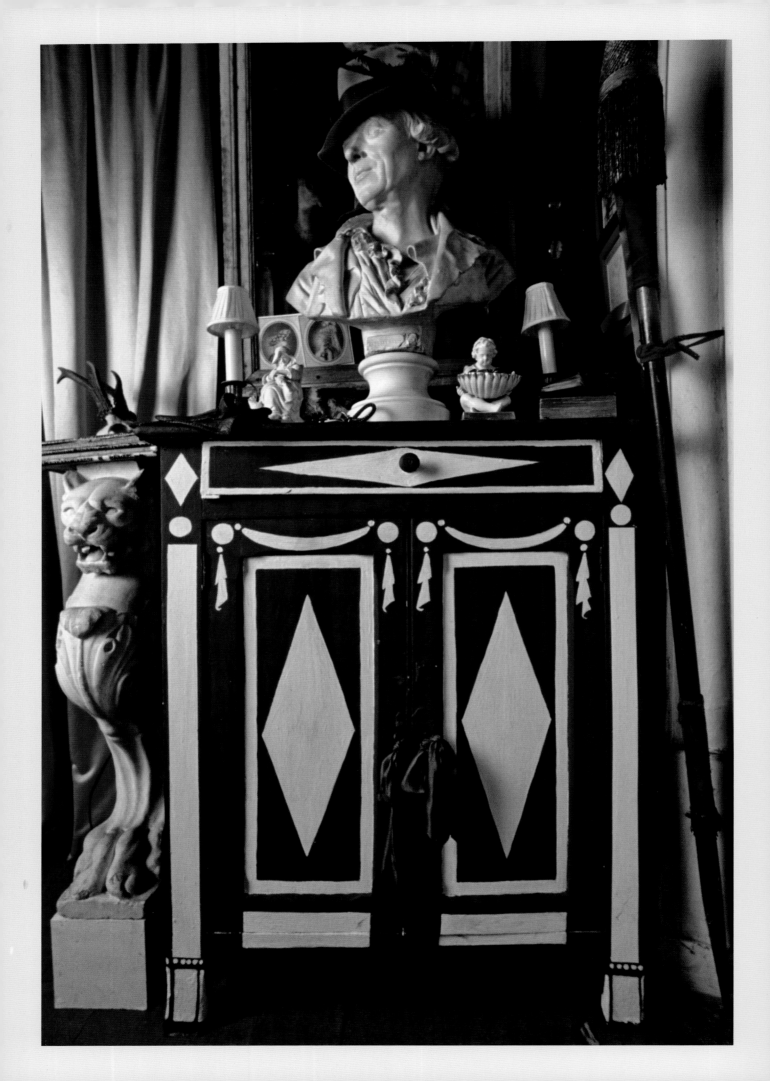

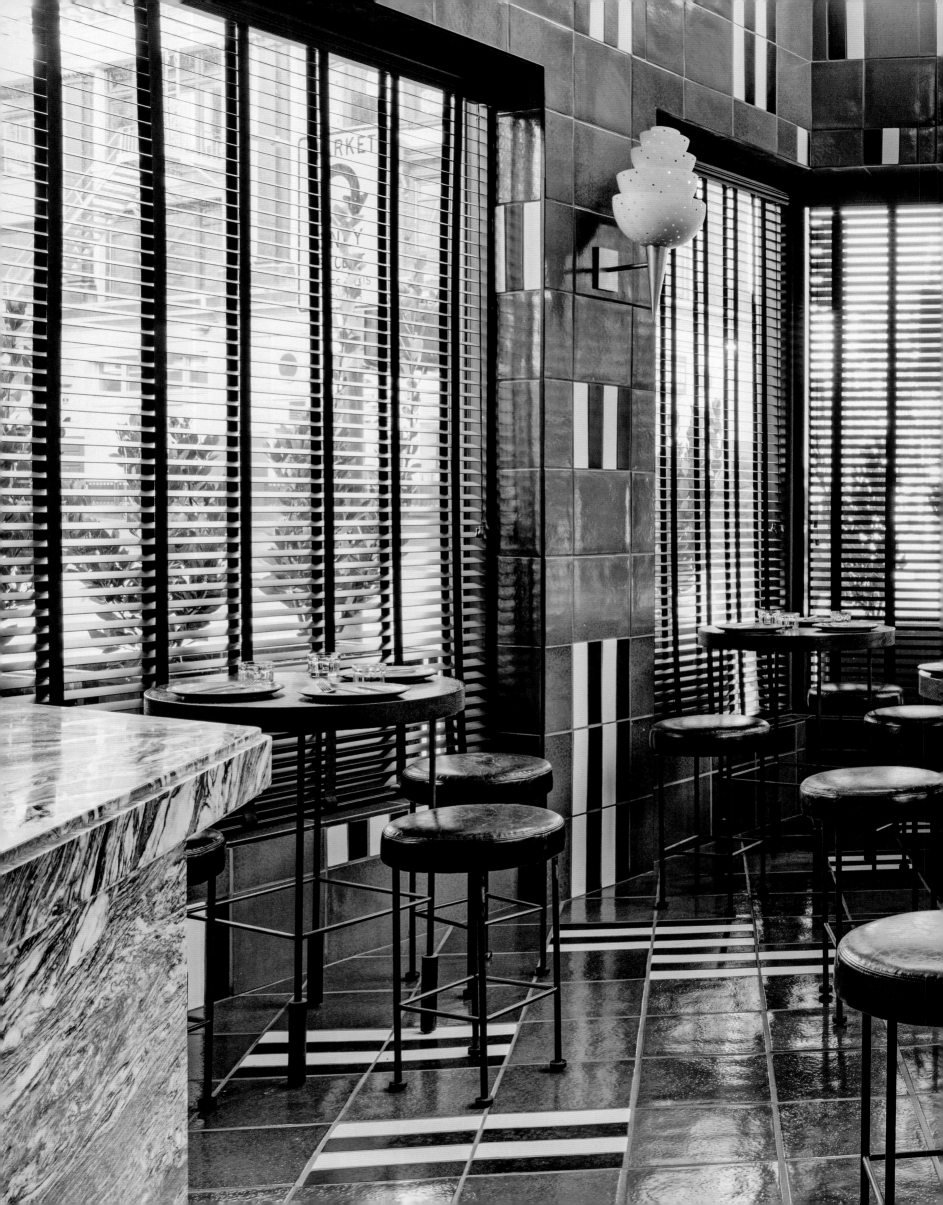

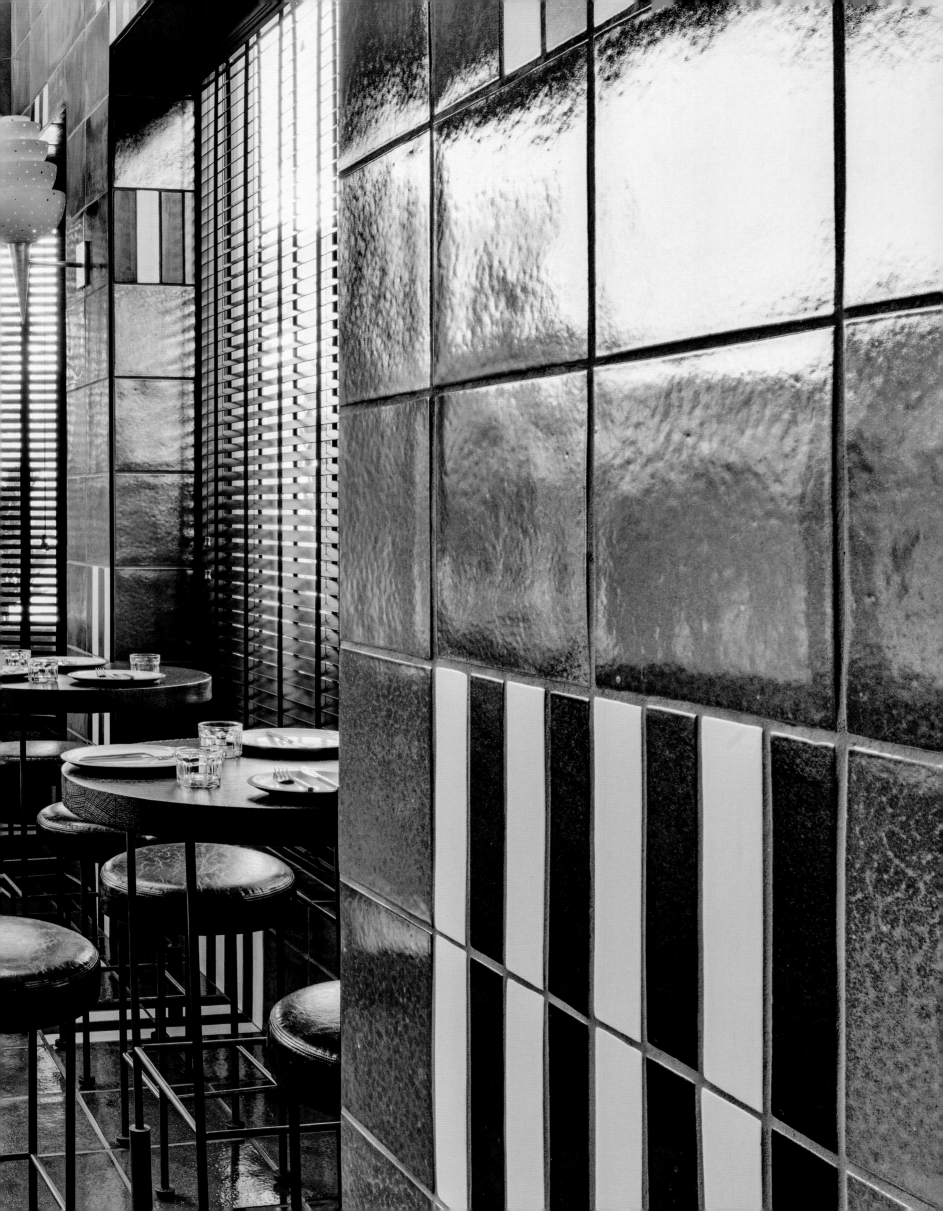

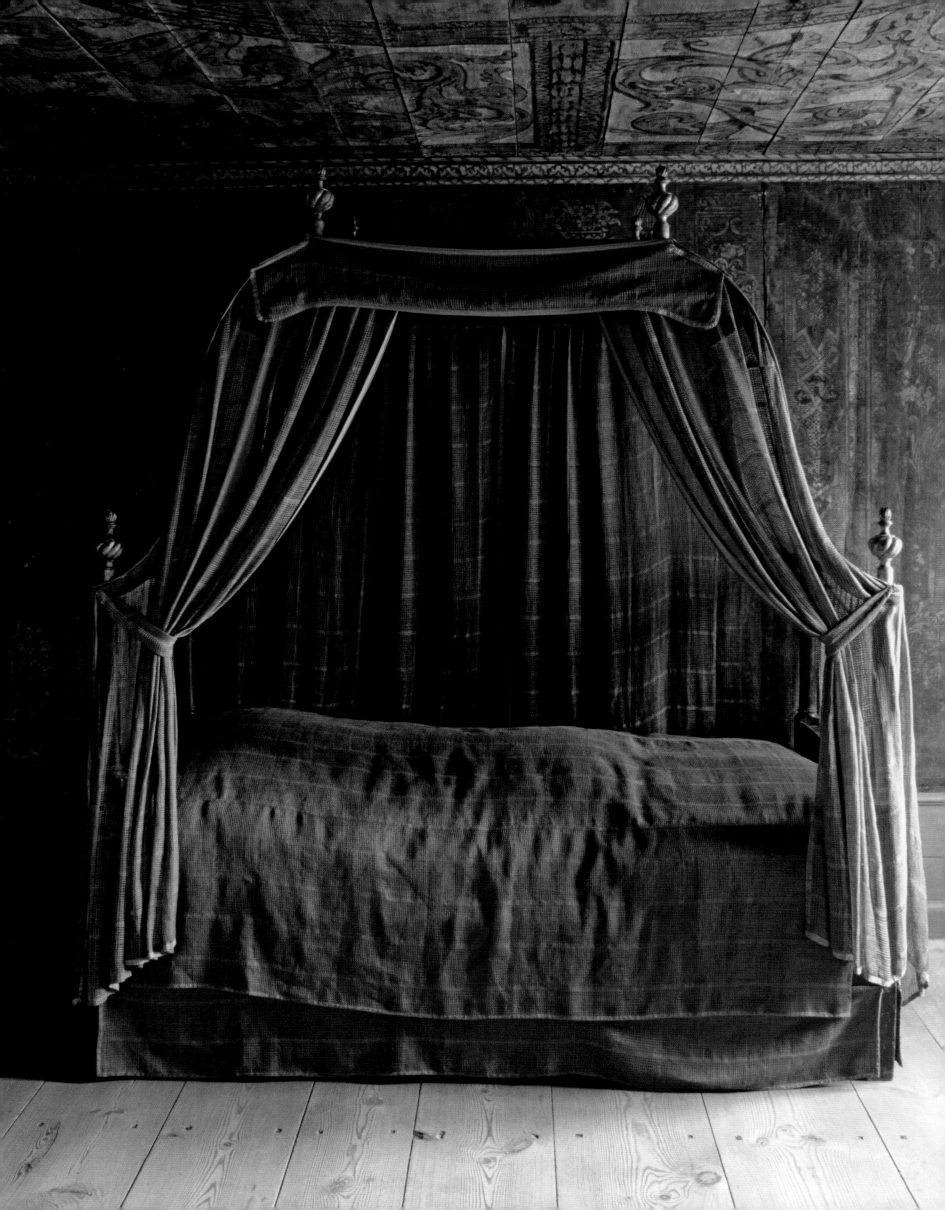

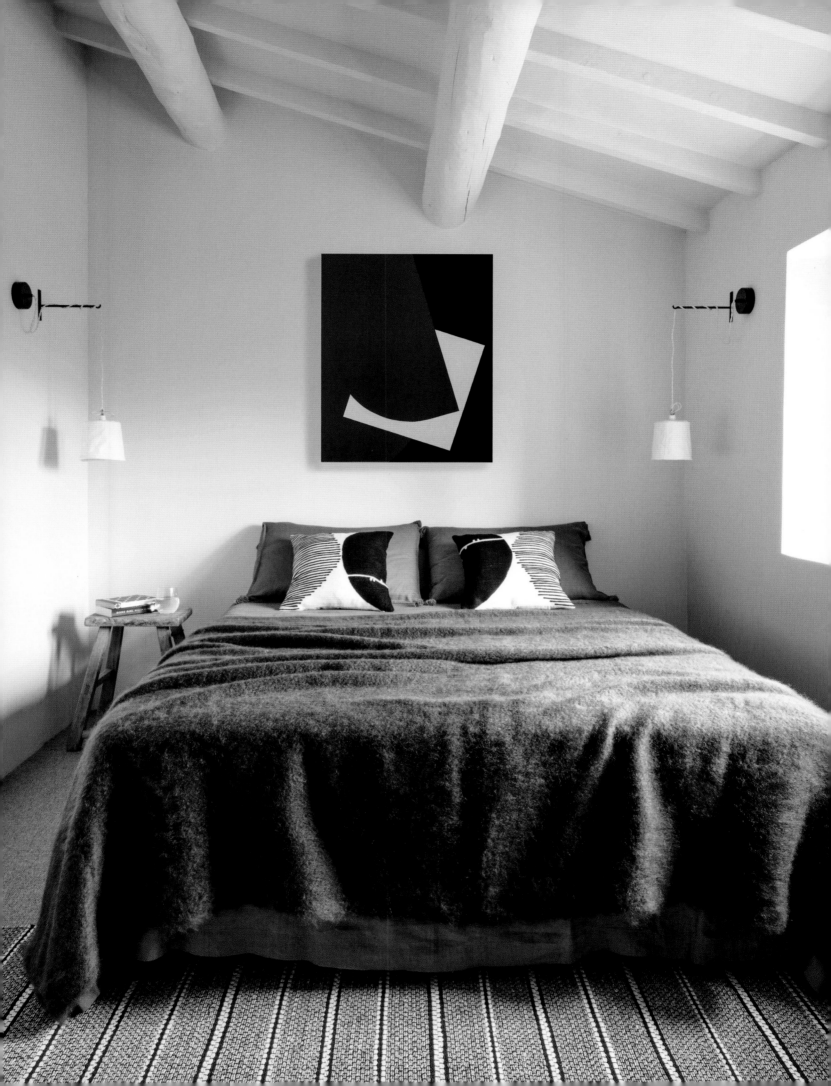

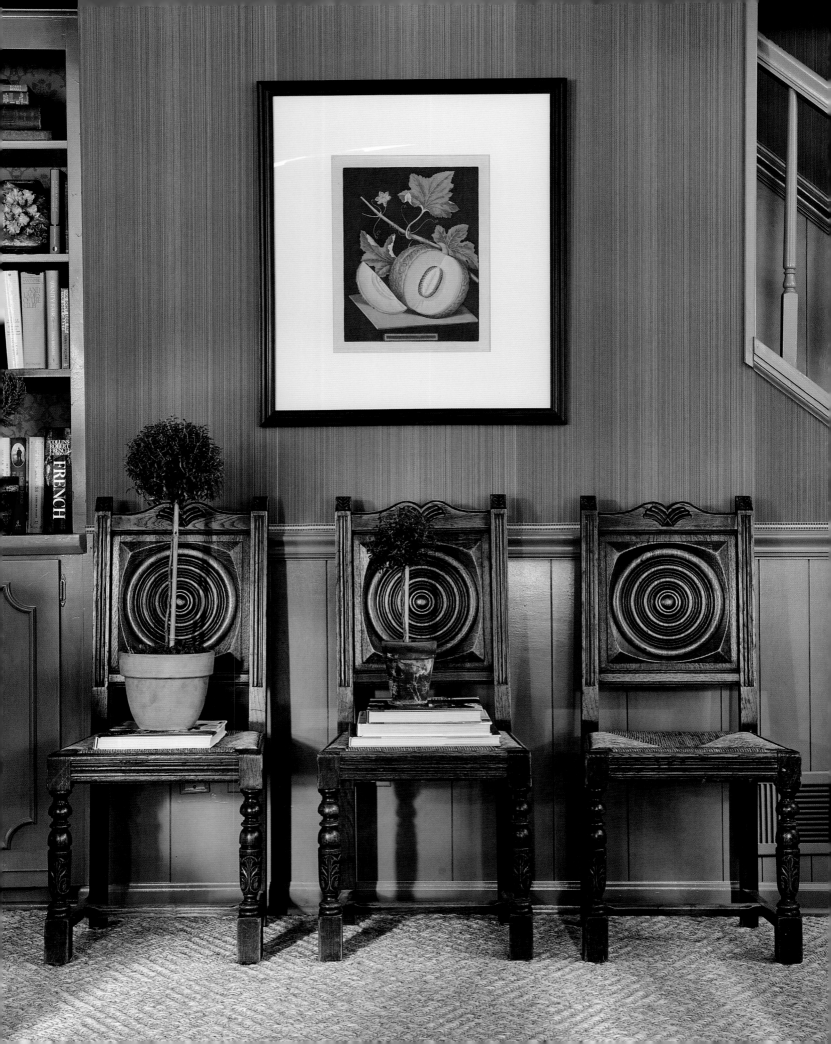

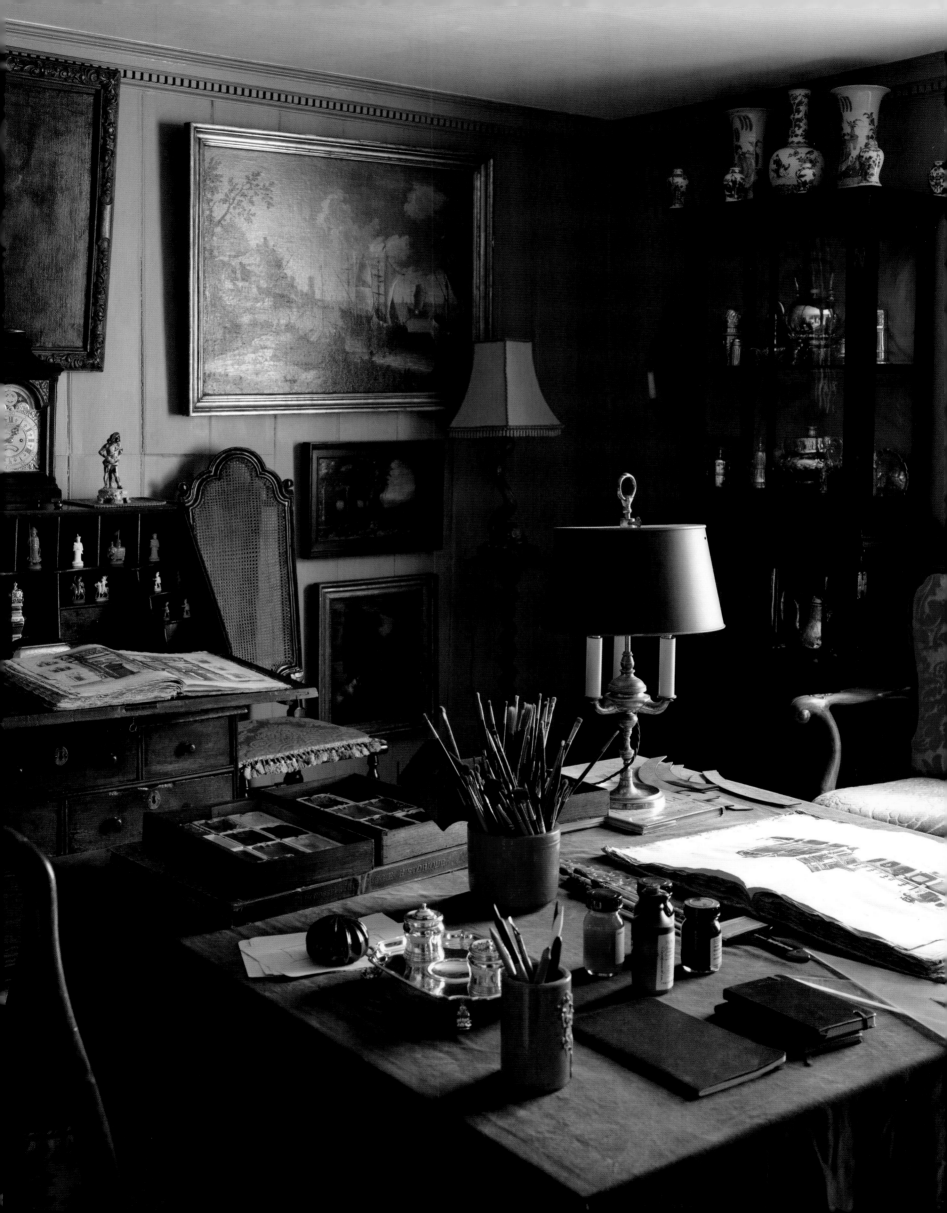

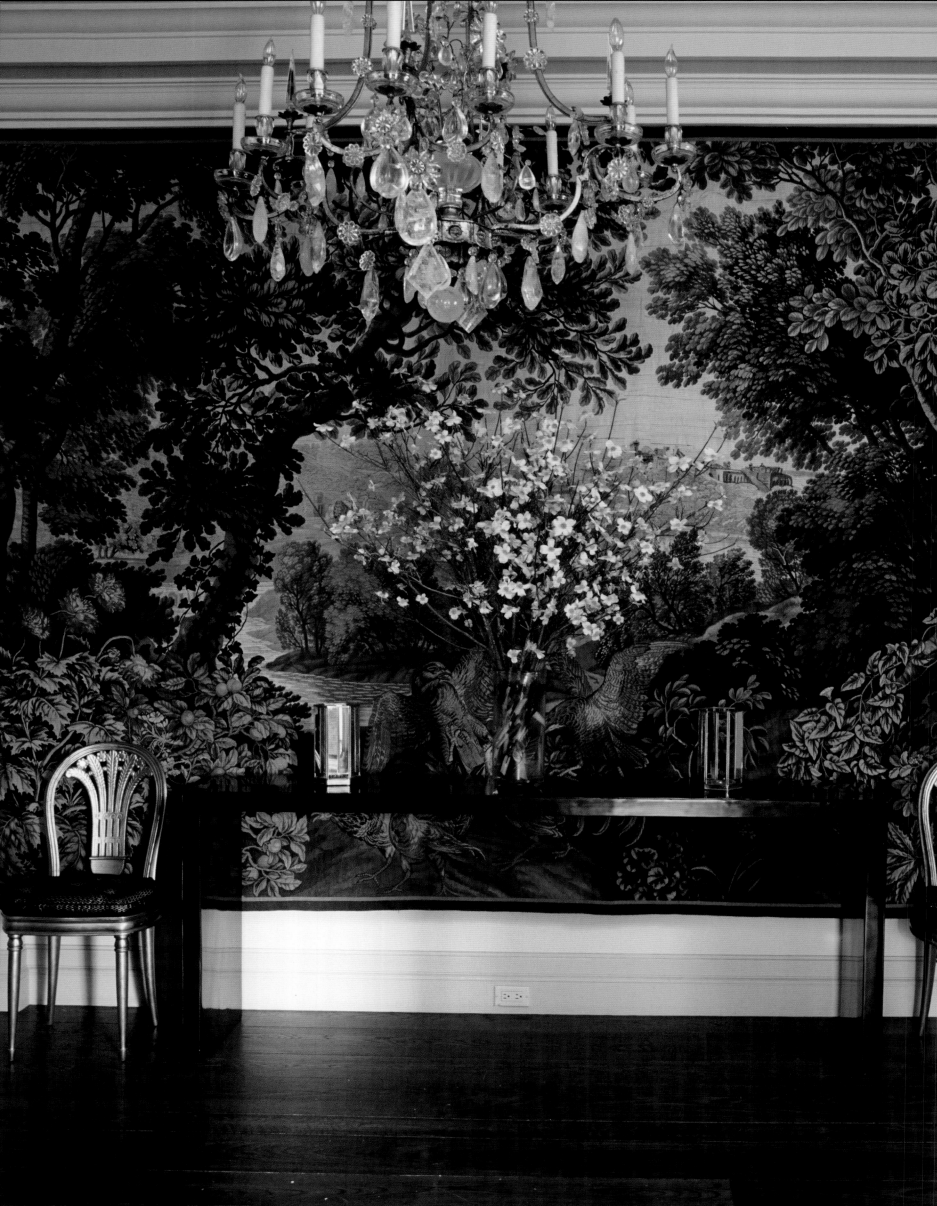

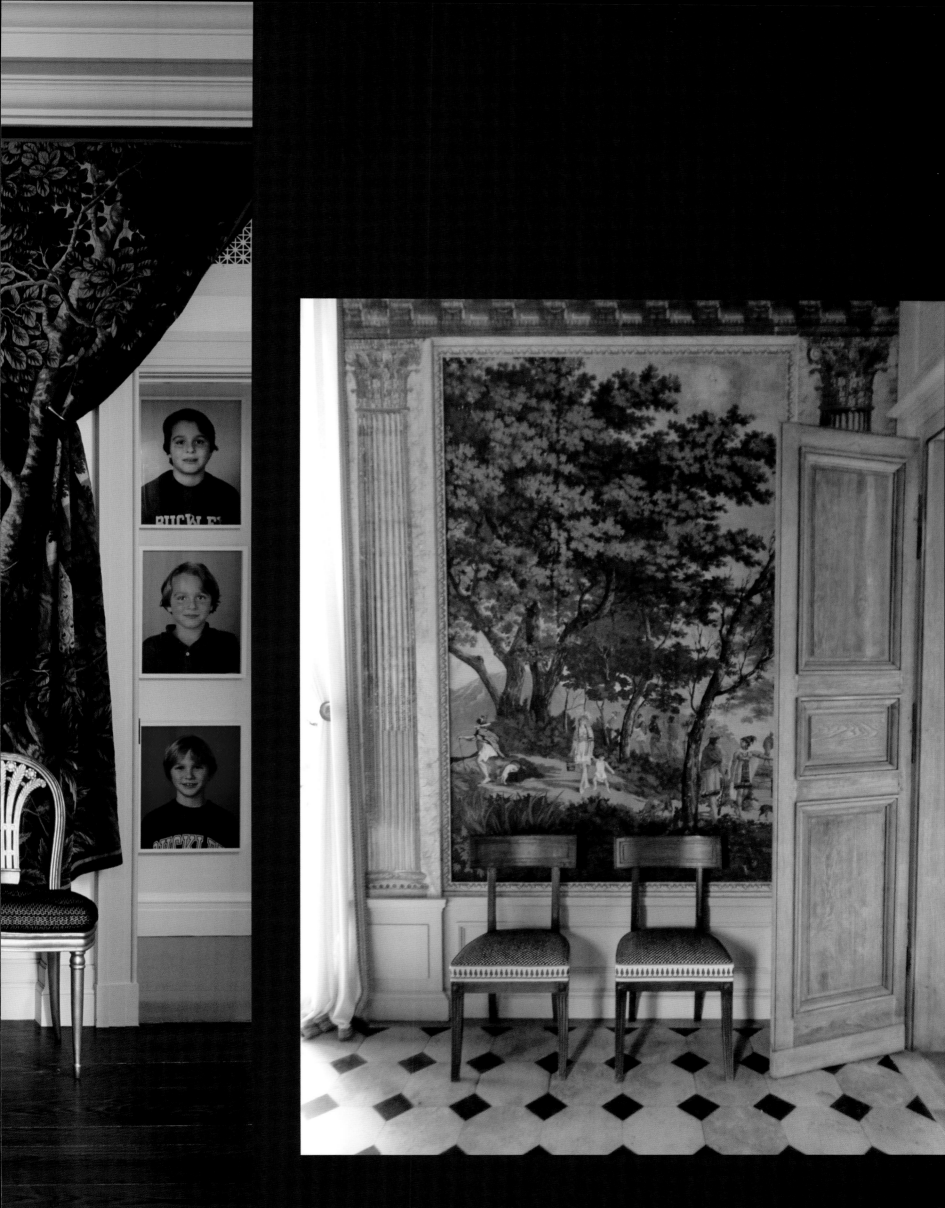

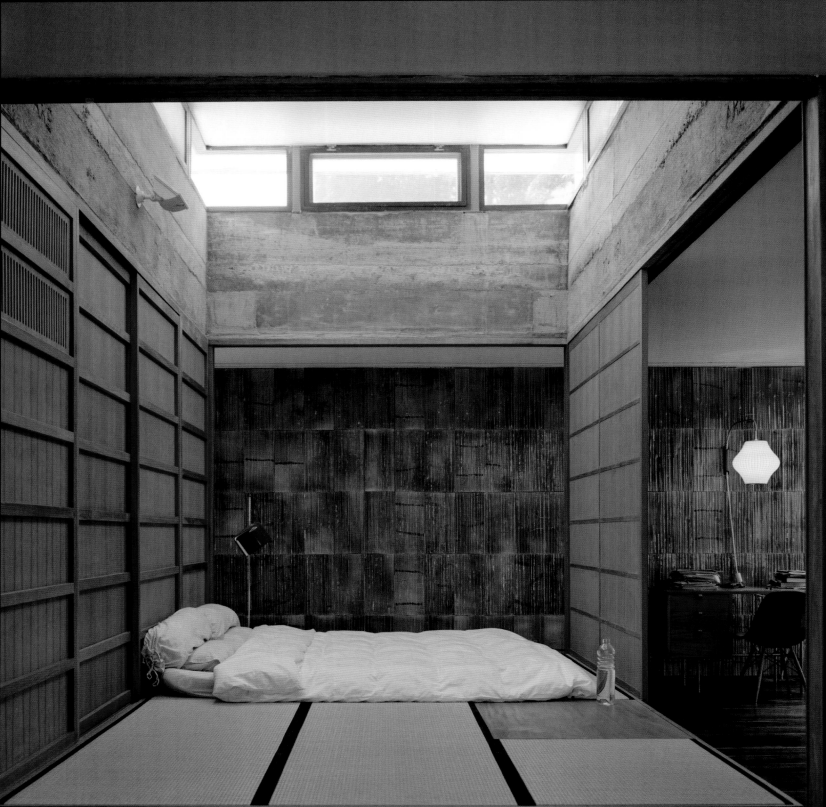

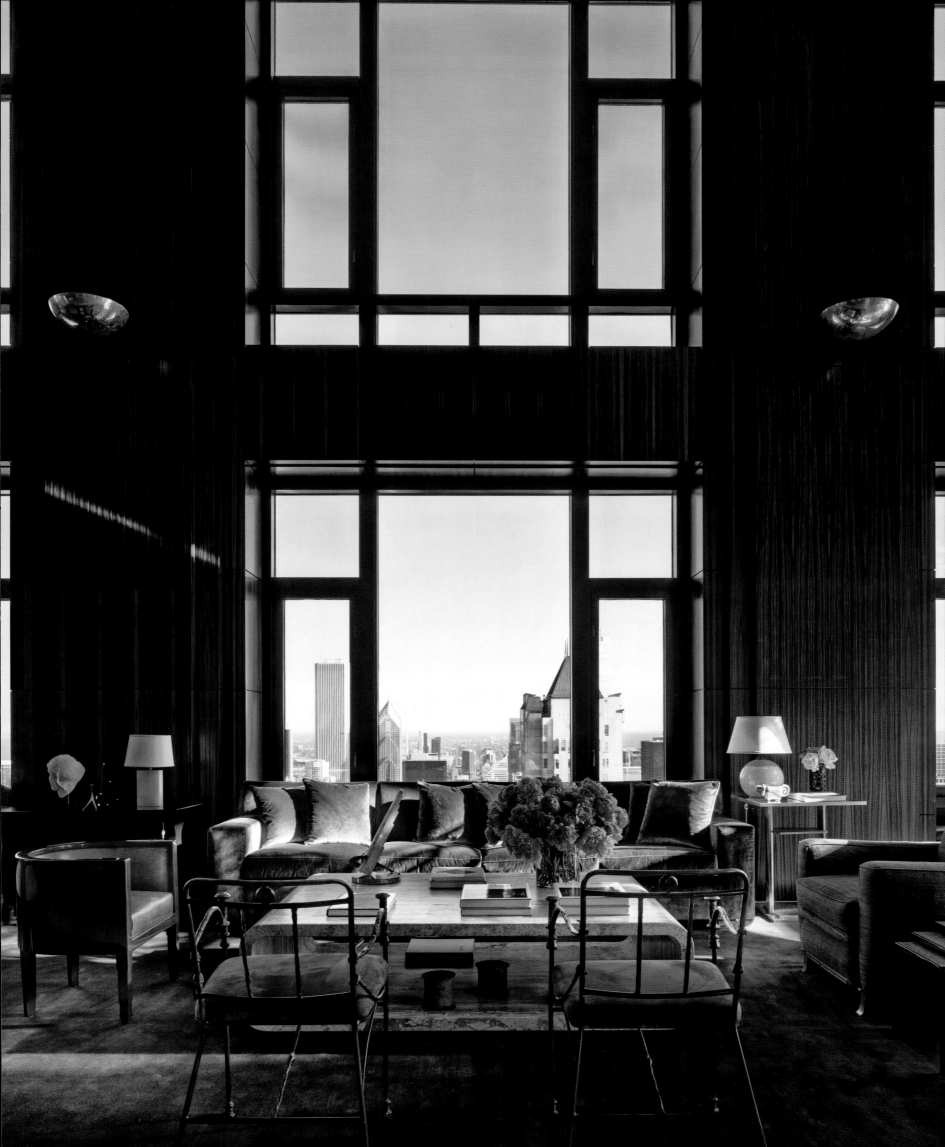

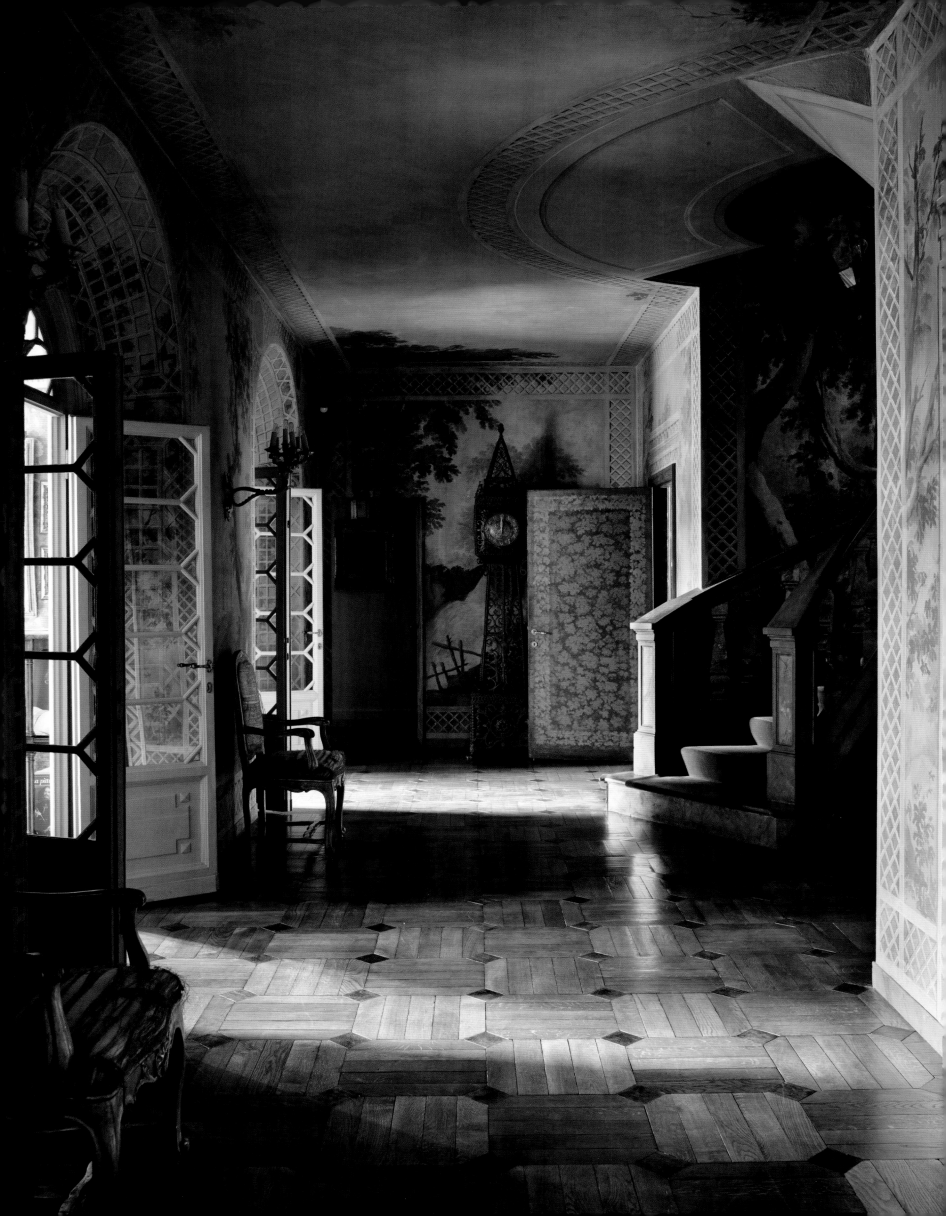

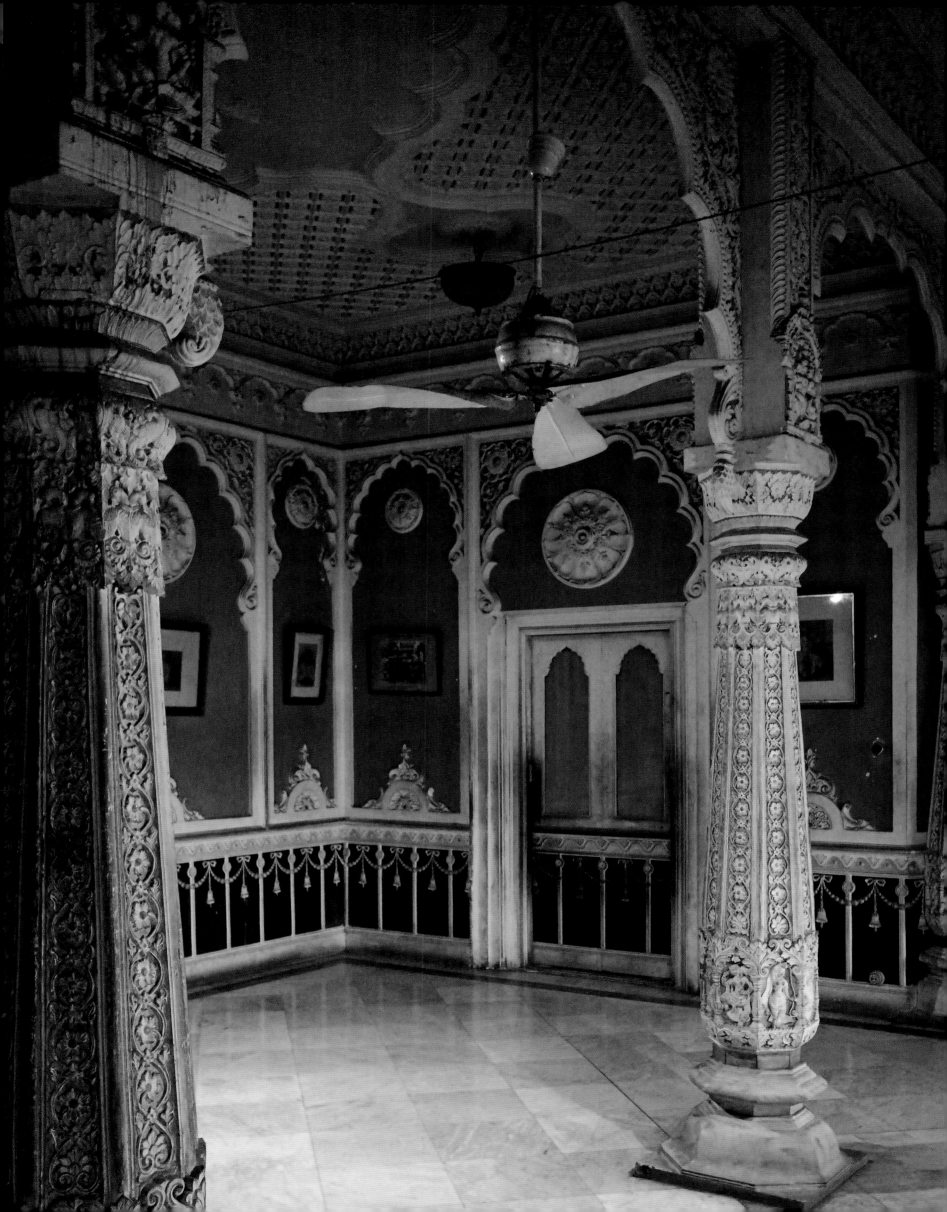

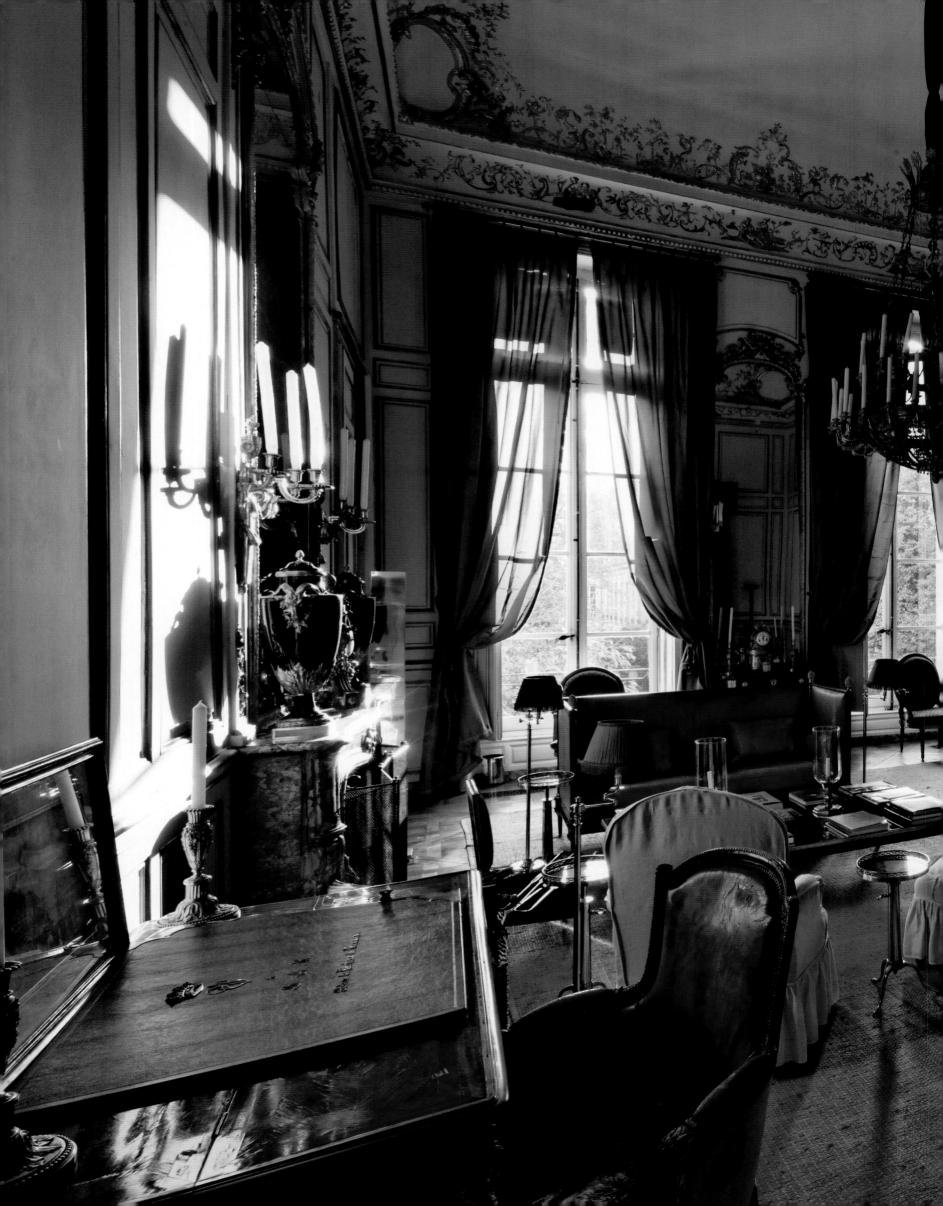

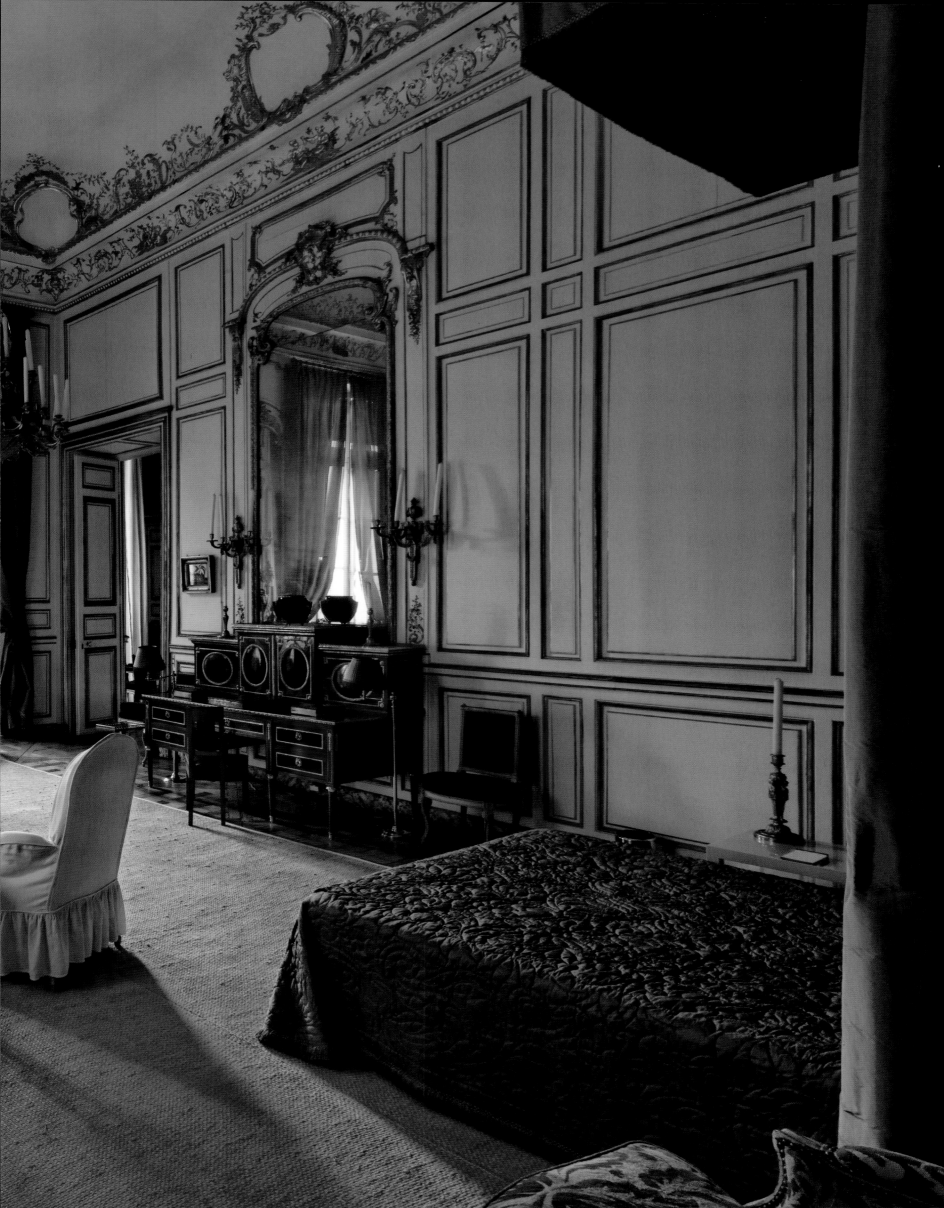

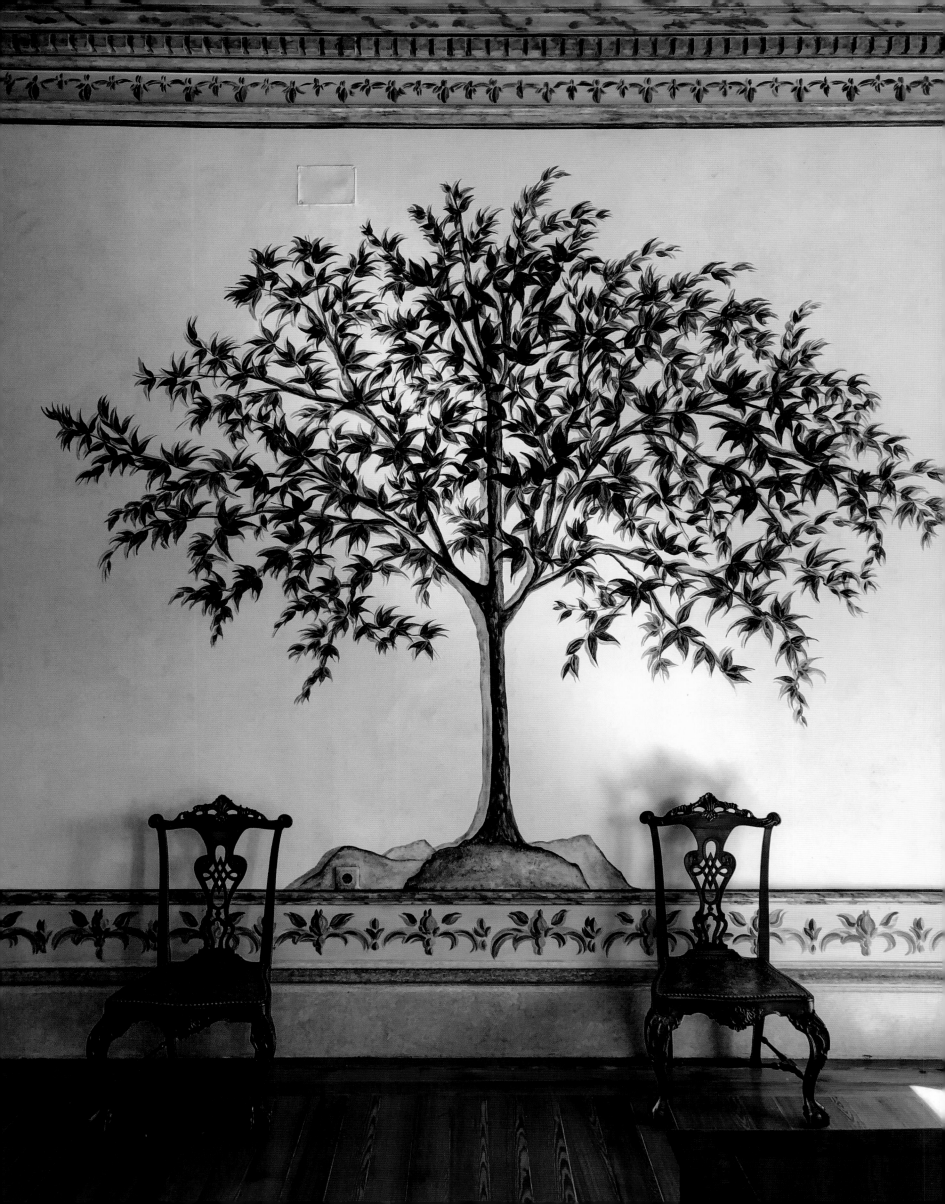

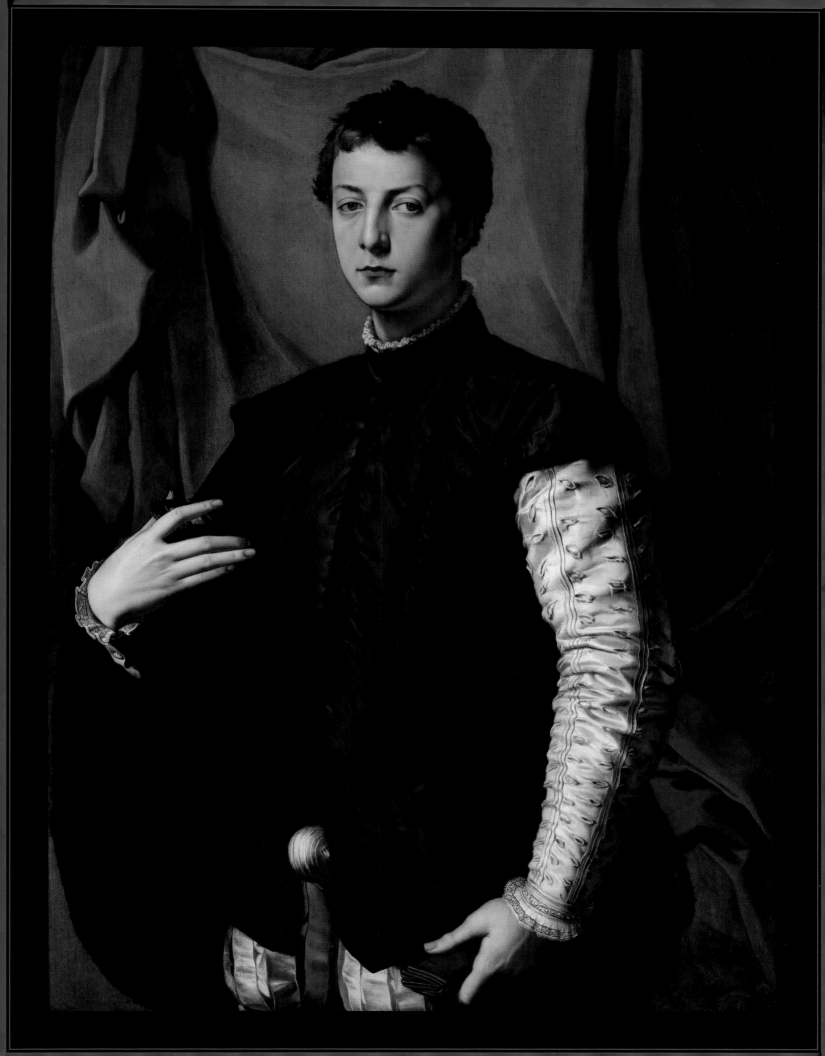

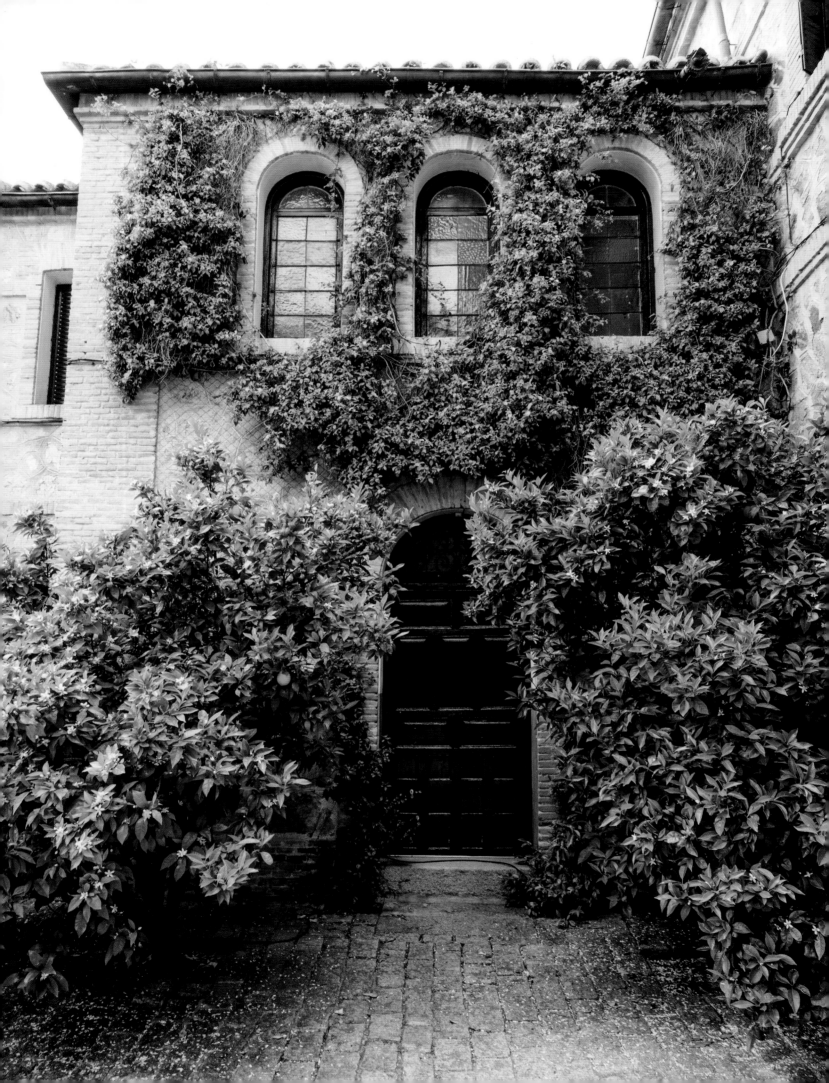

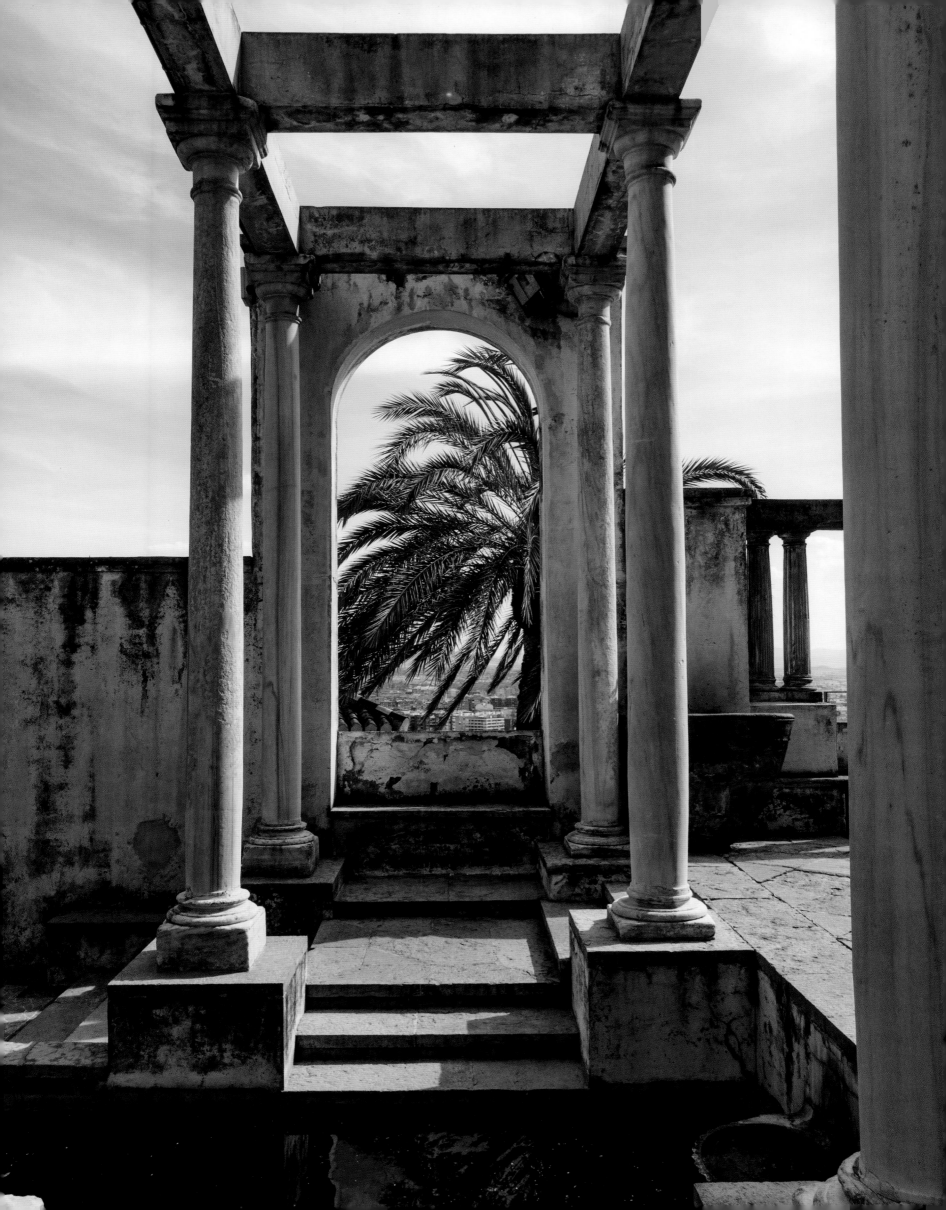

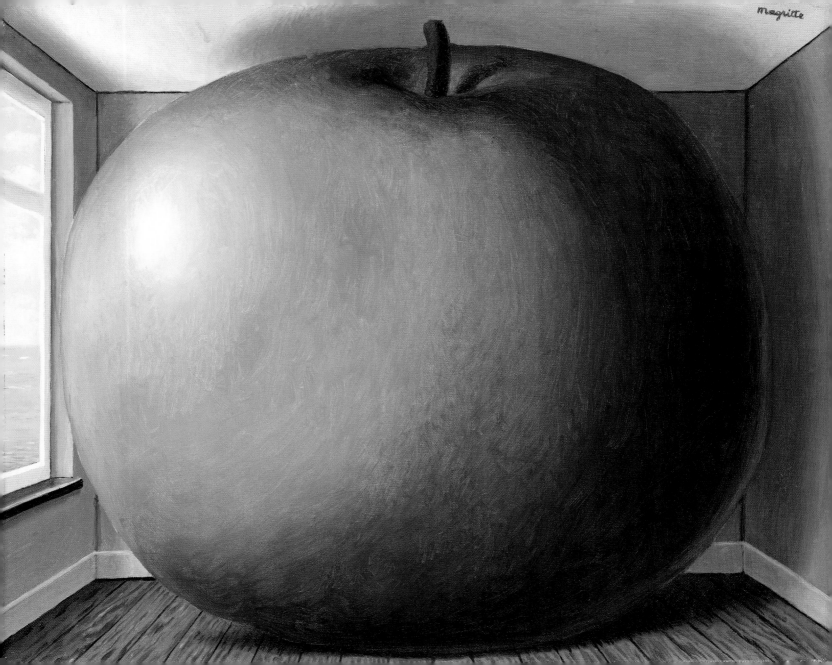

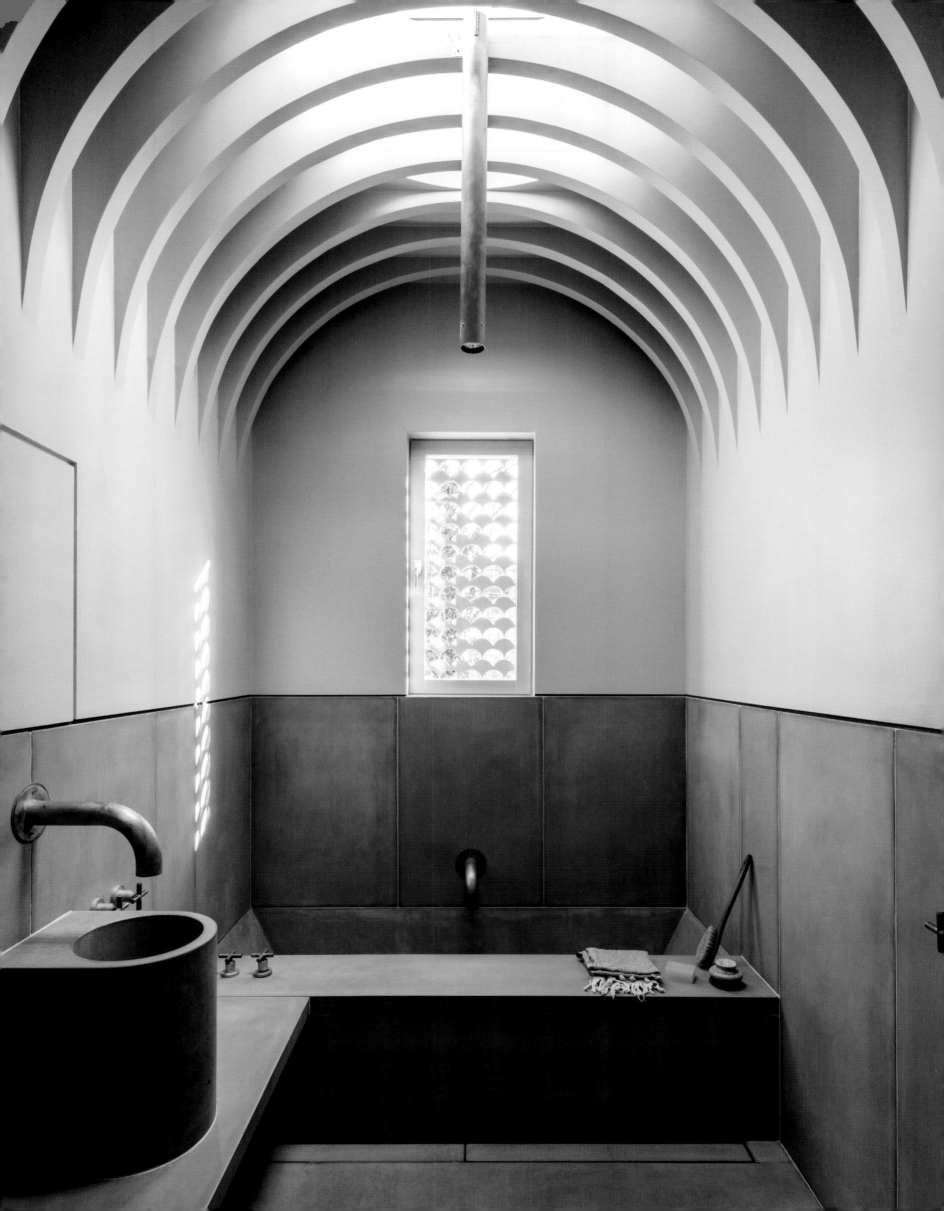

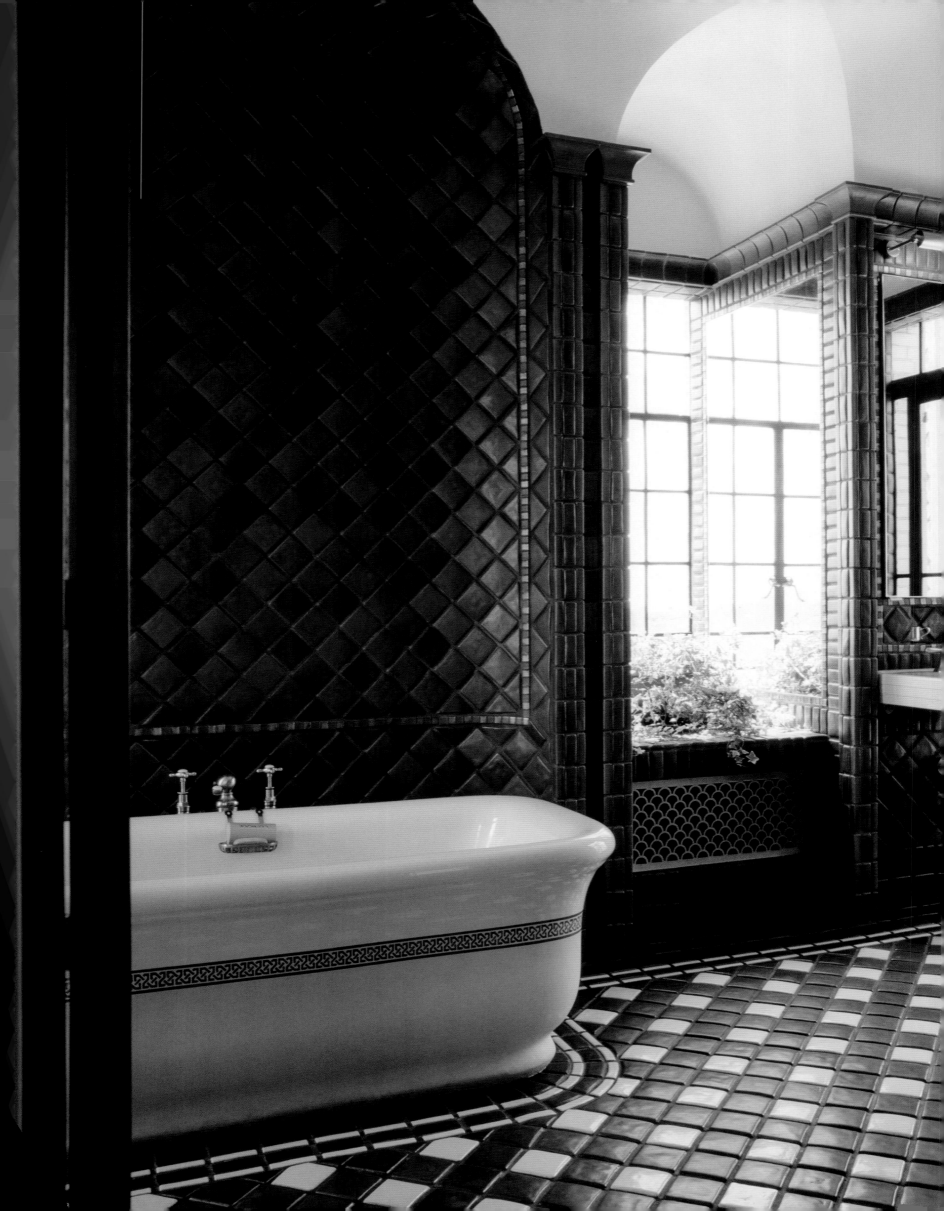

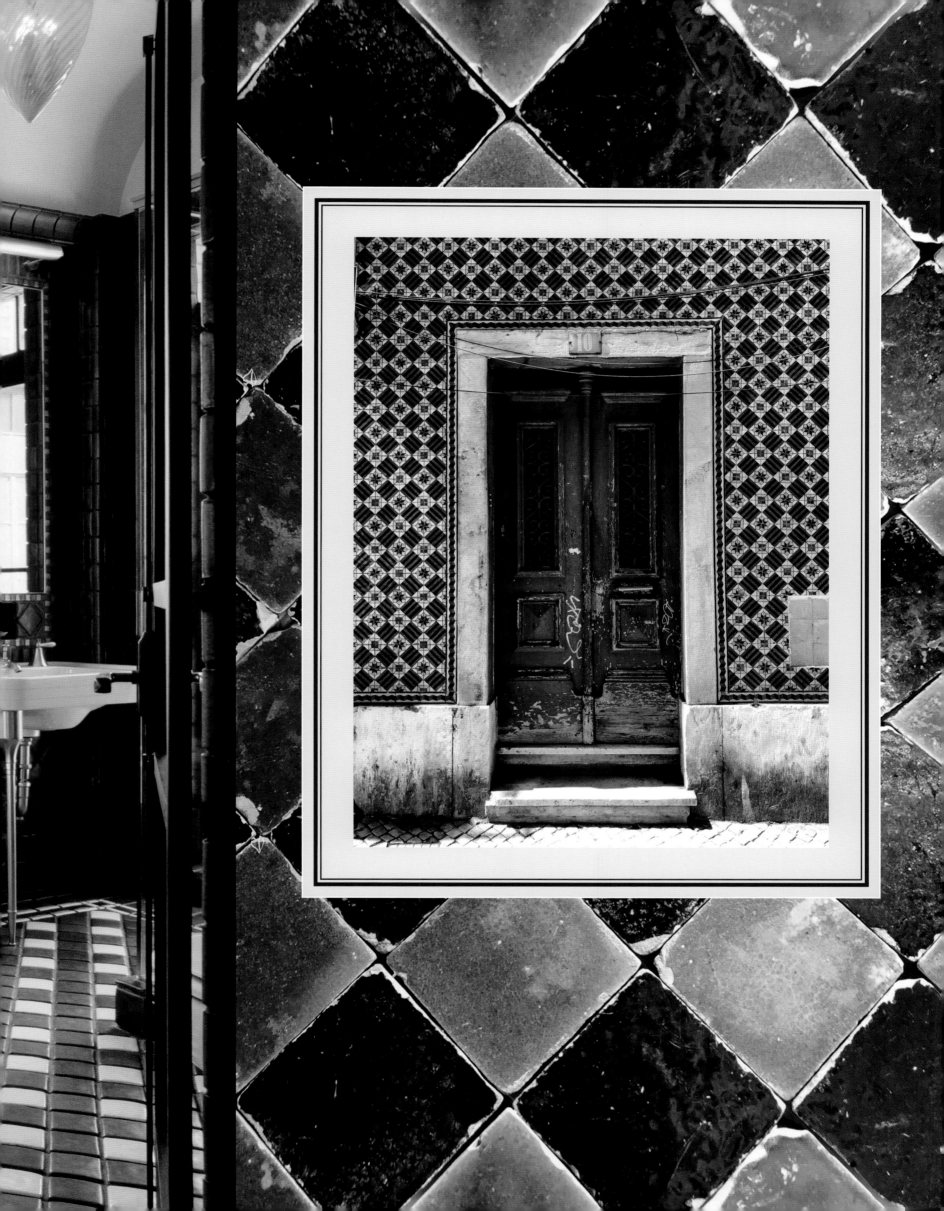

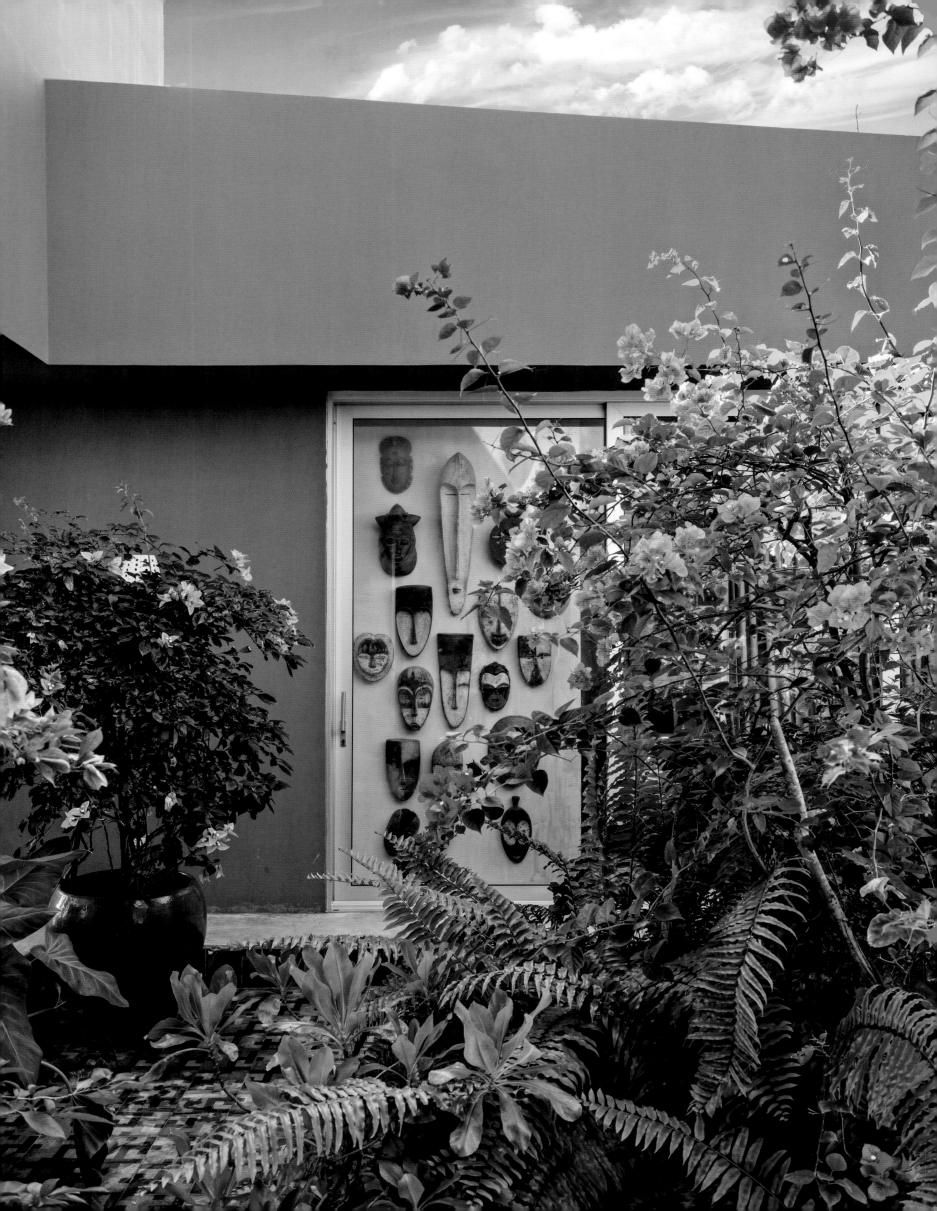

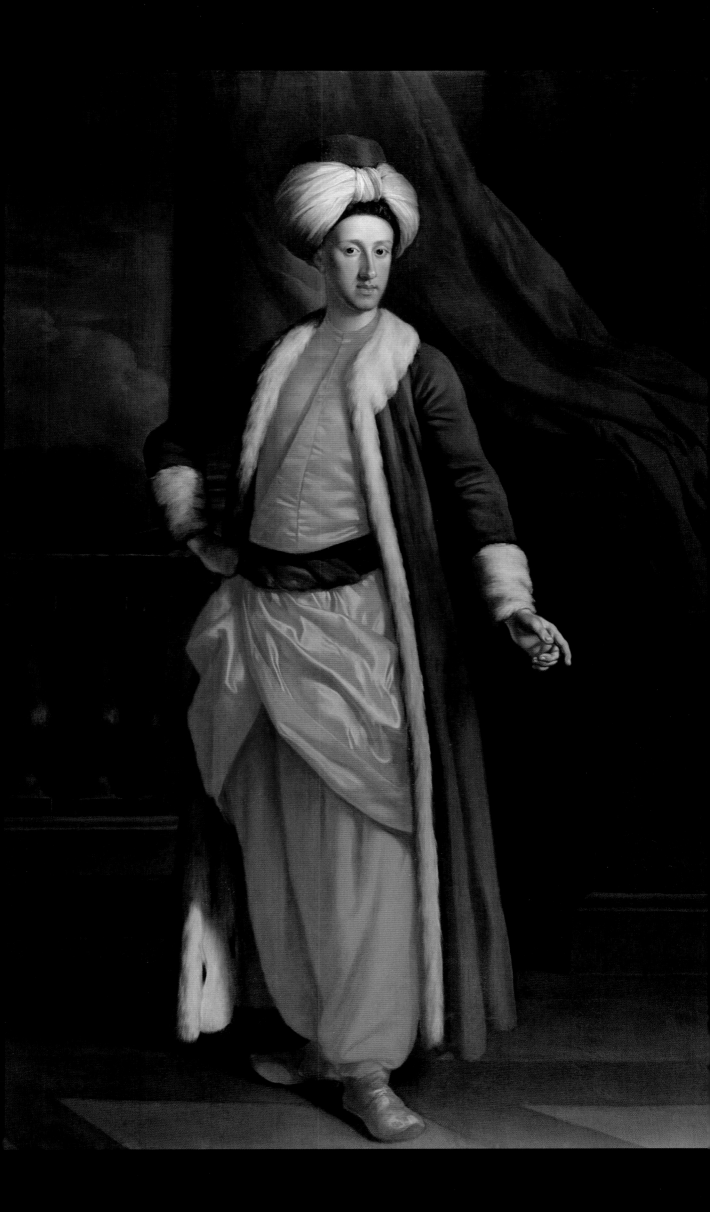

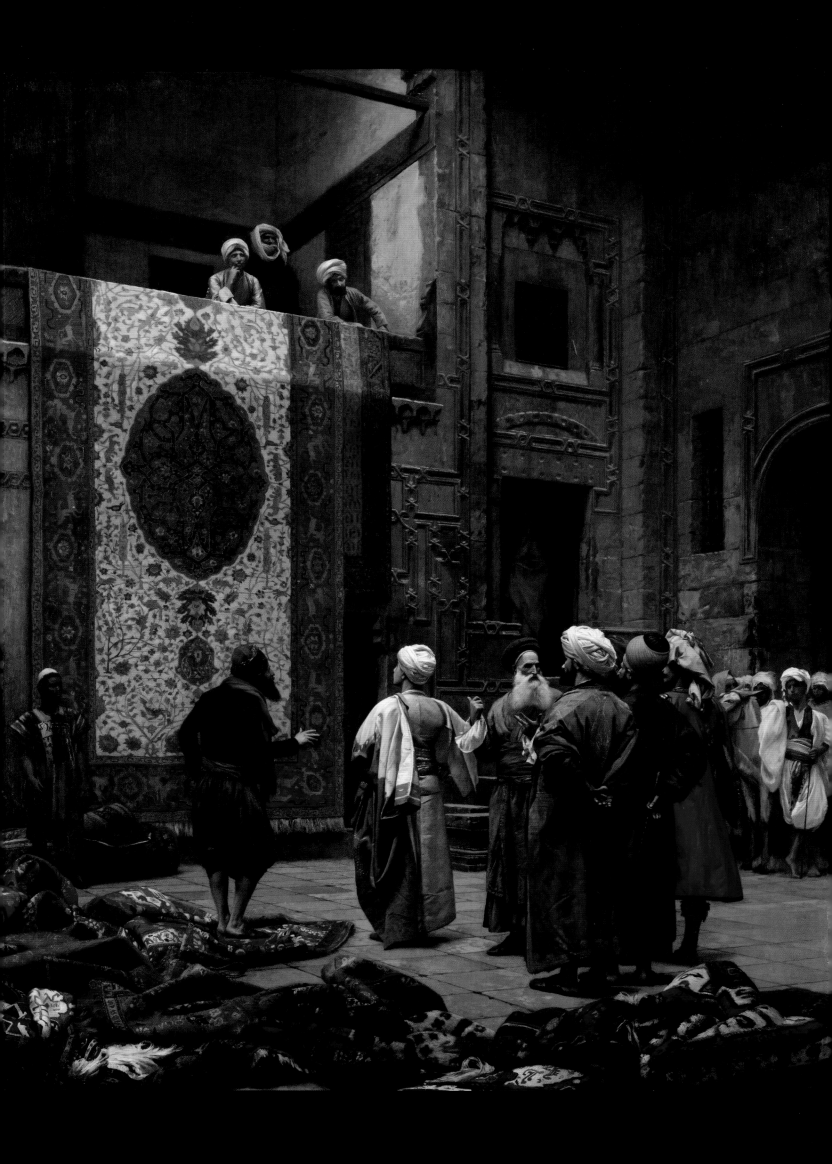

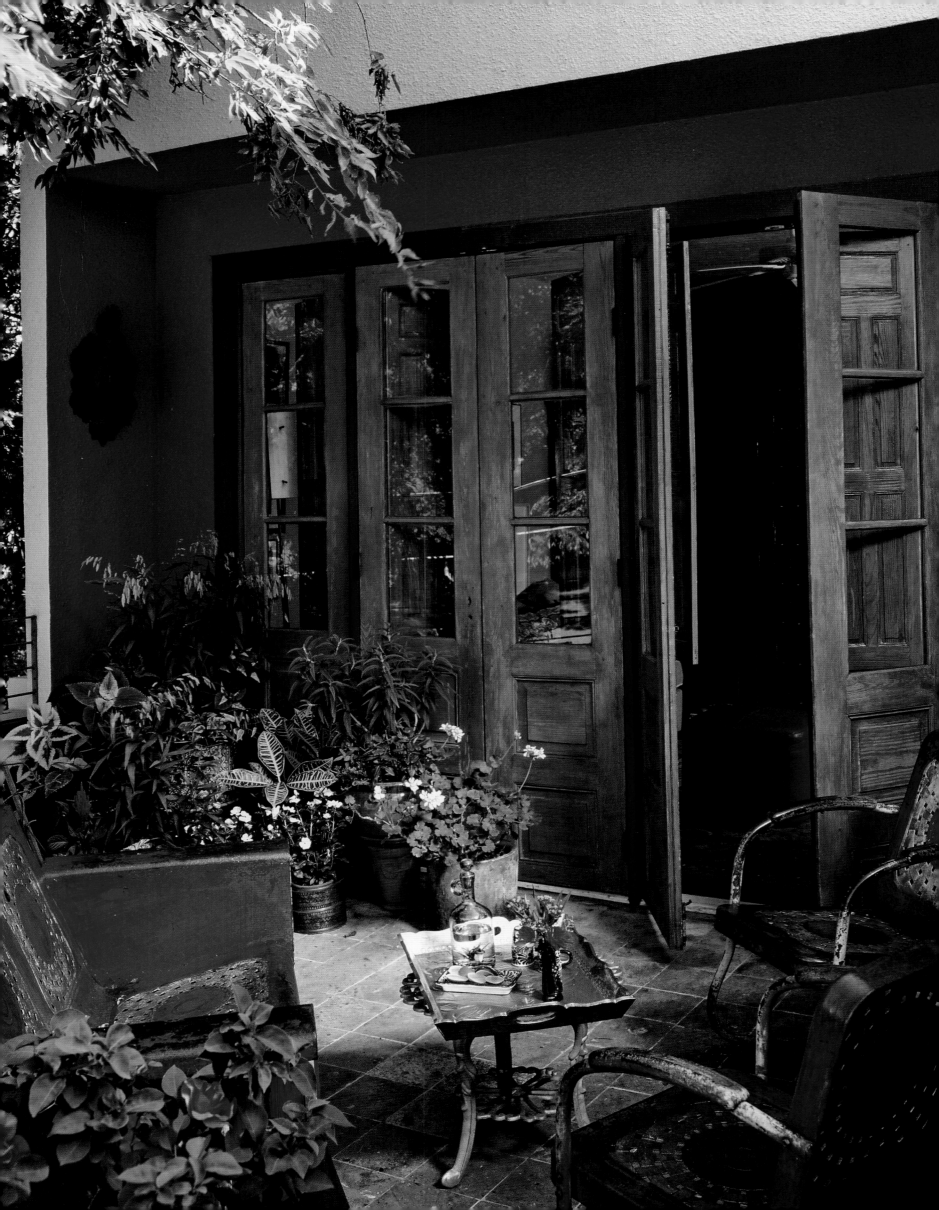

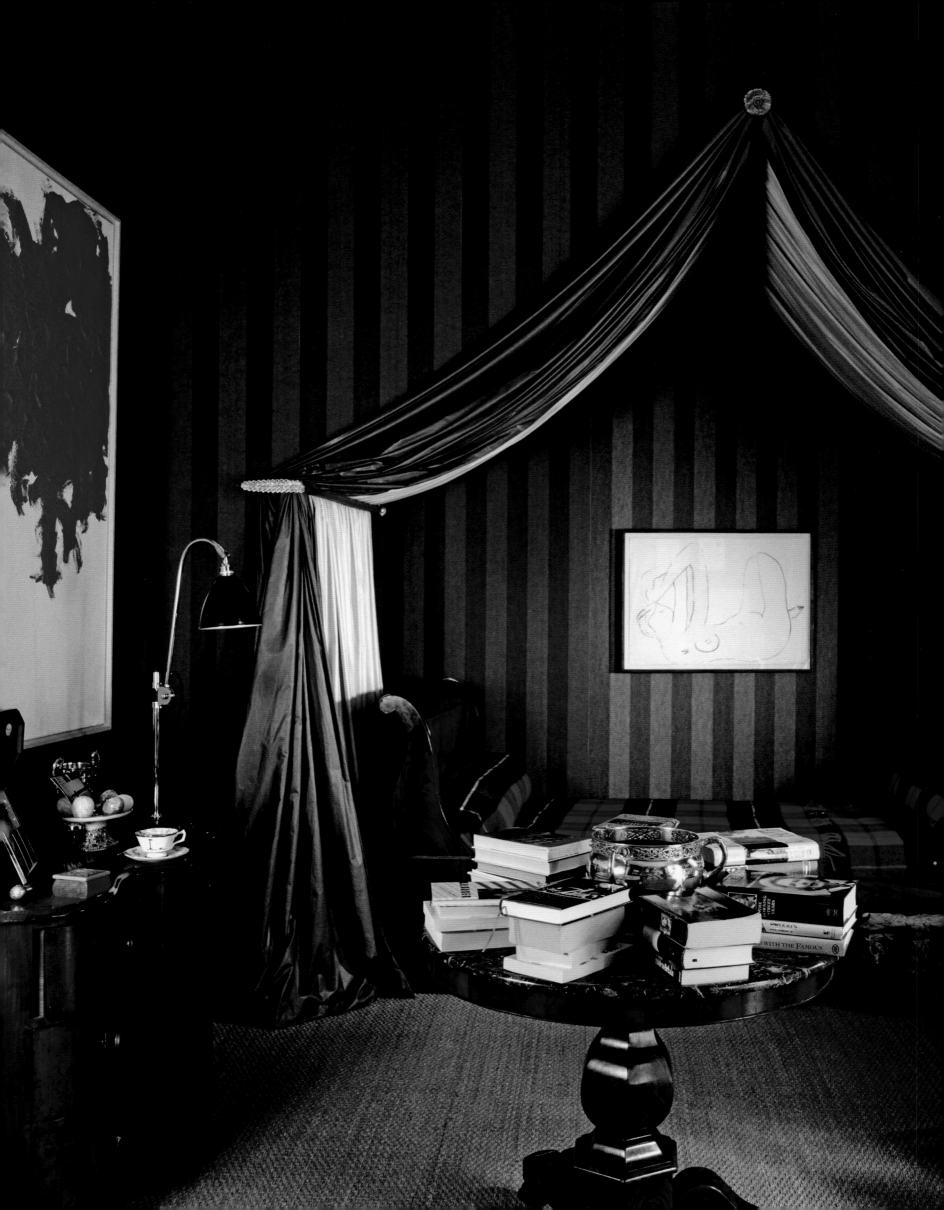

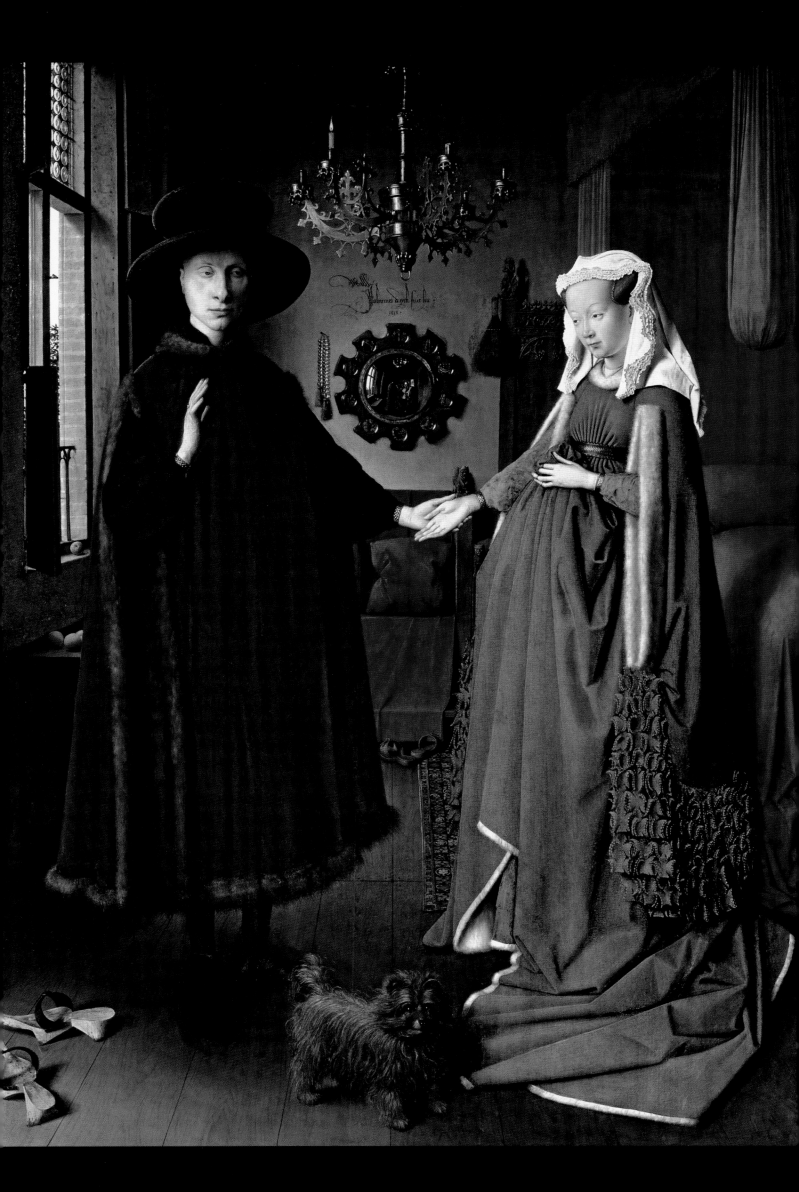

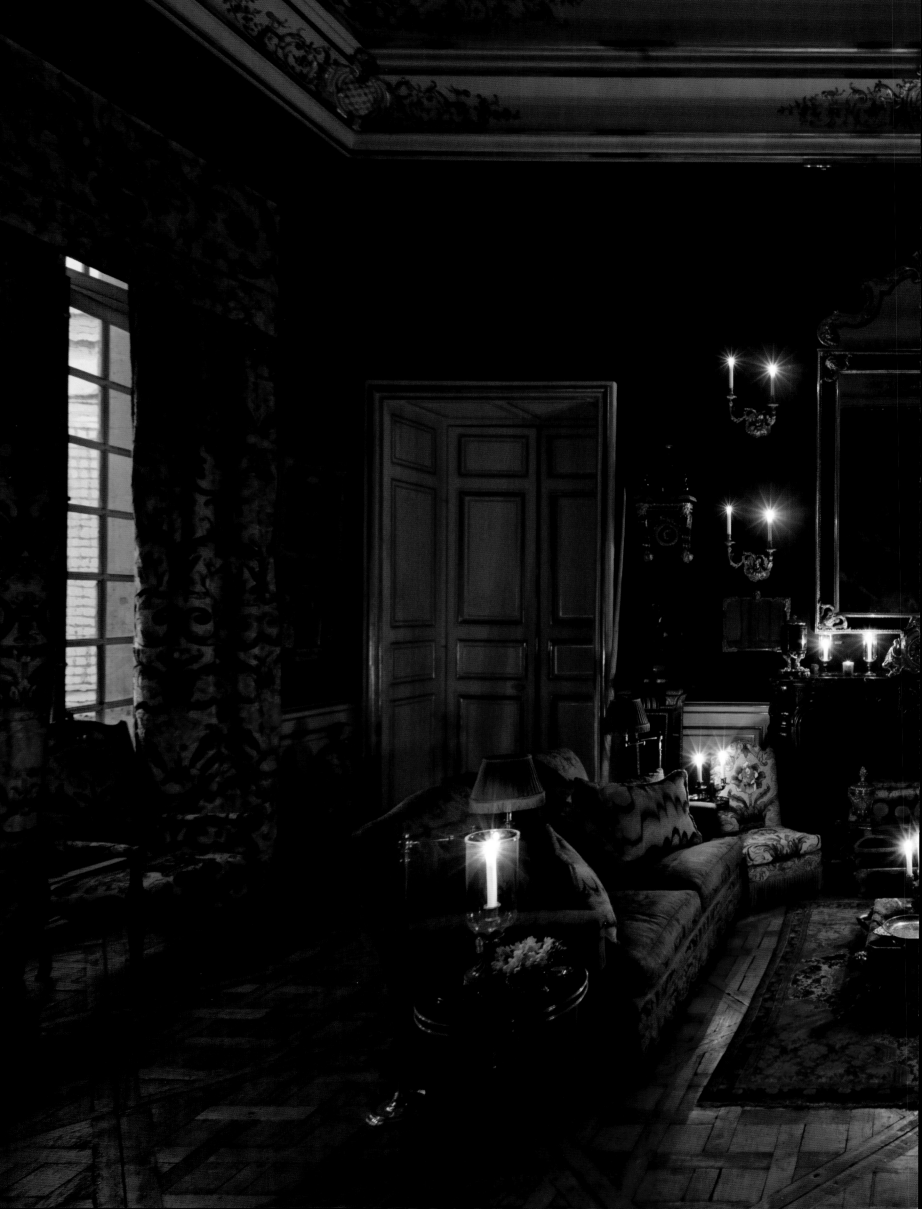

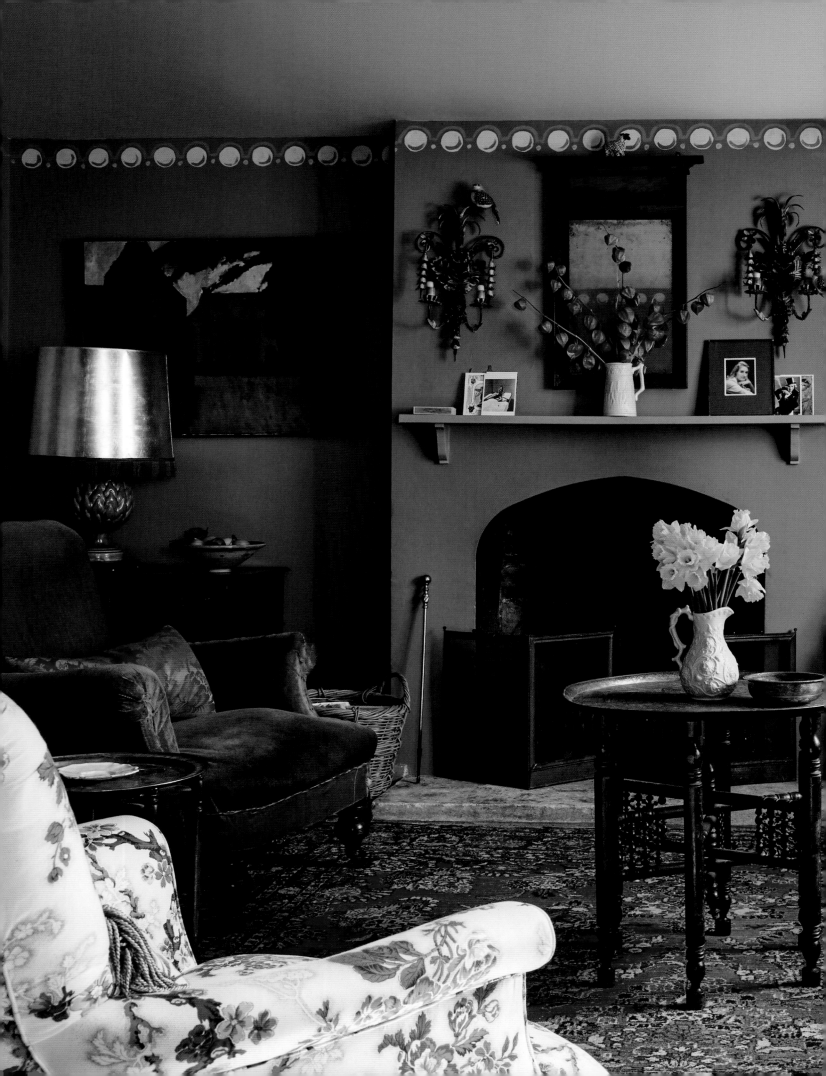

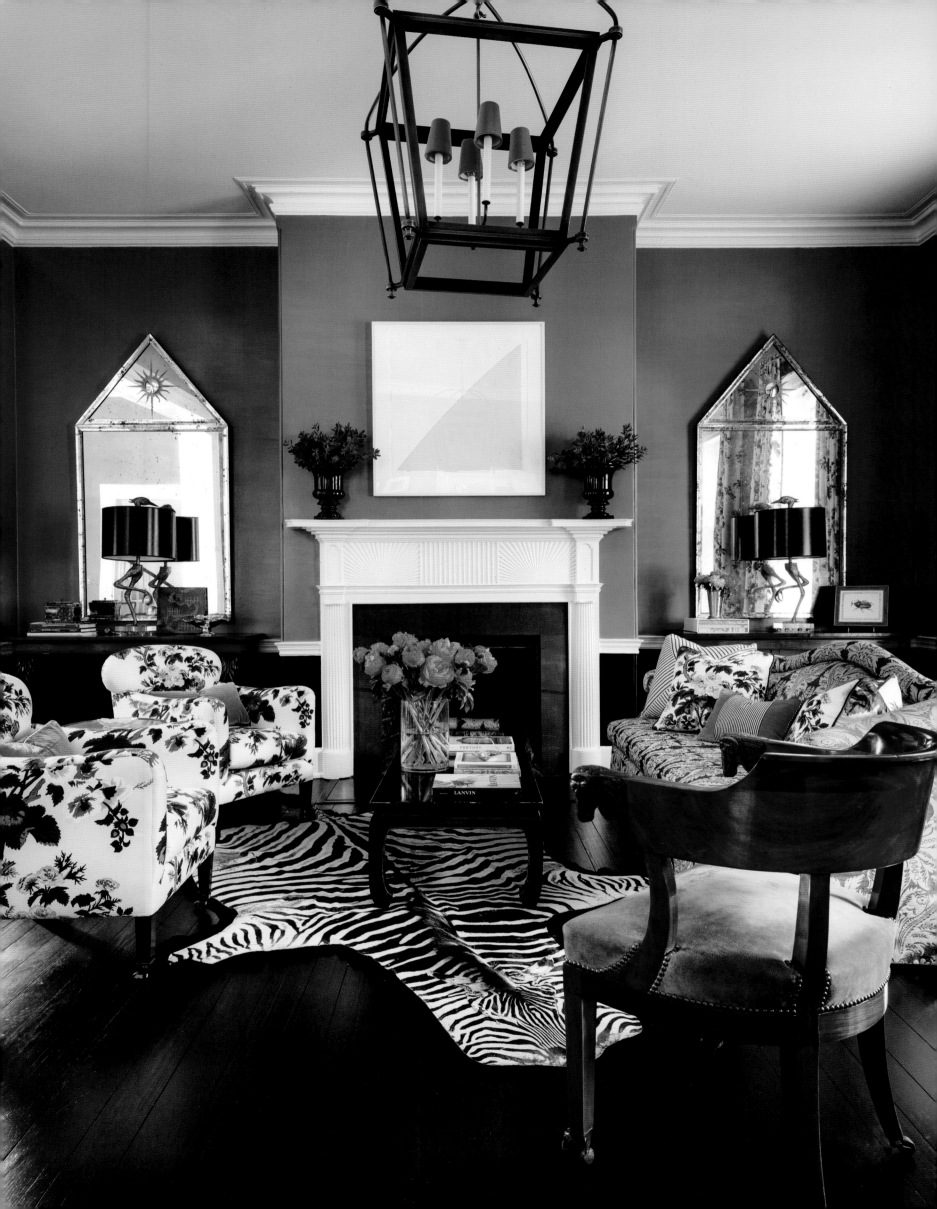

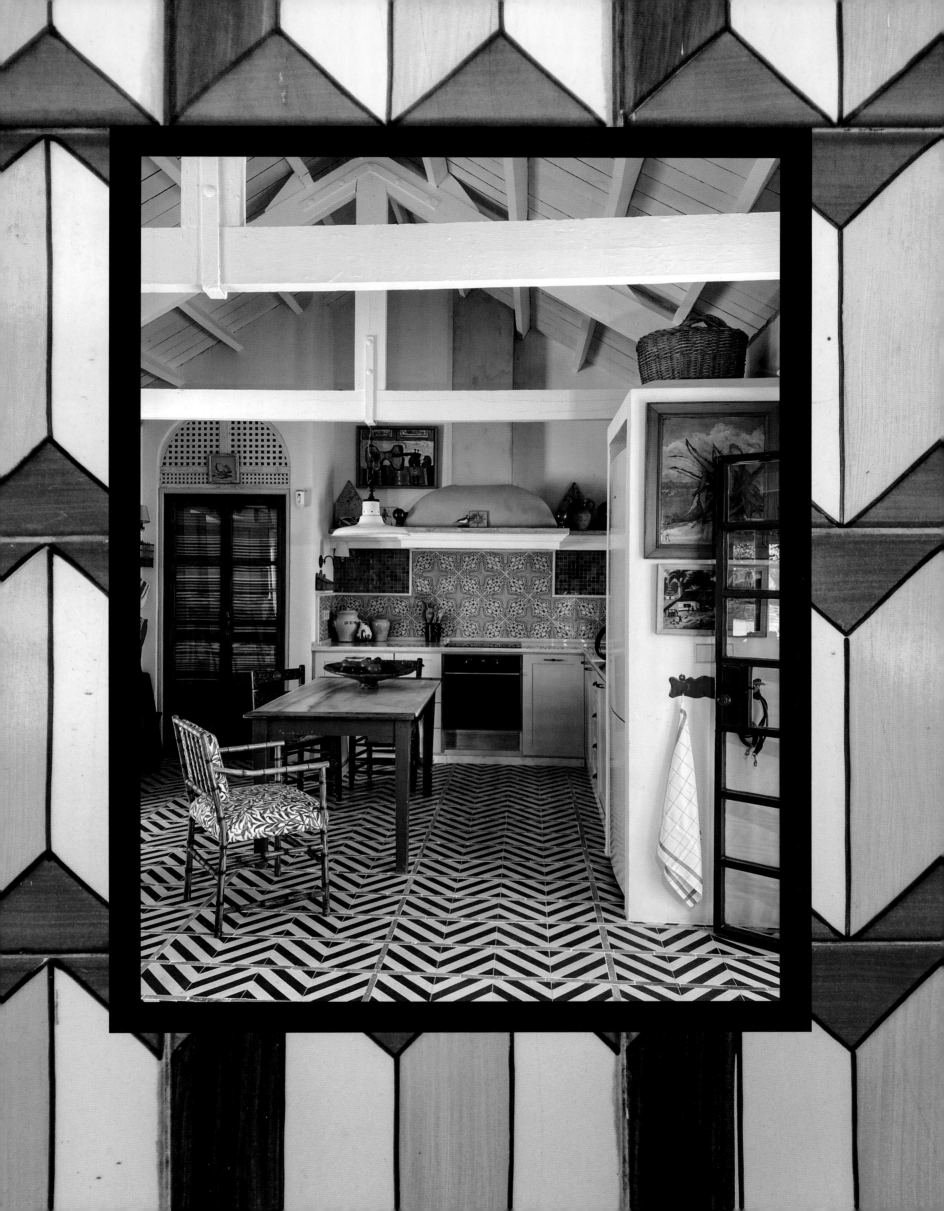

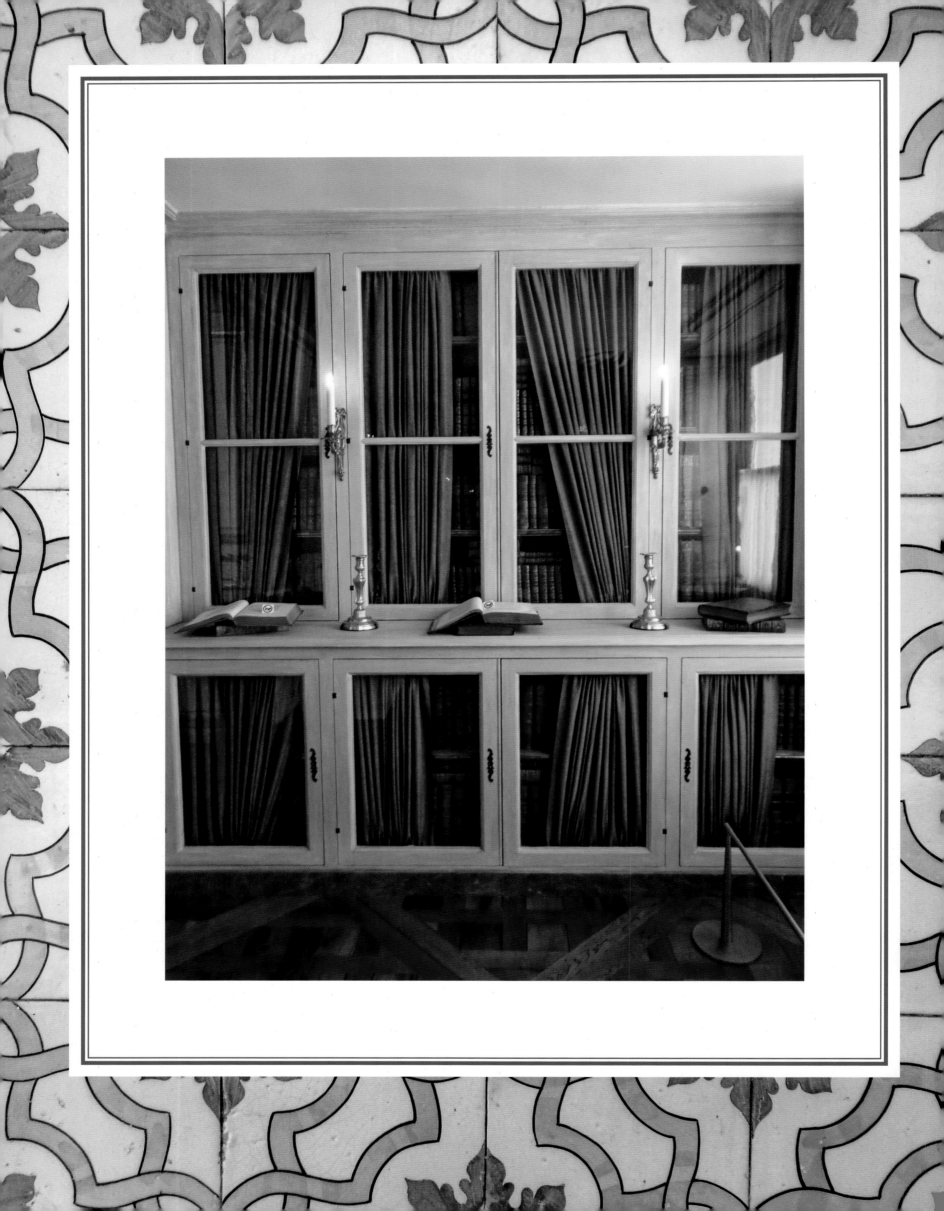

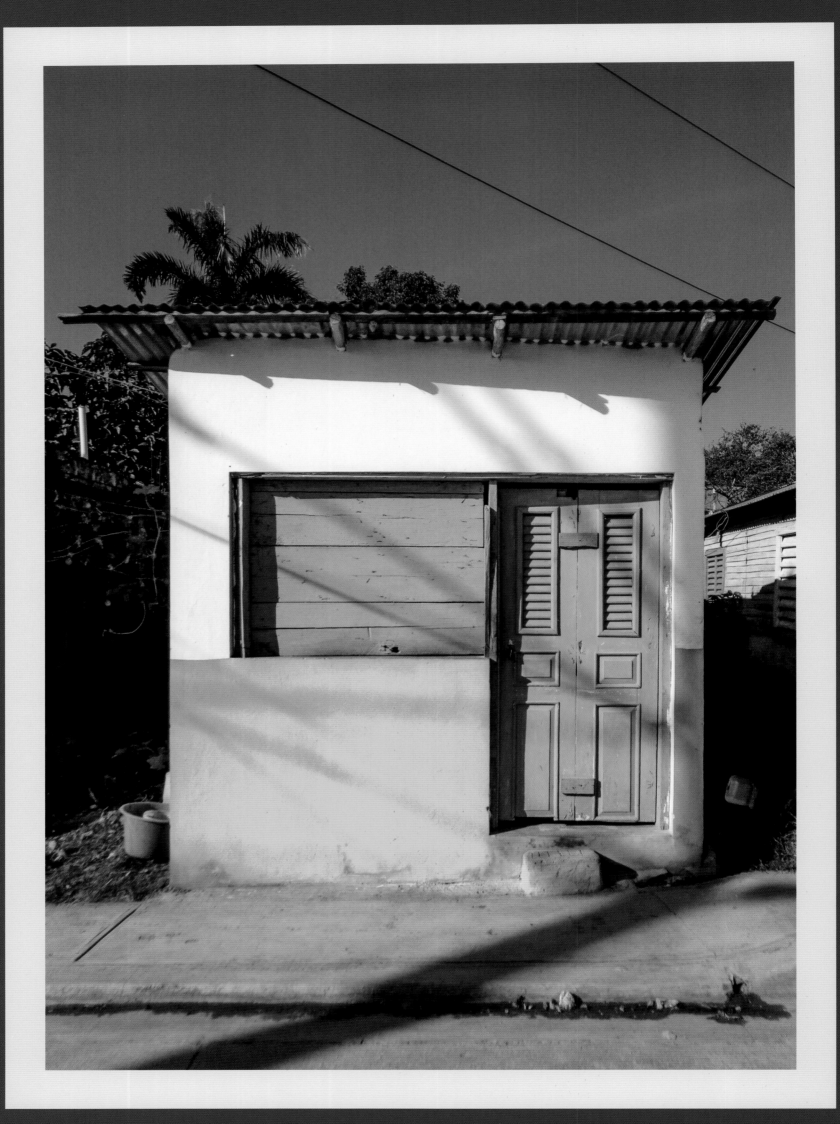

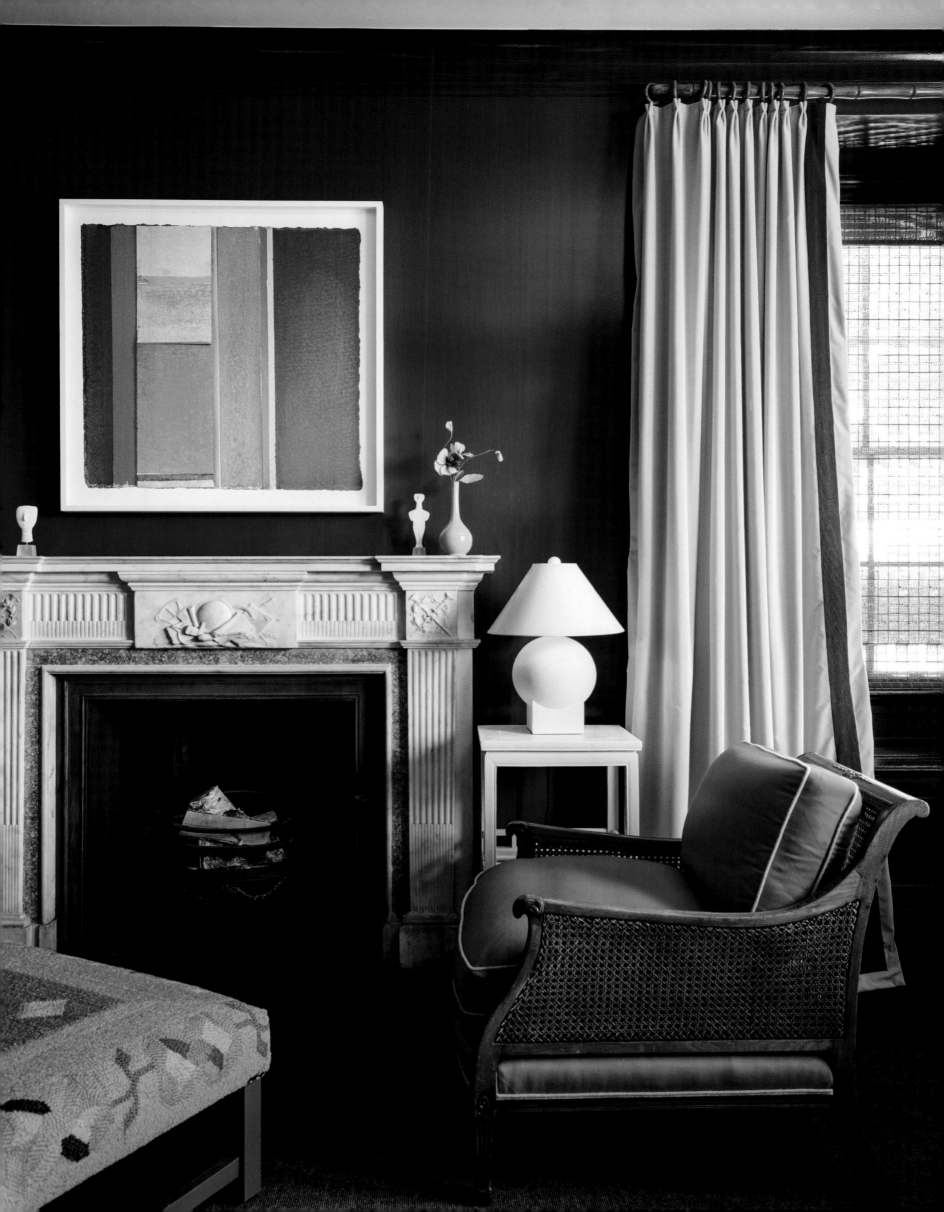

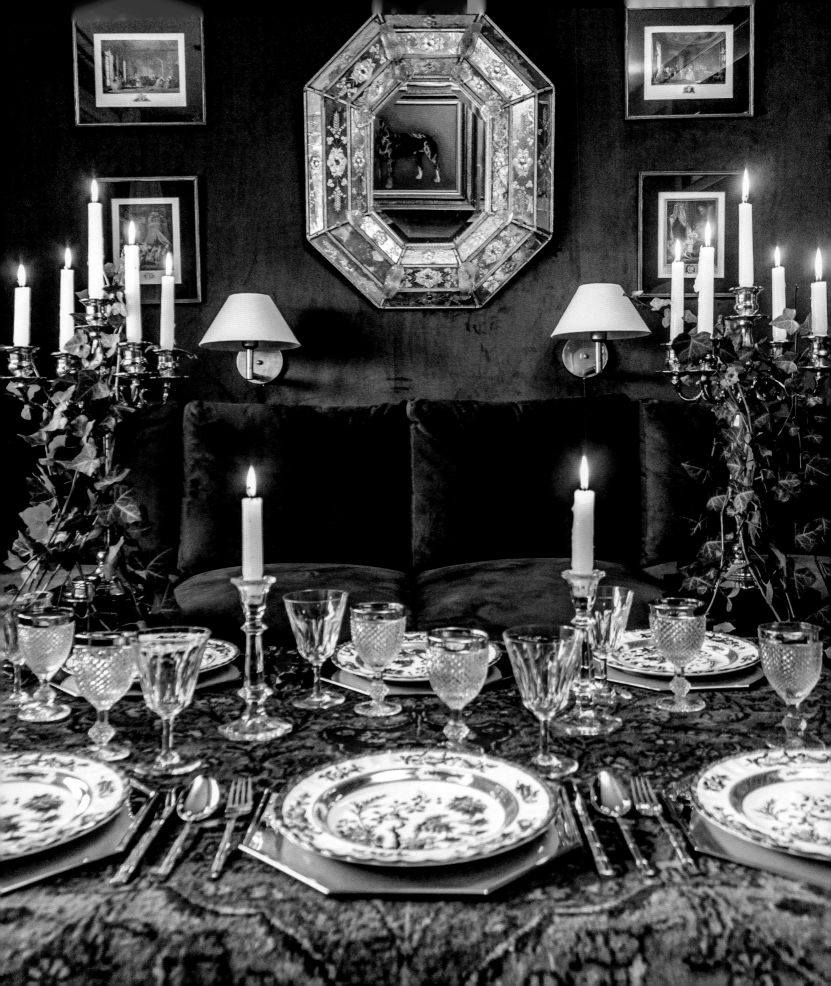

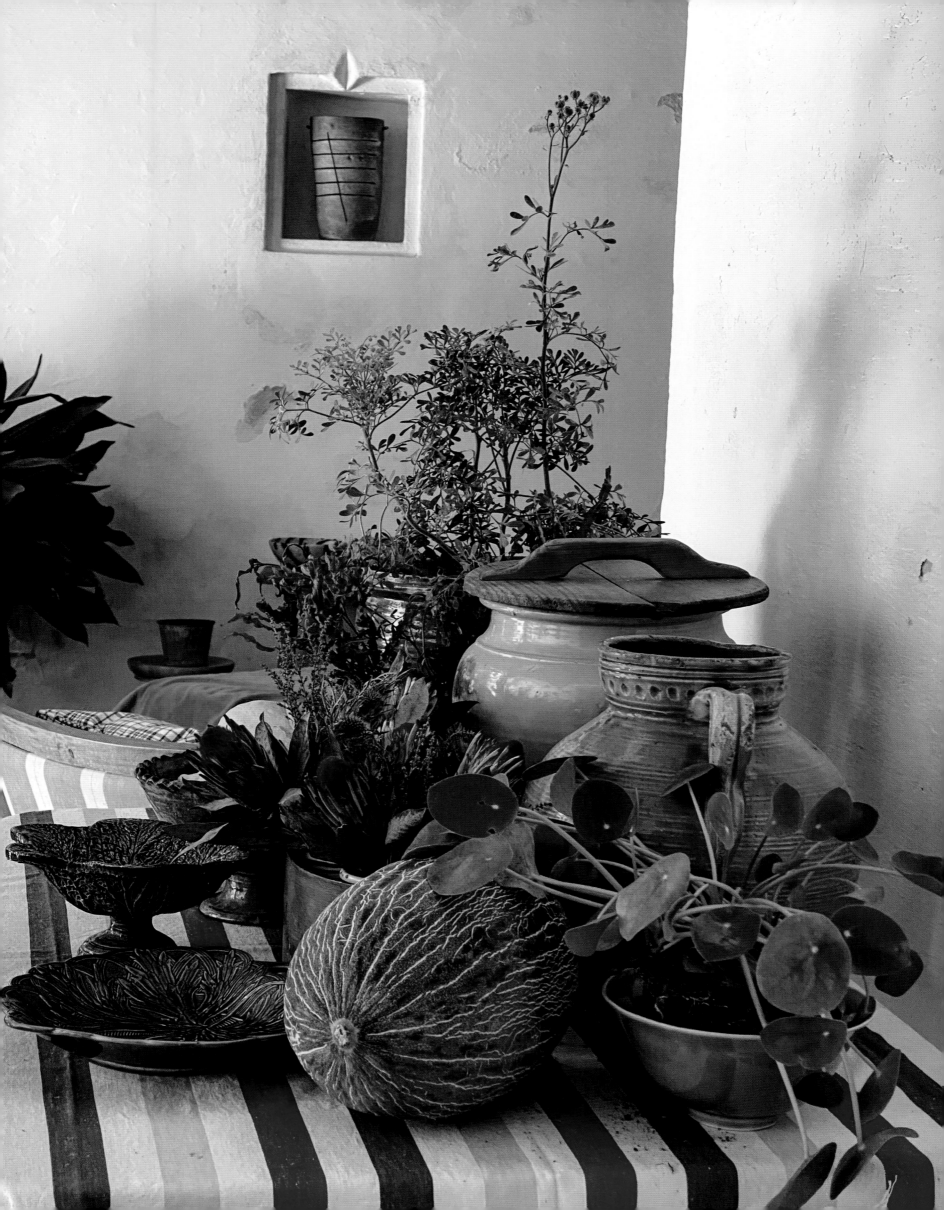

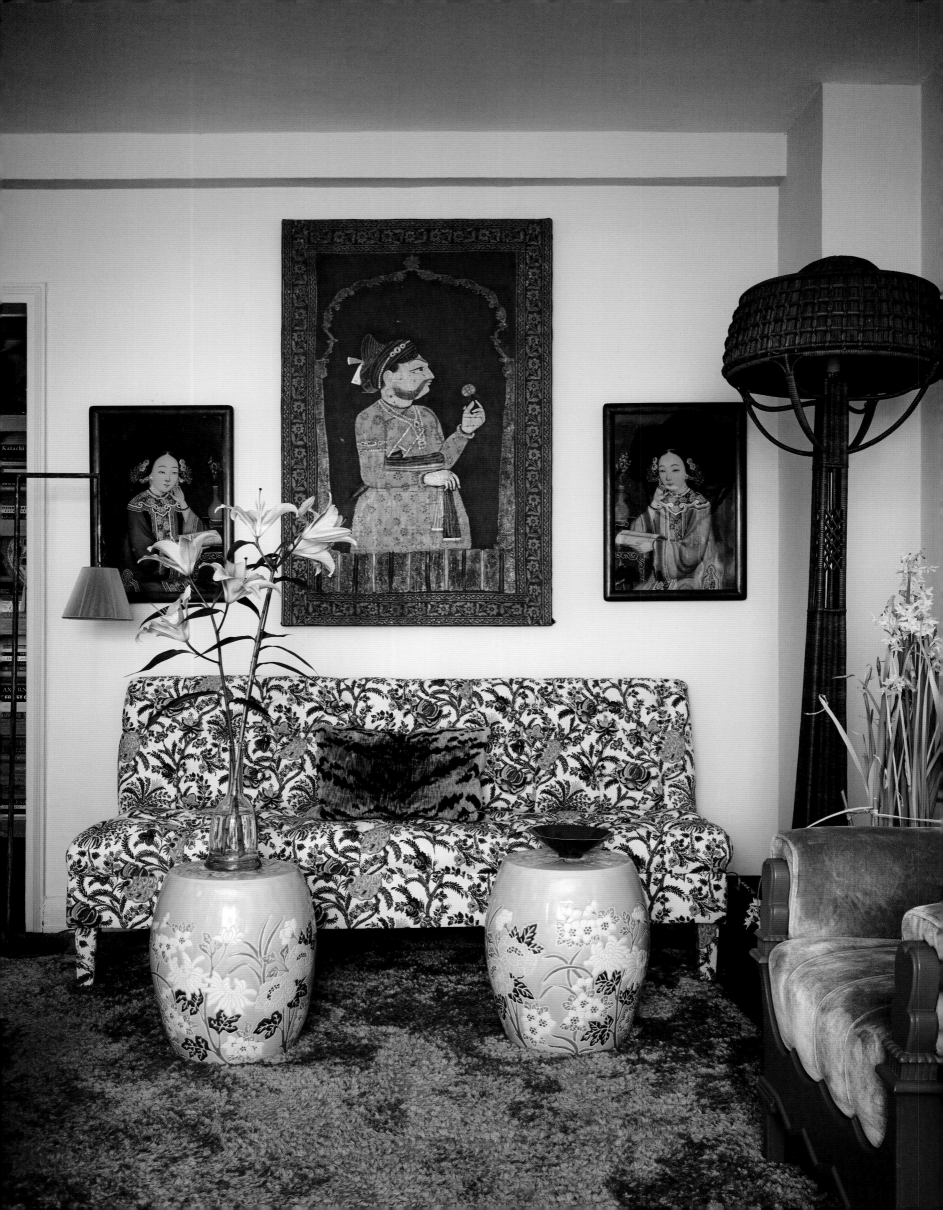

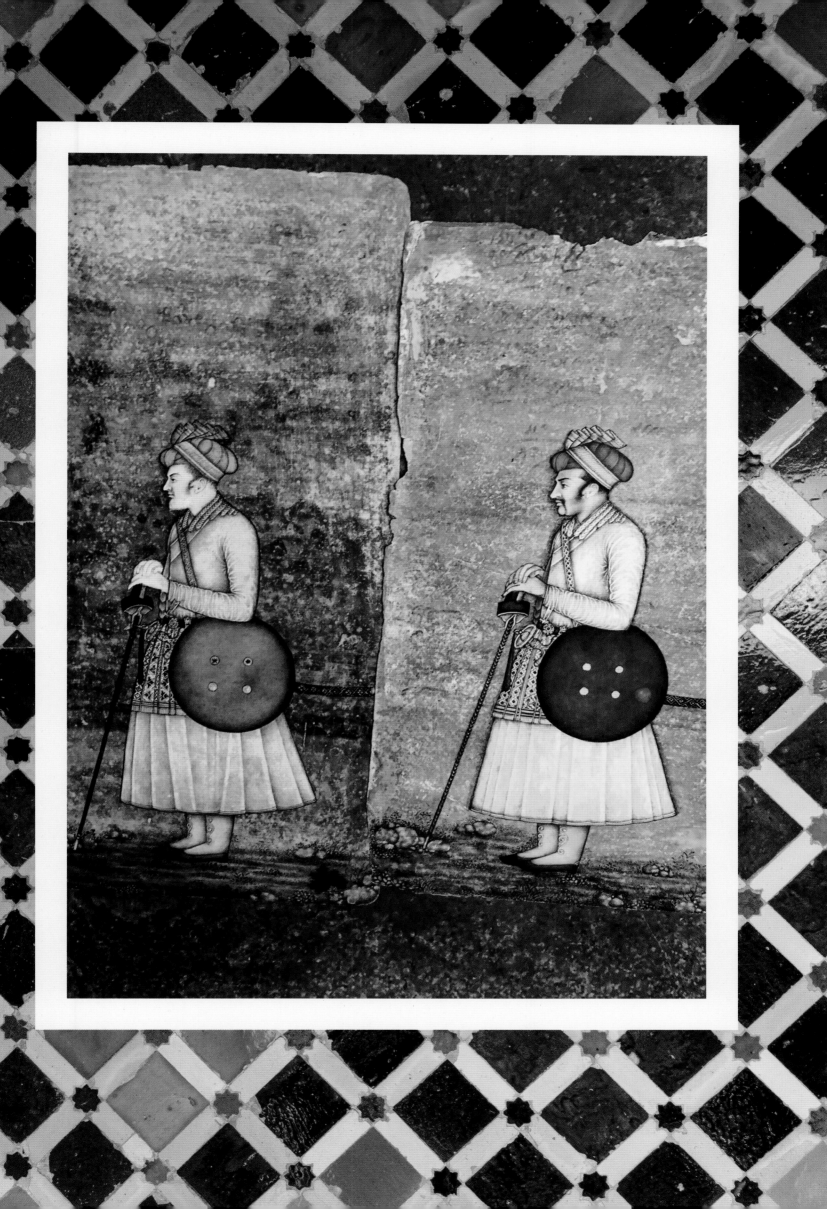

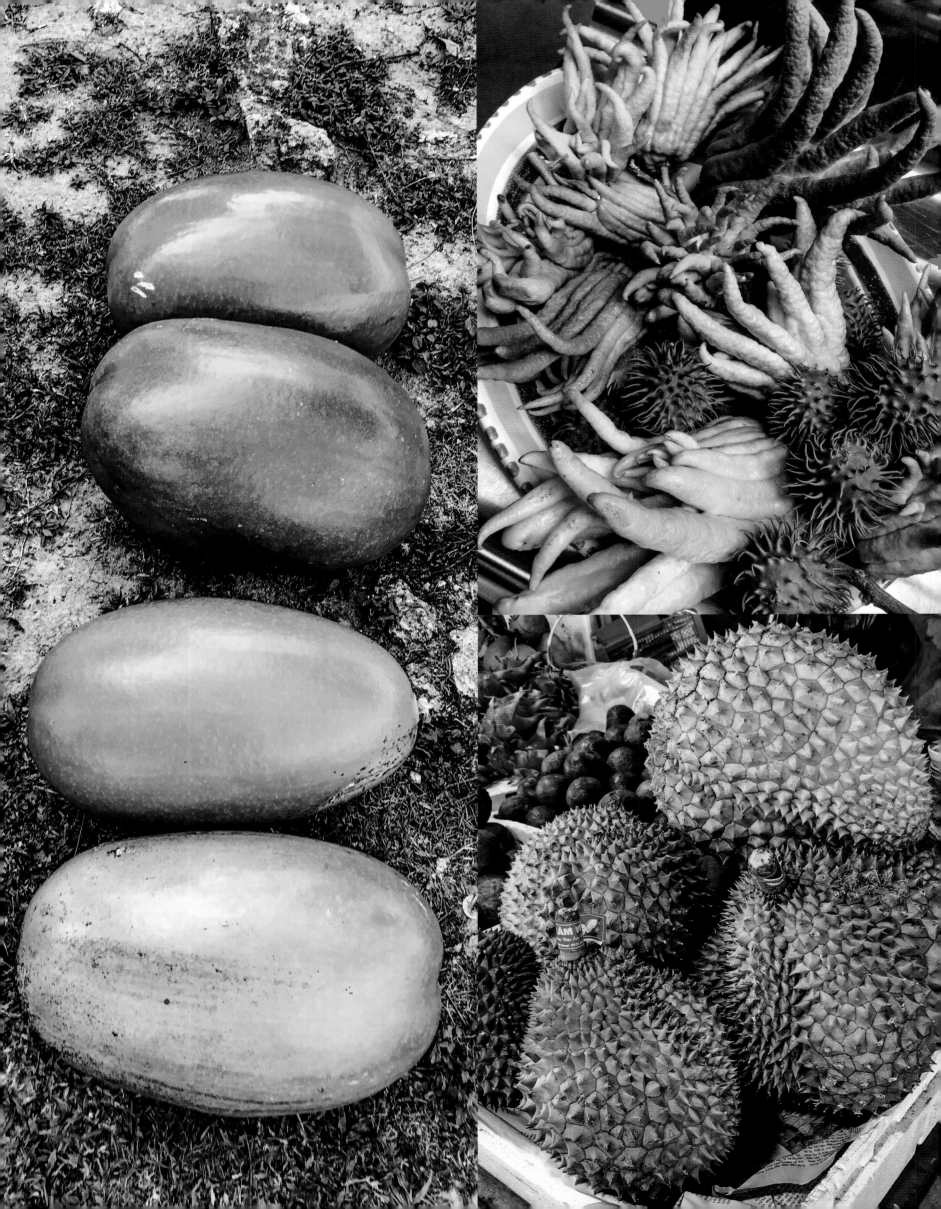

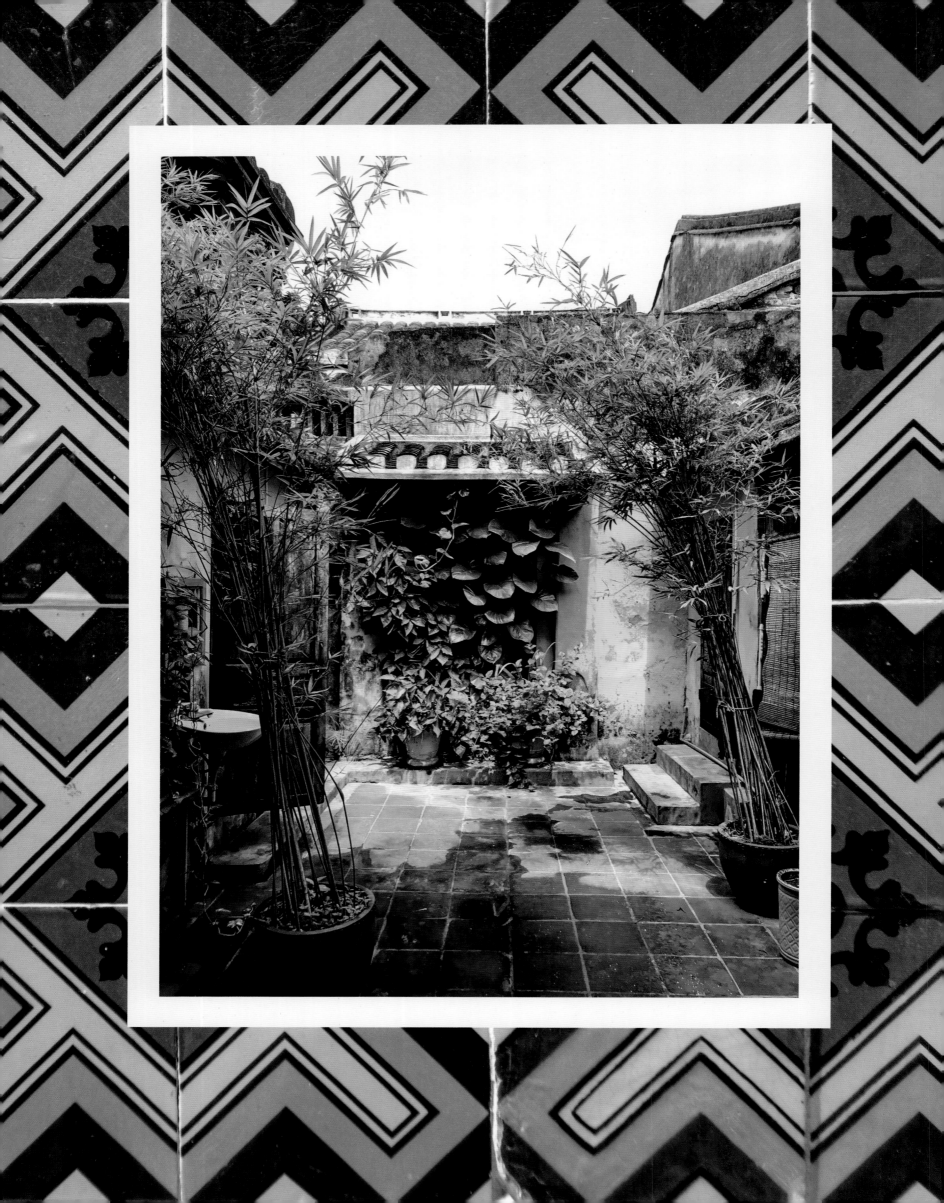

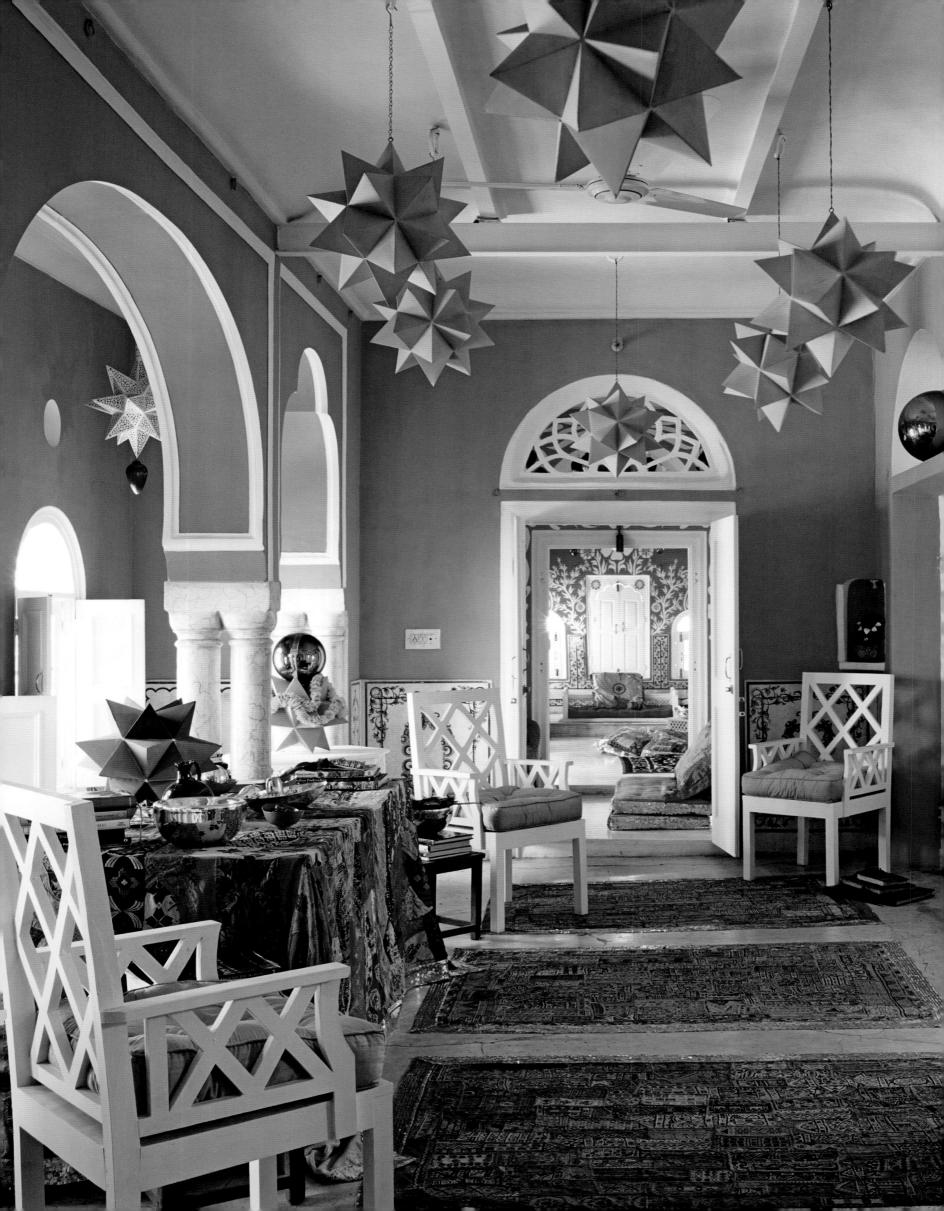

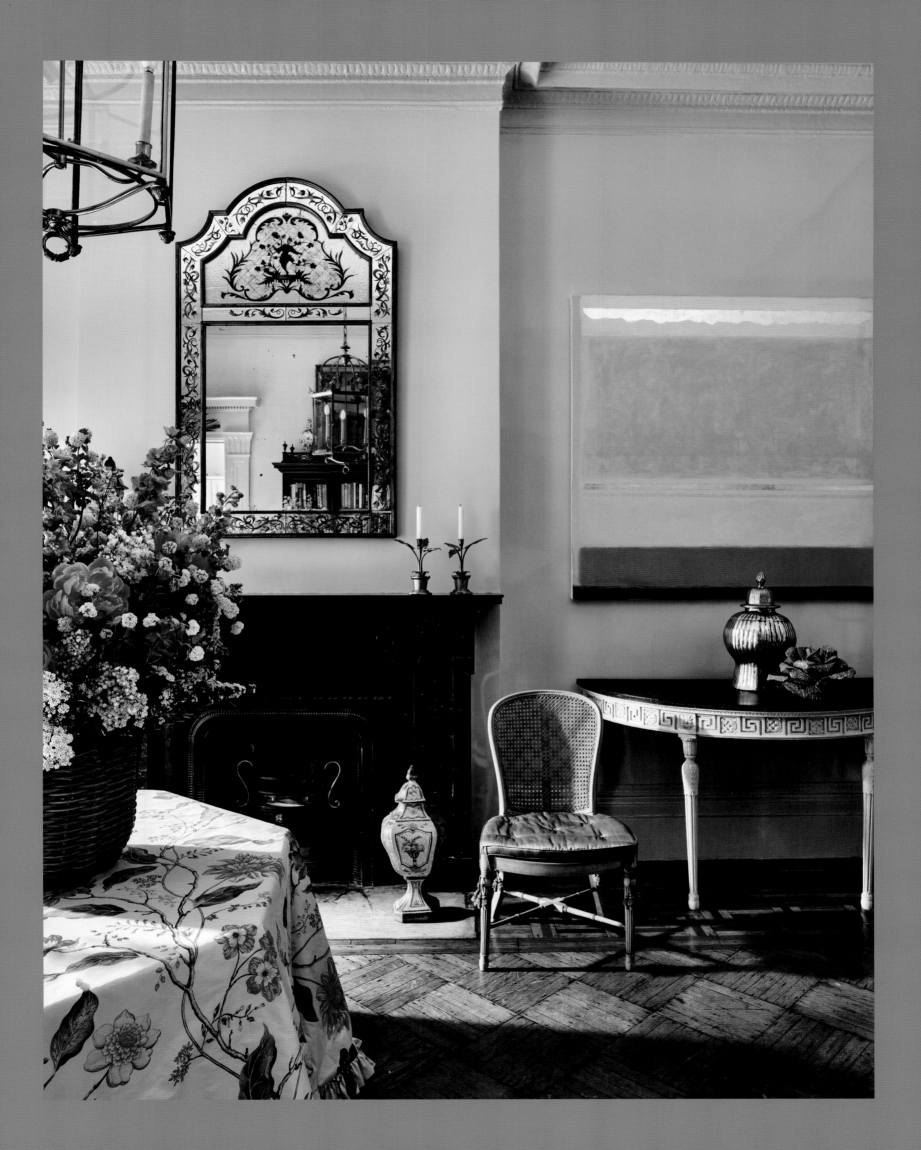

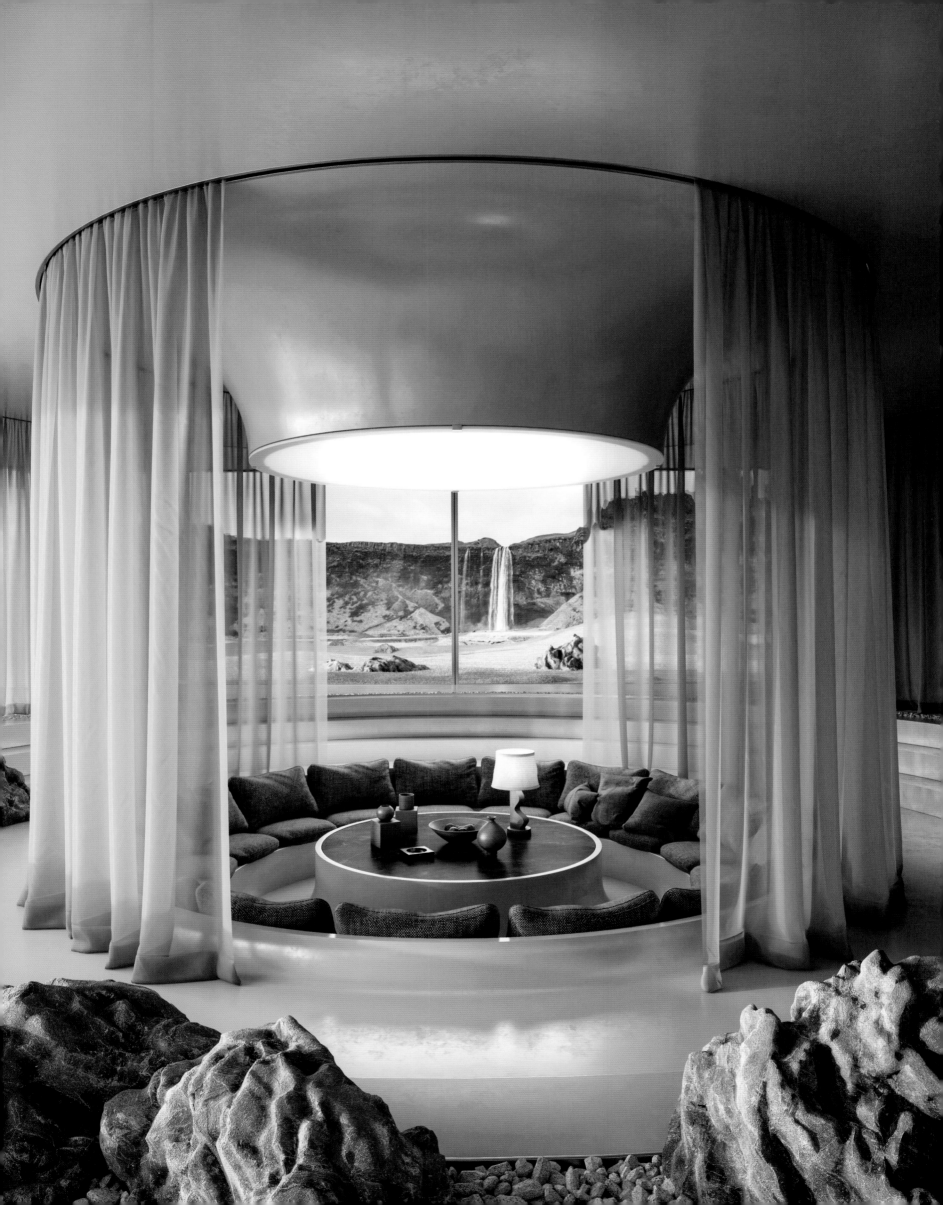

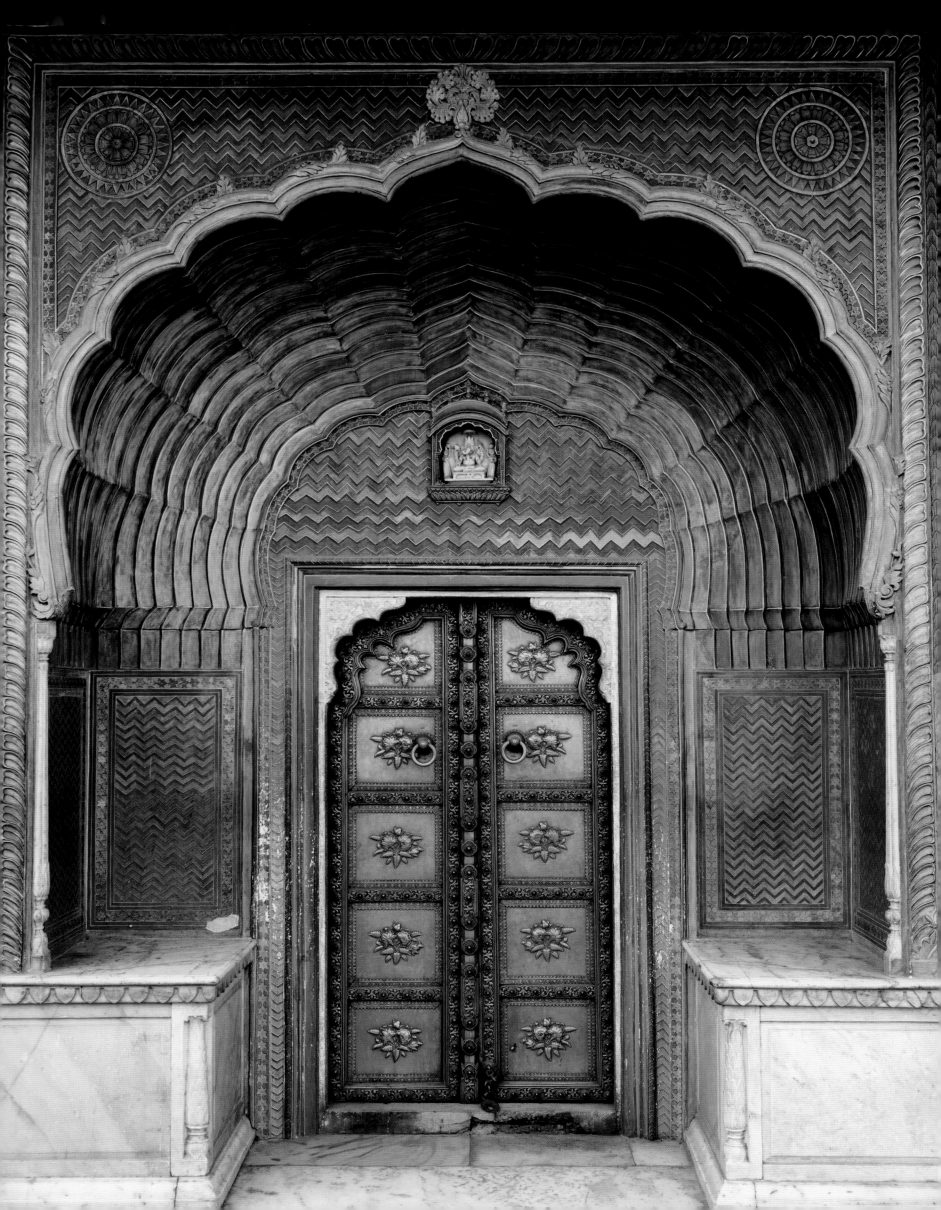

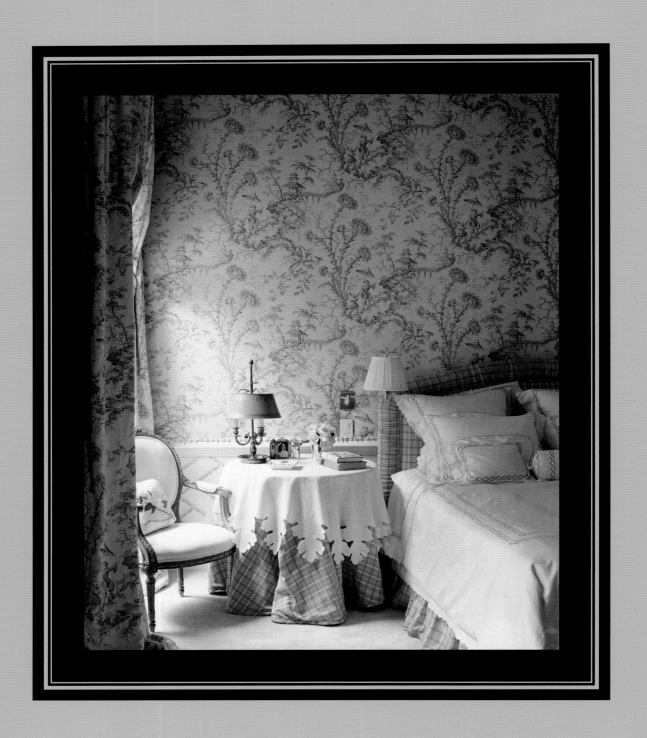

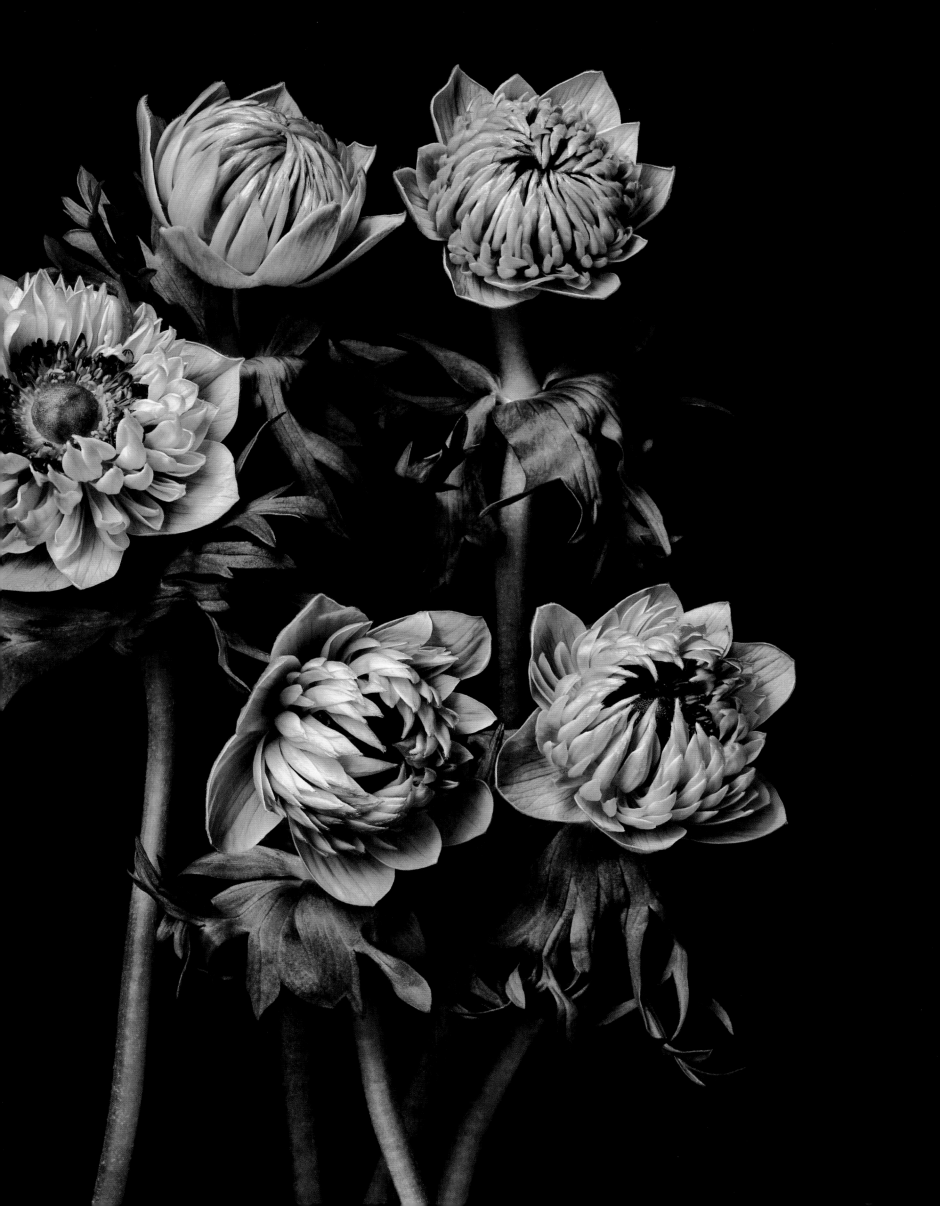

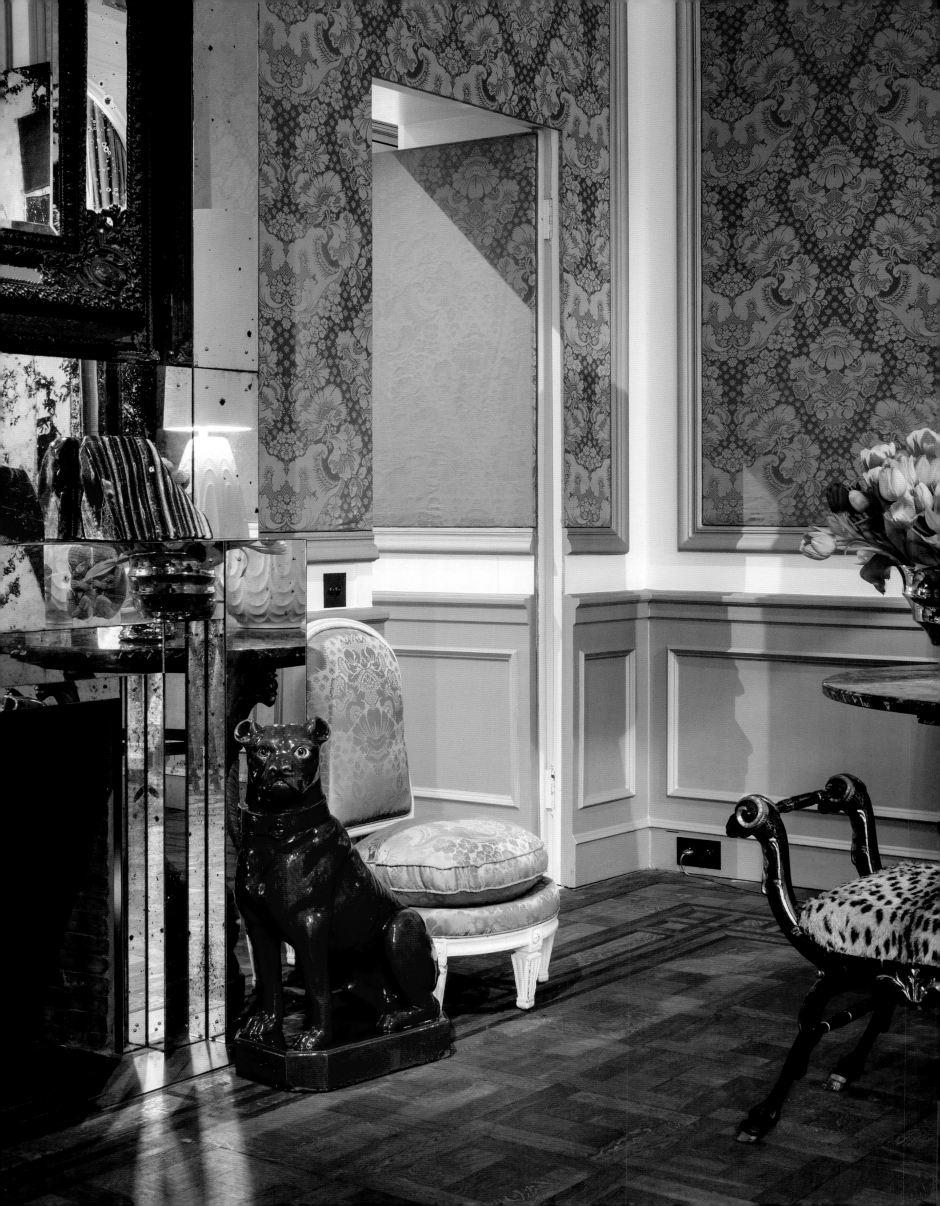

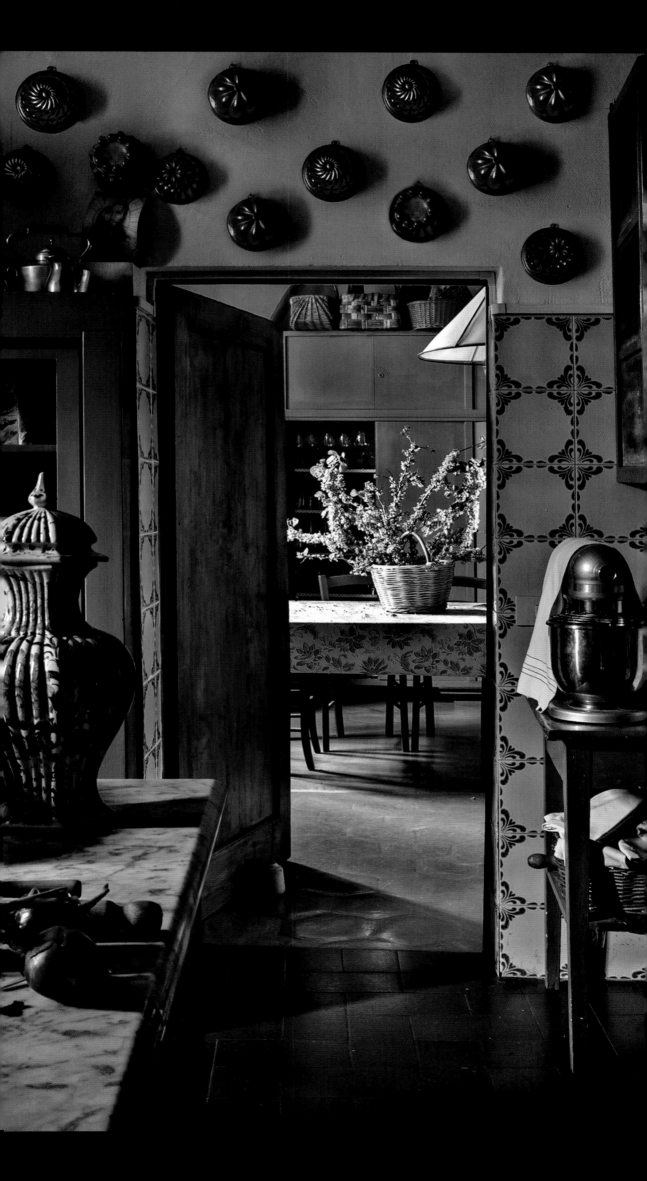

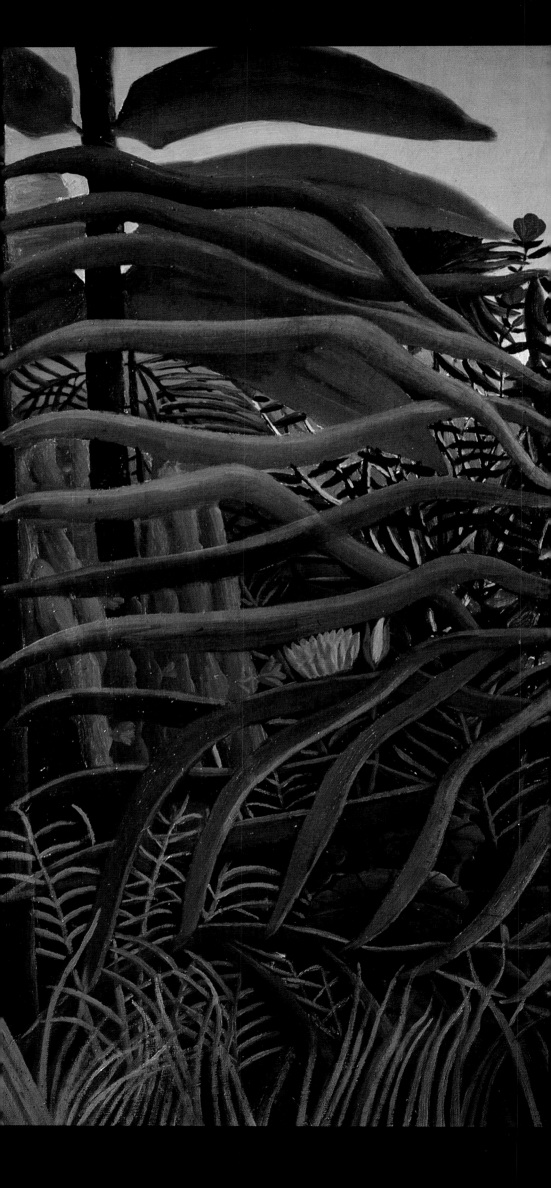

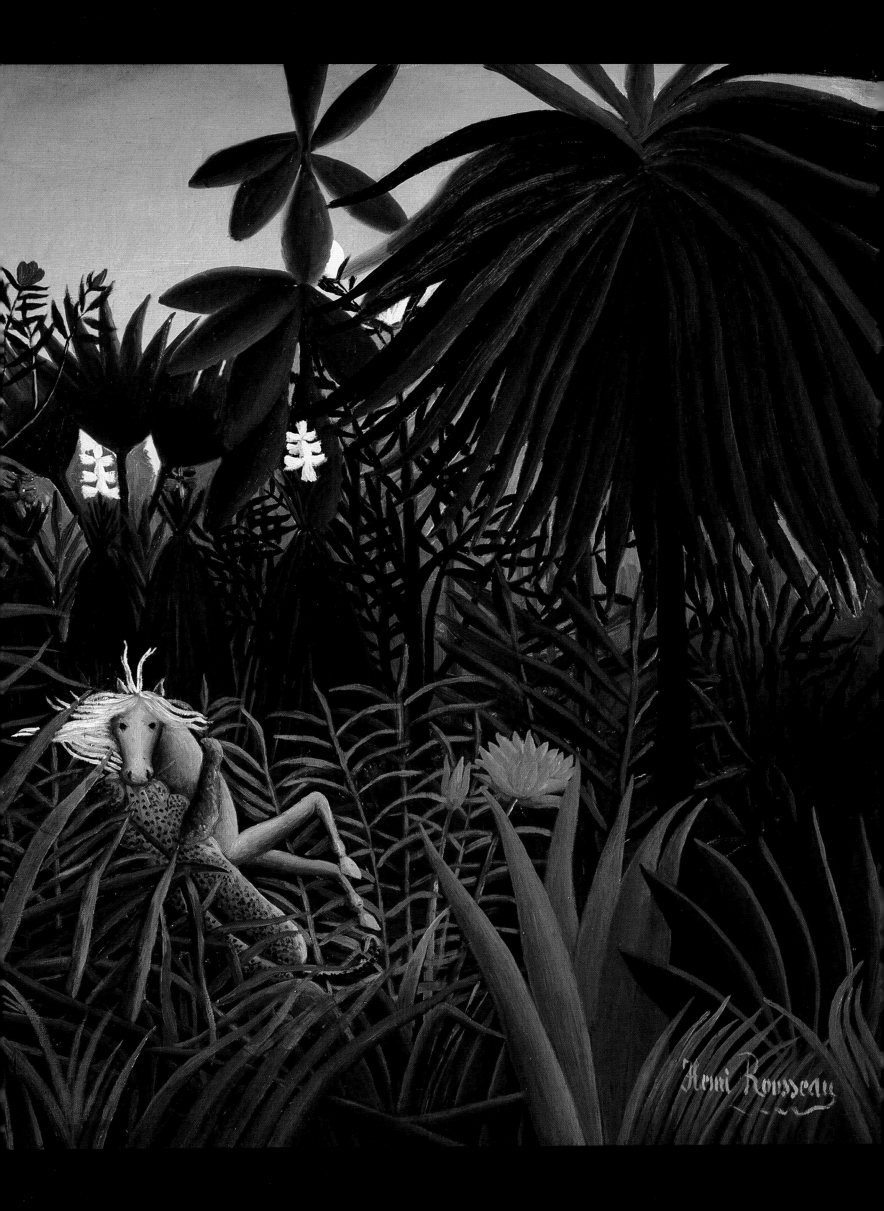

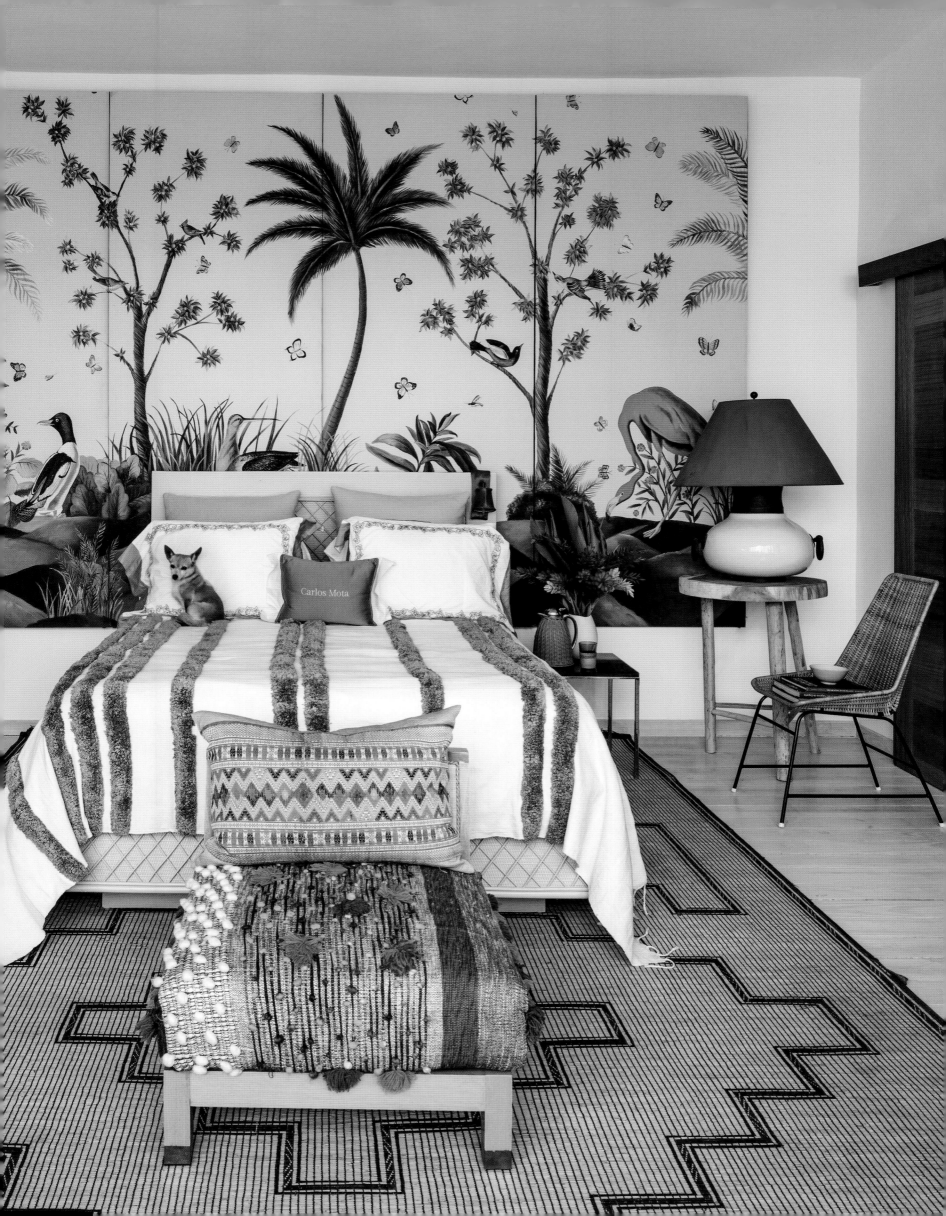

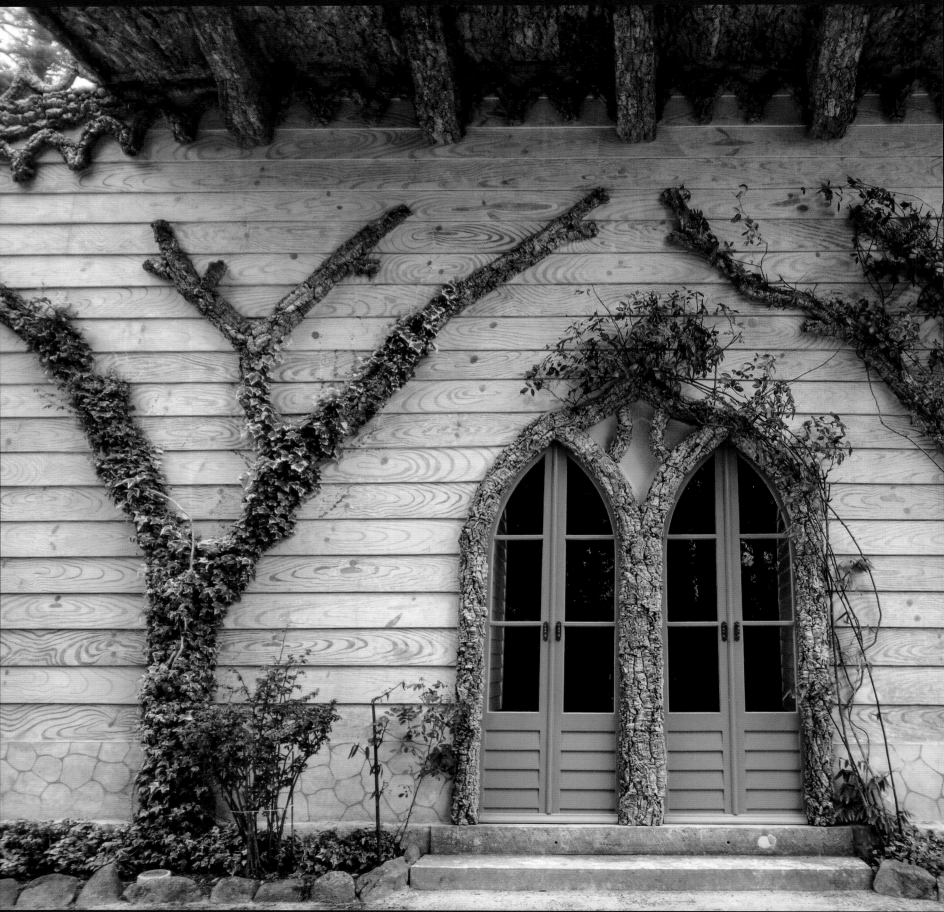

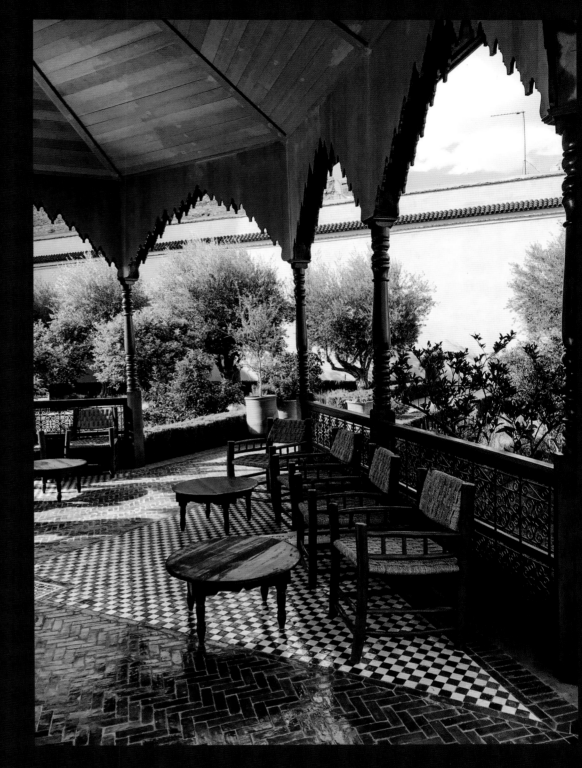

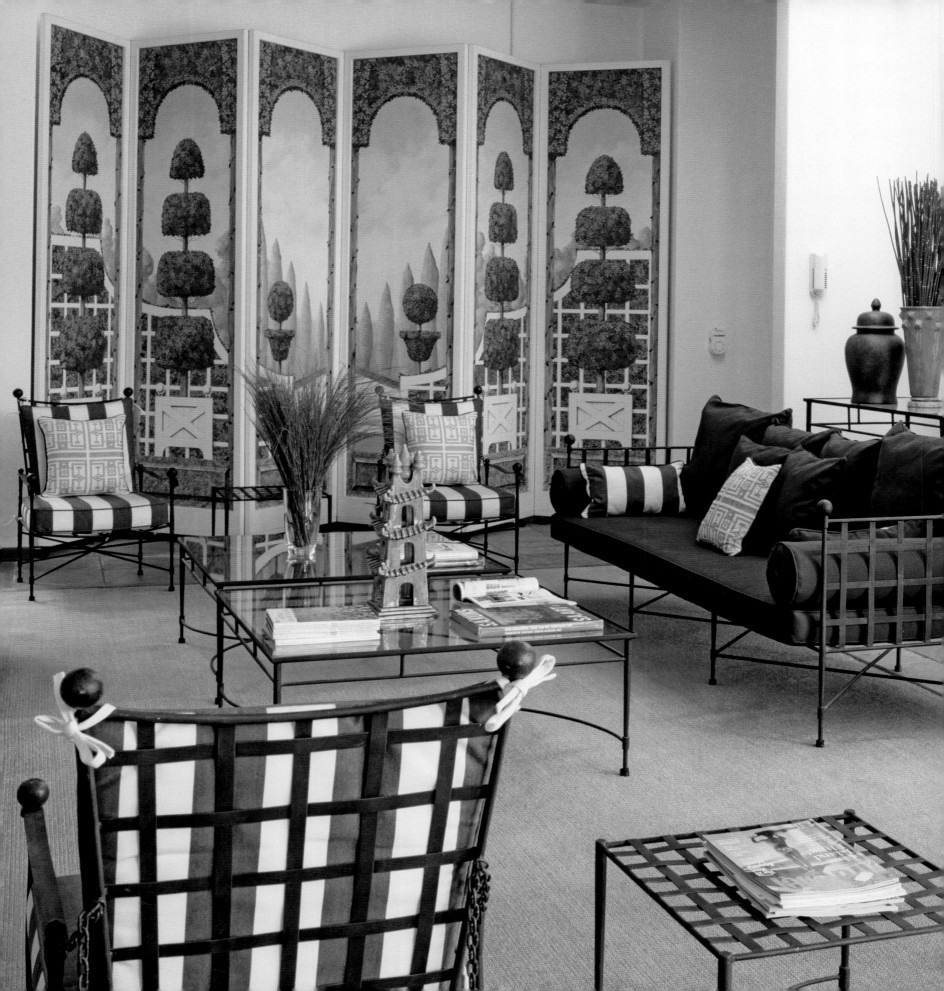

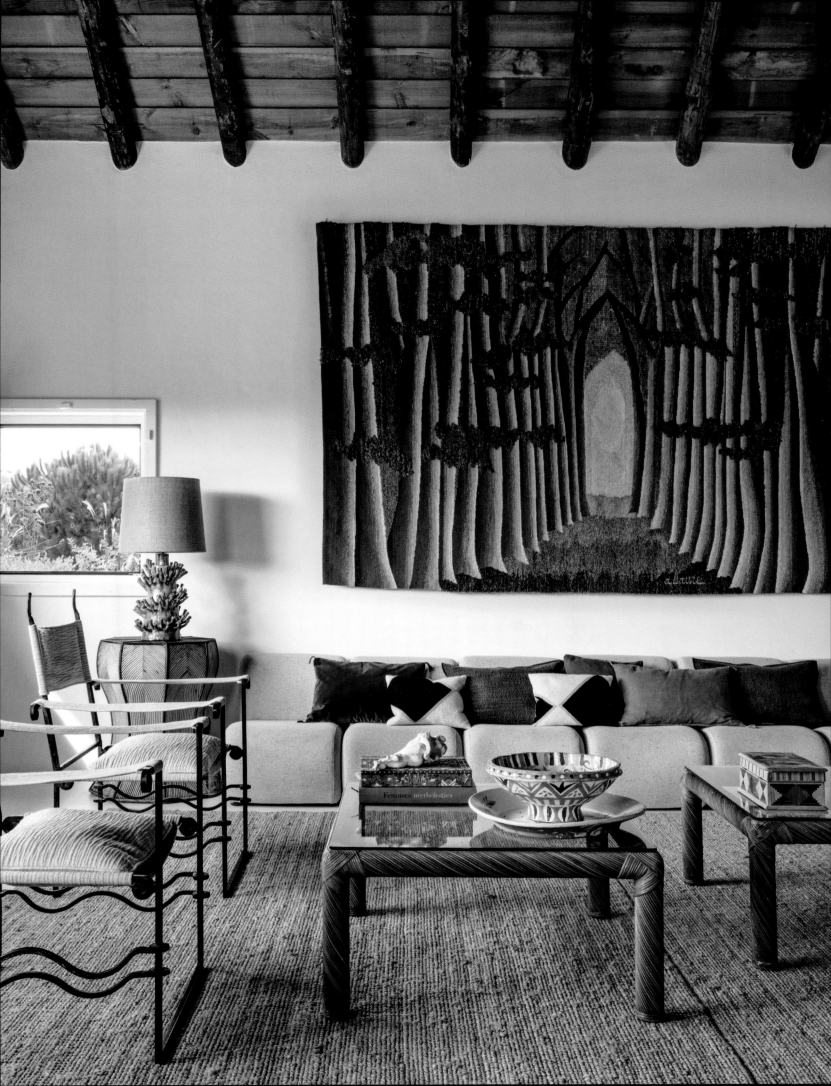

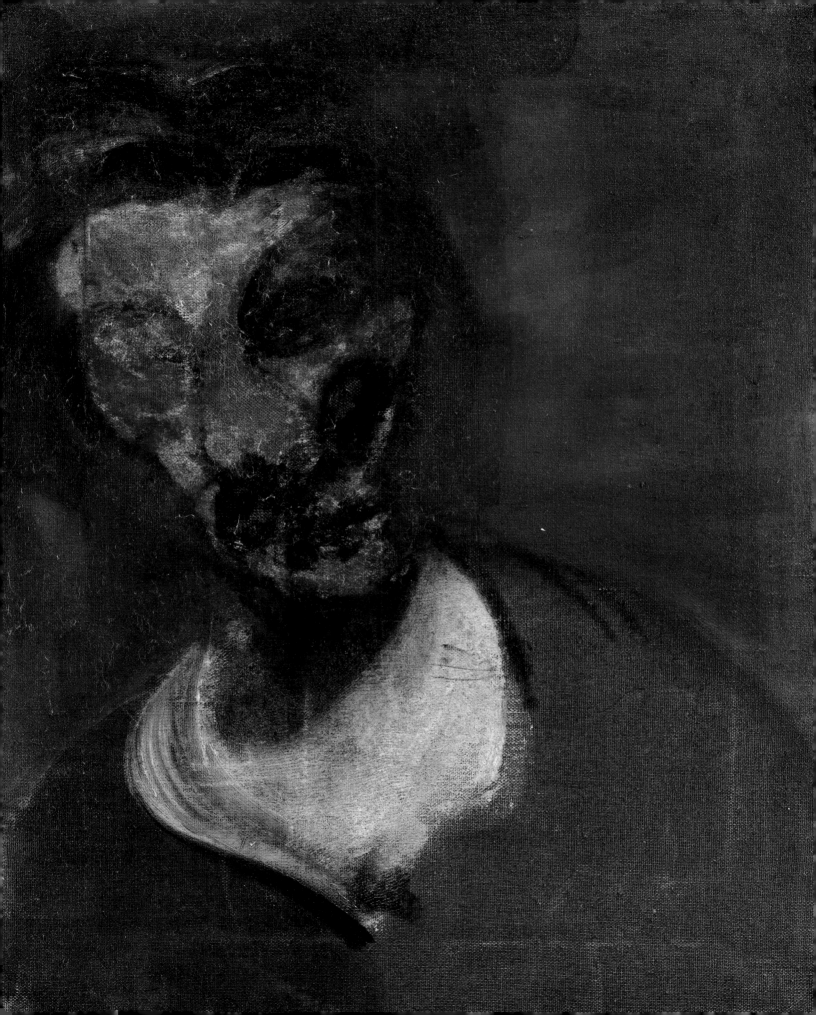

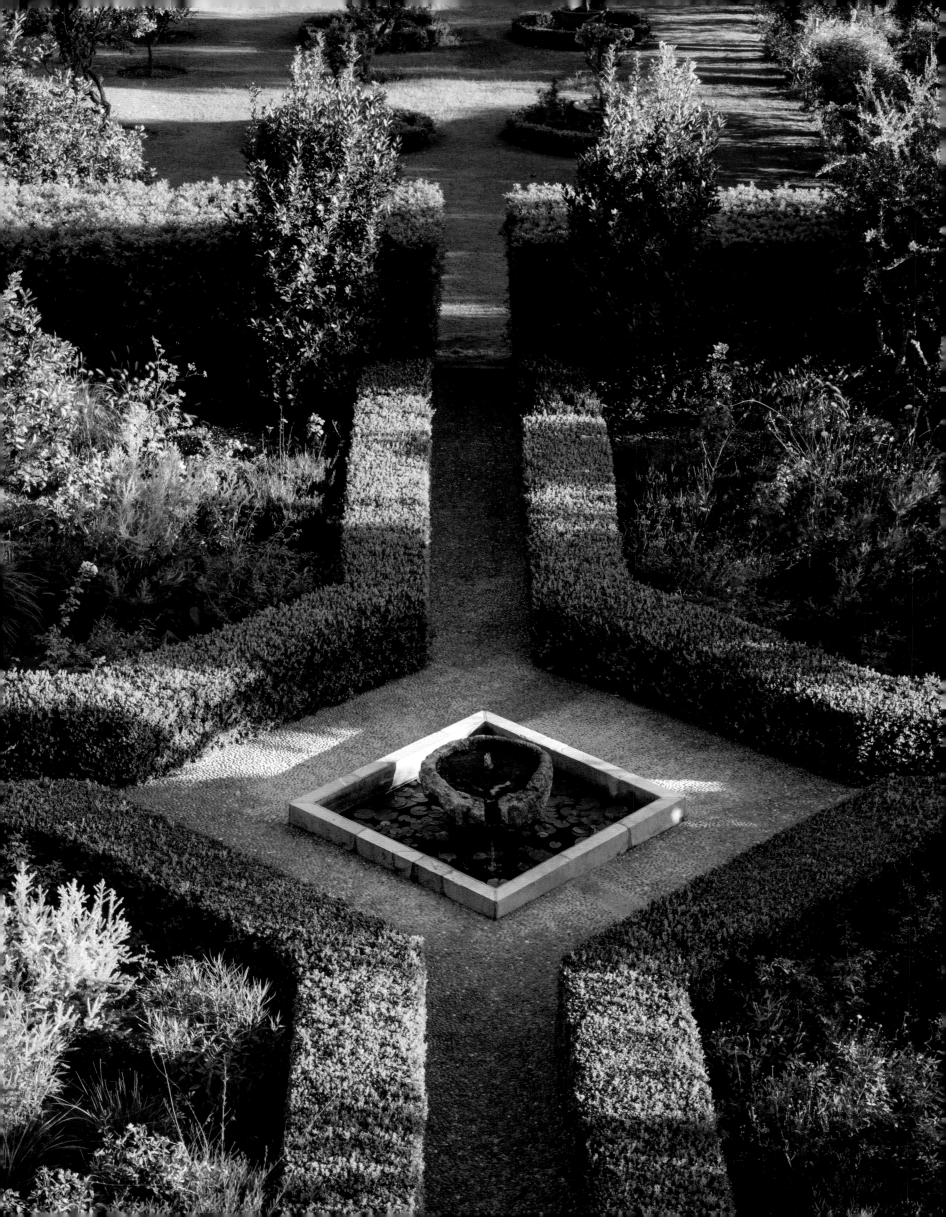

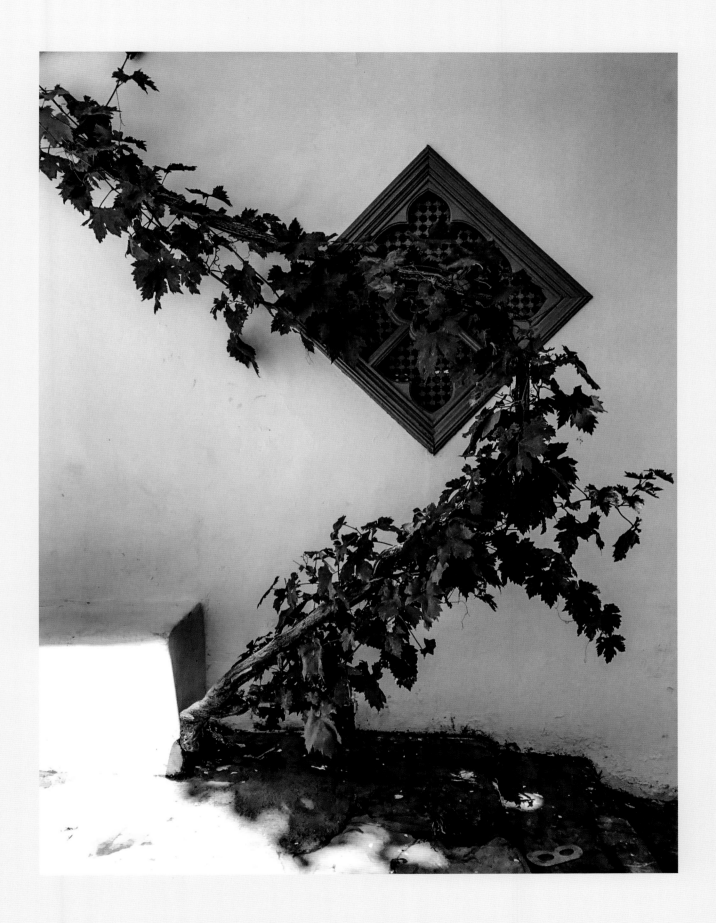

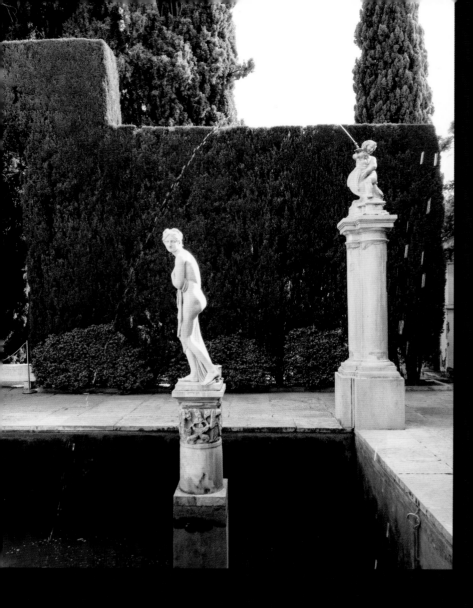
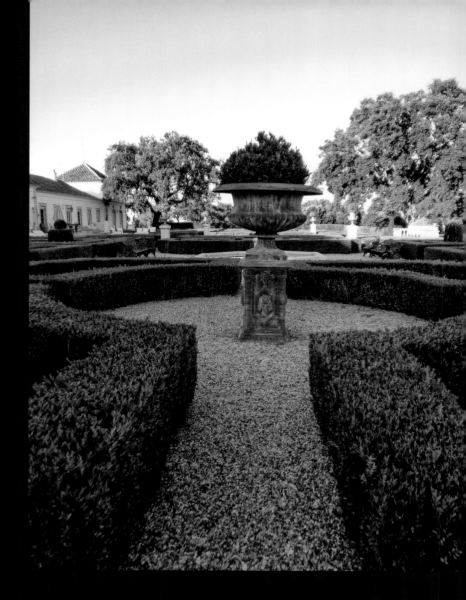
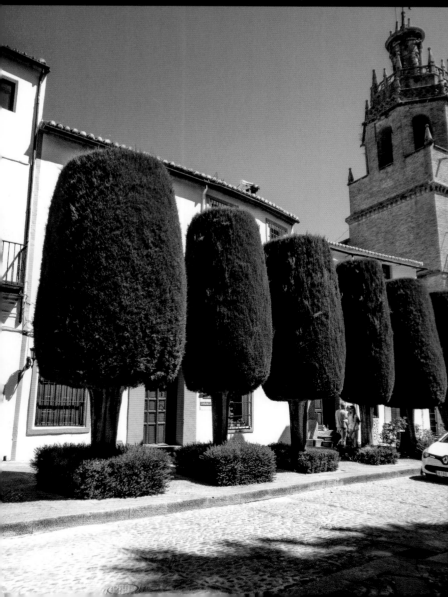
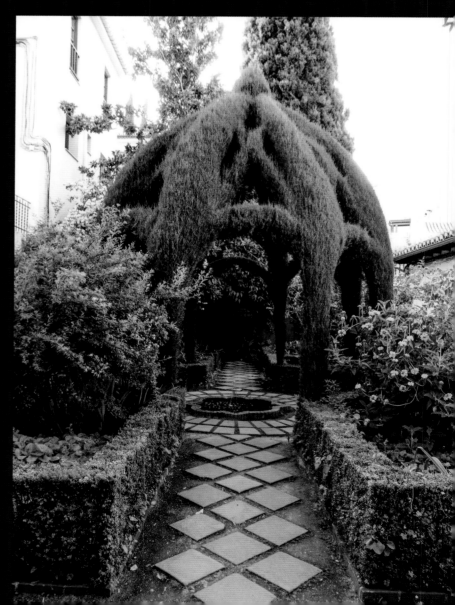

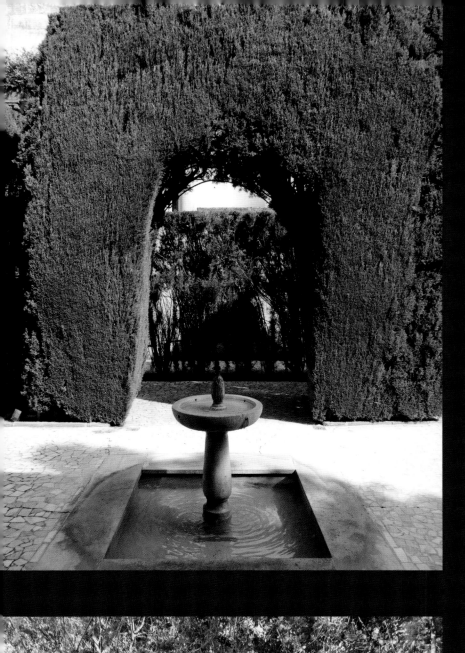
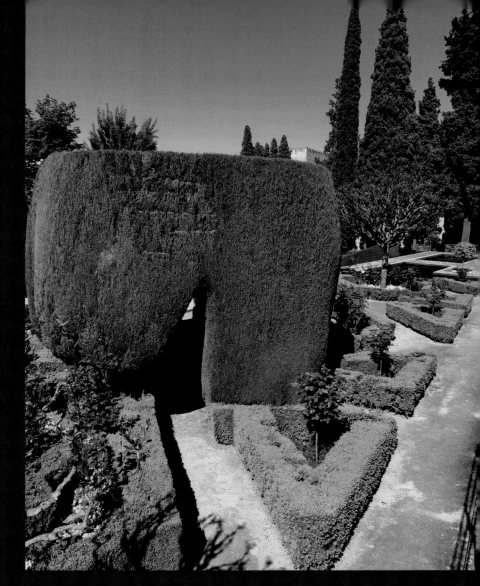
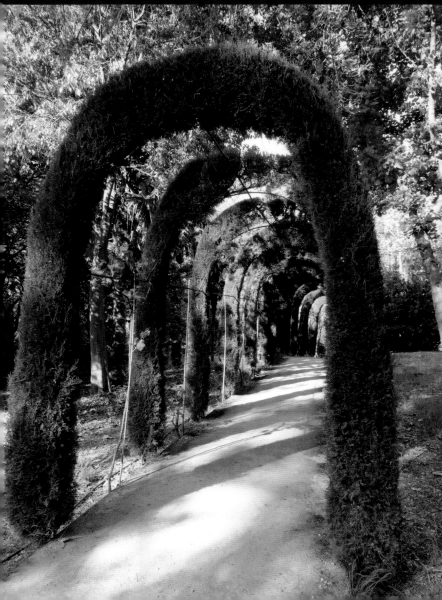
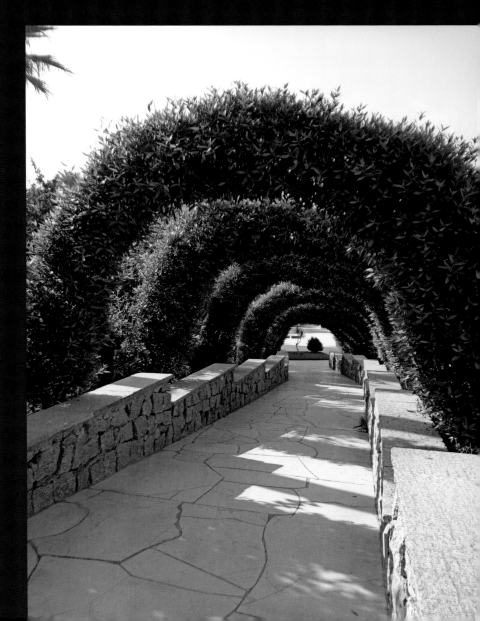

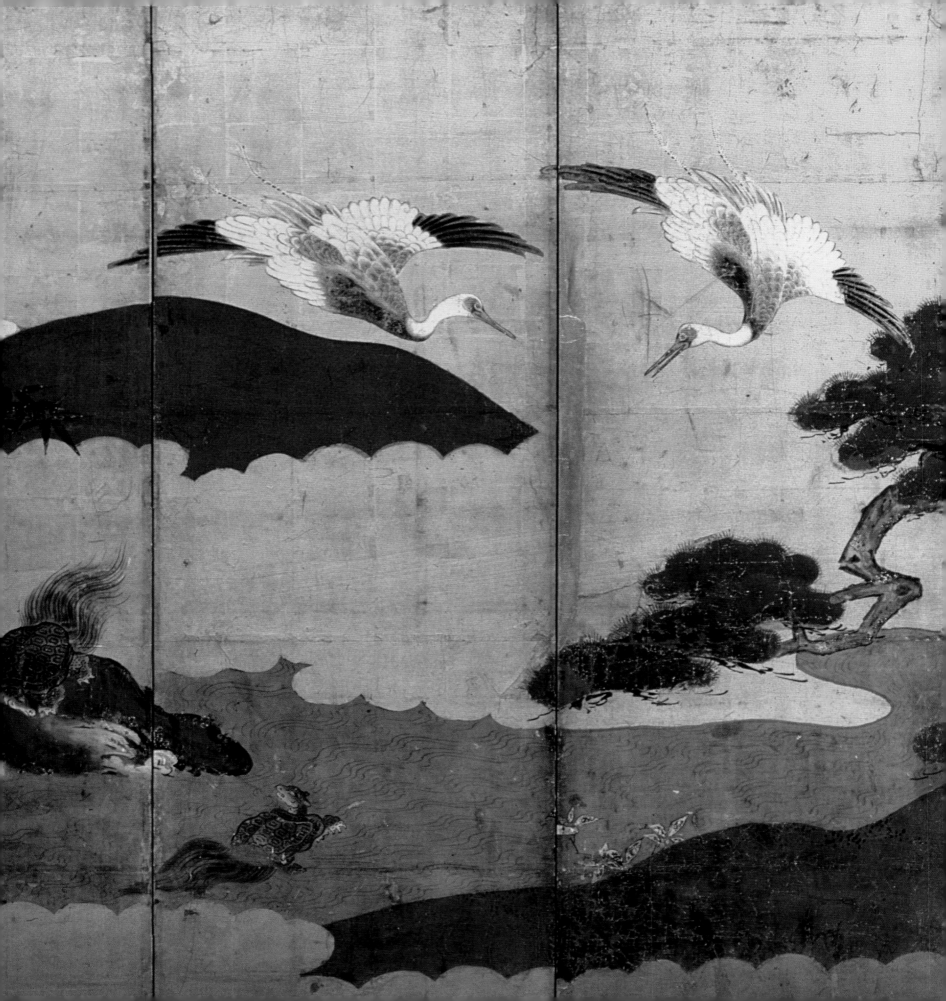

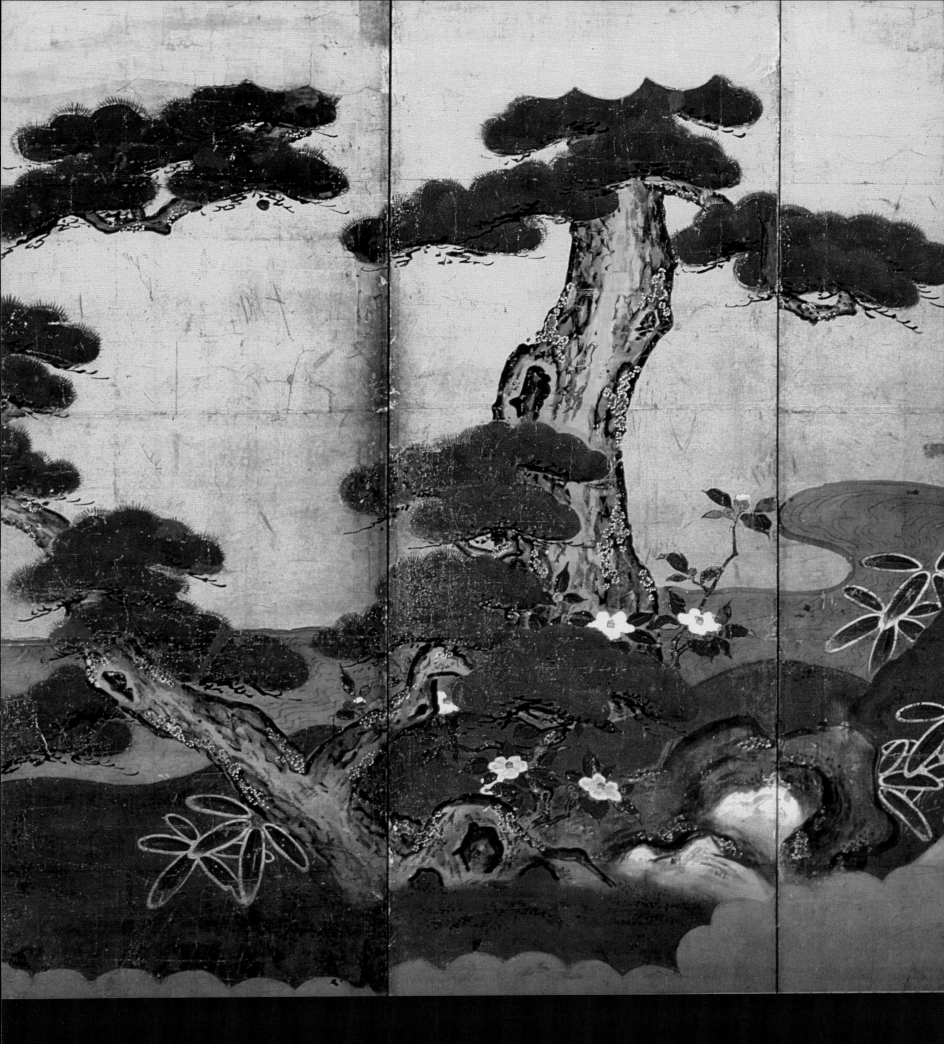

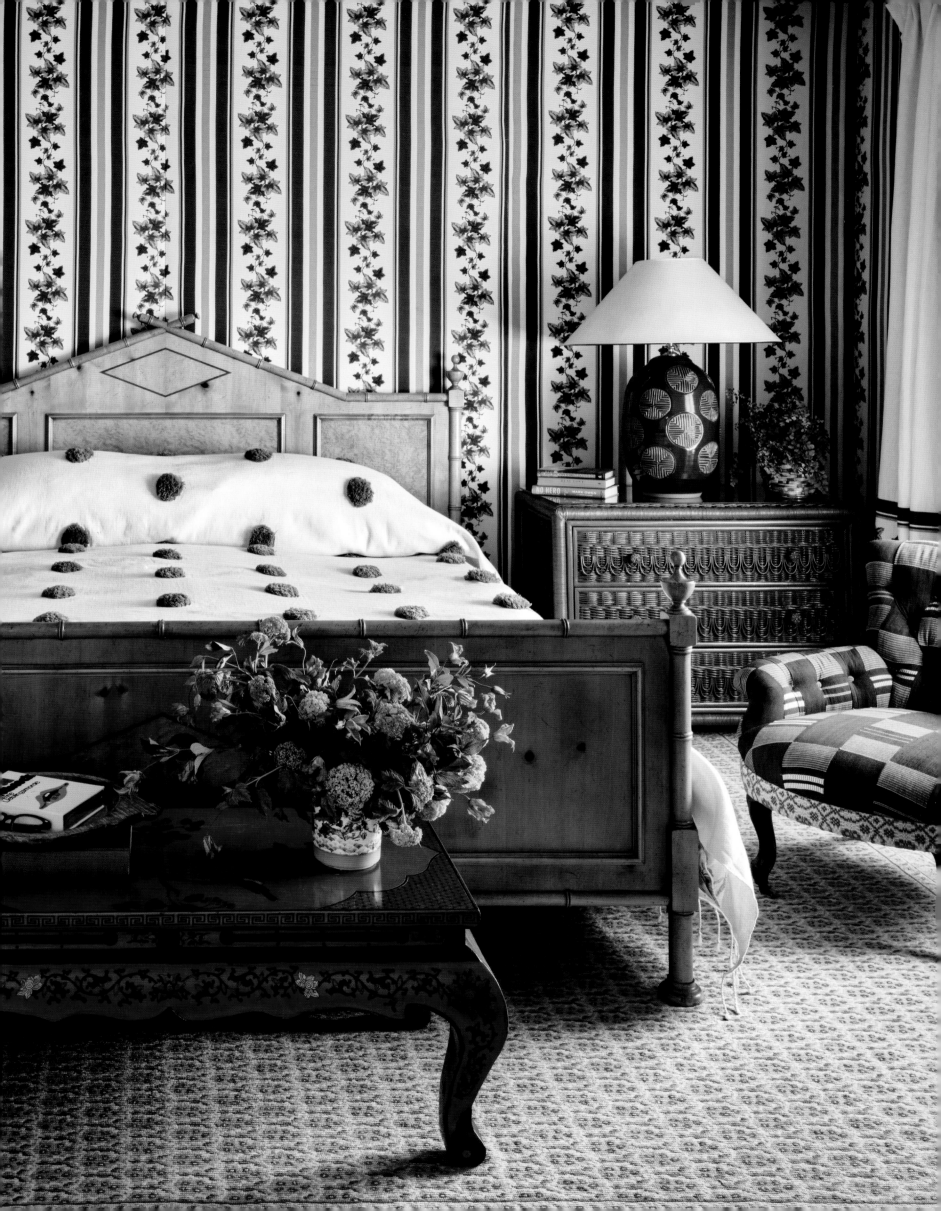

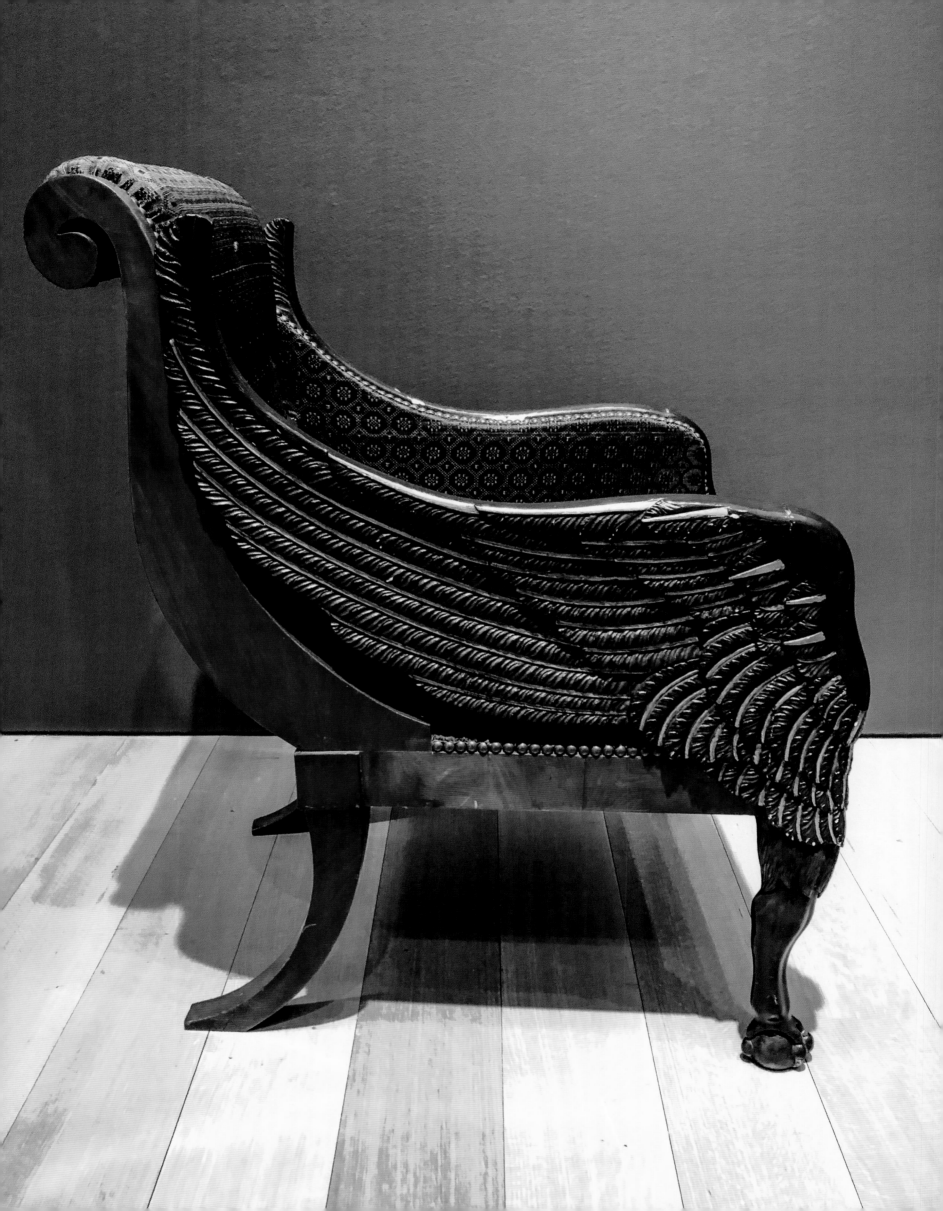

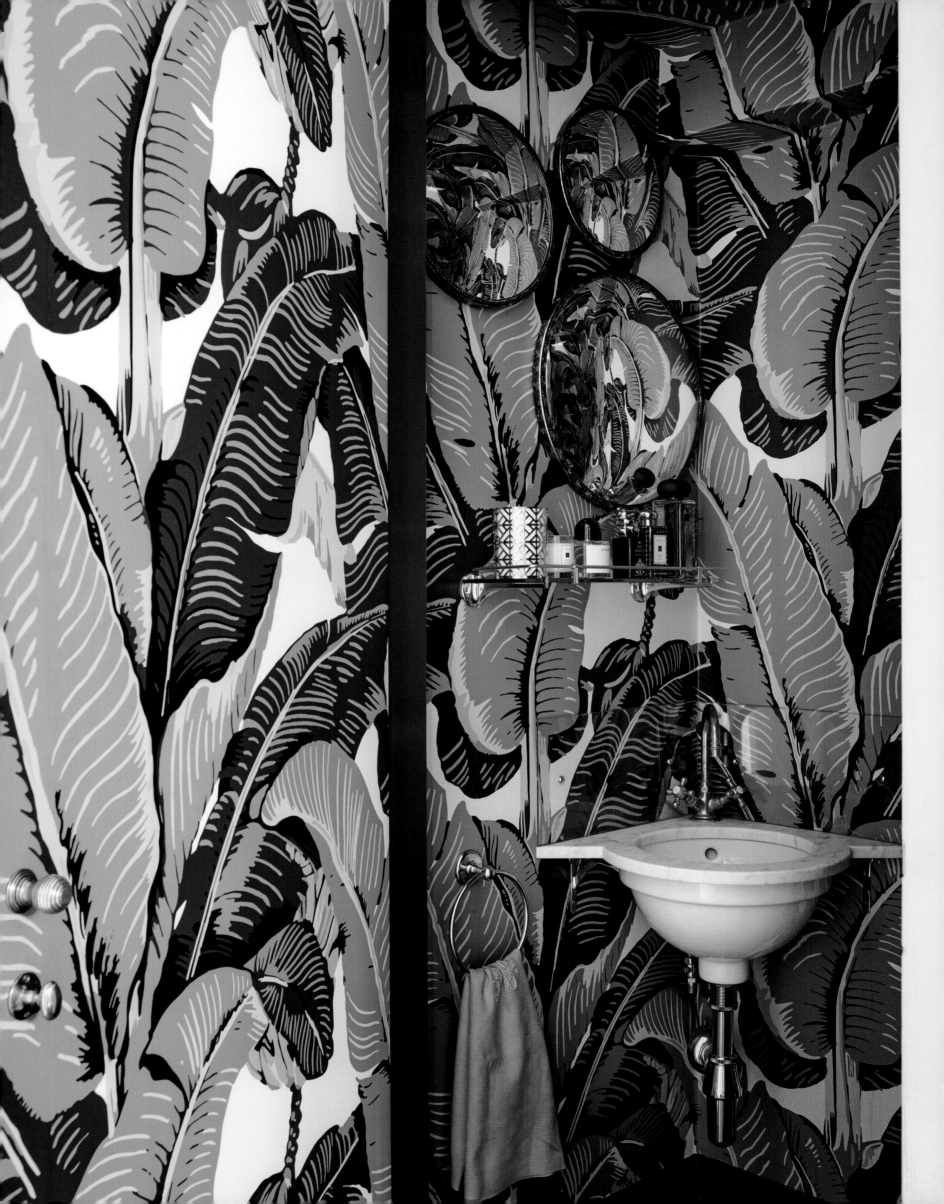

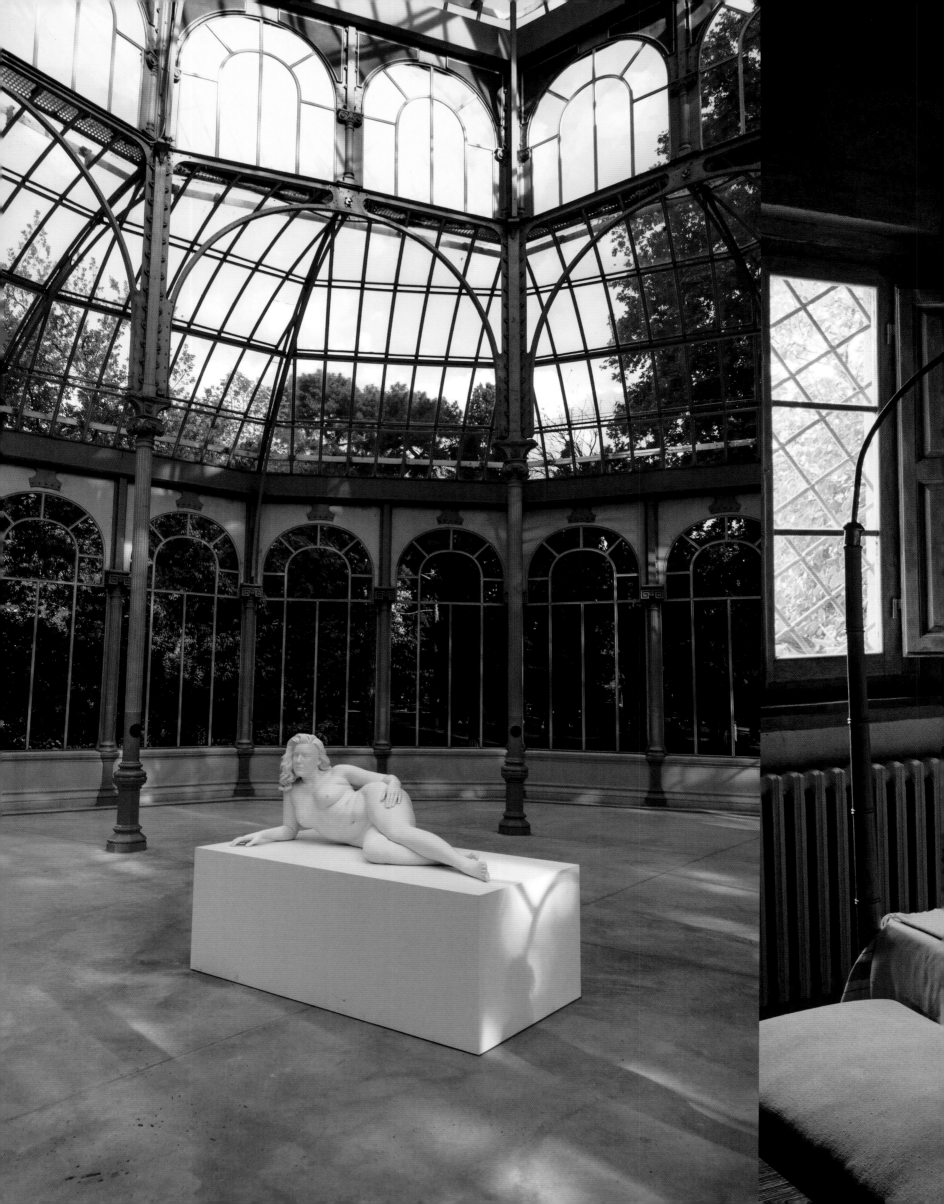

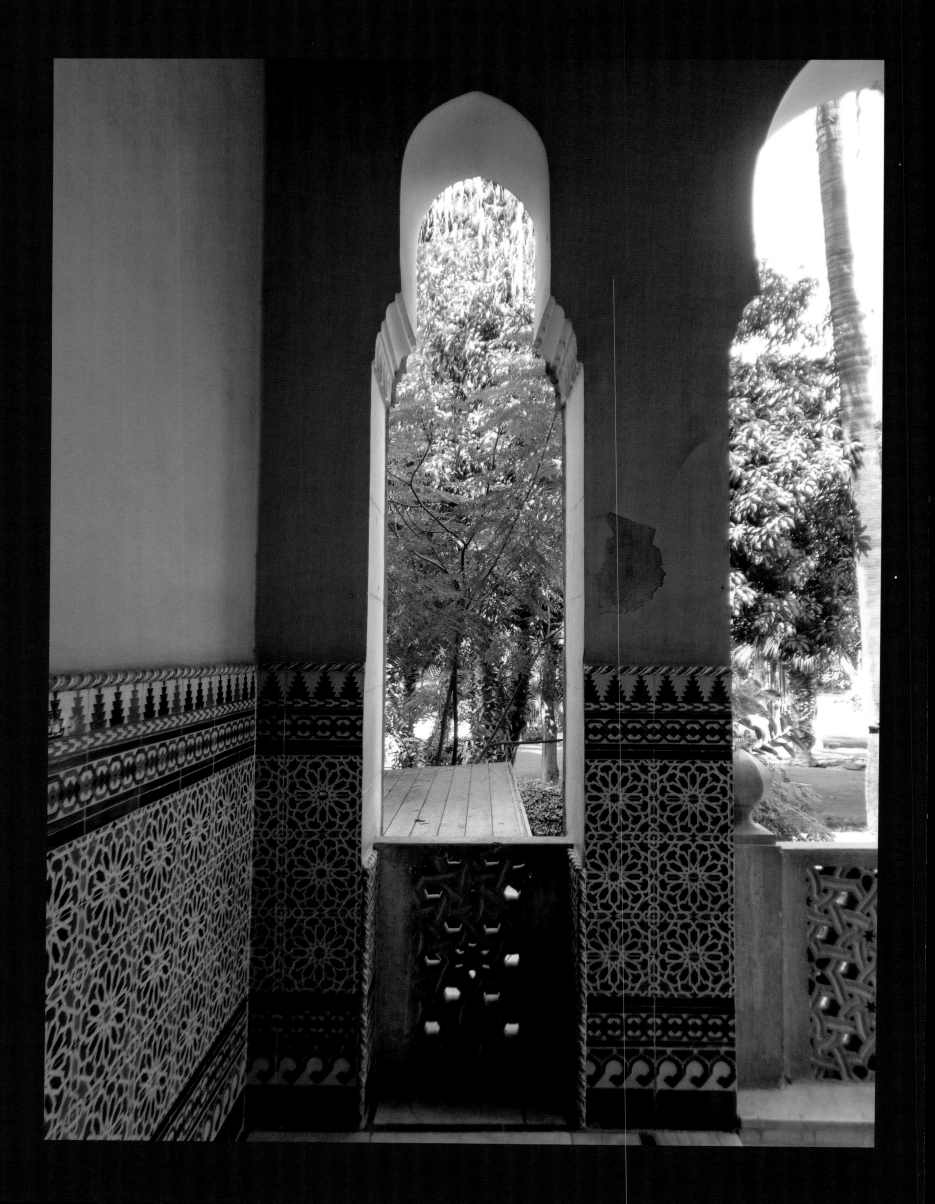

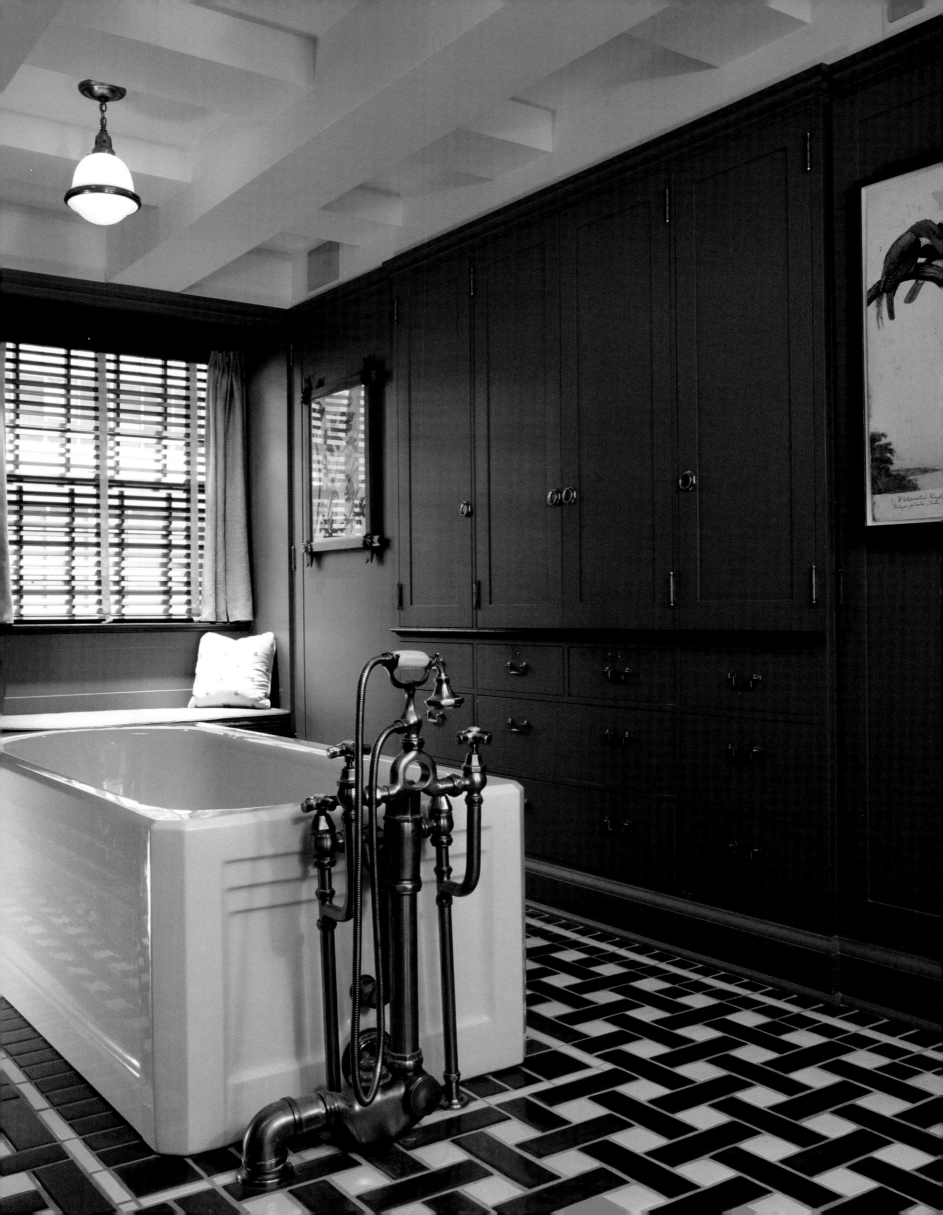

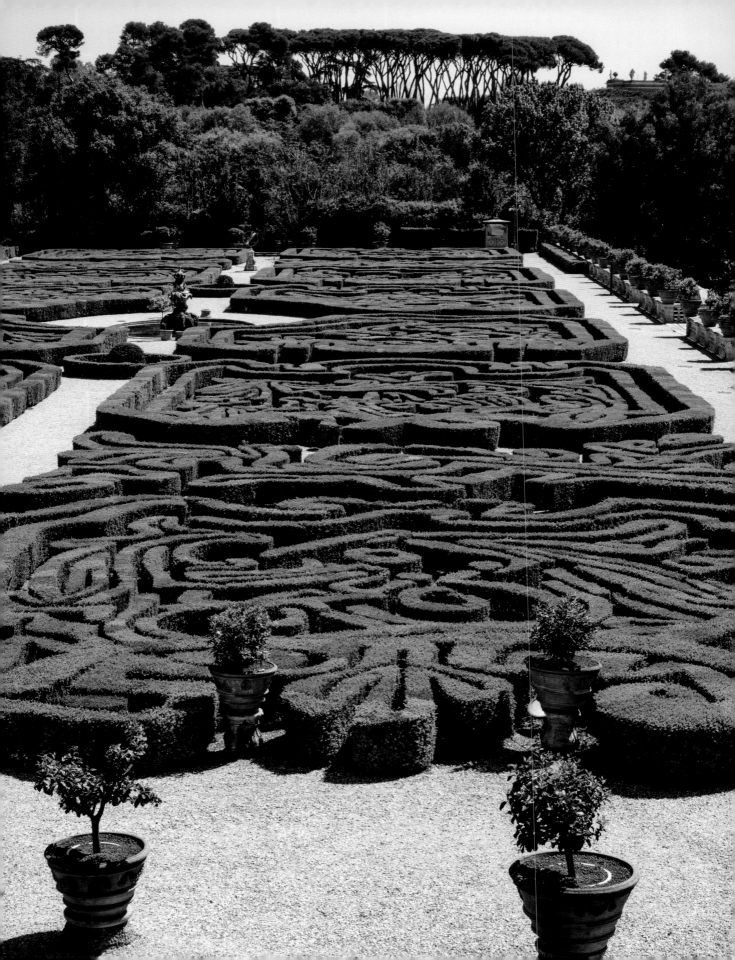

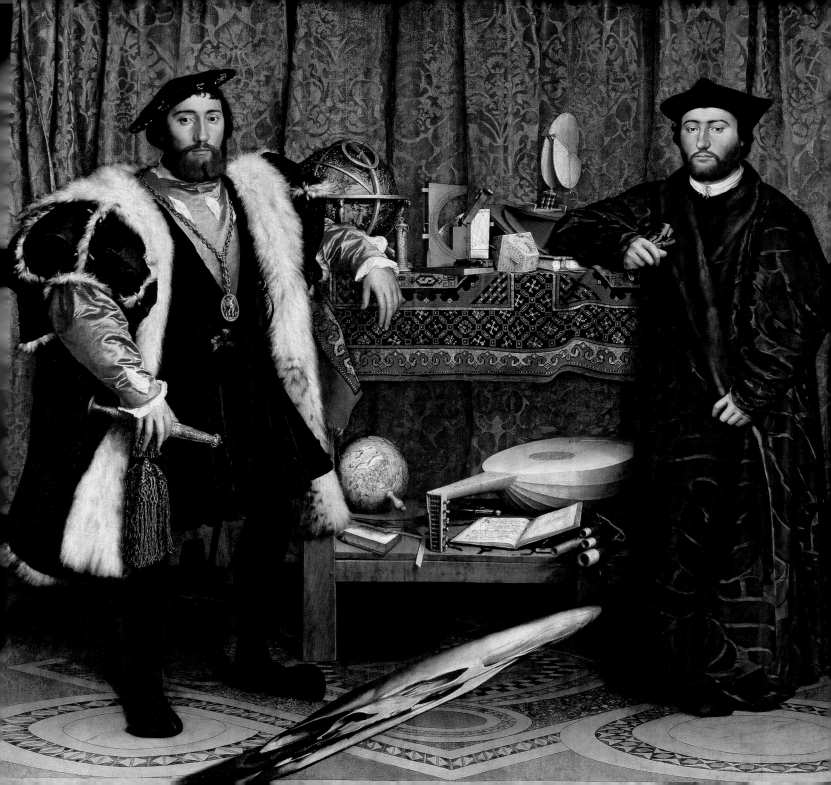

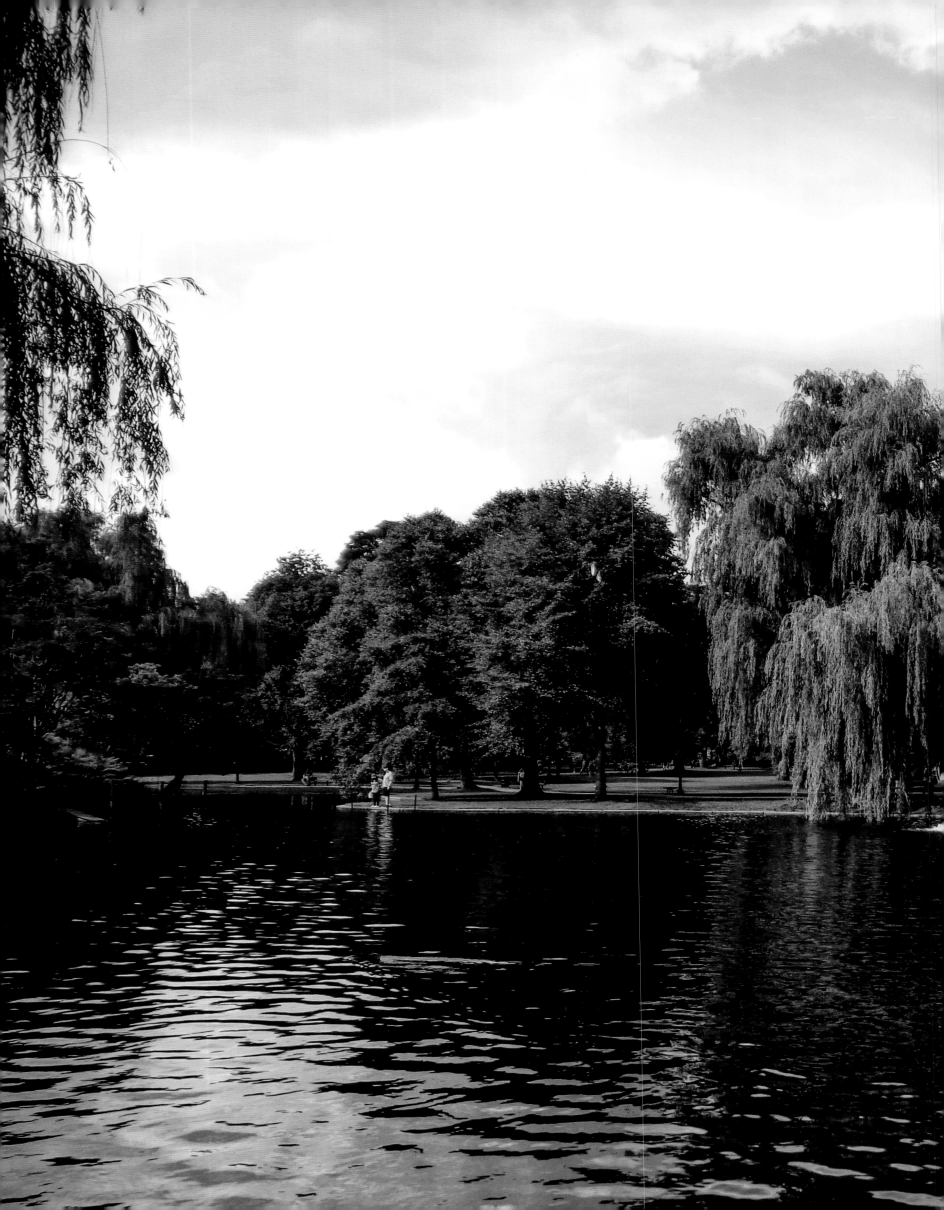

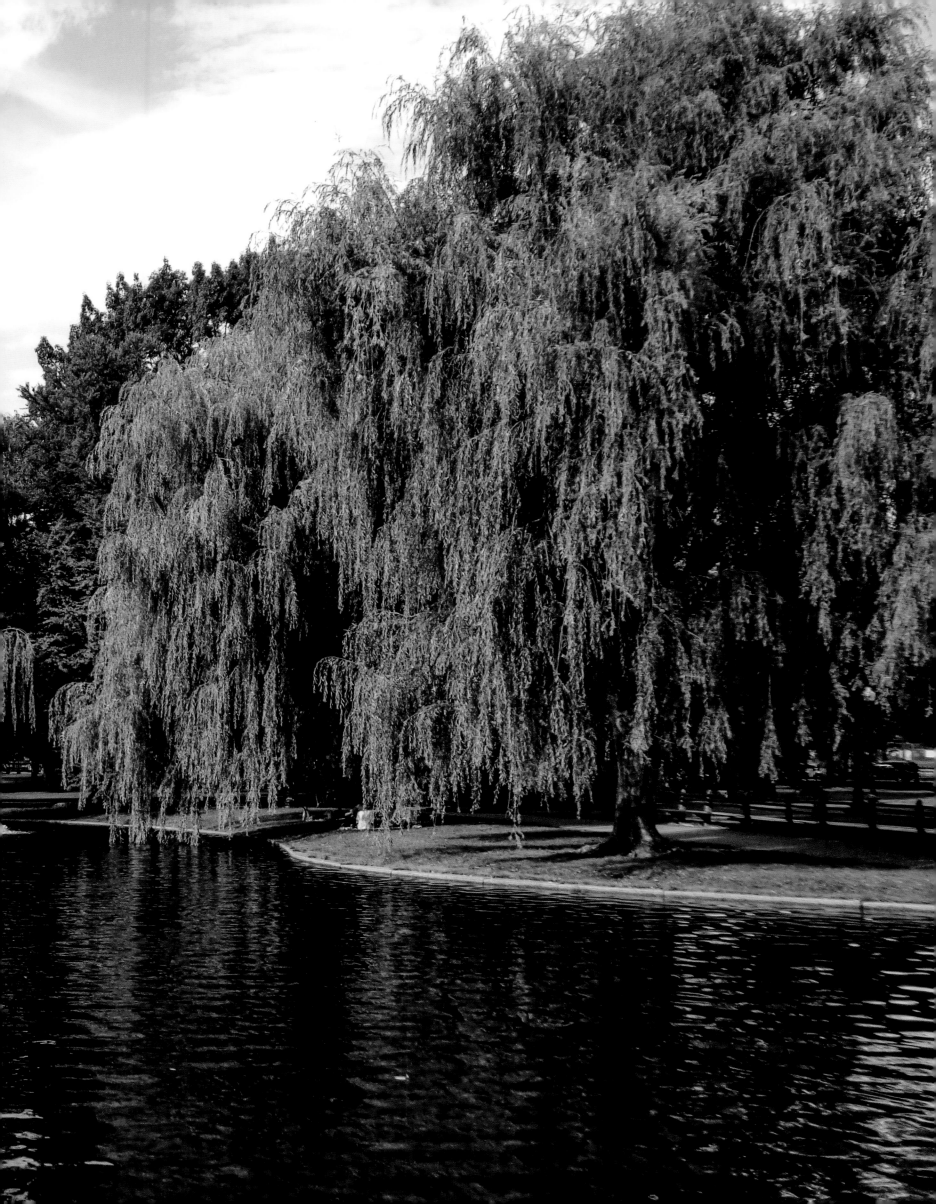

INDEX OF
PHOTOGRAPHS

Private garden, Portugal.
Photograph by Carlos Mota.

A market in Cairo.
Photograph by Carlos Mota.

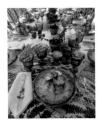

Residence of Tory Burch, Southampton, NY.
Photograph by Carlos Mota.

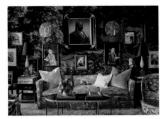

Residence of Carlos Mota, New York City.
Interior design by Carlos Mota. Photograph
© Simon Upton/The Interior Archive.

LEFT: Lucian Freud (1922–2011), *Still Life with Green Lemon*, 1947, oil on panel. Photograph © The Lucian Freud Archive, All rights reserved 2022/Bridgeman Images,
RIGHT: William de Morgan (1839–1917), Persian-style tile panel, ceramic. Photograph © De Morgan Foundation/Bridgeman Images.

LEFT: Photograph by Carlos Mota.
RIGHT: Hoi An, Vietnam. Photograph by Carlos Mota.

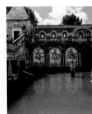

LEFT: Palácio dos Marqueses de Fronteira, Lisbon. Photograph by Carlos Mota.
RIGHT: Private residence in Marrakech. Photograph by Carlos Mota.

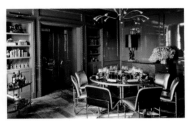

Interior design by Ken Fulk. Photograph © Douglas Friedman/Trunk Archive.

LEFT: Marfa, Texas. Photograph by Carlos Mota.
RIGHT: Interior design by Douglas Mackie. Photograph © Simon Upton/The Interior Archive.

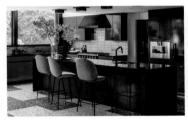

Private residence in Katonah, New York. Interior design by Alberto Villalobos. Photograph © Eric Piasecki/OTTO.

LEFT: Photograph by Carlos Mota.
RIGHT: Interior design by Mark D. Sikes. Photograph © Amy Neunsinger.

LEFT: Garden of Veere Grenney, Tangier. Photograph by Carlos Mota.
RIGHT: Garden of Christopher Burch, Senlis, France. Photograph by Carlos Mota.

LEFT: Melnotte evening slippers, 1840s. Photograph © Fashion Museum Bath/Bridgeman Images.
RIGHT: Shoe shop in Tangier. Photograph by Carlos Mota.

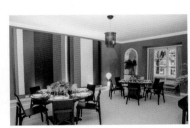

Private residence in Buenos Aires. Interior design by Solana Braun. Photograph © Steven Sierra.

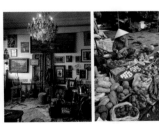

LEFT: Bar in Cairo. Photograph by Carlos Mota.
RIGHT: Market in Hoi An, Vietnam. Photograph by Carlos Mota.

LEFT: Interior design by Annie Austin. Phtograph © Bjorn Wallander.
RIGHT: Antiques store in Cairo. Photograph by Carlos Mota.

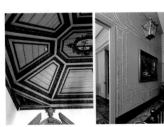

LEFT: Ceiling of a palace in Portugal. Photograph by Carlos Mota.
RIGHT: Private residence in New York City. Photograph © Kelly Marshall/OTTO.

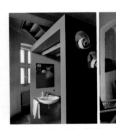

LEFT: Teaching Hotel Château Bethlehem, Maastricht. Photograph © Nicolas Mathéus/Laurence Dougier.
RIGHT: Interior design by Françoise Smilenko. Photograph © Vincent Knapp/The Interior Archive.

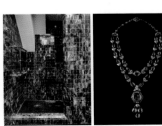

LEFT: Interior design by Gert Voorjans. Photograph © Tim Van de Velde.
RIGHT: Necklace by BHAGAT, Mumbai, India. Photograph by Jignesh Jhaveri.

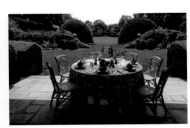

Residence of Tory Burch, Southampton, NY. Photograph by Carlos Mota.

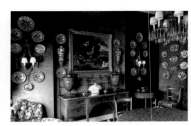
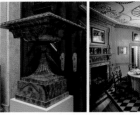

LEFT: Interior design by Hubert de Givenchy. Photograph © Francis Hammond.
RIGHT: Georgia O'Keeffe, *Alligator Pears*, 1923, oil on board, 13 ¾ × 9 ⅞ in. Photograph © 2021Georgia O'Keeffe Museum/Artists Rights Society (ARS), New York.

LEFT: Georges Jacob (1739–1814), Fauteuil, ca. 1785–90. Photograph © Bowes Museum/ Bridgeman Images.
RIGHT: Residence of Christopher Burch, Senlis, France. Photograph by Carlos Mota.

Private residence, Rome. Photograph © Tommaso Ziffer.

LEFT: Photograph © Konstantin Pukhov/Alamy Stock Photo.
RIGHT: George Washington's Mount Vernon, small dining room. Photograph by Rob Shenk, courtesy of Mount Vernon Ladies' Association.

LEFT: Private residence in New York City. Interior design by Alexia Leuschen. Photograph © Bjorn Wallander.
RIGHT: Residence of Miguel Amaral Netto, Lisbon. Photograph by Carlos Mota.

LEFT: Fortuny Moresco fabric.
RIGHT: The garden at Castello Ruspoli, Vignanello, Italy. Photograph © Antonio Monfreda.

LEFT: Window in Portugal. Photograph by Carlos Mota.
RIGHT: Private residence in the Dominican Republic. Photograph © Simon Upton/The Interior Archive.

LEFT: Garden in Granada, Spain. Photograph by Carlos Mota.
RIGHT: Residence of Amanda and Christopher Brooks, Oxfordshire, England. Photograph by Carlos Mota.

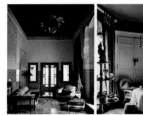

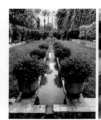
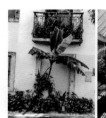

LEFT: Interior design by Stephen di Renza and Bruno Ussel. Photograph © Douglas Friedman/ Trunk Archive.
RIGHT: Residence of interior designer Gert Voorjans, Antwerp. Photograph © Miguel Flores-Vianna/The Interior Archive.

LEFT: Detail of an antique wallpaper, Lisbon. Photograph by Carlos Mota.
RIGHT: The Alhambra, Granada, Spain. Photograph by Carlos Mota.

LEFT: Private garden in Marrakech. Photograph by Carlos Mota.
RIGHT: Garden at Museu Serralves, Porto, Portugal. Photograph by Carlos Mota.

LEFT: Street in Lisbon. Photograph by Carlos Mota.
RIGHT: Greenhouse at the residence of Tory Burch, Antigua. Photograph by Carlos Mota.

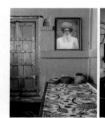
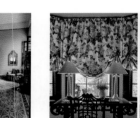

LEFT: Alcuzcuz Hotel Boutique, Málaga, Spain. Photograph by Carlos Mota.
RIGHT: Residence of Rachel and Ara Hovnanian, Miami. Photograph by Carlos Mota.

LEFT: A mosque in Cairo. Photograph by Carlos Mota.
RIGHT: Private residence in New York City. Interior design by Alexia Leuschen. Photograph © Bjorn Wallander.

LEFT: Jodhpur, India. Photograph by Jean-Marc Palisse, Alix de Dives/The Interior Archive.
RIGHT : Residence of James Jordan in Mérida, Mexico. Interior design by John Prentice Powell and James Jordan. Photograph © Matthieu Salvaing.

LEFT: Interior design by Patrick Mele. Photograph © Kyle Knodell.
RIGHT: Interior design by Gert Voorjans. Photograph © Tim Van de Velde.

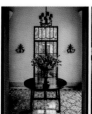
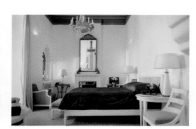

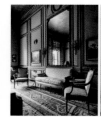

LEFT : Residence of James Jordan, Mérida, Mexico. Interior design by John Prentice Powell and James Jordan. Photograph © Matthieu Salvaing.
RIGHT: Photograph © ImageBROKER/Alamy Stock Photo.

Residence of Yves Saint Laurent and Pierre Bergé, Tangier. Interior design by Jacques Granges. Photograph © François Halard.

LEFT: Residence of Robert Indiana, Vinalhaven, Maine. Photograph © Douglas Friedman/Trunk Archive.
RIGHT: Dodie Thayer ceramics. Photograph © Douglas Friedman/Trunk Archive.

LEFT: Private residence in New York City. Interior design by Alexia Leuschen. Photograph © Bjorn Wallander.
RIGHT: Private residence in Amsterdam. Interior design by Trudy Derksen. Photograph © Joanna Maclennan/The Interior Archive.

LEFT: Photograph © Debi Shapiro.
RIGHT: Private residence in New York City. Interior design by Alexia Leuschen. Photograph © Bjorn Wallander.

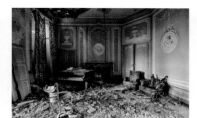

Ouverture. Photograph © Reginald Van de Velde.

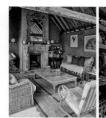

LEFT: Interior design by Sarah Vanrenen. Photograph © David Parmiter.
RIGHT: Residence of designers Liza Bruce and Nicholas Alvis Vega, Ourika Valley, Morocco. Photograph © Simon Upton/The Interior Archive.

Photographs by Carlos Mota.

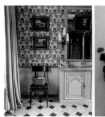

LEFT: Residence of Christopher Burch, Senlis, France. Photograph by Carlos Mota.
RIGHT: Private residence in Portugal. Photograph by Carlos Mota.

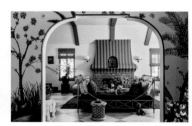

Residence of Jessica Hart and James Kirkham, Los Angeles. Interior design by Carlos Mota. Photograph © Douglas Friedman.

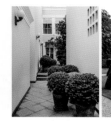

LEFT: Garden designed by Carlos Mota, Lima, Peru. Photograph © Gonzalo Cáceres Dancuart.
RIGHT: Garden of Christopher Burch, Senlis, France. Photograph by Carlos Mota.

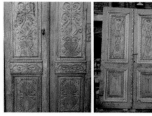

Doors in an antiques store, Cairo. Photographs by Carlos Mota.

LEFT: Baron Empain Palace Museum, Cairo. Photograph by Carlos Mota.
RIGHT: A bathroom in Milton Hall, Cambridgeshire, England. Photograph © James Fennell/The Interior Archive.

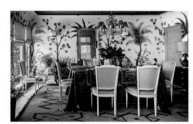

Residence of Jessica Hart and James Kirkham, Los Angeles. Interior design by Carlos Mota. Photograph © Douglas Friedman.

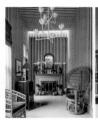

LEFT: Interior design by Nicholas Obeid. Photograph © Gieves Anderson/Trunk Archive.
RIGHT: Cabana on the beach, Lisbon. Photograph by Carlos Mota.

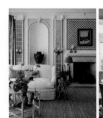

LEFT: Private residence in New York City. Interior design by Alexia Leuschen. Photograph © Bjorn Wallander.
RIGHT: Interior design by Marianne von Kantzow. Photograph © Simon Upton/The Interior Archive.

LEFT: Photograph by Carlos Mota.
RIGHT: Shop in Capri, Italy. Photograph by Carlos Mota.

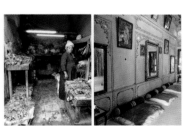

LEFT: A market in Cairo. Photograph by Carlos Mota.
RIGHT: Jaipur, India. Photograph by Carlos Mota.

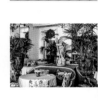

LEFT: Restaurant Florio, Villa Igiea Hotel, Palermo, Sicily. Interior design by Paolo Moschino and Philip Vergeylen. Photograph © Massimo Listri.
RIGHT: Private residence in the Dominican Republic. Interior design by Carlos Mota. Photograph © Misael Ramirez.

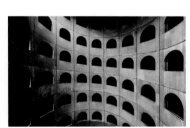

Celestins. Photograph © Reginald Van de Velde.

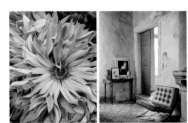

LEFT: Photograph by Carlos Mota.
RIGHT: Interior design by Irene Salvagni. Photograph © Nicolas Mathéus/Laurence Dougier.

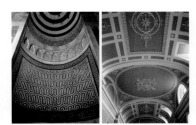

LEFT: A mosque in Cairo. Photograph by Carlos Mota.
RIGHT: Milton Hall, Cambridgeshire, England. Photograph © James Fennell/The Interior Archive.

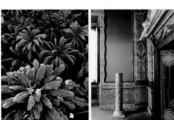

LEFT: Photograph by Carlos Mota.
RIGHT: A palace in Rome. Photograph by Carlos Mota.

LEFT: Interior design by M + M. Photograph © Aimée Mazzenga.
RIGHT: Residence of Jessica Hart and James Kirkham, Los Angeles. Interior design by Carlos Mota. Photograph © Douglas Friedman.

LEFT: Interior design by Gerard Decoster. Photograph © Jacques Dirand/The Interior Archive.
RIGHT: Ceramic frogs, Madrid. Photograph by Carlos Mota.

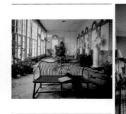

LEFT: Residence in Port Eliot, Cornwall, England. Architecture by Sir John Soane. Photograph © Fritz von der Schulenburg/The Interior Archive.
RIGHT: Residence of James Jordan, Mérida, Mexico. Interior design by John Prentice Powell and James Jordan. Photograph © Matthieu Salvaing.

LEFT: Residence of José Duarte Lobo de Vasconcellos, Santiago de Cacém, Portugal. Photograph by Carlos Mota.
RIGHT: Interior design by Hubert de Givenchy. Photograph © Francis Hammond.

LEFT: Residence in Madrid. Photograph by Carlos Mota.
RIGHT: Private residence in New York City. Interior design by Alexia Leuschen. Photograph © Bjorn Wallander.

LEFT: Photograph © unpict/Alamy Stock Photo.
RIGHT: Avocado soup, Dominican Republic. Photograph by Carlos Mota.

LEFT: Photograph © Jakob Faurvig/Thorvaldsens Museum.
RIGHT: Alcuzcuz Hotel Boutique, Málaga, Spain. Photograph by Carlos Mota.

LEFT: Residence of José Duarte Lobo de Vasconcellos, Santiago de Cacém, Portugal. Photograph by Carlos Mota.
RIGHT: Private residence in New York City. Interior design by Alexia Leuschen. Photograph © Bjorn Wallander.

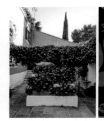

Alcuzcuz Hotel Boutique, Málaga, Spain. Photographs by Carlos Mota.

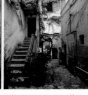

LEFT: Detail of painting by Joaquín Sorolla. Photograph by Carlos Mota.
RIGHT: Ravello, Italy. Photograph by Carlos Mota.

LEFT: Photograph by Carlos Mota.
RIGHT: Private garden, Portugal. Photograph by Carlos Mota.

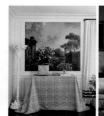

LEFT: Interior design by Mary McGee. Photograph © Ngoc Minh Ngo.
RIGHT: Chatsworth House, Derbyshire, England. Photograph © Simon Upton/The Interior Archive.

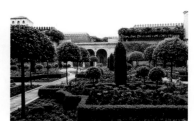

Garden at Casa de Pilatos, Seville, Spain. Photograph by Carlos Mota.

LEFT, CLOCKWISE FROM TOP LEFT: Outdoor seating in Spain, France, Spain, and France. Photographs by Carlos Mota.
RIGHT: Bench in Lisbon. Photograph by Carlos Mota.

LEFT: Shack, Dominican Republic. Photograph by Carlos Mota.
RIGHT: Photograph by Carlos Mota.

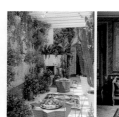

LEFT: Residence of designers Liza Bruce and Nicholas Alvis Vega, Ourika Valley, Morocco. Photograph © Simon Upton/The Interior Archive.
RIGHT: Interior design by Gérard Tremolet. Photograph © Simon Upton/The Interior Archive.

LEFT: Manasterly Palace, Cairo. Photograph by Carlos Mota.
RIGHT: Temple of Kom Ombo, Egypt. Photograph by Carlos Mota.

LEFT: Detail of wallcovering at Chatsworth House, Derbyshire, England. Photograph © Simon Upton/The Interior Archive.
RIGHT: A market in Cairo. Photograph by Carlos Mota.

LEFT: Detail of tiles, Lisbon. Photograph by Carlos Mota.
RIGHT: Private residence in New York City. Interior design by Carlos Mota. Photograph © Bjorn Wallander.

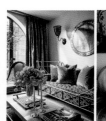

LEFT: Residence of Titina Penzini and Carlos Valedon, New York City. Interior design by Carlos Mota. Photograph © Bjorn Wallander.
RIGHT: Private residence in New York City. Interior design by Carlos Mota. Photograph by Carlos Mota.

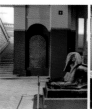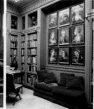

LEFT: Egyptian Museum, Cairo. Photograph by Carlos Mota.
RIGHT: Interior design by François-Joseph Graf. Photograph © Simon Upton/The Interior Archive.

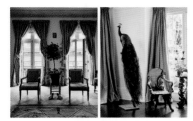

LEFT: Private residence in New York City. Interior design by Alexia Leuschen. Photograph © Bjorn Wallander.
RIGHT: Private residence in San Francisco. Interior design by Thomas Britt and Ann Getty. Photograph © Simon Upton/The Interior Archive.

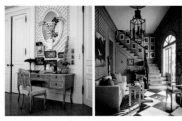

LEFT: Private residence in New York City. Interior design by Alexia Leuschen. Photograph © Bjorn Wallander.
RIGHT: Historic Creole cottage, New Orleans. Photograph © Eric Piasecki/OTTO.

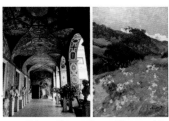

LEFT: Palazzo Altemps, Rome. Photograph by Carlos Mota.
RIGHT: Detail of a painting by Joaquín Sorolla. Photograph by Carlos Mota.

Residence in Venice. Photograph © Antonio Monfreda.

LEFT: Beaulieu House, Newport, Rhode Island. Interior design by Valerian Rybar. Photograph © Douglas Friedman/Trunk Archive.
RIGHT: Egyptian Museum, Cairo. Photograph by Carlos Mota.

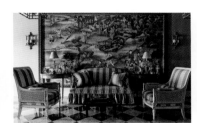

Interior design by Cathy Kincaid. Photograph © Bjorn Wallander.

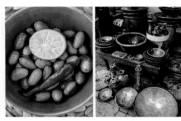

LEFT: Photograph © Tim Clinch/The Interior Archive.
RIGHT: Souk in Marrakech. Photograph by Carlos Mota.

LEFT: Doorway, Cairo. Photograph by Carlos Mota.
RIGHT: Interior design by Stephen Sills. Photograph © Simon Upton/The Interior Archive.

LEFT: Palácio da Bolsa, Porto, Portugal. Photograph by Carlos Mota.
RIGHT: Cabana on the beach, Lisbon. Photograph by Carlos Mota.

LEFT: Interior design by Paula Caravelli. Photograph © Simon Upton/The Interior Archive.
RIGHT: Interior design by Elisabeth Leriche and Thomas Boog. Photograph © Nicolas Mathéus/ Laurence Dougier.

LEFT: Photograph © Snowdon/Trunk Archive.
RIGHT: Pablo Picasso, *Woman Seated in a Chair*, 1941, oil on canvas, 39 ⅜ × 31 ⅞ in. Photograph © Christie's Images/© Succession Picasso/ DACS, London 2022/Bridgeman Images.

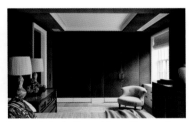

Interior design by Pappas Miron. Photograph © David A. Land/OTTO.

LEFT: Design by Cristóbal Balenciaga. Photograph © Chicago History Museum/Getty Images.
RIGHT: Parque del Retiro, Madrid. Photograph by Carlos Mota.

LEFT, CLOCKWISE FROM TOP LEFT: Grocery store, Egypt; Claire Tabouret, *Self-Portrait at the Table*, 2020; Grocery store, Egypt; Indian miniature painting. Photographs by Carlos Mota.
RIGHT: Greenhouse at the residence of Tory Burch, Antigua. Photograph by Carlos Mota.

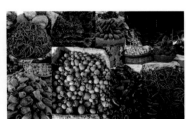

Photographs by Carlos Mota.

LEFT: Design by Hubert de Givenchy. Photograph © Francis Hammond.
RIGHT: Garden at Palazzo Avino, Ravello, Italy. Photograph by Carlos Mota.

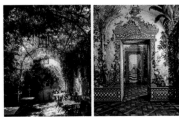

LEFT: Restaurant in Seville, Spain. Photograph by Carlos Mota.
RIGHT: Photograph © Schloss Schönbrunn Kultur- und Betriebsges GmbH/Photo Alexander Eugen Koller.

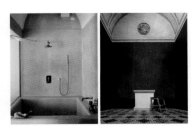

LEFT: Villa Cenci, Puglia, Italy. Architecture by Alberto di Santo & Bianco Bros. Photograph © Stefano Scata/The Interior Archive.
RIGHT: *Intimacy*. Photograph © Jakob Faurvig/ Thorvaldsens Museum.

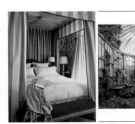

LEFT: Interior design by Alessandra Branca. Photograph © Thibault Jeanson.
RIGHT: *Orangerie Hof ter Borght*. Photograph © Reginald Van de Velde.

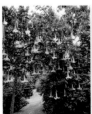

LEFT: Lima, Peru. Photograph by Carlos Mota.
RIGHT: Photograph © Simon Upton/The Interior Archive.

LEFT: Photograph by Carlos Mota.
RIGHT: Opal and emerald earrings by BHAGAT, Mumbai, India. Photograph by Jignesh Jhaveri.

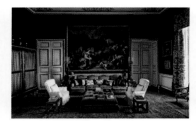
Interior design by Hubert de Givenchy. Photograph © Francis Hammond.

LEFT: Residence of Veere Grenney, Tangier. Photograph by Carlos Mota.
RIGHT: Villa Doria Pamphili public park, Rome. Photograph by Carlos Mota.

LEFT: Dosso Dossi (Giovanni di Nicolò Luteri), *Saint Sebastian*, 1526–27, oil on panel, 71 5/8 × 37 3/8 in. Photograph Pinacoteca di Brera.
RIGHT: The Alhambra, Granada, Spain. Photograph by Carlos Mota.

LEFT: Residence of Muriel Brandolini, Hampton Bays, New York. Photograph by Carlos Mota.
RIGHT: *The Hotel, Lago Maggiore*. Photograph © Reginald Van de Velde.

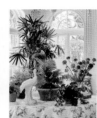
LEFT: Interior design by Mary McGee. Photograph © Ngoc Minh Ngo.
RIGHT: Private residence. Interior design by Carlos Mota. Photograph © Bjorn Wallander.

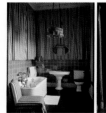
LEFT: Interior design by Flora Soames. Photograph © Simon Upton.
RIGHT: Interior design by Nicky Haslam and Studio QD. Photograph © Simon Upton.

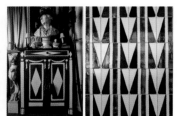
LEFT: Residence of antiques dealer Ranuncho de St Armand, Normandy. Photograph © Jacques Dirand/The Interior Archive.
RIGHT: Detail of tiles, Lisbon. Photograph by Carlos Mota.

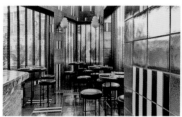
La Bande restaurant, San Francisco. Interior design by Kelly Wearstler. Photograph © Manolo Yllera.

LEFT: Skogaholm Manor, Sweden. Photograph © Jacques Dirand/The Interior Archive.
RIGHT: Architecture by Jean Bosc. Photograph © Nicolas Mathéus/Laurence Dougier.

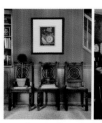
LEFT: Interior design by Mark D. Sikes. Photograph © Amy Neunsinger.
RIGHT: Residence of Pablo Bronstein in Deal, Kent, England. Photograph © Brotherton-Lock.

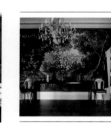
LEFT: Residence of Aerin Lauder in New York City. Interior design by Jacques Grange. Photograph © Simon Upton/The Interior Archive.
RIGHT: Residence of Christopher Burch, Senlis, France. Photograph by Carlos Mota.

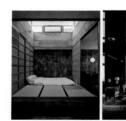
LEFT: Residence of Thai artist Rikrit Tiravanija. Architecture by Aroon Puritat and Fernlund + Logan. Photograph © Jason Schmidt/Trunk Archive.
RIGHT: Architecture by Atelier AM. Photograph © Nikolas Koenig/OTTO.

LEFT: Interior design by Studio Peregalli. Photograph © Simon Upton/The Interior Archive.
RIGHT: Palace in India. Photograph © Bjorn Wallander.

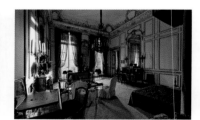
Interior design by Hubert de Givenchy. Photograph © Francis Hammond.

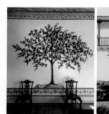
LEFT: Palácio da Bolsa, Porto, Portugal. Photograph by Carlos Mota.
RIGHT: Hotel courtyard in Cuzco, Peru. Photograph by Carlos Mota.

LEFT: Shop in Tangier. Photograph by Carlos Mota.
RIGHT: Agnolo Bronzino, *Lodovico Capponi*, 1550–55, oil on panel, 45 7/8 × 33 3/4 in. Photograph The Frick Collection.

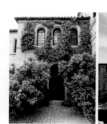
LEFT: Private residence in Toledo, Spain. Photograph by Carlos Mota.
RIGHT: Residence in Granada, Spain. Photograph by Carlos Mota.

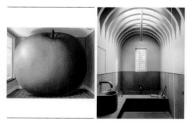
LEFT: René Magritte, *The Listening Room*, 1958, oil on canvas, 14 3/4 × 18 in. Photograph © Christie's Images/Bridgeman Images/DACS London 2022.
RIGHT: Interior design by Studio Ben Allen. Photograph © French + Tye.

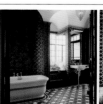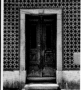
LEFT: Interior design by Jed Johnson. Photograph © Fritz von der Schulenburg/The Interior Archive.
RIGHT: Doorway, Lisbon. Photograph by Carlos Mota.

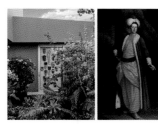

LEFT: Residence of Carlos Mota, Dominican Republic. Interior design by Carlos Mota. Photograph © Misael Ramirez.
RIGHT: Jean-Étienne Liotard, *The Fourth Earl of Sandwich*, 1738, oil on canvas, 85 7/16 × 56 1/2 in. Photograph © Agnew's, London/Bridgeman Images.

LEFT: Jean-Léon Gêrome, *The Carpet Merchant*, ca. 1887, oil on canvas, 33 7/8 × 27 1/16 in. Photograph © Minneapolis Institute of Art/The William Hood Dunwoody Fund/Bridgeman Images.
RIGHT: Interior design by Veronica Prida. Photograph © Michel Arnaud/The Interior Archive.

LEFT: Detail of a sarcophagus, Cairo. Photograph by Carlos Mota.
RIGHT: Enoc Perez, *Manhattan Apartment of Si and Victoria Newhouse, NYC (with Barnett Newman's "Who's Afraid of Red Yellow and Blue")*, 2021, oil on canvas, 60 × 60 in. Photograph © S. J. Newhouse, courtesy Enoc Perez Studios and Galerie Enrico Navarra.

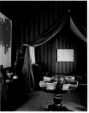

LEFT: Interior design by Adelheid von der Schulenburg. Photograph © Fritz von der Schulenburg/The Interior Archive.
RIGHT: Jan van Eyck, *The Arnolfini Marriage*, 1434, oil on panel, 30 × 24 in. Photograph Bridgeman Images/National Gallery, London.

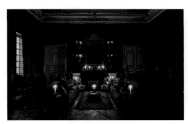

Interior design by Hubert de Givenchy. Photograph © Francis Hammond.

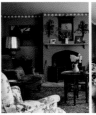

LEFT: Interior design by Gavin Houghton. Photograph © Bozho Gagovski.
RIGHT: Interior design by Alessandra Branca. Photograph © Thomas Loof.

LEFT: Photograph by Carlos Mota.
RIGHT: Residence of Javier Gonzlaes, Spain. Photograph © Javier Gonzales.

LEFT: Musée national de la Marine, Paris. Photograph by Carlos Mota.
RIGHT: Ronda, Spain. Photograph by Carlos Mota.

LEFT: Shack, Dominican Republic. Photograph by Carlos Mota.
RIGHT: Interior design by Patrick Mele. Photograph © Kyle Knodell.

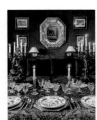

LEFT: Interior design by Vinicius Sandi. Photograph © Allan Casagrande.
RIGHT: Residence of Javier Gonzales, Spain. Photograph © Javier Gonzales.

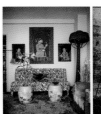

LEFT: Private residence in New York City. Interior design by Carlos Mota. Photograph © Bjorn Wallander.
RIGHT: Indian miniature painting. Photograph by Carlos Mota.

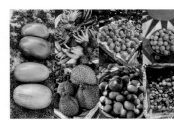

Photographs by Carlos Mota.

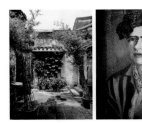

LEFT: Hoi An, Vietnam. Photograph by Carlos Mota.
RIGHT: Painting in a Paris flea market. Photograph by Carlos Mota.

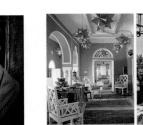

LEFT: Residence of designers Liza Bruce and Nicholas Alvis Vega, Ourika Valley, Morocco. Photograph © Simon Upton/The Interior Archive.
RIGHT: Residence of Emily Eerdmans in New York City. Interior design by Emily Eerdmans. Photograph © Kelly Marshall/OTTO.

LEFT: Photograph by Carlos Mota.
RIGHT: Shack, Dominican Republic. Photograph by Carlos Mota.

LEFT: Photograph by Carlos Mota.
RIGHT: Villa Ortizet in Saint-Pierre-le-Vieux, France. Architecture and interior design by Anthony Authié and designer Charlotte Taylor of Zyva Studio. Photograph courtesy of Anthony Authié, Charlotte Taylor.

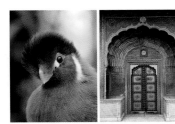

LEFT: Photograph © Panther Media GmbH/Alamy Stock Photo.
RIGHT: A door of the City Palace, Jaipur, India. Photograph © John Harper/Getty Images.

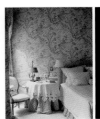

LEFT: Interior design by Alessandra Branca. Photograph © Thomas Loof.
RIGHT: Photograph © Debi Shapiro.

LEFT: Interior design by Gert Voorjans. Photograph © Tim Van de Velde.
RIGHT: Interior design by Manfredi della Gherardesca. Photograph © Antonio Monfreda.

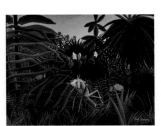

Henri Rousseau, *Jaguar Attacking a Horse*, 1910, oil on canvas, 45 5/8 × 35 7/16 in. Photograph © Henri J. F. Rousseau (1844–1910)/Bridgeman Images.

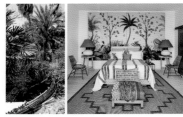

LEFT: Garden in Aswan, Egypt. Photograph by Carlos Mota.
RIGHT: Residence of Carlos Mota, Dominican Republic. Interior design by Carlos Mota. Photograph © Misael Ramirez.

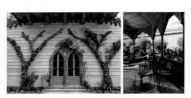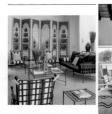

LEFT: Chalet of the Countess of Edla, Sintra, Portugal. Photograph by Carlos Mota.
RIGHT: Garden in Marrakech. Photograph by Carlos Mota.

LEFT: Interior design by Stephen Falcke. Photograph © Fritz von der Schulenburg/The Interior Archive.
RIGHT: Interior design by Alexandre Neimann; *Cathédrale d'arbres* tapestry by Anne Laure. Photograph © Nicolas Mathéus/Laurence Dougier.

LEFT: Avocado salad by Chef Samih Ahmed. Photograph by Carlos Mota.
RIGHT: Francis Bacon, *Head*, ca. 1967, oil on canvas, 18 ½ × 15 in. Photograph © The Estate of Francis Bacon. All rights reserved. /DACS, London/ARS, NY 2022, catalogue raisonné No 67-25.

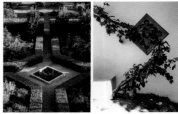

LEFT: Private garden in Mallorca. Photograph © Filippo Venturi.
RIGHT: Tangier. Photograph by Carlos Mota.

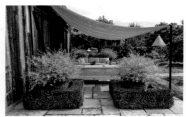

Garden at the Santo Domingo residence, Southampton, New York. Photograph by Carlos Mota.

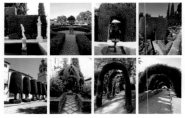

Topiary around the world. Photographs by Carlos Mota.

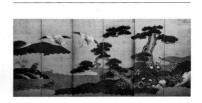

Japanese School screen, 18th century. Photograph © Christie's Images/Bridgeman Images.

LEFT: Photograph by Carlos Mota.
RIGHT: Residence of Jessica Hart and James Kirkham, Los Angeles. Interior design by Carlos Mota. Photograph © Douglas Friedman.

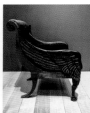

LEFT: Antique chair. Photograph by Carlos Mota.
RIGHT: Interior design by Joanna Plant. Photograph © Simon Upton/The Interior Archive.

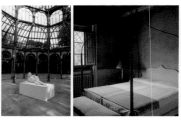

LEFT: Parque del Retiro, Madrid. Photograph by Carlos Mota.
RIGHT: Interior design by Piero Castellini Baldissera. Photograph © Simon Upton/The Interior Archive.

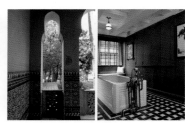

LEFT: Manial Palace, Cairo. Photograph by Carlos Mota.
RIGHT: Interior design by Jed Johnson. Photograph © Fritz von der Schulenburg/The Interior Archive.

LEFT: Villa Doria Pamphili public park. Photograph by Carlos Mota.
RIGHT: Hans Holbein the Younger, *The Ambassadors*, 1533, oil on panel, 81 × 82 ½ in. Photograph © Bridgeman Images.

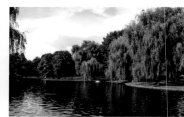

Boston Public Garden. Photograph by Carlos Mota.

Acknowledgments

Working on a book takes a village—
a small village of wonderful people.

Most important are the amazing photographers
whose incredible images are the life blood of this book,
and the friends, clients, and designers who opened their
extraordinary homes to be part of *G*.

My beautiful and oldest friend Titina, for all the
incredible watercolors throughout the book,
adding that extra-special touch.

My remarkable team at Vendome:
Celia Fuller, Jackie Decter, Jim Spivey,
and the elegant Mark Magowan.

My expert photo researcher, Karen Howes.

Charles Cator and Tancredi Massimo di Roccasecca,
for suggesting Hubert de Givenchy's dictum
as the epigraph of the book.

But my deepest gratitude goes not to a person but to NATURE
for being a constant inspiration and for always forgiving us
humans. We abuse you, we destroy you, and we take you for
granted, but you are always there, giving our lives beauty.
I salute you and I thank you.

—CM

G: Forever Green
First published in 2022 by The Vendome Press
Vendome is a registered trademark of The Vendome Press LLC

VENDOME PRESS US
P.O. Box 566
Palm Beach, FL 33480

VENDOME PRESS UK
Worlds End Studio
132-134 Lots Road
London, SW10 0RJ

www.vendomepress.com

Distributed in North America by Abrams Books
Distributed in the United Kingdom, and the
rest of the world, by Thames & Hudson

ISBN 978-0-86565-408-2

PUBLISHERS:
Beatrice Vincenzini, Mark Magowan, and Francesco Venturi
EDITOR: Jacqueline Decter
PRODUCTION DIRECTOR: Jim Spivey
DESIGNER: Celia Fuller
ILLUSTRATOR: Titina Penzini

Library of Congress Cataloging-in-Publication Data
available upon request

Printed and bound in China by 1010 Printing International Ltd.

FSC
www.fsc.org
MIX
Paper from
responsible sources
FSC® C016973

FIRST PRINTING